A History of
American Pewter

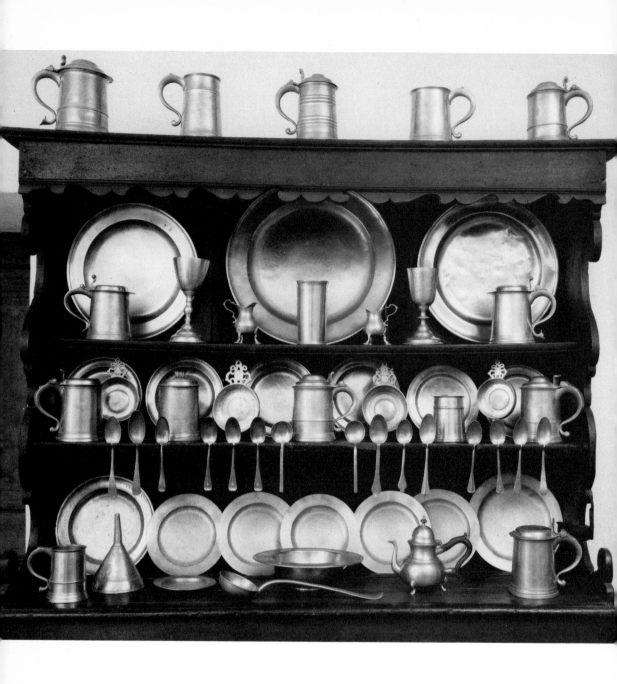

Revised and Enlarged Edition

A History of American Pewter

Charles F. Montgomery

A Dutton Paperback

A Winterthur Book

E. P. Dutton · New York

To Ledlie Irwin Laughlin,
mentor to collectors of American
pewter from the 1930's to the present

Frontispiece: A variety of eighteenth-century pewter objects from the Middle Atlantic colonies displayed on the shelves of a walnut cupboard in the Kershner Kitchen of The Henry Francis du Pont Winterthur Museum.

For information contact: E. P. Dutton, 2 Park Avenue, New York, N.Y. 10016

Library of Congress Catalog Card Number: 77-77937

ISBN: 0-525-47467-6

Published simultaneously in Canada by Clarke, Irwin & Company Limited, Toronto and Vancouver

10 9 8 7 6 5 4 3 2 1

Contents

Acknowledgments

The chase for American pewter and for information about pewter has brought me many friends. It all began with Herbert Rublee, a kindly master at Mercersburg Academy, who opened my eyes to the qualities of old pewter about 1934—and in so doing changed the course of my life. He introduced me to Ledlie I. Laughlin, author of *Pewter in America*. Throughout this book, reference will be made to those three magnificent volumes. The reader is directed to them for biographical information about American pewterers and their work that is not included here. The present book, as is true of most writing on American pewter since 1940, depends heavily on Mr. Laughlin's basic research. My debt to him is great for counsel, guidance, and the information he has furnished me since 1934 in hundreds of letters—each carefully written in beautiful longhand. Typical of his generosity is the loan of many photographs of objects in his collection and others for illustration in this book.

Edgar P. Richardson, who followed me as director of the Winterthur Museum, encouraged me to undertake this publication; Charles van Ravenswaay, Winterthur's present director, and John A. H. Sweeney, senior deputy director in charge of collections, have done all in their power to bring it to conclusion. John D. Morse, former editor of Winterthur publications, offered suggestions for its format. Ian M. G. Quimby, present editor, has read the manuscript and has pointed out ways to improve it, as has John J. Evans, Jr. Nancy Goyne Evans, museum registrar, has read parts of the manuscript and shared with me many references to pewter and its use gleaned in the course of her research. Further, her study "Britannia in America" has been extremely useful to me. Illustrated with objects in the Winterthur collection, and published in *Winterthur Portfolio II*, it stands as the best study of britannia and its production.

To Victor F. Hanson, head of the Winterthur Museum's Analytical Laboratory, I am deeply grateful for opening a whole new field of information about the components of American pewter alloys.

As sources of information about current discoveries in "pewter land," I call attention to the *Bulletin* of the Pewter Collectors' Club of America and *Antiques* magazine. In particular, I express my appreciation to the former and present editor of the latter, Alice Winchester and Wendell Garrett. The late Carl Jacobs, his wife, now Celia Jacobs Stevenson, and Thomas D. and Constance R. Williams scouted out much American pewter over the past thirty years and passed on valuable information to me.

Thanks are due Barbara Gilbert Carson for her exploration of the archives of Harvard College in search of information on the early use of pewter in the college. Her husband, Cary, is among the many individuals who provided helpful notes and useful information of many kinds. Others who helped are: Thomas R. Adams, Bart Anderson, Louise C. Belden, Helen R. Belknap, Whitfield J. Bell, Jr., Helen Duprey Bullock, Lester J. Cappon, John H. Carter, Wilford P. Cole, Wendy Cooper, Eric de Jonge, Leon de Valinger, Jr., Lynne Delehanty DiStefano, Joan Dolmetsch, Catherine Fennelly, Donald L. Fennimore, Joseph France, Avis and Rockwell Gardiner, James Garvin, Harold Gill, Suzanne C. Hamilton, Robert L. Harley, Loomis Havemeyer, Constance Vecchione Hershey, James J. Heslin, Elizabeth Hamlin Hill, John H. Hill, Sinclair H. Hitchings, Mary Norton Holt, Charles F. Hummel, Amy L. Jarmon, J. Stewart Johnson, John D. Kernan, John T. Kirk, Leonard W. Labaree, Dorothy D. Lalone, Dwight P. Lanmon, Christine Meadows, Mr. and Mrs. Charles N. Mellowes, Joseph K. Ott, Charles S. Parsons, Huldah Smith Payson, Harold Peterson, William M. Pillsbury, William C. Pollard, Mary Lyn Ray, Lola S. Reed, Elizabeth A. Rhoades, Esther Rich, Edward M. Riley, Stephen T. Riley, Karol A. Schmiegel, Mrs. Samuel Schwartz, Jane S. Shadel, Ray-

mond V. Shepherd, Jr., Clifford K. Shipton, Charles B. Simmons, Charlotte and Edgar Sittig, John J. Snyder, Jr., Charles V. Swain, Nicholas B. Wainwright, and Elizabeth Ingerman Wood.

For many courtesies during their lifetime, I am grateful to Paul J. and Edna Franklin. After the latter's death, Bart Anderson kindly made available to me her clippings and photographs of old pewter.

The excellent photographs that illustrate this book are for the most part the work of Geoffrey Clements of Staten Island, New York, Curtis Robinson of Newark, Delaware, and George J. Fistrovich.

For permission to illustrate objects in their collections I thank the following: Mrs. Peter H. Alderwick; American Antiquarian Society; The Brooklyn Museum; Chester County Historical Society; Mr. and Mrs. Oliver Deming; Mrs. Merritt Dexter, Christ Church Parish, West Haven, Conn.; General Assembly of the United Presbyterian Church in the United States of America; Historical Museum, Rotterdam; Historical Society of York County, Pennsylvania; International Business Machines Corporation; William F. Kayhoe; John H. McMurray; The Metropolitan Museum of Art, New York; Museum of Fine Arts, Boston; New Haven Colony Historical Society; The New York Historical Society; The New York Public Library; Pocumtuck Valley Memorial Association; Mrs. Ralph B. Post; Salem Lutheran Church, Aaronsburg, Pennsylvania; Smithsonian Institution; Suffolk Museum and Carriage House; Charles V. Swain; Toledo Museum of Art; Mr. and Mrs. Richard F. Upton; Mr. and Mrs. Thomas D. Williams; Yale University Art Gallery, The Mabel Brady Garvan Collection; Mr. and Mrs. Paul M. Young.

Benno M. Forman gave me many notes and much helpful criticism, and I often turned to Barbara C. Kroll for editorial advice. Catherine H. Maxwell organized and kept in order files out of which she helped draft captions for many illustrations. She typed the first versions of the manuscript and edited the last one. This book owes a great deal to her. My long-time friend the late Donald D. MacMillan hunted background illustrations and helped with preliminary organization of the book. My son, Charles F. Montgomery, Jr.,

has brought enthusiasm and clear thinking to the manuscript. His blue pencil has clarified many passages and saved the reader much repetition. I am particularly indebted to my wife, Florence, who has lived with this book for so many years.

The task of transforming manuscript and photographs into a beautiful book has been accomplished by Praeger Publishers. I especially appreciate the patience of Brenda Gilchrist and the precision and painstaking devotion of Cherene Holland, senior editor and assistant editor, respectively, of the art book division, and the logical mind of Nora Conover, special editor. Matthew Held was in charge of production and Gilda Kuhlman was the designer of the book.

To all of the people mentioned above I offer my warmest thanks. But the one man who made it possible is the late Henry Francis du Pont, founder of The Henry Francis du Pont Winterthur Museum. He created the Winterthur collection on which this study is so closely based. Mr. du Pont began to buy pewter in 1923. In that year he acquired lamps and candlesticks, probably with the thought of electrifying them to provide light for cupboards and dark corners. By 1938, when I first visited Winterthur, he had collected more than a hundred pieces, including some important forms and rare marks. Eleven pieces from his collection were shown in the great pewter exhibition held at the Metropolitan Museum of Art in 1939. From that time until his death he bought piece after piece of American pewter. To say that he liked pewter more than furniture, china or textiles, would be a distortion, for, great collector that he was, he appreciated all arts. However, I know of few instances after 1938 when he failed to buy an important piece of pewter offered for purchase. The Winterthur pewter collection, because of the variety of seventeenth-, eighteenth-, and nineteenth-century forms, many of which are outstanding examples of their kind, stands among the greatest collections of American pewter. After having had an active part in the discovery and acquisition of many pieces illustrated in this book, it is my happy lot to write about them.

CHARLES F. MONTGOMERY

A Special Note for
the New Edition of
A History of American Pewter

I am pleased to be able to add to this new edition a chapter on "The Collecting of American Pewter Before 1950," which could not be included in the first edition because of space limitations. As originally written, this chapter began with some notes on the development of the literature of American pewter and included brief statements about people who had formed major collections. In most cases I had followed the growth of their collections and had personally known the collectors and their ways of collecting.

Now, Cyril I. Nelson, editor of this edition, has asked that I add my own views on how to collect pewter. This is a special pleasure, for my remarks may provoke accumulators to give more thought to what they buy for their cupboards. I realize that what I say may arouse controversy. If that happens, bravo; so much the better! People will then start thinking more deeply about the subject and more interesting collections could be the result.

A History of
American Pewter

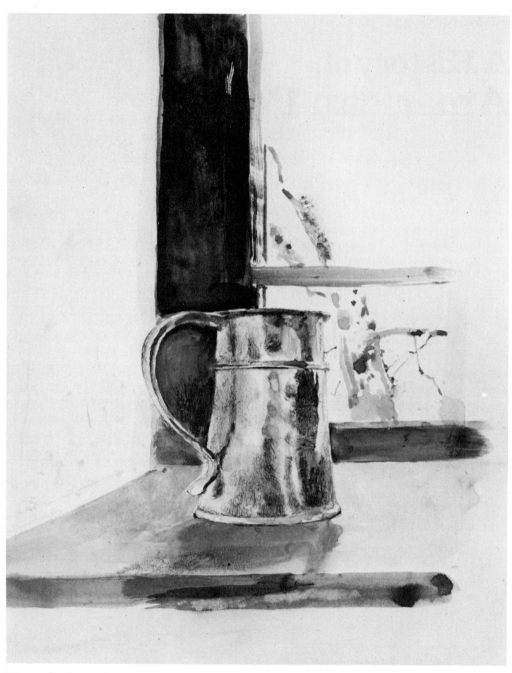

Watercolor by Andrew Wyeth of a pewter mug, 1968 (collection of Mr. and Mrs. Charles F. Montgomery).

Introduction

From the time of first settlement through the Revolutionary War, all Americans aspired to eat and drink from pewter. Every American who could afford it used pewter daily. For the common man the appeal of pewter continued into the 1870's, by which time the nineteenth-century version of pewter, called britannia, lost its identity and became the white-metal base for silver plate. Even before britannia production was phased into silver-plate manufacture, there were antiquarians who regarded pewter as worth saving. An old pewter beaker was the first recorded object given to the New Hampshire Historical Society in Concord in 1839. Soon thereafter, private individuals began to collect old pewter along with old furniture and other objects, and by the early 1900's there was an active trade in antique pewter. By 1934, a group of pewter collectors had founded the Pewter Collectors' Club of America, which has held regular meetings and published a semiannual bulletin since that time. Indicative of early research and publication is the list of nearly 100 books and articles on American pewter presented in the PCCA *Bulletin*, no. 15, for October, 1945.

The artistry of the American pewterer was memorialized in an extraordinary loan exhibition of 370 pieces of marked American pewter held at the Metropolitan Museum of Art in 1939. As Joseph Downs, then curator of the American Wing, ex-plained in the museum *Bulletin*, the two-fold purpose of the exhibition was "first to show the diversity of form which the earliest pewterers gave to their work, with attention paid to both the sleekness of the contours and the quiet beauty of the metal, and second, to show the widest variety of clear and complete touches, or makers' marks." The beauty of the "pewter selected from the foremost collections in the country, arranged with feeling and taste, and displayed to its best advantage" apparently had an effect on Henry Francis du Pont. Already his collection was more than a modest one, with eleven pieces included in the exhibition, but soon thereafter he began to collect pewter in earnest. About this time Mr. du Pont learned of the versatility of the highly reputed Philadelphia pewterer Colonel William Will. He set out to acquire other pieces to accompany what was then his most important piece, a dish 16⅜ inches in diameter—the largest known. Eventually Mr. du Pont was to fill a cupboard with 38 pieces of Will's pewter showing the range of forms made by this talented Philadelphian. Study of these 27 different forms in the Fraktur Room at Winterthur (Fig. 1–1) reveals at the same time Will's changing styles and Henry Francis du Pont's enthusiasm and perseverance in collecting. In 1939 many of these pieces were already in private collections, but over the years they found their way to Winterthur—in part by gift

from Charles K. Davis and Joseph France and in part by purchase from the collections of Mrs. Harry Horton Benkard, Charles A. Calder, Ivan Culbertson, Charles F. Hutchins, Edward E. Minor, Melville T. Nichols, and Senator and Mrs. Richard S. Quigley.

Upon my first view of an old pewter dish, I was caught by its color, its character, and its form. Since that day in 1934, old pewter has had a very special appeal which I have tried to put into words and pictures. Indeed, one of my most compelling reasons for wanting to write this book was to illustrate pewter in such a way that others could sense its color, soft sheen, and textural qualities as they appear to me. For several years I tried to reproduce in photographs the images that were in my mind's eye. I experimented with various kinds of photographic rigs—translucent glass table tops and backdrops, cloth tents, shower curtain enclosures, and, finally, a white polyethylene barrel. In the latter, highlights and harsh reflections were controlled, but the pewter looked white, like cast aluminum.

One day, after examining several unsatisfactory photographs, I noticed by chance the olive and brown shadows in a watercolor sketch of a pewter mug painted for me by Andrew Wyeth. Soon afterward, I acquired an amber plastic barrel from the late Eric Glenn, former manager of the Delaware Plastics Division of the Container Corporation of America. Pewter illuminated in this barrel really looked like pewter, and in my photographs it looked like pewter. For larger objects and groups, the same company provided an amber 500-gallon drum (6 feet long and 4 feet in diameter), which is shown on page 3, with various lights arranged for photography. The barrel (with shower curtain hanging in front) enables one to control the variables of lighting, permitting overall illumination comparable to daylight without the un-

pleasant reflections of direct lighting. Most of the excellent photographs of pewter at Winterthur were taken with this kind of apparatus by Geoffrey Clements and Curtis Robinson.

In the present book I have undertaken a cultural approach to pewter objects, treating them as craft products filling daily physical needs of early Americans, as art forms and as objects treasured by collectors. For firsthand references to the use of pewter I have turned to journals and travel books. Paintings and prints have been included to provide intimate views of life in the pewter era. New information about craft practices has come from Pierre Auguste Salmon's *L'Art du Potier d'Etain*, published as part of the Royal Academy of Science's great eighteenth-century encyclopedia, *Descriptions des Arts et Métiers*. Locked in its archaic French, and not hitherto translated, were many secrets about the pewterer's craft and the way the designs of the pewterer were achieved.

In the only known journal of a pewterer, that of Richard Lee of eastern Massachusetts and North Springfield, Vermont, the author is reticent about his craft. He tells us of his misfortunes and wanderings, but little more. Indeed it is difficult to find an account by *any* diarist that describes either the manufacture or the marketing of objects used in everyday life before 1850. There are few drawings, prints, watercolors, or oil paintings of early American shops or homes. The only known eighteenth-century view of a shop interior is the one painted on the banner carried by the Society of Pewterers in the New York Federal Procession of 1788 (Fig. 2–1).

No account or letter book of an eighteenth-century, or earlier, American pewterer has been located. Were the records of such successful pewterers as Simon Edgell, Frederick Bassett, and William Will available, they could provide in-

valuable information about the craft—annual production, volume of business, sales and distribution, and wholesale operations. Did Philadelphia's most important early pewterer, Simon Edgell, for example, supply traders and storekeepers with his wares for resale? What were the relationships between pewterers? Did Frederick Bassett buy tankard lids, thumb pieces or handles from his neighbors Henry Will, William Kirby, and William Elsworth, or did he sell these parts to them? How many journeymen or apprentices were working in any one of their shops? Were journeymen paid on a piecework basis? Did they specialize as hammermen, casters, or finishers? What was their daily output? What was the most

A polyethylene barrel used in making many of the photographs in this book enabled the photographer to control the variables of lighting and to avoid the unpleasant reflections occasioned by direct illumination.

popular size of dishes, plates, porringers, or mugs? How did the amount of pewter made in America in 1750 compare with production in 1790? What was the relationship between the cost of labor and the cost of material in pewter articles? When was the American pewterer able to buy pure tin to upgrade the alloy of the old pewter that he was reworking? Connecticut pewterers seem to have been involved in the tinsmithing trade as well. Many employed peddlers to hawk their wares through the countryside. Account books would throw new light on these transactions. Discovery of such American pewterers' records would be a great find! I hope one of my readers will be so lucky as to uncover such a group of manuscripts and be kind enough to bring them to my attention.

The pewter plate, mug, or tankard bears the same relationship to the molds in which its parts were cast that an engraving bears to the plate from which it was struck. Each is a multiplied image. Each justifies the great effort that went into the preparation of the brass molds for making pewter castings or into etched and engraved copper plate for creating an inked impression on paper. Like the engraver's plate, the pewterer's mold repeats the perfection or shortcoming of the original form. All pewter underwent a finishing process of scraping by hand or skimming and polishing on a lathe, but the character of the finished product was produced by the molds made by master pewterers.

New research confirms that the American pewterer made his own molds and thus was capable of being an artist rather than a mere mechanic giving form to the designs of English mold makers, as has sometimes been thought. Pewter designs changed over time, but the very considerable effort and outlay for raw materials that went into each new set of molds served as a brake on rapid swings in fash-

ion. In general, stylistic changes in silver forms are reflected in pewter, but old forms continued in use long after new ones were introduced.

Today, pewter collecting offers a challenge to find rare and beautiful objects, and a game to identify them and group them into a meaningful array as an ornament to one's house and daily life. Some collectors are caught up by the beauty of the metal, the relationships of form to material, and the ingenuity of the pewterer in combining parts to make new shapes. Others find pleasure in the role individual pieces played in the life of the times in which they were made.

The chance of finding a bargain and the opportunity to pit one's judgment against the market are unquestionably strong motivators for most collectors. Investors in choice eighteenth-century pewter have seen their investments rise tenfold in the past twenty years to become almost as negotiable as stocks and bonds. Collectors are often ahead of museums in their desire to preserve objects for the next generation.

Social considerations also contribute to the interest of collecting. Fellow collectors find pleasure in sharing common interests and new discoveries. Collecting friendships cut across all class barriers. The Pewter Collectors' Club of America has added greatly to the camaraderie and to the growth of pewter collecting in the United States. In 1972, the club had a membership of about five hundred, which probably included half the pewter collectors in the country.

To the eighteenth-century housewife, pewter objects were beautiful things to be kept polished and gleaming. From earliest times to 1850, no self-respecting woman would have set her table with dirty pewter or served tea from a dingy teapot, but, as so often happens in history, attitudes change. By 1903, some early collectors had come under the influence of "the cult of the antique" and, as ex-

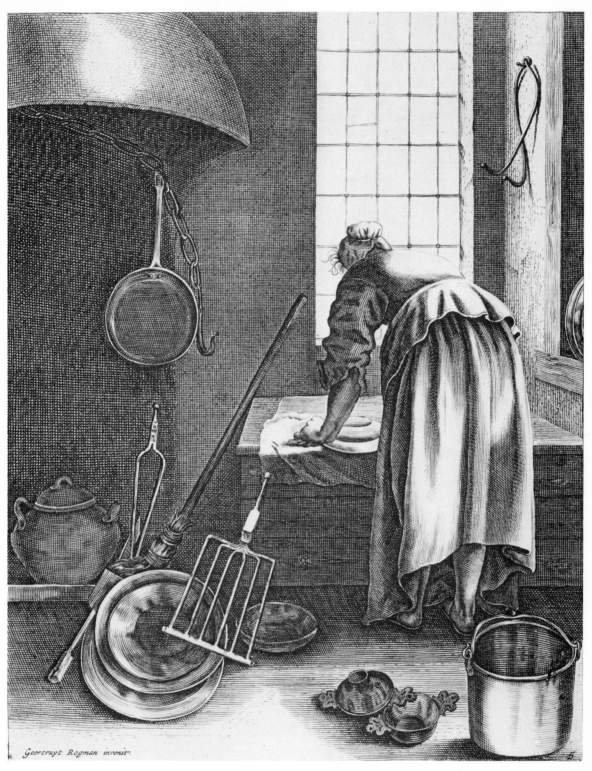

Geertruydt Roghman, *Polishing Metal*, ca. 1650 (The Metropolitan Museum of Art, Whittelsey Fund, 1956).

plained by Edwards J. Gale in *Pewter and the American Collector* (1903, pp. 87–88), they held the view that those who polished pewter willfully removed its chief charm and "effaced the revered and hardly acquired marks of age." Another writer of the period stated that the large majority of collectors left their pewter unpolished through thoughtlessness, uncertainty of the results of cleaning, or fear that proof of its genuineness would be lacking if it did not have "signs of dirt, tarnish, and corrosion." This school held that pewter should be left as found, in contrast to those who argued that to display corroded or oxidized or battered pewter was a disgrace to the metal. Today those in favor of clean pewter are very much in the majority, and directions will be found on page 240 for effectively cleaning old pewter without harming it.

Chapter One

Pewter in Everyday Life

The Chinese, Egyptians, Greeks, and Romans are known to have used vessels of pewter, an alloy composed largely of tin, to which is added in varying amounts lead, copper, antimony, and bismuth. Plautus mentions pewter dishes as being used at a banquet, and Galen recommends the keeping of antidotes and other drugs in vessels of glass, silver, or pewter.[1]

The widespread, almost universal, use of pewter in North America in the seventeenth and eighteenth centuries was not a colonial phenomenon. It was simply an extension of English and European practice. In the British Isles and on the Continent, pewter had been used for hundreds of years by all who could afford it. As Viollet-le-Duc pointed out, "Pewter in medieval days was the material in universal use for the tables and sideboards of the middle and upper classes, silver plate appearing only in the royal palaces and in the dwellings of the highest nobles, and then probably in very limited quantities at the upper table on the dais. The peasant and the artisan, it will be remembered, used plates, dishes and platters of wood."[2] This was also true in America. From the time of the first settlement, many used wooden plates and dishes, but those who could afford it used pewter.

Few colonials used china—either pottery or porcelain—before 1780. In 1857, John Fanning Watson recalled a conversation with an elderly lady who recounted that before the Revolution "pewter plates and dishes were in general use . . . [and that] China on the dinner tables was a great rarity."[3]

In his autobiography, Thomas Danforth Boardman, of the Danforth pewtering family in Connecticut, wrote:

> From the Landing of the Pilgrims to the Peace of the revolution Most all, if not all, used pewter plaits and platters, cups, and porringers imported from London & made up of the old worn out. This was done in Boston, New York, Providence, Taunton and other places.[4]

Few others commented so explicitly as Boardman on the long period of popularity of pewter in America and on the reworking of old, worn-out English pewter in American shops. Great quantities of pewter were imported to America from England. In his study of English export records, Robert W. Symonds found that

around 1720 the value of pewter imports from England began to exceed the combined totals of the value of silver objects, furniture, upholstery wares, including bedding, curtains, carpets, hangings, and upholstered furniture.[5] The average annual imports of pewter grew steadily. For the eight-year period ending 1728, they averaged a little more than £3,000 sterling annually. By the 1740's, the figure had increased to about £8,000 per year, and by the 1760's it had swelled to some £22,000 per year. These figures, based on a wholesale price of three pounds ten shillings per hundredweight, mean that in the 1760's more than three hundred tons of pewter were shipped annually to America. That was the equivalent of almost 1 million 8-inch pewter plates or 300,000 quart mugs or 250,000 quart tankards or 200,000 15-inch dishes.[6]

Daniel Wister, a Philadelphia merchant, ordered pewter regularly from his friend, the London pewterer John Townsend. The size of his orders is staggering. The order (detailed below) for 12,916 pieces is but one of three that Wister placed with Townsend in 1763.[7] The packaging that Wister requested is interesting. He asked for twenty-six casks, twenty-four of which were to be packed with 256 representative pieces each, and it is the writer's assumption that Wister considered the assortment a proper stock for a shop to which he might sell it en bloc. In each of the twenty-four casks he requested:

½ doz. Soup Dishes Vizt
1 dish of 3½ lb [size]
2 ” ” ” 3 lb
1 ” ” ” 2½ lb } common pewter
1 ” ” ” 2 lb
1 ” ” ” 1½ lb

½ doz. Shallow Dishes Vizt
1 dish of 3½ lb
2 ” ” ” 3 lb } common pewter
1 ” ” ” 2½ lb
1 ” ” ” 1½ lb

1 doz. soup plates . 10 lb
1 doz ” ” 9 lb
1 doz Shallow ” 8 lb } common pewter
1 doz ” ” 9 lb
1 doz ” ” 10 lb

28 Basons Vizt
4 ” 4 Quarts
10 ” 3 ” } common pewter
12 ” 2 ”
2 ” 1 ”

6 Quart Tankards
1 doz Porringers . . 6/6
1 doz ” 5/ } common pewter
3 pint Teapots without legs
3 pint ½ ” ” ”

6 Pint Pocket bottles
6 half Pint ”
3 doz hard metal spoons
3 doz common pewter spoons
3 doz hard metal Teaspoons

In two additional casks, he requested the following items, which may have been for over-the-counter sales in his own shop:

6 gross hard metal Tablespoons 19/–21/ grs [shillings per gross]
10 grs hard metal Tablespoons 25/ or 26/
3 grs common pewter ”
30 doz Shallow plates 7 lb 8 lb 9 lb 10 lb & 11 lb
12 doz Soup plates 10 lb 11 lb & 12 lb
42 Basons from 4 to 1 quart, most of the middle sizes
1 doz Quart Tankards
6 doz Porringers 5/ to 8 [per] doz

The ancient mines of Cornwall produced most of the tin used in Europe, and England enjoyed almost a monopoly of the metal, making possible the exportation of English pewter articles of all kinds, not only to America but to much of Europe. In the words of Pierre Auguste Salmon, an eighteenth-century pewterer of Chartres and author of *L'Art du Potier d'Etain*, "The number of places to which the English export their pewter is astonishing. It goes to North and South America, to the Levant, to Sumatra, in fact everywhere that they trade."[8]

Pewter was an important item in the English economy, bringing great revenue to the country and income to English

1–1. A variety of forms made by the Philadelphia pewterer William Will (w. 1764–98), displayed on shelves of a corner cupboard in the Fraktur Room of The Henry Francis du Pont Winterthur Museum.

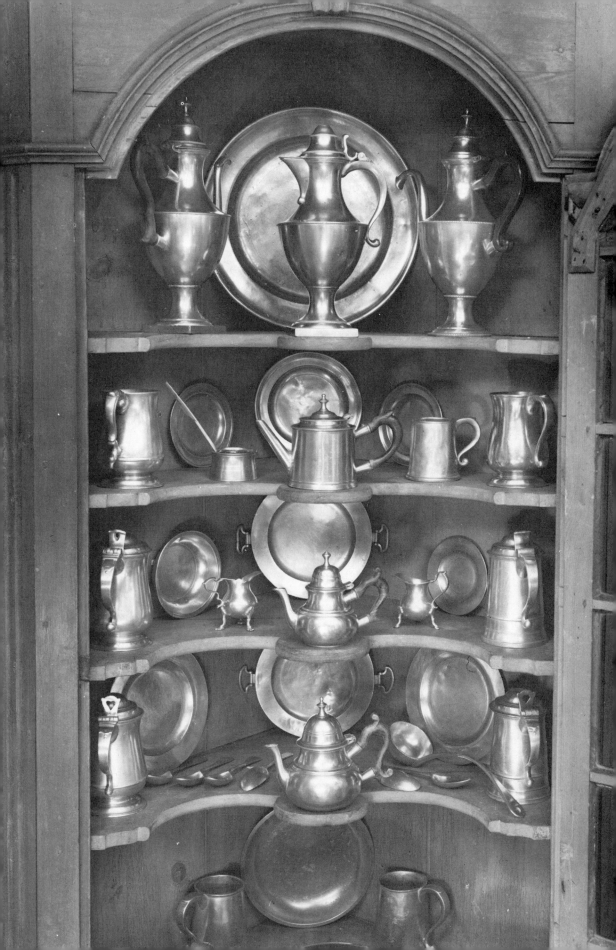

pewterers in that "several thousand families were well employed and supported, and the Nation considerably enrich'd by that trade."[9] The English Lords of the Board of Trade protected pewterers in several ways: They prohibited the export of pure tin to British colonies, granted pewterers the right to mix tin with other ingredients to form pewter alloy, and laid an excise tax on unworked pewter but not on finished vessels made for export. As a result, the American merchant could import pewter plates, dishes, and other vessels almost as cheaply as the pewterer could import new basic ingredients from which to fashion the pewter (were he able to evade English restrictions).

The worth of the metal in pewter vessels was at least 50 per cent, sometimes 70 per cent, of their original cost; therefore American pewterers set up shop in many cities and converted old and worn-out vessels into new ones. By so doing, they rendered a useful service to society and earned a livelihood for themselves. Typical of many transactions is William Fergus's request to James Glassford of Norfolk, Virginia, to have "a small Box of old pewter [about 31 pounds] . . . run into Shallow plates." William Willett, a pewterer who lived near Upper Marlboro, Maryland, advertised in 1756 that he "new Moulds old Pewter at 9d per pound, or will return one half good new Pewter for any quantity of old, and to be cast in whatever Form the Employer pleases, either flat or soup Dishes, or flat or soup Plates. N.B. He will wait on any employer within 20 or 30 miles to receive their old, or return their new Pewter."[10]

American pewterers also did repair work. Philip Will, at his shop called the Dish and Worm on Third Street, Philadelphia, opposite the inn The City of Rotterdam, advertised in 1763 that he "makes all kinds of new and repairs old hollow and flat pewterware."[11]

The situation of the American pewterer was ideal. In his workroom he could recast old pewter articles and sell them side by side with imported pieces for which he did not own molds. He had the opportunity not only to work as a craftsman but also to fill the function of merchant, buyer, and seller of goods.

The first generation of pewterers in America came from England, where they had served their apprenticeships and worked under the regulations of The Worshipful Company of Pewterers. This strong craftsmen's guild, which had been granted a royal charter in 1473 by King Edward IV, was vigorous and had broad powers. By the terms of its charter, the Company was granted the right of search and seizure of any wares offered for sale that did not meet the standards of the Company. Such goods were subject to confiscation without recompense, and their makers were liable to fine or imprisonment. So high were the standards maintained by the Pewterers' Company (as it came to be known) that by 1710 English pewter was brought to its "utmost Fineness and Perfection"[12] and was regarded as without equal throughout the Western world. For this reason, Continental pewterers frequently marked their work in such a way as to capitalize on the reputation of English pewter. German pewterers, for example, sometimes marked their work *Englisch Zinn.*

American pewter was far more variable in quality than English pewter, but surviving examples are, for the most part, well made and of good metal. There are no records to suggest that the products of American pewterers were so closely scrutinized as English pewterwares. Nevertheless, as early as 1678, the inhabitants of Boston expressed concern that "care may be taken that all wares made of pewter or silver, whether brought to the countrie or made here and exposed to sale may be of ye just alloy."[13] In order to compete

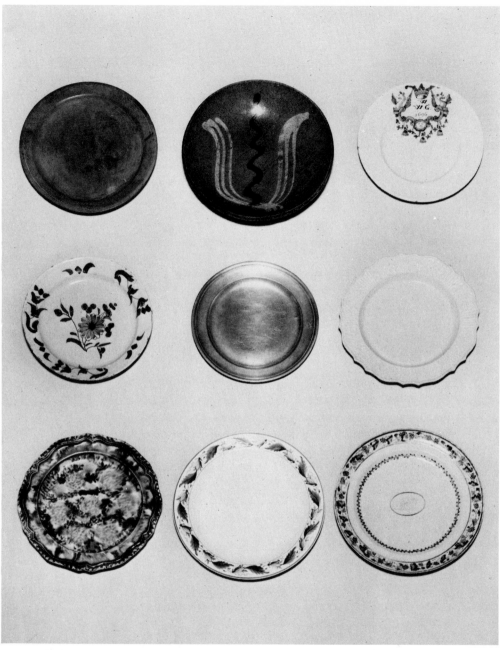

1–2. *Pewter and Its Rivals.* Dinner plates.

Top row (left to right): Wood, eighteenth century; slip-decorated pottery, nineteenth century; English delftware, dated 1696.

Middle row: English delftware, mid-eighteenth century; American pewter, late eighteenth century; English salt-glazed ware, mid-eighteenth century.

Bottom row: English tortoise-shell (Whieldon) ware, mid-eighteenth century; English creamware (Wedgwood), ca. 1780; Oriental export porcelain, ca. 1800.

Pewter in Everyday Life/11

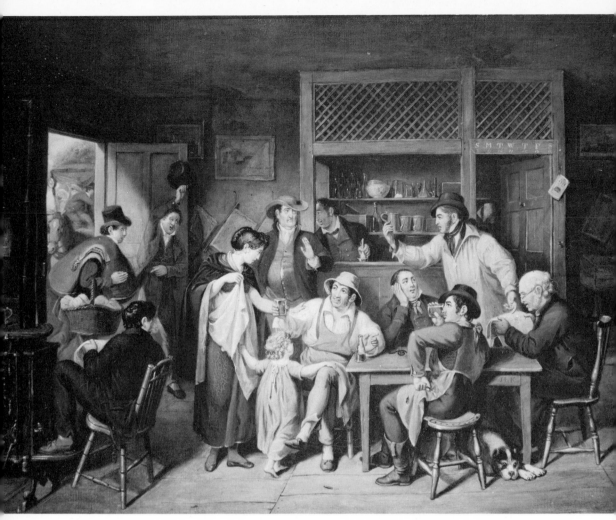

1–3. John Lewis Krimmel, *Interior of an American Inn,* 1813. Oil on canvas (The Toledo Museum of Art: Gift of Florence Scott Libbey, 1954). For at least 300 years, connoisseurs insisted that beer and ale tasted best in pewter mugs and tankards.

with highly regarded English pewter, the American pewterers advertised their wares, as did Edward Kneeland of Boston, "at the very lowest Prices for Cash, or old Pewter, Brass or Copper."[14]

As the power of the Pewterer's Company declined, some English pewterers apparently cheated—a point commented upon by Thomas D. Boardman.[15] He noted that after the Revolution the English shipped large quantities of pewter to America made of about 20 per cent lead.

According to him, this pewter was deceptively stamped *LQNDON* (with a *Q* substituted for the first *O*) and also bore the marks "WS & R.B. or Robert Bush." Inasmuch as many surviving pewter articles marked by Bush bear a *LQNDON* touch, it is likely that Bush, whose establishment was in Bristol, used the *Q* to evade the law of the Pewterers' Company that forbade country pewterers from stamping their wares *LONDON.*[16]

Pewter was expensive in the seven-

teenth and eighteenth centuries. A dish, a tankard, or a flagon cost as much or more than a skilled craftsman earned in a day.[17] Pewter vessels, although only one-tenth the price of silver, were nevertheless more valuable than those of wood, tin plate, and various kinds of pottery such as delft, salt-glazed, tortoiseshell (i.e., Whieldon), and creamwares. Pewter cost as much as some "burnt china," i.e., porcelain (Fig. 1–2). But worn-out pewter had the advantage of being reusable, and old pewter was readily salable to the local pewterer or to an itinerant tin peddler. The metal was in demand, and the value constant. Pewter almost passed as currency.

In contrast to the high trade-in value of pewter, pottery or china was worthless when broken. One poignant line in Samuel Sewall's diary, dated October 14, 1689, tells the story: "I broke my white plate."[18] At best, Sewall's white plate, probably delft, could have been glued together for show, but not for use.

Pewter was taken so much for granted that written references to its popularity are scarce, and only an occasional comment reveals the liking for it. John Hancock was explicit: He preferred pewter because "the contents of the plates were not so apt to slide off" and "the use of them caused no clatter in contact with knives and forks."[19] There was, in fact, a lore surrounding pewter. Habbakuk O. Westman remarked in 1845 that a pewter mug "can impart an etherial flavor to fluids brewed from apples and malt." And he added:

> It is known to the learned in porterhouse lore that pewter pots impart a peculiar flavor to ale, beer, and cider; the phenomenon is due to an electro-galvanic influence, excited by contact of the metallic alloy with the liquids[20] (Fig. 1–3).

Pewter became almost a symbol of gentility. En route from Albany in 1744, Dr. Alexander Hamilton and his traveling companion came upon a small log cottage on the west side of the Hudson River near New York City and "observed severall superfluous things" that "showed an inclination to finery in these poor people, such as a looking glass with a painted frame, half a dozen pewter spoons and as many plates, old and wore out but bright and clean, a set of stone tea dishes, and a tea pot." These, the minister said, "were superfluous . . . and wooden plates and spoons would be as good for use. . . . But the man's musket was as useful a piece of furniture as any in the cottage."[21] His utilitarian point of view was shared by many but not all Americans. For example, it was common practice for important men to have their crests engraved on their pewter. On August 6, 1759, Richard Cleeve, a London pewterer, charged "Col. George Washington" £9 18s. 3d. for 183 pounds of pewter at thirteen pence the pound, and £1 4s. for engraving ninety-six crests (Washington's) at three pence each on the "2 dozen assorted Superfine hard mettle dishes and 6 dozen of the very best Plates."[22]

Though the use of pewter plates began to wane after the Revolution, in 1783 John Hancock ordered for his own use "a set of Best Pewter" from Captain James Scott of London. "If Mr. Ellis is living," Hancock wrote, "I beg he may make . . . 6 Doz. very best Pewter Plates, with their proportion of proper sizes, oval or long dishes for Saturday's Salt Fish. You know how it used to be. My crest to be engraved in each Dish and Plate."[23]

Although the engraved crests and coats of arms on pewter were the exception rather than the rule, it was nonetheless common practice throughout the seventeenth and eighteenth centuries to stamp or engrave the owner's initials on pewter dishes, basins, tankards, mugs, and plates. Such two- or three-letter monograms were highly individual and served to

identify one's possessions if loaned or stolen.[24]

American pewter tablewares before 1725 consisted of plates eight or nine inches in diameter, dishes (flat or deep) more than ten inches in diameter, open salts, porringers, mugs, tankards, and basins (called breakfast bowls, if small, and wash basins, if large). According to an English writer in 1845:

A dinner set of pewter comprised three dozen dishes and plates, one dozen saucers, a tankard or flagon, salts, mustard pot, pepper box, half a dozen mugs, and one or two dozen spoons. The whole was arranged on a kind of sideboard or dresser with shelves, called the pewter rack. Women prided themselves on keeping the whole brilliant as silver. In some parts of Europe they are yet to be seen but are rapidly disappearing.[25]

Sometimes pewter, delft, and other pottery were all displayed in the same cupboard. In the inventory of Edmond Haines of Burlington County, New Jersey, a "Corner Cupboard, and pewter, Delph &c." were valued at four pounds. More often, pewter was displayed in the manner described by Benjamin Chase of Chester, New Hampshire, on "a set of open shelves—set off with platters and plates, basins and porringers . . . spoons were mostly made of pewter. They were clumsy, and very liable to be broken."[26]

So frequently is pewter listed in inventories before or after cupboards and dressers, and in context with delftware, that one sees special significance in John F. Watson's observation in 1832 that "where we now use earthern-ware, they then used delfware imported from England; and instead of queens-ware [then unknown], pewter platters and porringers, made to shine along a 'dresser,' were universal." He also noted that "some, and especially the country people, ate their meals from wooden trenchers."[27]

At Harvard College during the seventeenth century, both wooden and pewter utensils were used. Students received their breakfast or "morning bever" of bread and beer from the buttery hatch and ate it in their rooms. Not until 1764 was breakfast served in the hall. Dinner at eleven o'clock was the formal meal of the day. Undergraduates ate from wooden trenchers, drank beer from pewter "cue-cups" (mugs holding a full pint), and provided their own spoons and knives.[28] "An Inventory of Colledge utensills belonging to the Kitchin and Butlerie" (November 18, 1674) itemized "52 pewter platters, 11 sawcers, 2 pye plates," and 30 other "salt sellars, bowls, potts, juggs, and tankards, mostly having lost their lids, . . . unfitt for service [or] battered."[29] A 1683 inventory shows an increase in drinking vessels owned by the College; among them were "4 Flagons Good and Serviceable."

By 1734, a new code of college laws stipulated that "the Tables Shall be covered with clean linnen cloaths . . . twice a week, and furnished with Pewter Plates, the plates to be procured at ye Charge of the College, and Afterwards to be maintain'd at the charge of the scholars." It was further ordered: "The Butler and Cook shall constantly keep the rooms and Utensils, belonging to their several Offices, Sweet and clean fitt for Use. And ye Kitchen Pewter in constant Use shall be Scoured Twice a Quarter; and the Butlers drinking Vessels once a month."[30]

The rental of pewter for large parties or gatherings seems to have been an accepted practice. In the records of The Worshipful Company of Pewterers of the City of London, there are frequent references indicating that the Company furnished pewter for special events, and there are several entries in the Harvard College accounts just before and after 1700 for "hire of pewter" as a part of commencement expenses.[31]

In early America, porridge, mush, and

stew were eaten daily. John S. Williams, in *Our Cabin; or Life in the Woods*, wrote that during the fall and winter of 1800, just after his family had moved to Ohio:

Our regular supper was mush and milk. . . . The methods of eating were various. Some would sit around the pot, and every one take therefrom for himself. Some would set at table and each have his tin cup of milk, and with a pewter spoon take just as much mush from the dish or the pot, if it was on the table, as he thought would fill his mouth or throat, then lowering it into the milk, would take some to wash it down. . . . Others would mix mush and milk together.[32]

There is much evidence to indicate that most people in America until about 1820 ate with pewter spoons, off pewter plates, filled from pewter dishes. Babies first took their milk from a pewter "sucking bottle," if not from the breast; and as children they drank from pewter mugs. Men were served their cider, beer, and ale in pewter mugs and tankards.

Pewter's Rivals

Pewter had two chief competitors in America—wood and pottery, the latter both native-made and imported. Wooden plates and bowls were common in the seventeenth century and continued to be used well into the nineteenth century, particularly in rural areas. The "knot" bowls and dishes occasionally found in turners' accounts and in inventories were highly prized burl bowls and plates. A New Hampshire diarist, Matthew Patten of Bedford, wrote that on March 8, 1754, he "Carried eight Knots to Charles Emerson's to be turned into Dishes," and on March 11, "'Charles Emerson Brought me home 11 dishes he Turned for me and he Charged me £.2-0-0."[33]

Local redware pottery was probably much cheaper than pewter, as were the well-made salt-glazed stonewares and the rough, gravelly wares that William Rogers of Yorktown, Virginia, produced by the 1730's.[34] In Rogers's household inventory of 1739, pewter was valued at one shilling per pound. At this rate, quart mugs would be worth two shillings (twenty-four pence each)—six times the four-penny value placed on his pottery mugs. A comparable discrepancy in price probably prevailed between that for pewter articles and redware pottery.

During the colonial period, English merchants shipped large quantities of delft, brown-spotted and striped yellow wares, and simple redwares to this country. The challenge to pewter, the staple dinnerware, began with the ever-increasing importation of salt-glazed English pottery in the 1730's–50's. Tortoiseshell wares added more competition at midcentury, and the market for pewter began to decline after the introduction of Josiah Wedgwood's improved creamwares of the 1760's. Creamware's low cost, durability, and light and handsome appearance accounted for its popularity, as did the elegant name, "Queen's ware," given to this new pottery (Fig. 1–2).

Intimations of changing attitudes toward pewter in comparison with china and silver can be sensed about the time of the Revolution. In Benjamin Franklin's account of his early life, he wrote that in the 1730's

our Table was plain and simple, our Furniture of the cheapest. For instance my Breakfast was a long time Bread and Milk, (no Tea) and I ate it out of a two-penny earthen Porringer with a Pewter Spoon. But mark how Luxury will enter Families, and make a Progress, in Spite of Principle. Being call'd one Morning to Breakfast, I found it in a China Bowl with a Spoon of Silver. They had been bought for me without my Knowledge by my Wife, and had cost her the enormous Sum of

three and twenty Shillings, for which she had no other Excuse or Apology to make, but that she thought *her* Husband deserv'd a Silver Spoon and China Bowl as well as any of his Neighbours.[35]

Fashionable people turned increasingly to the new pottery wares, China-trade porcelains, and, for drinking vessels, glass. But pewter plates, basins, and dishes continued to be prized on the frontier after they had gone out of fashion in urban areas (Fig. 1–4). John Williams, whose boyhood diet of mush and milk was mentioned earlier, indicates the importance of pewter to a pioneer family in 1800. He tells us, in his description of the 24-by-18-foot family cabin:

. . . in the interior supported on pins driven into the logs, were our shelves. Upon these shelves, my sister displayed in ample order, a host of pewter plates, basins, and dishes, and spoons, scoured and bright. It was none of your new-fangled pewter made of lead, but the best London pewter, which our father himself bought of Townsend, the manufacturer. These were the plates upon which you could hold your meat so as to cut it without slipping or dulling your knife. But alas! [Williams wrote in 1843] the days of pewter plates and sharp dinner knives have passed away never to return.[36]

Inhabitants of rural areas may have been the last to use pewter plates and dishes on their tables, but old-fashioned

1–4. Artist unknown, *The Yankee Peddler*, ca. 1845. Oil on canvas (collection of the IBM Corporation, New York). Peddlers traveling through the country sold pewter plates and dishes as well as other wares.

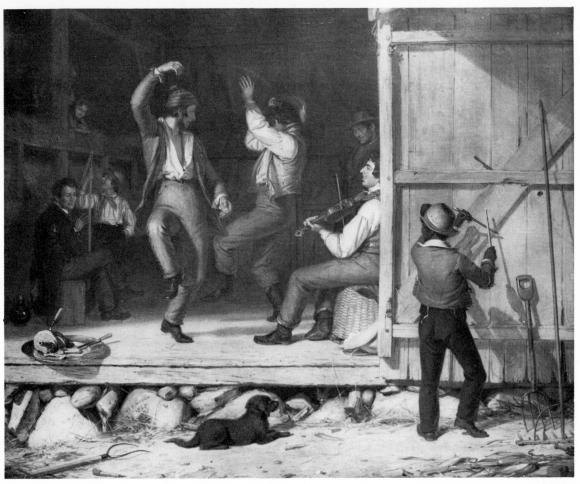

1–5. William Sidney Mount, *Dance of the Haymakers*, 1845. Oil on canvas (Suffolk Museum and Carriage House, Melville Collection, Stony Brook, Long Island, New York). In this painting, Mount depicted simple joys of rural America—a fiddler's music, a heel-stomping jig, and a baked ham on a pewter platter.

and conservative city people were also slow to give them up (Fig. 1–5). The latter included some of the very rich. In 1817, Stephen Girard, a Philadelphia financier, bought from his fellow townsman, the pewterer Parks Boyd, "one dozen soup plates, one dozen shallow plates, two large dishes, four small dishes, [and] two gallon basins"—the whole, weighing 53½ pounds, cost $26.75 (at fifty cents a pound). Against this, Girard received a credit of $1.19 for old pewter.[37]

Under the pressure of competition from

the china industry, late eighteenth-century English pewterers coined a new term and introduced what they heralded as a new ware—britannia. Harder, thinner, and lighter in weight than pewter, it required less metal and could be manufactured at a lower cost. In brilliance and thinness of body, it resembled silver. It looked even more like the silver-plated wares called Sheffield plate today. Despite its cheapness, britannia could not compete with some forms of china—plates, dishes, and wash basins. Metal ones were out of favor

HALL & BOARDMAN,
MANUFACTURERS OF

BRITANNIA WARE,

Tea Setts, Coffee Pots,

Tea Pots,

Cream Cups,

SUGAR BOWLS,

SLOP BOWLS,

MOLASSES CUPS,

CHILDREN'S CUPS,

PITCHERS,

Beer Mugs,

CASTORS,

LADLES,

TABLE SPOONS,

COFFIN PLATES, &C.

TEA SPOONS,

Spittoons,

Decanter Stoppers,

CANDLESTICKS,

Fluid Lamps,

OIL AND LARD LAMPS,

COMMUNION SETTS,

GOBLETS,

Tankards and Plates,

COFFEE-MILL HOPPERS,

MUSIC PLATES,

PLATED WARE OF ALL KINDS,

Nos. 93 and 95 ARCH STREET, below Third,

PHILADELPHIA.

1–6.
Advertisement from George W. Colton's *Atlas of America, with Business Cards of the Prominent Houses in Philadelphia* (Philadelphia: Published by A. J. Perkins, 1856). "Tea Setts, Coffee Pots, Tea Spoons, and Oil and Lard Lamps" were the most popular britannia objects made and sold by such large manufacturers as Hall and Boardman of Philadelphia.

1–7.
A variety of American-made plates and dishes.

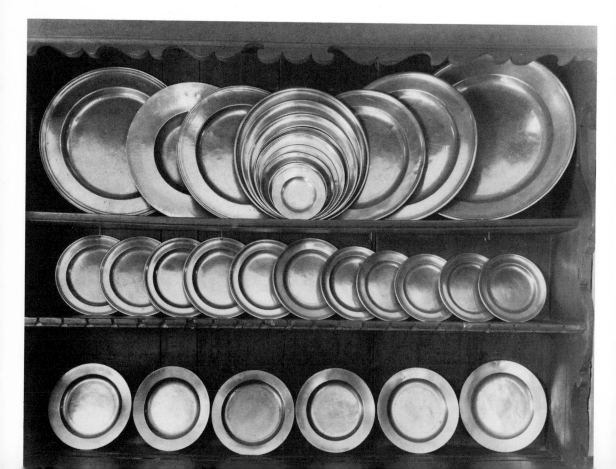

by 1830, but for those objects that were traditionally made of silver—tea and coffee sets, candlesticks, lamps, communion sets, and water tumblers—britannia was popular. By 1835, Ashbil Griswold of Meriden, Connecticut, was shipping large quantities of teapots, sugar bowls, cream pitchers, lather boxes, and spoons to agents all over the country, including several merchants in New York City. One of them, H. B. Hall, in January, 1836, had a working inventory of 86,279 pieces.[38]

Britannia was popular indeed. Whether made in the United States or imported, the name sounded special. With its high luster and low price, britannia continued to be made and sold for at least sixty years (Fig. 1–6). However, about 1850, when the new process of electroplating was introduced commercially into the United States, it became possible to give britannia (and other metals) an inexpensive coating of silver. Gradually over the next twenty years, most of the britannia makers either shifted to the manufacture of plated wares or went out of business. Soon after the Civil War, the manufacture of pewter and britannia ceased, but not before collectors and historical societies had begun to gather old pewter vessels as "bygones," symbolic of an earlier way of life.

One might suppose that by the mid-twentieth century the use of pewter had died out except for a few mugs in service here and there in ancient pubs, or a teapot or sugar bowl used by lovers of the old metal. However, the experience of Whitfield J. Bell, Jr., librarian of the American Philosophical Society, suggests otherwise. He writes:

A few years after the war [World War II] I called in at a secondhand (or "antiques") store in Edinburgh, to ask for pewter plates. The proprietor and his wife were eating a meal in the back room, as I could see. He heard my request, asked me to wait a minute, returned to the kitchen, closing the door behind him; and, after a moment, when I heard the sound of scraping, returned with two pewter plates—both still wet from the washing. I bought them, but worried for a long time thereafter about what those enterprising Scots ate their next meals from.[39]

Chapter Two

The American Pewterer and His Craft

Many clues to the thinking, the manner of working, and the products of the American pewterer are suggested by the banner carried by the New York Society of Pewterers in the Federal Procession of 1788, which celebrated the adoption of the U.S. Constitution (Fig. 2–1). At left is the new American flag, a shield displaying a worm for distilling, and the words "Solid and Pure." On either side of the shield are two men carrying shallow pails. On the banner at the upper right-hand side, the faith of the Society of Pewterers in the new Constitution is proclaimed in the verse:

The Federal Plan Most Solid & Secure
Americans Their Freedom Will Ensure
All Arts Shall Flourish in Columbia's
 Land
And All her Sons Join as One Social
 Band.

On a shelf beneath the verse stand two pewter tankards and a teapot. Below is the only known American picture of an eighteenth-century pewterer's shop. At the left in this small room, one workman appears to be casting pewter. Another is turning a great wheel lathe for a third workman skimming a pewter plate. In the foreground, a man is hammering (planishing) a larger pewter dish.[1]

The craft of pewtermaking was practiced at an early date in America. Pewter spoons were probably made and buttons "run" before 1610 at Jamestown, Virginia. And as early as 1635, Richard Graves, a youth of twenty-three, having completed his apprenticeship as pewterer, set sail for Massachusetts from London on the ship *Abigail*. Here, the colorful and contentious Graves settled in Salem and was listed as a proprietor in 1637. In 1645, he was in Boston in connection with some "brazen moulds" that were in dispute. He was still pursuing his trade in 1665 when he styled himself a pewterer in a deed to John Putnam.[2]

By 1640, three other pewterers—Samuel Grame, Henry Shrimpton, and Thomas Bumstead—are recorded as working in Boston, and the names of fourteen pewterers who were working in the colonies before 1700 are now known: nine in Massachusetts, two each in Virginia and

Pennsylvania, and one in Maryland.[3] All of these pewterers emigrated from England to America.

Why did they do so when the position of the English pewterer was such an enviable one? In England he was assured of raw materials; he had access to a wide variety of expensive molds; he was a member of a well-organized guild system that fixed selling prices; and he benefited from a large export trade. As yet the answer is not completely clear, but it appears that pewterers were needed in America to rework the metal in worn-out vessels. Instead of the influx of English pewter being devastating to American workmen, it exerted a strong influence in their favor. The metal was valuable, and hardware merchants (Fig. 2–2) and pewterers, such as John Gooch of Portsmouth,

New Hampshire, sought to reclaim it with advertisements of "cash for old pewter, brass, or copper, or one pound of new pewter for two pounds of old."[4] It would have been uneconomical to return old pewter to England if it could be reworked here. And pewterers in America did just that.

Presumably, the worn-out, secondhand pewter cost the American pewterer less than new metal cost his English counterpart, and the American pewterer had no charges for freight, insurance, or middleman's profit; hence he could sell his wares for less than imported goods. Repeatedly, American pewterers emphasized the cheapness of their wares.[5] Despite such claims, the public regarded English pewter highly; for centuries its quality had been guaranteed by strict laws. The word-

2–1. Activities and products of the pewterer are depicted in a banner carried by the New York Society of Pewterers in the Federal Procession of 1788 (courtesy of The New-York Historical Society, New York City).

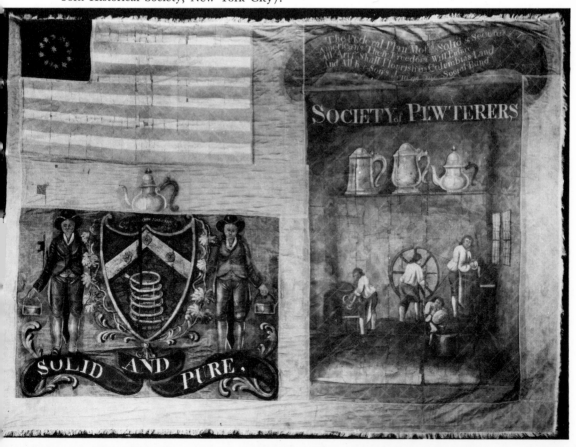

ing of the laws changed from time to time, but English pewterers were required to clearly mark the articles they made so that users of low-grade alloys could be identified and prosecuted.

Most American pewterers also marked their wares, stamping their products with one or more marks called touchmarks or touches, showing their name or initials and often the town in which they worked. Some marks used before the Revolution were similar to those used by English pewterers and featured symbols such as the lion or rose and crown (Fig. 3–4). As already noted, a few provincial English pewterers and an occasional American one sought to enhance their wares with the deceptive marks LQNDON or LOИ-DOИ on objects that, in some cases, appear to be made of leady metal. But lead-adulterated pewter was the exception rather than the rule, and the practice seems to have been no more widespread in America than in England.

The marks *Boston, Middletown, New York,* and *Philadelphia* boldly proclaimed the American origin of plates, dishes, and basins. After the Revolution, American eagles did the same. Gershom Jones of Providence advertised that "his Customers may be supplied with the best of Pewter Ware (warranted good as any, and better than much that is imported)." In 1761, John Skinner of Boston offered "the best *New-England* Pewter, in small or large Quantities, extraordinary cheap for Cash or old Pewter." Later, in the *Boston Gazette* of July 1, 1765, he emphasized the quality of his wares with the statement that "he continues to make hammer'd Plates the same as London, . . . [and has for sale] all other sorts of Pewter Ware usually made in New England."[6]

New England pewter seems to have had a good reputation of its own. The 1736 inventory of the Boston brazier and pewterer Jonathan Jackson listed as "New England made" two lots of fourteen dozen and five dozen, respectively, "hard mettle" plates, of the finest quality pewter, and eight dozen spoons of the same material.[7]

Although the aspirations of the American craftsman are seldom stated explicitly, case histories of successful artisans show them supplementing their craft activities with mercantile enterprises. The first step up the economic and social ladder was for the craftsman to sell goods made in his own shop by apprentices and journeymen. The next step was to buy goods made abroad, where labor was cheap, for sale in America. When pewter objects, of his own make or imported (Figs. 2–2, 2–3), were worn out, he bought them back, reworked the metal, and sold it for a profit. This appears to have been the custom in the trade from the 1630's, when Richard Graves began working in Salem, to the end of britannia making, about 1875.

The career of one pewterer, Henry Shrimpton, is an unusual success story. After completing his apprenticeship as a brazier and pewterer in London, he came to Boston in 1639 at the age of twenty-four. He established himself as a pewterer and brazier, became a merchant, and died a wealthy man in 1666. The inventory of his estate listed several thousand pounds of pewter appraised at more than £300, but this was less than one sixth of his assets, valued at the then enormous sum of £2,000.[8] Henry Shrimpton could never have accumulated such an estate from his craft alone, when three shillings was the maximum pay stipulated by Massachusetts law for a day's work by a skilled artisan.

Today, not a single piece of Shrimpton's pewter is known, but the comparatively large valuation of £37 placed on his molds and brazier's and pewterer's tools shows that he was equipped to make many different sizes and shapes of ves-

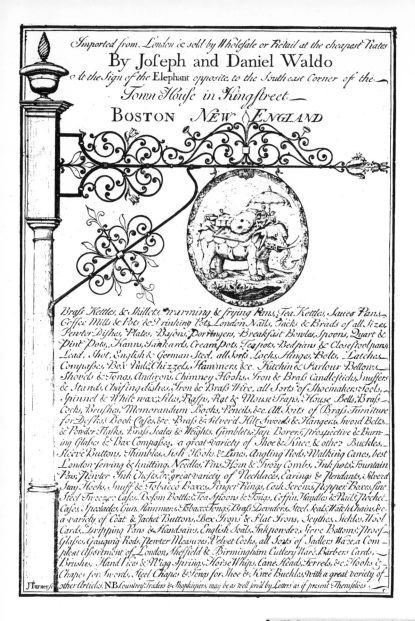

2–2.
1748 broadside of Joseph and Daniel Waldo, Boston. Merchants offering imported hardware and pewter (American Antiquarian Society).

2–3.
Pewterers were merchants as well as manufacturers. William Kirby offered imported items, as well as pewter of his own manufacture. *The Daily Advertiser* (New York), November 19, 1757 (courtesy of The New-York Historical Society, New York City).

JERSEY MONEY.
WILLIAM KIRBY, Pewterer,
At No. 23, Great Dock-ftreet, oppofite the Old-Slip, and near Hanover-fquare,

HAS for fale, a large and general affortment of PEWTER WARE, wholefale and retail, confifting of the following articles, for which Jerfey Paper-Money will be received without any difcount: ---Difhes, Plates and Bafons; Tankards, quart and pint pots, quart and pint and 1-2 tea-pots; ftraight and round ditto; pint and half-pint porringers; foup, table and tea fpoons; ditto ladles and round bowl fpoons; large chamber-pots; chair and bed pans; meafures, from a gallon to a gill; quart and pint bowls; infufing pots, approved of in colds and confumptions; dish and bafon callenders; hogfhead, barrel and bottle cranes; with many other articles in the Pewter way too tedious to mention. Old Pewter will be taken in exchange for new.
N. B. Said Kirby has feveral LOTS of GROUND to difpofe of, lying near the North River. m

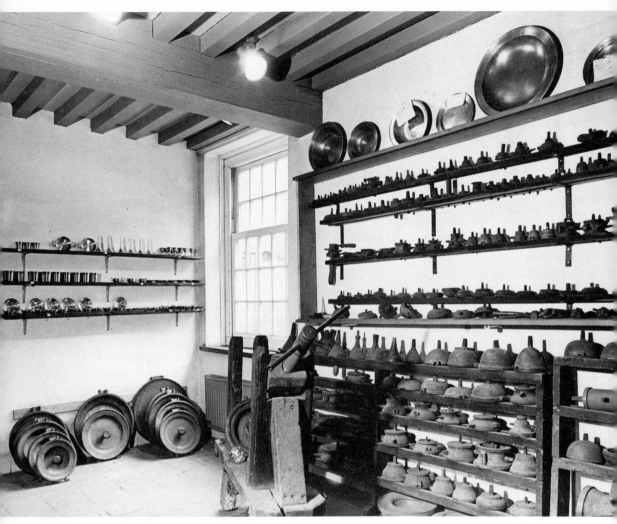

2–4. Molds for casting pewter objects (photo, courtesy of John Klaver, Rotterdam).

sels. He died owning 2,334 pounds of pewter dishes, 508 pounds of basins, 69 pounds of wine pots, 248 pounds of platters (of which 80 pounds were "unwrought," perhaps unhammered or not skimmed), 1,137 pounds of "fine metal unwrought," 592 pounds of old pewter, 623 pounds of "lay mettle" (low-grade pewter), 132 pounds of spooning metal, and 115 pounds of "pewter wormes" for stills. In addition, there were more than 5,000 other objects.

For some pewterers, making a living was not easy. On October 20, 1783, Edward Kneeland petitioned the Gentlemen Assessors of the town of Boston for the abatement of his taxes. In his words:

I have Spent much Time & Money in Public Service as an Officer of Militia and have Sent into Actual Service not Less than Four hundred Men for a Longer or shorter time. . . . I have met with losses by bad Debts & by Sea—The Peace has

nearly Destroyed my Present Business by the Great importations of Pewter from England, From all which Causes I have sunk Four Tons of Stock.[9]

Kneeland was but one of many American businessmen ruined by the flood of goods dumped on the market by English merchants after the Revolution.

Pewterers also had to contend with tinkers and handymen who produced widely used and easily made pewter buttons and spoons. Householders sometimes had their own spoon and button molds, as is shown by the 1761 inventory of Roger Kirk of West Nottingham Township, Chester County, Pennsylvania, which listed "one pair spoon moulds" at 4s. 6d.[10] According to a 1770 advertisement, "An Irish servant man . . . Had on when he went away, a light colour'd cloth jacket with home made pewter buttons."[11]

For those embarking upon the business of pewter manufacturing, the ownership of plate and dish molds was essential, and each immigrant pewterer arriving here in the seventeenth century surely brought with him molds for these and other basic forms, many of which are illustrated in Figure 2–4. Upon landing in one of the coastal cities, he probably set up his wareroom with a display area and shelves facing the street on the first floor of his house, where he sold both imported pewter and that of his own manufacture. Many small craftsmen carried on the manufacturing part of their business in a small outbuilding or shop, often no larger than 10 by 20 feet. An eighteenth-century American pewterer's shop interior (Fig. 2–5) shows the cramped quarters with an iron pot for melting pewter, a man-powered turning lathe, and an anvil where a workman hammered plates and dishes.

Each master pewterer needed a helper, for unlike other trades in which a master could practice his craft alone, the pewterer could not; the finishing of plates, dishes, and hollowware required a lathe turned by an assistant. The first pewterers may have brought an indentured helper, then called a servant, with them. More often pewterers and other craftsmen recruited apprentices here who assisted as they learned their trade. Boys aged fourteen or younger were bound by a contract of apprenticeship, called an indenture, which stipulated a training period of seven years or the time until the apprentice reached the age of twenty-one. According to the terms of the standard indenture, the master agreed to "teach, or cause the said apprentice, to be taught, the art and mystery" of a pewterer. In turn, the apprentice agreed faithfully to serve his master, "his secrets keep, his lawful commandments everywhere obey." Sometimes parents of apprentices were required to pay a fee for "the keep and training of their children," and normally the master provided "sufficient meat, drink and washing in winter time fitting for an apprentice."[12]

By the nineteenth century, formal apprenticeships became shorter and masters offered more generous terms, as in the agreement quoted in full between Ashbil Griswold, pewterer of Meriden, Connecticut, and Luther Boardman, who was later to become a large manufacturer of britannia spoons.

> This indenture made by and between Jason Boardman & Luther Boardman his son on the one part & Ashbil Griswold on the other part Witnesseth Jason Boardman & Luther agree that the said Luther shall serve the said Ashbil Griswold as an apprentice to the pewtering Business till he arives at the age of twenty one Which will be in the year 1833 December 23 and to obay the said Griswold in all his lawfull Comands & to serve & be a faithfull apprentice and the said Ashbil Griswold on his part agrees to take the above named Luther Boardman as an apprentice at the

Pewtering Business & to learn him the trade in all its Branches that he works at & to provide for him in sickness & in health Giving Nessary & payed expences except his Clothing till he arrives at the age of twenty one years & in lue of Clothing the Said Griswold to pay twenty five Dollars a year to commence from the 8 December 1828

N.B. When the said Luther arrives at the age of twenty one When his apprenticeship will Expire I will give him as a present twenty five Dollars worth of Goods

Dated at Meriden the 6 of December 1829
In Presence of

Phebe Bonfaez Jason Boardman
John Price Luther Boardman
 Ashbil Griswold[13]

In the seventeenth and eighteenth centuries, American civil authorities used indentures of apprenticeship to ensure mastery of a trade to orphans who might otherwise become indigents and a burden to the community. For example, on December 18, 1759, the court at Princess Anne County, Virginia, ordered that "Jonathan Huggins be bound to Mungo Campbell for five years from this time, that he teach the said Orphan to read & write & the Trade of a pewterer & take Indentures to that purpose."[14]

The work of the pewterer began with the assaying, or testing (Fig. 2–6), of old metal, for as already noted, the American pewterer used scrap pewter for his raw

2–5. An eighteenth-century pewterer's shop, as shown in a detail from the banner of the New York Society of Pewterers carried in the Federal Procession of 1788 (courtesy of The New-York Historical Society, New York City).

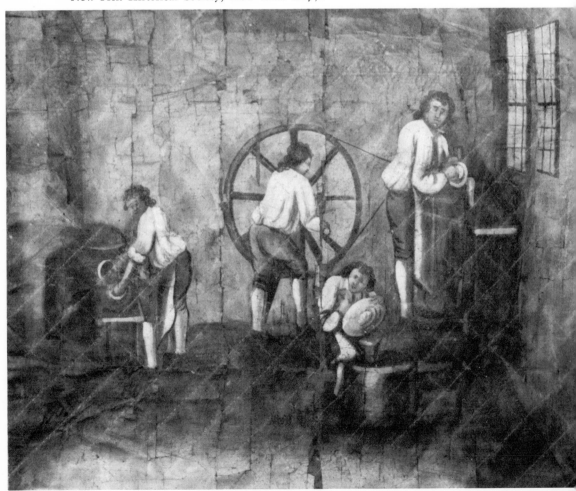

material, the composition of which varied piece by piece. Before discussing the methods used for assaying, let us review the proportion of ingredients used in pewter. Fine pewter contains above 90 per cent tin and usually such hardeners as copper, antimony, or bismuth, with little or no lead. The copper was sometimes added to the mix in the form of brass; hence, zinc, an ingredient of brass, may be a component of the alloy. Little has been written about the use of antimony prior to the britannia period, but it appears that many eighteenth-century English pewterers made use of it in their finest pewter. It was commonly used in spoons because it made the metal stronger.

Lead was little used in the best English pewter, but it was cheaper than tin, and the addition of a small amount made the alloy easier to cast and to work. At least 5 per cent lead was used in much pewter, with the lowest grade containing as much as 40 per cent. In their alloys, some pewterers used bismuth, a metal that expands when it cools, ensuring sharp, neat castings.

Hard metal, the finest pewter sold in the eighteenth century, is "easily known by its nearly resembling silver," wrote the anonymous author of *The Compleat Appraiser,* a London handbook first published in the 1750's as an aid to appraisers of secondhand goods. "The best pewter

2–6. Pierre Auguste Salmon, *L'Art du Potier d'Etain* (Paris, 1788), plate 1, detail (Winterthur Museum Libraries). Old and worn-out pewter provided the raw material for American pewterers. By means of the spot method, the master pewterer could judge the degree of purity of the old pewter.

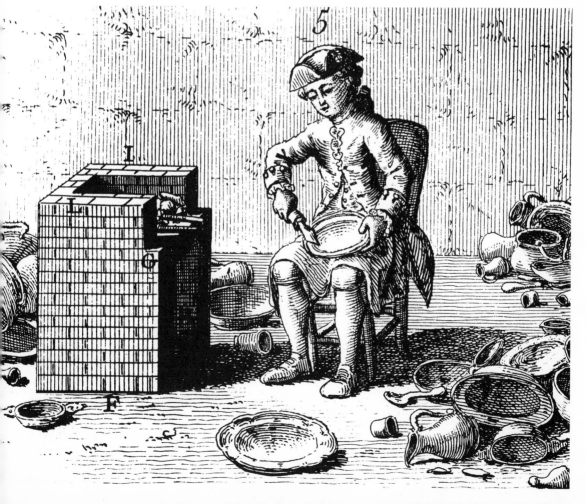

dishes, plates, cullenders, tankards, spoons &c.," the writer added, "were made of Hard Metal" and "are generally marked with an X with a Sort of a Crown over it."[15]

American pewterers who marked their best wares with an incised, crowned X included John Will and two of his sons, Henry and William, Peter Young, Daniel Curtiss, the Danforths, and the Boardmans. At least two American pewterers had hard-metal touches: Henry Will's scroll mark reads *Superfine Hard Metal*, and for his finest pewter Samuel Hamlin used a suspended sheep touch, after the practice of some English pewterers. John Will and André Michel of New York used similar devices that may also have signified fine metal, though the words "hard metal" are not included. Hard-metal pewter objects commanded a premium price because their fine alloy was free from lead and a part of their surface was hammered, making the metal harder and stronger. Some of the earliest American dishes, like seventeenth-century English examples, are found hammered over their entire surface. Among them are three broad-brimmed and six or seven multiple-reeded seventeenth-century-style dishes attributed to the Dolbeares of Boston (Figs. 8–2, 8–3) and two single-reeded dishes of outstanding quality made by Simon Edgell of Philadelphia (w. 1713–42).[16] Later eighteenth-century plates and dishes, if hammered at all, are hammered only on the booge, the curved section between the brim and the bottom.[17] Especially beautiful hammering is to be found on work by Henry Will and Peter Young (Fig. 8–5). So precise are the paths of their hammer marks that they seldom overlap. That the barrels of two fine American tankards are completely hammered is of special interest (Fig. 6–21), for only recently Ledlie Laughlin has suggested the possibility that their *B D* touch may be the mark of Benjamin Dolbeare, a nephew of Edmund Dolbeare to whom the superbly hammered, broad-brimmed dish shown in Figure 8–3 is ascribed.[18]

Second-quality pewter, called *trifle metal*, was used to make "Ordinary Dishes and Plates, Ale house Pots [mugs], Porringers, Funnels, Stool pans, [and] Candlesticks," observed the author of *The Compleat Appraiser*. *Lay metal*, the lowest grade of pewter, was used to make "Chamber pots and Wine Measures." According to the same author, trifle and lay metal are easily distinguished from each other: "For the Trifle metal has a coarse Resemblance of the Hard Metal; and the Lay-Metal looks almost as coarse as Lead."[19] These grades, which were applied to pewter exported from England into the colonies, appear to have set the standard for American pewter until 1790, when pewterers began to import pure tin, bismuth, and other ingredients with which to make their own alloys.

Prior to 1790, American pewterers sorted the old pewter they had bought into various grades by assaying it. Evidence is lacking to indicate the method they used, but the *spot method*, one of several known, was the simplest. Salmon stated that this method "is to us pewterers . . . what the *touch* method is to the silversmith." By this process the pewterer sorted his metal into four grades. "With one soldering iron in his hand, and an extra one always heating" (Fig. 2–6), he melted a small spot in the piece, leaving a tiny cavity which was called a beauty spot or *mouche*. The master pewterer could judge by the color of that spot the degree of the metal's purity and the nature of the alloy.[20]

Salmon makes a point of great interest to English and American pewter collectors in his discussion of second-grade pewter alloys. He describes pewter *à la rose* as containing 7 or 8 per cent lead, and adds, "the English mark it with a rose."[21] Ap-

parently, this refers to the English and American pewter so beautifully marked with a rose and crown, but only metallurgical analyses of old pewter thus marked will tell.

After assaying and sorting the old pewter, the artisan threw pieces of like grade into his iron melting pot and brought the metal to a molten state, adding, as necessary, a small amount of brass (copper and zinc), iron, or bismuth to achieve the desired standard. Soon the casting was under way, with the pewterer pouring the molten alloy into a mold (Fig. 2–7).

2–7. Pierre Auguste Salmon, *L'Art du Potier d'Etain* (Paris, 1788), plate 28, detail (Winterthur Museum Libraries). A pewterer is pouring molten pewter into a spoon mold.

2–8. American pewterers used molds to shape their wares. In one pour, five different sizes of buttons complete with raised ornamentation were cast simultaneously in this eighteenth-century brass button mold. L. of mold 9⅛″ (WM 53.22).*

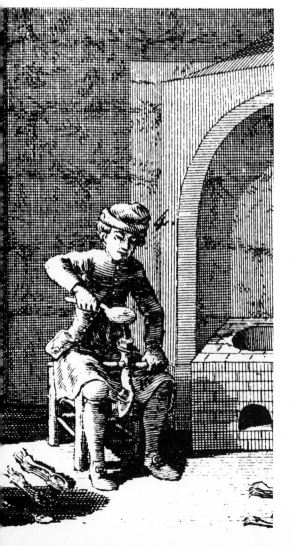

Molds

In America prior to 1807, all pewter was shaped by casting in molds, usually made of brass, though occasionally of more easily fashioned and less durable materials, such as soapstone, plaster of Paris, or even a special grade of pewter for infrequently made forms (Figs. 2–8, 2–9).[22] Until recently the general assumption has been that American pewterers used molds acquired in England, but several discoveries of the past few years make it clear that American craftsmen not only had the skills necessary to produce their own molds but to do so was in accord with Old World pewtermaking traditions. Near the beginning of chapter 12 in his celebrated work, Pierre Auguste Salmon states unequivocally: "It is . . . the pewterer who makes his molds." Then he describes the artistry and the art that lie

* *Objects for which accession numbers are given are in the collection of The Henry Francis du Pont Winterthur Museum.*

behind the designs of pewter objects. According to him, all the work "of this [the pewterer's] art, particularly those objects which can be turned, are embellished with moldings taken over from the ornaments of architecture," which the pewterer must learn to draw "in order to accustom the eye to seeing them and the hand to forming them."[23]

Because the principles set forth by Salmon extend far beyond the design of pewter and illuminate all eighteenth-century and much nineteenth-century design, they are quoted here at length. Salmon articulates fundamental principles that craftsmen absorbed through shop training and apprenticeship to the extent that their application became instinctive and automatic. He writes:

It is necessary that he [the pewterer] be acquainted with architectural moldings and that he know how to form them first on his models [usually of wood] and then transfer them to the [brass] molds themselves . . . according to the most agreeable of proportions [Fig. 2–10].

To Salmon's mind the making of the molds is of the greatest importance because, as he writes, "in the skimming process, it is only necessary to follow the moldings that have been profiled in the mold."[24]

Repeatedly in his discussions, Salmon shows the same high regard for the principles of architecture evident in the books of Thomas Chippendale, Thomas Sheraton, and other early English writers on the designing of furniture. Invariably they

2–9. A late eighteenth-century brass spoon mold and two recently cast spoons with an eagle on their faces. "The process of making pewter goods differs from that of working most metals. Articles are formed complete, or nearly so, by running the fused material into clay, brass or other moulds. A spoon, for example, is cast in a moment, whereas a gold or silver one has to be forged into shape." From Habbakuk O. Westman, *The Spoon* (London: Wiley & Putnam, 1845), p. 240.

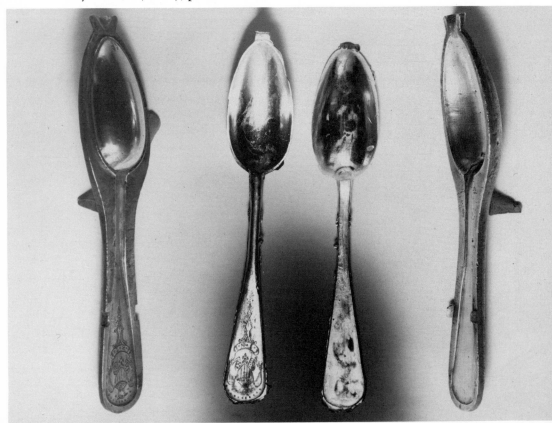

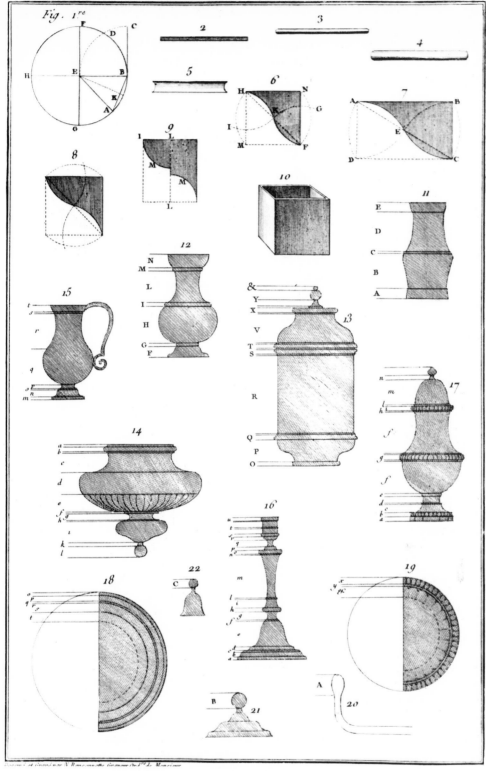

2–10. Architectural moldings, from Pierre Auguste Salmon, *L'Art du Potier d'Etain* (Paris, 1788), plate 16 (Winterthur Museum Libraries).

illustrate the "Orders of Architecture" in their publications and in so doing proclaim architecture as the mother of the arts, with the clear implication that cabinetmakers ought to be familiar with the orders, their proportions, and their parts as basics of furniture design. Salmon goes even further to explain the application and use of architectural elements with such injunctions as "all round moldings should be noticeably separated one from the other, either by flat moldings, or by sunken fillets" or "one should be careful to keep a nice proportion between the widths and the different degrees of protrusion or recession of the moldings, that is to say . . . that the largest members should not exceed by too much the smaller ones, nor should the protrusions be too large, nor too jutting, and the sunken parts too narrow nor too deep." Pragmatist though he may be, Salmon recognizes that "there is nothing more difficult for an artist, as all artists will tell you, than to give rules for the distribution of moldings on a piece of work. The eye alone and the good taste of the workman are freed from specific rules after having absorbed certain general precepts established by the most knowledgeable architects. All turners observe these precepts, and their sensitive eyes are disturbed by the least disproportion." At one point Salmon sums up the creation of pewter designs:

> These, then, are the principal moldings from which one assembles an infinite number of different ornamental profiles, just as from the letters of the alphabet one puts together an infinite number of words. But as in combining letters of the alphabet to form a book, each author should follow the inclination of his genius without constraint.[25]

Salmon can be regarded as an articulate spokesman for the validity of "the rules of architecture" and the infallibility of design which is based on those orders.

Few writers have gone as far as Salmon in interpreting for workmen the classical language of architecture in terms of moldings, geometry, and proportions. For the most part, these precepts were unwritten and were passed on by word of mouth from one generation to another from master to apprentice.

Full-fledged pewterers immigrating to America undoubtedly brought molds with them when they came from England or Germany, and it is known that some molds continued to be used by successive generations of American pewterers. Just how long they were used is not known because most surviving pewter was made after 1750, and it is largely on the basis of the later pewter that judgments can be made. It can be assumed that eighteenth-century pewterers did not often use molds of an earlier date because none of the highly prized seventeenth-century plates or dishes have been found with the marks of pewterers whose careers began in the eighteenth century.

As yet, no regular procession of styles in eighteenth-century American pewter can be delineated except in the teapots of William Will. However, regional preferences for certain forms seem apparent. Massachusetts and Rhode Island householders preferred narrow-brimmed dinner plates of small size and less depth than those favored by New Yorkers.

Certain American pewterers produced highly individual forms without English counterparts. Notable among these are the strap-handle mugs of Nathaniel Austin (Fig. 6–5), Gershom Jones, and Richard Lee and the porringers of Samuel Hamlin (Fig. 9–11), Elisha Kirk (Fig. 9–13), Richard Lee, Jr. (Fig. 9–4), and David Melville. Also without precedent are the flagons of Henry Will (Fig. 4–41), Philip Will (Fig. 4–42), and Samuel Danforth (Fig. 4–7). Not only are the coffeepots of William Will (Fig. 11–15) unique, but much of his other hollowware differs sig-

nificantly from the English or German norm.

The earliest known references to mold-making in America appear in the records of William, Daniel, and Samuel Proud, Providence chairmakers and turners (w. 1773–1835), which list many transactions with pewterers.[26] Beginning August 9, 1773, William Proud charged Samuel Hamlin "To making some molds," "To 2 molds, Turning for," "To altering 2 Molds," "To turning 2 partes for an Mold," "To a mold for a handl," and so forth. Hamlin's use of these wooden patterns is made clear in his November 23, 1773, *Connecticut Courant* advertisement, which informed the public that "the Pewterers and Braziers business is carried on . . . by Samuel Hamlin . . . near the Great Bridge in Providence," and that "He has nearly completed a set of moulds, of the newest and neatest fashions, and flatters himself that they will upon tryal give universal satisfaction."[27]

If we but had Samuel Hamlin's account of the making of these molds, telling us what they included, how he arrived at their design, how long it took to make them, to whom he sold them, and for how much, our information about pewter-making would be less speculative. We can only guess that among these molds there may have been one for the first of the Rhode Island flowered-handled porringers.

Hamlin was not alone in carrying on both the brazier's and the pewterer's crafts. Among the many other pewterers who also styled themselves braziers were Henry Shrimpton (Boston, mid-1600's), Jonathan Jackson (Boston, early 1700's), Joseph Belcher (Newport, as early as 1763), Samuel Hamlin's one-time partner Gershom Jones (late 1700's), and Job Danforth, Jr. (Providence, early 1800's).

In brass and pewter making, similar tools and processes were employed. Both metals were finished on a lathe by skimming and burnishing or, in the case of irregularly shaped objects, by hand scraping or filing. Brass objects, like pewter ones, were shaped by casting, though the molds were different. The pewterer used brass molds over and over again. The brazier prepared a new sand mold for each casting by impressing three-dimensional wooden or lead patterns into flasks of sand.[28] The impressions in the sand gave form to the molten brass poured into them. To fashion a new mold, the pewterer first made or had made a model of wood or lead to his specifications. From this model the brazier, usually the pewterer himself, produced a brass casting that was a facsimile of the wooden pattern.

For the brazier this was neither a difficult nor a costly task. But the finishing—that is, the smoothing of the inner curved surfaces of the mold parts so that they would fit tightly together to prevent leakage—was a laborious task unless it could be done on a lathe. To design a mold and vent it to make perfect pewter castings required skill, and it is now clear that American braziers had that skill.

Information on the cost of new brass molds for making pewter is yet to be found; however, the price placed on used molds in pewterers' inventories is surprisingly modest—usually about the same price per pound as new pewter. In the 1696 inventory of the Boston pewterer John Baker, two lots of fine pewter (120 and 820 pounds) were valued at sixteen pence per pound—two pence more per pound than 1,280 pounds of molds. Slightly more than a century later, Richard Austin's 395 pounds of brass molds were valued at twenty-five cents per pound, exactly the same price per pound as the new pewter basins and porringers in his inventory.

Before use, pewterers' molds were customarily coated, according to Salmon and others, with "a light layer of earthy ma-

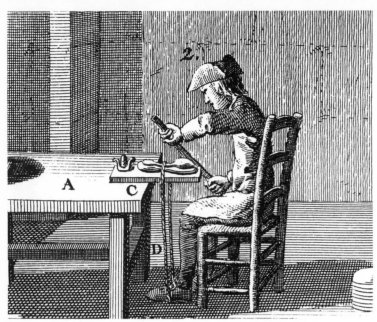

2–11. Pierre Auguste Salmon, *L'Art du Potier d'Etain* (Paris, 1788), plate 27, detail (Winterthur Museum Libraries). After being cast, pewter objects were skimmed to make them smooth and ready for use. Spoons and handles for mugs and porringers were scraped by hand.

2–12. Bronze mold for 8-inch pewter plate, 1780–1820, America, L. 21″, W. 10⅛″ (Gift of John J. Evans, Jr., WM 73.43).

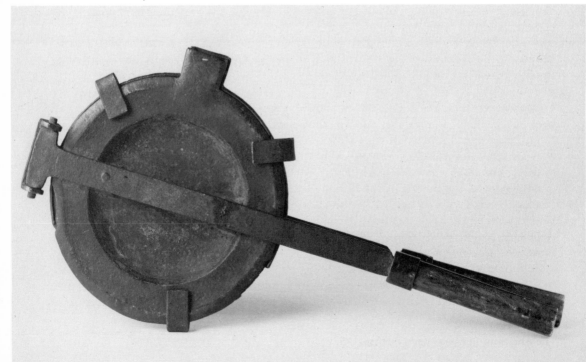

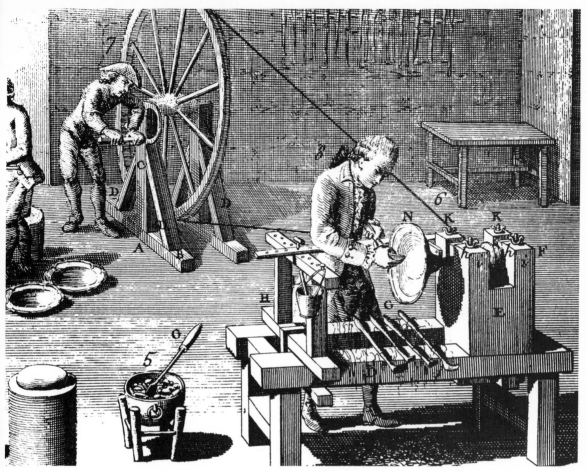

2–13. Pierre Auguste Salmon, *L'Art du Potier d'Etain* (Paris, 1788), plate 4, detail (Winterthur Museum Libraries). Master pewterers or journeymen skimmed or smoothed round pewter objects by holding a tool called a hook against them as they rotated on a lathe turned by a helper.

terials." Some pewterers used calcinated pumice stone or soot; others employed yellow ochre. To apply any one of these, Salmon says:

> One heats the mold, and as soon as it is a little warm, one takes aqua fortis [nitric acid], spreads it with a feather, and after effervescence, there is left a coating . . . on which one puts the dust or powder.[29]

A pewterer with good molds could make many castings in an hour. Poor castings were thrown back into the melting pot. As the first step in the finishing process, rough edges or excrescences were clipped or rasped off and small holes filled with a soldering iron.

Then such items as spoons (Fig. 2–11) and the handles of porringers and mugs were scraped and burnished by hand. Round forms were finished on a lathe (Fig. 2–13). Ingenious blocks and fittings enabled the pewterer to mount plates, basins, dishes, mugs, tankards, and other hollowwares on his lathe and skim them with a "hook" or other cutting or scraping tool as they revolved before him.

Plates, basins, and dishes, now called flatware, were known in the eighteenth century as "sadware." They were cast in a two-part hinged mold, such as that illus-

2–14. Casting a handle on the bowl of a porringer (drawing by James L. Garvin). In America, pewterers cast the handles of their porringers in place on the bowl held by cloth-covered tongs.

2–15. A "linen mark" impression of the cloth-covered tongs made in the hot pewter when the handle of a porringer was cast on the bowl.

trated in Figure 2–12. Mugs, tankards, and teapots were called hollowware and were made up of several individually cast parts that, after skimming, were assembled and soldered together. Inasmuch as the solder was of the same composition as the parts, the joints were invisible after the final polishing. Skimming marks, however, are usually still found on the bottoms of round objects, where they appear as shallow, concentric ridges and grooves. Looking across the skimming marks on the bottom of a mug, tankard, or plate, one can see coarse radial lines extending from the center toward the circumference. These are "chatter" marks caused by the vibration of the skimming tool. Those on seventeenth- and eighteenth-century pewter, skimmed on primitive lathes with wooden bearings, are coarser than the chatter marks on modern pewter fashioned on lathes with precision metal mounts.

Although most handles were slush cast and soldered in place after the drums of mugs, tankards, and flagons had been skimmed and polished, some handles, like porringer handles, were cast in place. This appears to be the method usually followed in making New England straphandle mugs. As early as 1690, the English Pewterers' Company stipulated that porringer handles must be "burned on," i.e., cast into place, because this practice ensured a stronger bond between the handle and the bowl than that achieved by soldering.[30] With the exception of Pennsylvania tab-handle porringers, with bowl and handle cast as one piece in Continental fashion (Fig. 9–14), the handles of all other early American porringers were cast in place after the bowl had been finished and skimmed.

To make this delicate operation possible, the base of the handle mold was shaped to *exactly* fit the bowl (Fig. 2–14). In the drawing, a porringer bowl is held by metal tongs with curved ends

wrapped in cloth that perfectly conform to the inner contours of the bowl.[31] The cloth serving as a tinker's dam prevents the hot metal poured into the handle mold from melting a hole in the bowl and impresses its pattern on the softened metal of the bowl's inner surface (Fig. 2–15). This impression, called a linen mark, is invariably found in antique American pewter porringers. Modern and reproduction porringers, whose handles are soldered on, do not have linen marks.

Hollow mug and tankard handles are believed to have come into vogue about 1700 in America, but as late as 1721 quart and pint pots with "hollow handles" were singled out in separate listings. These handles were made by slush casting. In this process, the pewterer takes advantage of the fact that molten pewter congeals first where it is in contact with the mold. As soon as an outer surface has hardened, the pewterer up-ends the mold and pours out the remaining molten metal, leaving the casting hollow.

Britannia

The specific ingredients and their amounts in a successful alloy were subjects of secrecy. But some English pewterers were aware before 1750 of the benefits attending the use of antimony, and Salmon refers to antimonied pewter in his 1788 treatise.[32] However, most American pewterers were oblivious to its merits until much later. Thomas Danforth Boardman, for example, wrote, "in 1805 I first heard the name of Regulus of antimony, what it was I knew not." A little later, Boardman first tried using antimony with new tin and "concluded it was not the right thing and gave it up." However, a year later when he was unable satisfactorily to work some new English tin into teapots, he "melted them down and added 2 or 3

2–16. Artist unknown, *Portrait of Roswell Gleason*, ca. 1840. Oil on canvas. Gleason made pewter and britannia in Dorchester, Massachusetts, between 1821 and 1865.

per cent copper... and as much R[egulus] of antimony, which proved to be the right thing... the pots... were the best I had ever made," and, he added, "with proper proportion of regulus of antimony and copper, the ware would finish up equal to English bright [britannia?]."[33]

By his own account, Boardman's teapots made of the shiny new alloy were an immediate success. And, from 1806 until 1821, the Boardmans kept "the use of antimony in the composition" a secret, and their "journeymen and apprentices knew nothing of it."

About 1850, the introduction of the silver-plating process, known as electroplating, gave further impetus to the production of britannia, for britannia served admirably as a metallic base. Among the prominent manufacturers of the new prod-

uct were Roswell Gleason of Dorchester (Fig. 2–16), the Taunton Britannia Manufacturing Company, and the Meriden Britannia Manufacturing Company, the latter being a company formed of several Connecticut firms. The many illustrated catalogues of the 1850's, 1860's, and 1870's of the West Meriden company offered a great variety of both plated and britannia wares, and in the introduction of the 1867 catalogue, the company asserted:

We have now been before the public since 1852, manufacturing Electro Plated Goods, which have stood the severest tests of wear, in hotels, steamers and private families, and have given universal satisfaction, supplying as it does all the advantages of silver, in durability and beauty, at one-fifth the cost.[34]

English pewterers, in an endeavor to meet competition, introduced new wares called britannia in the late eighteenth century. In 1799, "5pr. Bretania metal Candlesticks" valued at $15.00 were listed in the inventory of William Will. The high valuation of $3.00 per pair (in comparison to $2.00 each for coffeepots and $1.67 for half-gallon measures) suggests these were large objects.[35] One is inclined to suppose these candlesticks—listed in the midst of objects of William Will's own manufacture—were made by him, but there is no evidence to either confirm or disprove this assumption. Hence, we are unable to award another first to that great Philadelphia pewterer.

Soon after Will's death, Thomas D. Boardman in 1806 apparently hit upon the formula for britannia, and the Boardman firm was the first to manufacture britannia on a large scale in the United States. Although Boardman does not call his teapots britannia, their composition, given in his biographical notes, coincides with that of britannia. Therein he cryptically refers to the arrival in America in the late 1700's of the "English ware called Britannia." To Boardman, britannia meant a lead-free alloy composed of about 90 per cent tin, with 5 to 10 per cent of antimony and copper. Because copper was sometimes introduced into the alloy in the form of brass, zinc (another component of brass) is sometimes found in britannia.

In each of ten britannia formulas for various purposes given in Isaac R. Butts, *The Tinman's Manual and Builder's and Mechanic's Handbook,* published in 1860, tin, copper, and antimony are the three ingredients cited.[36] However, the writer feels that the distinctive factor in these formulas is the absence of lead and the presence of 3 per cent or more of antimony in combination with a small amount of copper.

To pewterers in the period 1806–75, britannia clearly meant a kind of super pewter that was easily worked and that sold extremely well. To the public, britannia meant an alloy that was sparkling and bright, wrought in new-fashioned forms, contemporary with those of silver and Sheffield plate. As will be shown, britannia wares could be made in several different ways, but apparently the method of fashioning had nothing to do with whether a pewterer called an object britannia. The formula of the alloy provided the criterion. To William Calder, pewterer of Providence, there was indeed a real difference between britannia and pewter. During 1827, his accounts list many teapots, coffeepots, tablespoons, and teaspoons, usually without a descriptive adjective, until December 12, when there were entries of $2.00 for "12 Britania tumblers" and $1.75 for "12 pewter" ones.[37] Thereafter pewter and britannia articles were always explicitly differentiated. The greater cost of antimony may have been the determining factor in the higher price asked for the britannia tumblers, but manufacturers may also have charged more because the market would bear it.[38] Britannia objects had sales ap-

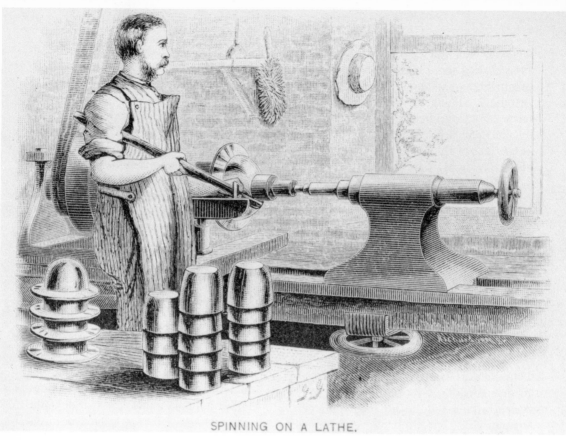

SPINNING ON A LATHE.

2–17. "Spinning on a Lathe," as illustrated in Randolph Townsend Percy, "The American at Work, Part IV: Among the Silverplaters," *Appleton's Journal* (1878), p. 487. Spinning on a lathe, stamping with dies, and seaming were new methods used in the nineteenth century to give form to thin sheets of pewter metal, then called "britannia."

peal because of their shininess and new-fashioned forms.

In the 1790's, English britannia makers began to fashion vessels from sheets of rolled metal—sometimes by spinning and sometimes by stamping. Possibly as early as 1807, the firm of Lee and Creesy of Beverly, Massachusetts, began the manufacture of sheet-metal britannia teapots, followed in 1812 by Israel Trask's larger and more prosperous undertaking when he bought out the firm.[39] Surviving teapots by Lee and Creesy and teapots and coffeepots by Trask (Figs. 11–8 and 11–14) were shaped in part by bending and seaming britannia sheet metal after the

manner of the tinsmith. They were usually engraved in "bright cut" silver fashion.

Slightly later, probably in the 1820's, the techniques of spinning and stamping britannia sheet metal were introduced by American manufacturers and were increasingly employed by large producers through the 1850's and 1860's (Fig. 2–17). However, examination of the great number of cast britannia objects that survive suggests that at least 50 per cent were shaped by casting.[40] Nevertheless, britannia wares were very different from earlier pewter objects. The shapes now accorded with nineteenth-century fashion. They

tended to be bolder in form and usually bore horizontal bands. These bands were light-catching and strengthened the thin vessel walls. The thinner walls, in turn, were made possible by sheet metal or castings of the harder, stronger alloy. If made of the latter, they could be skimmed thinner than pewter.

The lightweight vessels appealed to the buyer because they more closely resembled silver than old-fashioned pewter. Though britannia metal cost more per pound than pewter, less metal was required.

Britannia production was tremendous. In 1831, the Taunton Britannia Manufacturing Company received a single order for 10,000 sperm-oil lamps.[41] The magnitude of the trade is also suggested by the account books of Ashbil Griswold, where, as previously noted, the 1836 inventory of one New York merchant retailer recorded almost 90,000 items purchased from Griswold.[42] Many millions of useful household objects were made of britannia between 1806 and 1875. During this era, at least fifty different firms manufactured britannia in Connecticut alone. Beverly, Boston, and Roxbury, Massachusetts; New York; and Philadelphia were leading centers of manufacture, as well as Meriden and Middletown, Connecticut.

New fashions and new manufacturing techniques went hand in hand. Nineteenth-century taste emphasized the elaborate, the bold, and the ornamental. In turn, new techniques such as fluting, horizontal reeding, and ribbing gave added strength to vessels of thin rolled metal.

The American britannia manufacturer sometimes achieved fashionable forms by copying English models. More often he seems to have designed his own patterns or copied those of his American competitors. When first produced, britannia objects were bright and shiny, and they stayed that way for a long time. But today, after a hundred or more years, the silvery appearance is gone, and the color of the metal now approximates that of pewter. In consequence, the bulging, sometimes fussy shapes suffer in comparison to the sleek forms of earlier pewter. In the past, collectors scorned all britannia as unworthy of notice. Such a blanket indictment is unwarranted. Many nineteenth-century forms are pleasing and, when well polished, are glorified by the color of their metal. Indeed, the water pitchers of Rufus Dunham, the Boardmans, and Roswell Gleason (Fig. 7–6) are among the handsomest objects produced for home use. As we have come to understand nineteenth-century furniture and other decorative arts, they have risen in our esteem. Britannia also deserves our favor.

Chapter Three
Connoisseurship

Connoisseurs and collectors of long standing develop a kind of sixth sense about objects in their chosen field. This sense—call it instinct, if you will—coupled with enthusiasm, baffles the uninitiated. The layman asks, "How do you know that this thing is old, valuable, important, or a work of art?" To this question, one type of connoisseur—I shall call him the intuitive type—may reply, "It simply *is*." His instinct speaks to him, rather than long-reasoned judgment. Such instinct, combined with a keen sense of the thing that will sell; of commonness and rarity; of the good, the better, and the best—and the price to be attached to each—is the chief stock in trade of the dealer. Daily he is faced with making quick judgments: Does he like the object? Is it rare? Will it sell? What price will it bring?

Another type of connoisseur puts great emphasis on reason as well as instinct. This type of connoisseur is more likely to be a scholar than a dilettante. Certainly he is more apt to be analytical and to rely on careful study, as well as a calculating eye, to make judgments.

"How does one become a connoisseur?" One of the first to answer the question was Jonathan Richardson.[1] His observations apply to prints, paintings, and drawings and are as valid today as when written in 1719. Many have written on connoisseurship since Richardson's time, but no one has set forth the factors to be considered in evaluating American pewter, silver, or other small craft-made objects. This I shall now try to do.

The primary personal attribute of the connoisseur is a good visual memory stocked with infinite images of ordinary, fine, and superior objects. The connoisseur remembers especially those objects he has personally examined, but he also has in his mind published photographs of objects and the facts connected with them. Invaluable to the student are photographic files that can be readily shuffled or rearranged for comparison. Anyone who aspires to become a connoisseur must first learn to see, then he must look and look, and remember what he sees. In learning to see, I know of no exercise that equals the act of drawing with pencil on paper. Drawing sharpens the sense of both detail and over-all relationships.

During the first flush of excitement over a new discovery, the true collector is off

on a cloud, his senses hazy. This is the time when the spirit of inquiry is a major asset; the true connoisseur, instead of leaping to conclusions, will proceed cautiously. He will ask questions and consider the answers carefully. Objectivity on the part of the connoisseur becomes all important as he attempts to evaluate his prize. To do this, he must establish certain facts—the approximate date and the place where the object was made and, if possible, the author. In a high percentage of pewter objects, this is feasible because of pewterers' widespread custom of stamping their wares with a touchmark. The connoisseur judges the excellence of workmanship, the condition, and the effect of wear and tear. Historical evidence will be less important to the "object collector" than to the cultural historian. But both will be influenced by early ownership. In some cases, history

may contribute to the object's appeal as a work of magic, the magic of hand and mind known as craftsmanship, but in reality art. Who can see Capt. Ickes's mug (Fig. 3–1) and not be carried away?

Each connoisseur, consciously or unconsciously, looks at an object from many points of view and instinctively follows some, if not all, of the exercises set forth below. These steps are the prosaic homework of study and observation that provide data to identify an object, to evaluate its condition and quality, and to determine its comparative success as a work of art.

I. Over-all Appearance

When first looking at an object, it is important to try to get a sensual reaction to it. I ask myself: Do I enjoy it? Does it

3–1. Quart mug, ca. 1775–80, H. 5¾". Inscribed "Liberty or Death/ Huzza for Capt. Ickes," marked "Philadelphia" (WM 67.1369).

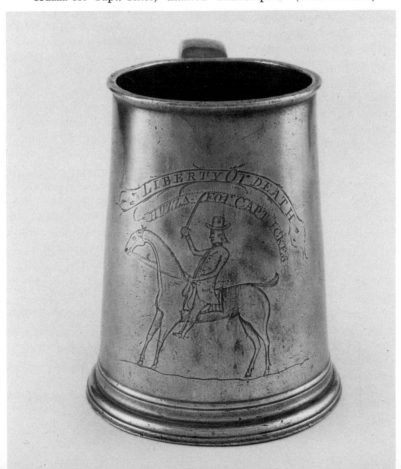

automatically ring true? Does it sing to me?

Sometimes I look at it with half-closed eyes from various angles to sense the sweep of line and massing of form. I ask myself: Are the lines clean and the masses in accord with its style? Is the stance one of grace? Does the object have unity? Is it sculpturesque in the relationship of solids and voids? Is there harmony in the whole, and are the parts integrated? Did the author successfully deviate from the norm to such a degree that he achieved something new and more interesting?

The character of the over-all design, the scale, proportions, and harmony of parts, can give an object nobility. These are the things to be assayed. Let us begin by examining the controlling factors of the artistry and design of American pewter. Because of the way in which pewter was made, the moldmaker could project his ideas through thousands of objects. Like engravings, every pewter object made before 1815 was a multiple image, its design and shape dependent on the molds in which it was cast. As the inventiveness and qualities of the printmaker's design on the copper plate, the lithographic stone, or the silk screen determines the character and artistry of the print, so the mold determined the character and artistry of pewter objects. The merits or shortcomings of pewter objects are in large part attributable to the designer and maker of the molds.

II. Form

Form, more than any other quality, distinguishes a work of art. Because certain examples are more successful than others, it is the goal of the connoisseur to recognize the subtleties of the best. Conception and proportion give an object nobility and distinction. In the training of the seventeenth- and eighteenth-century designer and craftsman, acquaintance with the orders of architecture was considered important. Emphasis was placed on subtle relationships between the size of parts and especially of moldings. Hence, the connoisseur needs to learn the norms of size and a sense of the relationship of parts to the whole. The pewterers of each area had favorite models. Connecticut pewterers preferred eleven- and thirteen-inch deep dishes, and fifteen- or sixteen-inch dishes made by Connecticut-trained pewterers are unknown. Boston pewterers favored plates with narrow brims. Thus, one should be suspicious of a New York marked example with this New England feature.

III. Ornament

I ask myself: Why is the ornament there? What is its purpose? Is the over-all effect the better for its presence? Basically, ornament is secondary to form and ought to heighten its effect rather than obscure it.

The range to be considered here is much broader for other kinds of objects than those of pewter. Obviously, to evaluate the effectiveness and quality of ornament, one must be well acquainted with (1) the types of ornament employed and the levels of technical excellence achieved by artists and artisans in different times and places, working in the style of the object in question; (2) the attitude of the artist or artisan toward ornament; and (3) what the ornament was intended to accomplish. Moldings provide the principal ornament for pewter objects. At best, they provide rhythm, pattern, and punctuation. Sometimes they unify the composition, as when the cover moldings of a tankard repeat and enlarge the moldings of the base.

Coats of arms, crests, cyphers (Fig. 3–2), initials (Fig. 3–3), or other personal attributes of early ownership provide ornament of a most interesting kind. Such

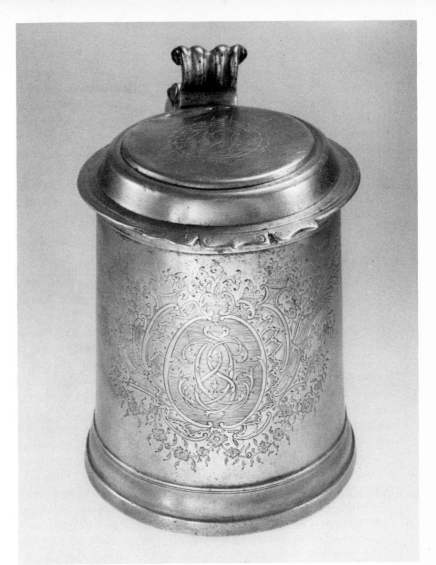

3–2. Engraved "CS" cypher on quart tankard, attributed to William Brad-
ford, Jr., w. 1719–58, New York City, H. of tankard 7¹⁄₁₆″ (WM
59.34).

3–3. A pewterer's identity may be suggested by the individuality of the
letters he used to stamp the initials of an owner. Joseph Leddell used
letters with crowns and, like most eighteenth-century pewterers, *I*'s
for *J*'s. An *M* or *S* of the same size and character as that shown below
would point to John Dolbeare, Boston pewterer, who struck these ini-
tials on a 15-inch multiple-reeded dish.

inscriptions are less frequently found on pewter than on silver articles. Indeed, it is rare to find more than a pair or triad of owner's initials, incised with the letter stamps that were a part of most pewterers' equipment. One of the most elaborate engraved ornaments is the cypher on the pewter tankard illustrated in Figure 3–2, which rivals the finest engraved American silver. The initials "C S" of an unidentified owner, framed by a flourish of rococo scrolls, grassy foliage, and dependent flowering vines are repeated within a leafy circlet on the cover. Marked with a *W B* and fleur-de-lis touch, similar to the touches of New York pewterers, this fine tankard is attributed to William Bradford, Jr. (w. 1719–58) of New York City.

Another American pewter prize with engraved ornament is a quart mug (Fig. 3–1) in the Winterthur collection, inscribed "Liberty or Death, Huzza for Capt. Ickes." This stirring sentiment, a rousing echo of Patrick Henry's revolutionary cry, and the spirited horse and rider depicted put this mug in a class by itself. To date it has been impossible to confirm the legend passed along with the mug when it was found in the 1930's near Carlisle, Pennsylvania, to the effect that the mug was a present to Captain Peter Ickes when he led his Pennsylvania troop off to the Revolutionary War. Of excellent metal and in fine condition, the mug is unidentified beyond the mark *Philadelphia* in its inner bottom.

IV. Color

Art historians have long sought a uniform color vocabulary for describing and analyzing paintings, and the student of painting must learn to chart value, hue, and intensity in order to describe color. Up to the present, no one known to the author has attempted a scientific description of the color of pewter. All agree that bright, clear, resonant metal is greatly preferred over leady-looking soft metal. But to adequately describe the soft glow and rich sheen of a dish or tankard made by Simon Edgell, Frederick Bassett, or William Will is beyond the power of words. Although comment on pitted pewter will be made later, it is important to note here that it is impossible ever to regain a satisfactory color on pewter scarred by pitting.

V. Materials and Analyses

Although collectors do not have the facilities to make laboratory analyses of the kind described here, information from such analyses confirms what connoisseurs come to know intuitively, for it is axiomatic that the character of each pewter object depends upon the alloy from which it is fashioned. Until recently, determination of that composition could only be made on a subjective guesswork basis because chemical analysis required a substantial sample of metal. In the last three years, Victor F. Hanson, head of the Winterthur Museum's Analytical Laboratory, has been working with a Kevex nondispersive x-ray analyzer, which uses a radioactive source to energize metals to be analyzed and a computer to translate data into usable form. In cooperation with the Museum's curatorial staff, the laboratory has established standards for the analysis of various metals, in particular, silver and pewter. Recently Mr. Hanson and his staff have at my request very kindly analyzed objects to provide much new information about the constituents of American pewter. From this new data we can begin to deduce the capabilities and practices of the American pewterer. One day we hope to have similar analyses of English, French, and other pewterwares to provide comparative information against which to judge the American craftsman's performance.

A summary of the Winterthur findings detailed on pp. 236–38 shows that lead-

ing New York and Philadelphia pewterers could control quite precisely the character of their alloys, the tin content of the different parts of their teapots, tankards, and other vessels seldom varying more than 2 or 3 per cent. An amazing discovery is that many vessels made by Frederick Bassett, Francis Bassett I, John Bassett, John Will, and William Will have a tin content of from 95 to 99 per cent. These vessels we may assume were those advertised as *hard metal* or *block tin.*

American pewterers could and did vary their alloys to accord with the use to be made of a vessel. In contrast to the high tin content, for example, of teapots and tankards, William Will's bed pan averages only 83 per cent tin with 13 per cent lead. His spoons show an even higher lead content, averaging 24 per cent. However the bismuth content of up to .17 per cent is somewhat higher than usual to make them harder and less susceptible to bending.

From these findings we must assume that city pewterers had access to bar tin (block tin) which, being nearly pure tin, enabled them to regulate the tin content of their mix. This assumption is supported by a century-old explanation for a Samuel Hamlin porringer that does not conform to the high quality expected. Its bowl tests only 78 per cent tin, with 17 per cent lead present (handle 57 per cent tin, 35 per cent lead). An explanation showing that this was not Hamlin's choice is found in an 1860 history of the Providence Association of Mechanics and Manufacturers, where it is stated that in the 1790's the Providence pewterers complained: "They labor under great discouragements, by being obliged to work large quantities of old pewter, which being of base [poor] quality, imported from Bristol, and sold here for London-made, they cannot by reason of the scarcity of block tin, make it equal to the London standard, and at the same time work all the old pewter in the country."[2]

Generally Connecticut and other country-made wares show a comparatively low tin content. Shortage of block tin may explain the lower standard, but it seems more reasonable to suppose that "common pewter" rather than hard metal was the norm of the country pewterer's shop.

VI. Techniques Employed by the Craftsman

Here the goal is to evaluate (1) the quality of craftsmanship; (2) the techniques and practices employed (and through this study to determine whether they are typical of a period, locale, and culture); (3) the personal idiosyncrasies of workmanship apparent in signed or documented pieces; (4) the congruency of the parts and whether the whole is entirely by one maker or was made up at a later date from antique parts. Such evaluation often reveals restorations. Study is only now beginning on britannia ware to determine whether a piece was spun, stamped, or cast. Quality of workmanship within a craft varies widely with time and place. Normally the craftsmanship of the great city pewterers such as the Bassetts, Simon Edgell, and William Will is far superior to provincial work.

The phenomenon of regional and national characteristics is widely recognized and is a factor understood by every connoisseur. Characteristics for most objects fall into a general pattern, more often than not peculiar to a particular area. The reasons behind these phenomena are not yet understood, but there appears to have been close cooperation among pewterers. Also, journeymen moved about from one shop to another.

VII. Trade Practices

It is helpful to study analogies to other decorative arts. By law the English silversmith stamped his wares with (1) a date letter, (2) a symbol indicating sterling

quality, (3) a maker's mark, and (4) a mark indicating the city of origin. In the American colonies, no mark was required, but most silversmiths identified their products with their names or initials and adhered closely to recognized English standards of quality. However, we know very little about the availability to the American pewterer of block or bar tin until about 1800. Without pure tin, the pewterer could not upgrade his alloy.

Later excise and tariff laws also resulted in practices that are of assistance in dating. The presence of *England, Japan,* or *China* on an object indicates that it was made after the 1891 McKinley Act requiring the name of the country of origin on new articles imported into the United States. Unscrupulous sellers often remove such marks. As further study is carried on, many more aids to identification will be discovered in every field, including pewter, if collectors approach each object with an inquiring mind as well as an inquiring eye.

VIII. Function

The study of function ought to lead to an understanding of basic character. One of the most widely used dictums of the twentieth-century designer, applicable to decorative arts as well as to architecture, is that "form follows function." Exploration of function and form leads to such questions as: Why was this object made? What were the limiting conditions imposed by materials, techniques, and skills? What was the intent of the maker?

Sometimes important clues to authenticity may be gleaned from observation of functional qualities. Can the object have adequately performed the use for which it was intended? Does the evidence of wear and tear occur where one could properly expect it? Does the dent made by a tankard's thumbpiece come at just the right spot on the handle? Do the marks made by wear and polishing on the bottom of a plate carry over the raised portion of the mark, as logically they should?

IX. Style

The analysis of style involves the study of form, ornament, color, craft techniques, and the weighing of data gained through virtually each of the preceding steps. Much can be learned by relating pewter forms to silver, ceramics, and furniture styles. Indeed the greatest shortcoming of the American collector is his frequent failure to attempt a stylistic analysis of the objects he collects.

Seventeenth-century-style American pewter, like furniture, has a strong horizontal emphasis. This is especially true of flat-top tankards with overhanging, serrated lips and out-reaching handles; broad-brimmed plates and dishes; wash basins with narrow brims and sloping sides; and spoons with long, severely straight handles and round or fig-shaped bowls. Flat-top tankards, which continued to be made in New York and Albany to the end of the eighteenth century, are the most satisfactory of all American pewter shapes, rivaled only by round, ball, and pear-shaped teapots and cream pitchers. The outlines of the pear-shaped ones follow the S curve, the basic line of the Queen Anne style lauded by William Hogarth in *The Analysis of Beauty* (1753). But before that publication, pear-shaped teapots and cream pitchers had been introduced in England and were being made in America. The teapot (Fig. 11–3) with the mark of Cornelius Bradford (w. 1753–85) and the pitcher (Fig. 7–1) by John Will (w. 1752–74) may well be the earliest known American *marked* examples of their kind.[3]

The Bradford teapot, probably made in Philadelphia, shows a medley of S curves. The outlines of handle, body, spout, cover, and cabriole legs with pad

feet resemble those on Queen Anne style furniture and echo in small scale the tension and dynamics of the baroque style.

Just when forms with undulating outlines were first introduced in American pewter is not known, but the tankards of Philadelphia's Simon Edgell with double-domed tops prove that outlines of sinuous contour had been introduced in America prior to 1742, the year of his death.

William Will's pewter better illustrates the evolution of styles than that of any other American pewterer. Several reasons underlie this phenomenon: The citizens of Philadelphia were extremely style conscious. Will, with a very large business, either made or acquired a steady stream of new molds to keep abreast of silverware. More than fifty different forms or variants (among some two hundred surviving pieces) provide a wider sample of his products than is known for any other American pewterer.[4] The working career of Will overlapped three style periods, beginning in 1764 as the Queen Anne style was waning and extending through the rococo, or Chippendale, into the neoclassical of the federal period.

Certain of Will's forms, such as his plates, dishes, and basins, are traditional eighteenth-century pewter shapes; but his teapots, tulip-shaped tankards, and mugs are typical forms introduced during the Queen Anne style period (ca. 1730–ca. 60) or soon thereafter. The tankard (Fig. 6–26), the mug (Fig. 6–13), and the teapot (Fig. 11–5) display the taut but flowing serpentine lines of fine Queen Anne examples. In some mugs (Fig. 6–12), the substitution of the double-C scroll handle and acanthus-leaf decoration show the introduction of Chippendale elements, as does the addition of claw-and-ball feet to some of his teapots. Subsequently he further modernized his pots (of the same shape) with new decoration—the neoclassical beaded ornament on the cover and finial of Figure 11–7. Just when Will introduced

neoclassical forms is not known, but his drum-shaped teapots (Fig. 11–8) and coffeepots (Fig. 11–15) and communion flagons with classical urn-shaped bodies (Fig. 4–38) are as ambitious attempts as were made by an American pewterer to keep abreast of fashion.

X. Date

To arrive at a date for an object requires not only consideration of all the preceding data but also visual comparison with documented objects. A knowledge of the evolution of form, ornament, and style plays an important part in arriving at an approximate date. However, some pewter forms, such as flat-top tankards and round-bowl spoons, continued in production long after their introduction in the seventeenth century. Presumably the pewterers' best market was among the very conservative (reluctant to accept change) and country people, either ignorant of or less interested in new fashions. Obviously located inland away from seaport cities, they had less opportunity to buy up-to-date forms in fragile imported china, not available, as was pewter, from the peddler's wagon.

XI. Attribution

For a maker's touchmark or a signature of any type, the observer must determine first whether it is actually that of the author applied at the time of manufacture, or an authentic mark (stamped with an old die) applied at a later date to an unmarked piece, or a fraudulent inscription or signature applied to an unmarked example by the forger. A common deception practiced by pewter fakers is to cast pewter in plaster molds modeled upon authentic plates and dishes. By this means the details of original marks are cast into the fake.

For purposes of identification, each London pewterer was required to stamp

A B

 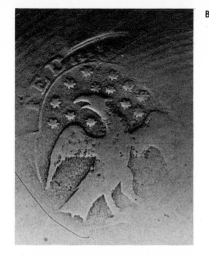

C

 D

3–4. Marks: (*a*) Pre–1782 maker's mark with lion; (*b*) post–1782 maker's mark with eagle. Name marks in plain rectangles were common from 1830 to 1860 (*c*). Intaglio maker's marks appeared in the early nineteenth century and became common after 1835 (*d*).

his wares with marks registered on a lead touch plate in the Hall of the Worshipful Company of Pewterers. In America the laws were not as stringent as in England, where the sale of inferior, especially leady, pewter was prohibited. There bad pewter was seized without recompense to the owner, and its maker was liable to a fine.

The character of marks changed with the passage of time. By the early eighteenth century, full-name marks were being used on plates and dishes, and apparently pewterers viewed their marks as valuable advertising. Probably America's high regard for English pewter prompted Joseph Leddell to mark his early wares with a full-rigged ship and *I L from Old England*. Following the Revolution, American pewterers quickly changed from English-looking lion or rose-and-crown marks to those featuring the American eagle, our new national symbol (Fig. 3–4 *a*, *b*).

Many pewterers' marks made before 1820 are beautiful; others, even though crudely cut, show great character. After about 1825, marks lost their distinction and appear as unornamented name touches in straight or saw-toothed rectangular frames (Fig. 3–4 *c*). Some later marks are no more than incised letters punched into the metal without a frame (Fig. 3–4 *d*).

Although American pewterers were not required by law to mark their wares, most of them did so, and the writer believes that (except for spoons) at least two-thirds of the several thousand extant pieces of American pewter and britannia were originally impressed with makers' marks. Some articles are more likely to be marked than others. At the head of the list are plates and dishes, most of which were marked when made. Perhaps half of the extant porringers are stamped with known marks or bear unidentified cast ini-

tials such as *E G*, *S G*, *R G*, *W N*, or *C P*, believed to have been made by a succession of New England pewterers. Miniature articles and others without a flat surface to receive a mark are usually unmarked, as, for some unknown reason, are most sugar, salt, and pepper shakers, cream pitchers, and sugar bowls. As previously noted, many surviving spoons were made by tinkers and householders, who either did not use any marks or else cut initials in their molds to leave cast marks in relief which, alas, cannot now be identified.

Even a novice with the aid of Ledlie Laughlin's *Pewter in America* or Celia Jacobs's *Pocket Book of American Pewter* can quickly identify the maker of most marked pieces. To differentiate between English and American pewter is not always easy, but if a mark is not listed in either of the above books, it may be found in Cotterell's *Old Pewter, Its Makers and Marks in England, Scotland, and Ireland*, which includes most known British marks. Some Continental pewter plates may be confused with English and American examples, but certain attributes are telltale Continental characteristics. Easily recognized are those examples marked with the often used angel and *Englisch Zinn* touches. To be noticed is the thicker and heavier metal of Continental plates, especially in the common 8¾-inch semi-deep dinner plate. Other typical Continental forms are wavy-edge plates and dishes, deep soup plates, 8½ to 9 inches in diameter, strengthened by a bead at the edge but without brim.

Usually the marks on pewter mean just what they read. However, there are exceptions. A few pieces marked *London* seem to have been made in America. It should be emphasized that such pieces are great rarities. As yet the Boston users of the *Semper Eadem* (always the same) touch and the *R B* and small rose-and-crown touch have not been positively identified

but seem alternatively to have stamped their wares *London* or *Boston*. Contrary to his usual practice, William Will also stamped at least one fine coffeepot with a *London* mark (Fig. 11–16).

Initial marks found in mugs, tankards, and occasionally on porringers and other pieces are to be attributed to a particular maker with caution. Attributions made in this book are for specific marks from a die identical to one for which there is supporting evidence. Many pewterers had the same initials, and the problems of attribution are illustrated by the five *F B* marks shown in Figure 3–5. (*a*) is known to have been used by Francis Bassett I (w. 1718–58) because it has been found on plates in conjunction with a Francis Bassett touch and on one splendid piece dated 1732, which is prior to the time Francis II (w. 1754-99) started to work. (*b*) has been found on plates in conjunction with Frederick Bassett's full-name touch, as has (*c*). Mark (*d*) has been attributed to one of the Francises or to Frederick. Any or all of them might have used it, but it occurs on many objects that are identical to pieces bearing one of Frederick's accepted marks. Thus, an attribution to Frederick appears to be the stronger one for (*d*). Not all *F B* marks were used by the Bassetts. Some Continental 8¾-inch plates have a centered *F B* in a rectangle like the mark shown in (*e*). To attribute such marks to one of the Bassetts is wishful thinking. To substantiate the attribution of an initial mark to a particular maker, evidence is necessary, the best being an initial mark accompanied by a full-name mark.

For the benefit of those who wish to study marks, it may be noted that marks of the same era and locale often show strong similarities—probably because one die cutter made the stamps for all pewterers in his vicinity. New York initial marks often include fleurs-de-lis; hence, one cau-

3–5. *F B* initial marks: (*a*) Francis Bassett I; (*b,c*) Frederick Bassett; (*d*) probably Frederick Bassett, though possibly Francis I or II; (*e*) mark often found on Continental plates.

tiously attributes a New York style tankard marked in the inside center of the bottom with a *W K* in a circle, with fleurs-de-lis above and below, to the New York pewterer William Kirby. After seeing several such tankards, and a few New York style porringers so marked, one's assurance of the attribution is strengthened.

The marks on 10 to 20 per cent of old pewter have become unreadable because of wear or pitting, but sometimes enough of a mark remains to permit identification by comparison with a complete mark.

Most collectors and dealers share an intense desire to attach a maker's name to every piece of unmarked pewter and to know when and where it was fashioned. Often unmarked objects are attributed to a particular pewterer because the whole object or, more often, a part is identical to that of an identified piece. Most collectors recognize that such attributions are weak. We know little of the lending or renting of molds and tools, although we are indebted to Thomas D. Boardman for telling us that he rented molds from Edward Danforth. We can but guess that castings were sold from one shop to another or that journeymen may have owned a few molds that they took with them from one employer to another.

XII. History of the Object and Its Ownership

In dealing with histories of ownership, one needs to ask: Is this history possible, plausible, or positive? Because of the possibility for error, it is wise to regard an object's history as supporting data rather than as primary data. True, there are certain exceptions, as in the case of books, where signatures, early bookplates, and shelf marks may be regarded as virtually irrefutable. The same may scarcely be said for objects described as "given to my great, great grandmother as a girl" on a label dated 1901.

The presence of owners' initials, even though they are unidentified, is of interest because there is always the possibility that the owners can one day be discovered.

The individuality of monograms may also help to identify a maker. Mention has already been made of the Boston inventories of John Comer and John Baker, each of which listed a set of letters for imprinting owners' initials on pewter objects. Inasmuch as the character of the letters in these sets was highly individual, the presence of identical letters in two monograms suggests that both pieces were originally sold from the same shop (Fig. 3–3).

Engraved coats of arms, crests, and inscriptions are considered one of the glories of early American silver and pewter decoration (Figs. 3–2, 6–16) and are highly prized by collectors and connoisseurs.

XIII. Condition

Evidence of natural aging and wear, such as coloration, patina, and softening of edges and corners, are attributes of an antique that add to its value. But the connoisseur must come to grips with the demerits of disfiguring wear, tear, and accidents. The connoisseur is prepared to accept more restoration, repairs, or blemishes on the earliest or most important objects.

To the connoisseur of pewter, the quality and condition of the metal are as important as the presence or legibility of the maker's mark. Thomas Jefferson once remarked that architecture must be good because it shows so much. The same can be said of the condition of metal and of form. These are the things that are seen first when one looks at a piece of pewter. Perhaps one piece in a hundred will be virtually unused and still retain its original skimming marks. Such a piece is to be treasured.

Pewter is susceptible to discoloring and pitting. This appears to flourish under cold, damp conditions. Rapid tranishing is followed over a period of years by the formation of black scale, a symptom of the disintegration of the metal. However, contrary to the author's earlier belief, pewter does not disintegrate, as tin is said to do, at temperatures of −39 degrees centigrade or lower.[5] When scale is removed by immersion in a lye or muriatic acid bath, the surface of the metal is usually pitted. Persistent polishing may smooth the surface, but it will never have the luster of unpitted pewter.

Objects that have been so badly dented as to stretch the metal will always show the effects of their mistreatment, but simple dents can be easily removed and cracks or breaks in the metal soldered. Even large holes can be patched or filled in. The results, of course, will depend in large part on the skill of the repairer. To locate an able workman, one usually turns to a good pewter dealer for assistance.

As will be noted later, some collectors find merit in dirty or corroded pewter and insist on leaving their pewter untouched. Historically and aesthetically, this attitude is beyond understanding. Housewives prided themselves on a fair (clean) garnish of pewter. Pewterers sought mixes that were slow to tarnish. Dirty pewter is like a dirty house, an affront to the eye. Further, the owner of dirty pewter is unfair to the metal he professes to like. In its unkempt state, it lacks the reflective qualities that bring out the character of the design with changing emphasis according to the time of day and the angle of viewing.

Old pewter is not meant to have the high sheen of silver and should never be buffed on a wheel: Buffing ruins old pewter by permanently changing its molecular structure. Buffing creates a shiny skin that is incompatible with the forms of pewter vessels. Buffing destroys the ideal tone of pewter, which is lustrous and soft in color,

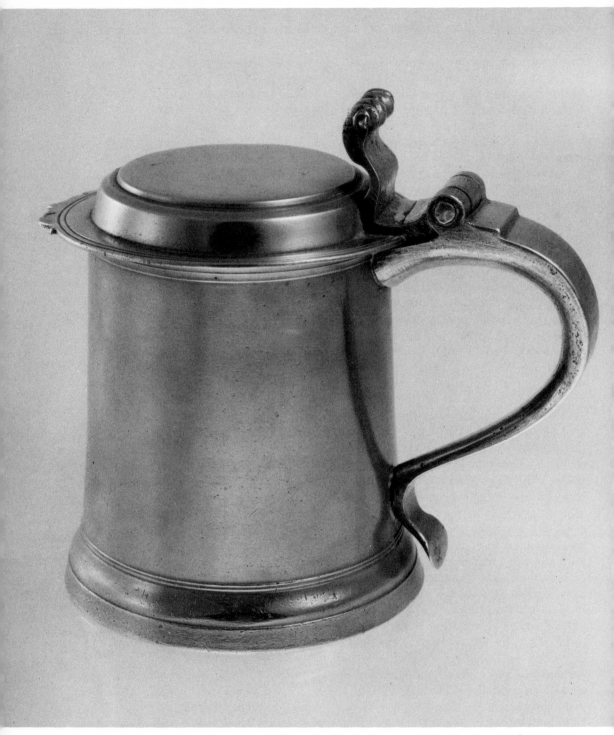

3–6. Quart tankard, attributed to William Bradford, Jr., w. 1719–58, New York City, H. 6½" (WM 65.2751).

resonant and alive. Buffing removes hammer marks, which give pewter the character of the hand-wrought. The eye delights in the rhythm and perfection of a well-planished plate or dish with its concentric rows of hammer marks left by the hammermen of Edmund Dolbeare, Simon Edgell, William Will, or Peter Young.

XIV. Evaluation

As a beginning to this subjective exercise, let us consider importance versus rarity. Whereas rarity has little effect on the price of a painting, it is a prime factor in determining the price of stamps, coins, or glass bottles. Since 1925, when Kerfoot published his lists of American pewterers categorized into four degrees of rarity, this criterion has strongly influenced the price of American pewter.[5] The wise collector looks for other virtues, and the connoisseur will weigh the merits of an object rather than be persuaded by rarity alone.

In all ages, the public has been fascinated by the large, the imposing, the grandiose, but the connoisseur more often has delighted in the miniature, the jewellike, and the exquisite.

Often, but not always, the most important objects are also the rarest. Large pewter pieces are in general both more important and rarer than small ones because few pewterers had molds for large pieces; also, large pieces required more metal and hence were more expensive.

Whereas for furniture and silver, a substantial percentage of the original production survives today, extant examples of pewter provide no fair sample of what once existed. Because the American pewter industry depended on the metal from worn-out pieces for its raw material, most early pewter went into the melting pot. Of the hundreds of thousands of American pewter objects made in the seventeenth century, not ten examples are now known. Of the millions made between 1700 and 1750, probably not a hundred are currently recognized. These early objects are what excites the knowing collector. Perhaps two thousand objects made between 1750 and 1800 are now known. Of these, the pewter of Frederick Bassett, the Wills, the Danforths, Samuel Hamlin, and Gershom Jones is relatively common. Each of them had large enterprises with a great variety of molds and were equipped to make many different forms.

Far rarer than the products of pewterers working in large centers are those of pewterers who fanned out from Connecticut to inland and southern towns. On the basis of rarity, high prices are asked for their work, which is largely restricted to plates, dishes, and basins, and much of it is of only ordinary quality. This pewter I find of little interest unless there is some special or unusual feature, as in the case of the pewter of William Nott, who, after training in Middletown, Connecticut, set up shop before 1817 in Fayetteville, North Carolina. His work is rare, but more interesting is his eagle mark incorporating a Masonic square and compass. I find the question of why he included this insignia fascinating. Was he an ardent Mason hoping to win the trade of other Masons by showing these emblems?

Equally interesting is a small group of plates, basins, and dishes marked with a portrait bust and the legend "General Jackson N. O." Sometimes these occur with the touches of Hiram Yale and Co. (Wallingford, Connecticut) or of Thomas S. Derby, who may have worked independently in the South, as well as with the Yales and with Joseph Danforth, respectively. Though this Jackson pewter is of ordinary quality, it is an example of a pewterer's relying on a national hero's image to sell his wares. As a homespun hero, Jackson was in the news continuously from 1815, following his victory at

New Orleans, until the end of his second Presidential term in 1837.

In comparison to the rarity of the above-mentioned pewter, probably five thousand other examples of nineteenth-century pewter and britannia survive by more prolific makers. Some of the best values for the pewter collector are to be found in the work of the Hartford Boardmans. With branch outlets in New York and Philadelphia, they enjoyed a prominent place in the industry. Their pewter is well made, and their flagons, tall beakers, and two-handled cups are handsome. Ironically, the qualities that brought the Boardmans great sales are now often passed over by the collector for the work of men whose inferior wares could not compete in their time.

Fakes

Objects offered for sale or displayed with the intent to deceive are called fakes. Many reproductions are authentic copies and give pleasure to their owners for what they are, but if offered as originals, they are fakes. As long as seventy-five years ago, writers were commenting on the amount of faking of American and other pewter that was being carried on. Today the great demand for pewter of all kinds makes faking even more profitable, and every collector should be on guard against spurious objects. To wit:

1. Parts of old objects with authentic marks reset in old, desirable forms that originally were unmarked.
2. Old objects stamped with new fake marks such as the *I A B*, for many years attributed to John Andrew Brunstrom of Philadelphia.
3. New objects stamped with new dies in imitation of known marks or of new and hitherto unknown marks.
4. Objects, especially plates, cast from molds modeled on authentic old plates,

dishes, or basins. Every fake made in this way will show exactly the same details of the mark and the same scratches and defects. Even the novice will be on his guard against *exact* pairs or sets of objects.

Certain new and highly desirable objects have been passed off as authentic for a long time. Pewter chandeliers, for example, have been widely faked for the past hundred years. Indeed, the writer does not know a single authentic example in the United States. In recent years, many fake sconces have been offered for sale by department stores and unknowing antique dealers. Easily recognized, these leady-looking sconces have backplates, about 3/16 of an inch thick, usually in the shape of a large bowknot or a shield with a silhouetted rampant lion on either side of the candle arm.

The authentic object will demand a "yes" response to the following: Are there construction telltales that reveal a traditional manner of working not normally followed by makers in the twentieth century? Are linen marks to be found inside porringer bowls opposite the handle join, inside teapots at the body joins, inside strap-handle mugs opposite the handle joins? Is the color the clear, soft color of old pewter rather than the harsh blue-gray of leady or acid-colored metal? Are there broad chatter marks (coarse rays) on the skimming lines of lathe-skimmed pieces denoting that the skimming was performed on an old-fashioned lathe? Are there true skimming lines present rather than ones reproduced by casting? Is the mark stamped and not cast?

The Verdict

In the game of connoisseurship, one's collection is the verdict. The quality of the objects in it reveal the standards and the goals of the collector. The connoisseur

recognizes that a great collection reveals in broad dimension the world of which its objects were originally a part, and at the same time bespeaks the knowledge and the point of view of its creator.

To sum up this study, let us examine a flat-top tankard (Fig. 3–6), which can be simply described as:

Quart tankard: with cylindrical, almost straight-sided body, flat cover, overhanging serrated lip, knurled thumbpiece, outflaring S-shaped strap handle ending in splayed flattened terminal. Two thin line fillets surmount an ogee molding above a flaring, straight base. W B with fleur-de-lis mark inside, center of bottom, fairly clear. There are no insignia of early ownership, and no family history is known, although the tankard was found in New York state.

Ht. 6½". Dia. base 4¹⁵/₁₆". Dia. top of barrel 4⁵/₁₆". Capacity 30 oz. Wt. 22 oz. This tankard was sold by George Mc-Kearin, antiques dealer of Hoosick Falls, New York, in 1935. It was acquired by Edward E. Minor of Mt. Carmel, Connecticut, and passed on to Henry Francis du Pont in 1947, who, in turn, gave it to the Winterthur Museum in 1965.

We now ask ourselves who made this tankard, where was it made, when was it made, how good is it. The very low, flat cover, strap handle, and splayed flattened handle terminal are attributes of 1660–90 English tankards of silver as well as pewter. These are sometimes called Stuart tankards after the Stuart kings. Of the many American tankards of this type that were undoubtedly made, only this tankard and one other (Fig. 6–17) are now known with strap handle and splayed terminal.

Flat-top tankards were a favorite form of New York pewterers.

Although the mark is somewhat similar in style to some later seventeenth-century and early eighteenth-century English marks, no identical English mark is known and fleurs-de-lis are often found in New York pewterers' marks. Slightly variant W B marks are found on well-made porringers and later-style tankards of New York design. The one known New York pewterer with the initials W.B. is William Bradford, Jr., who worked from 1719 to 1758. He seems the likely maker of this tankard. But until his full-name touch is found on the same piece as this initial touch, there is no proof that he is the maker.

The tankard is in superb condition without repairs, serious dents, or disfigurations. The metal is fine, clear, and resonant. Only on the inside of the handle is slight pitting to be seen.

The low center of gravity, the effect of mass, and the strong emphasis on the horizontal are in accord with seventeenth-century design. Most important, the parts form a coordinated unit with simple, strong silhouette and crisply detailed moldings. This is surely one of the monuments of American pewter.

Chapter Four

Church Pewter

Widespread use of pewter in early American churches is evident, but the full extent of its use in church services has still to be determined.[1] Part of the evidence was provided by Alice Morse Earle in her book *The Sabbath in Puritan New England.* Miss Earle pointed out that communion vessels "were not always of valuable metal; John Cotton's first church had wooden chalices; the wealthier churches owned pieces of silver which had been given to them, one piece at a time, by members or friends of the church; but communion services of pewter were often seen." (Fig. 4–1)[2]

Only a few churches today retain their pewter communion services. Among these are the churches in the area of Lancaster, Pennsylvania, which treasure chalices, flagons, and small plates made by Johann Christoph Heyne. The extent of former church holdings is suggested by present-day collections in historical societies. At the New Hampshire Historical Society in the fall of 1968, pewter communion services from twenty-three New Hampshire churches were displayed.[3] Communion services of several Connecticut churches are preserved in the Connecticut Histori-

cal Society, and much pewter from Pennsylvania churches is now held by the Presbyterian Historical Society in Philadelphia.

Pewter was less frequently engraved with the name of church and donor than was silver. Only seven of the 147 pieces of pewter shown in the New Hampshire exhibition were inscribed. Additional pieces in the Winterthur collection (Figs. 4–2, 4–3, 4–31) can be identified by their inscriptions. Of these, the fine, lidless flagon from the Ipswich Second Church (Fig. 4–2), inscribed with the date 1734, may be the earliest dated piece of church pewter with an American background. Marked four times *I N* in a shield in the manner of the early flatware attributed to the Dolbeares and John Baker of Boston, this splendid flagon with long, flowing handle and heavy fillet may be of New England origin, but as yet it cannot be identified.

The custom of having a standardized set of communion vessels seems to have developed in the late eighteenth century. Although the Meriden Britannia Company catalogue of about 1855 notes that communion sets "consist of 1 Flagon, 2 Goblets, 2 Plates, 1 Baptismal Bowl," churches

4–1. A service of baptism in the old Lutheran Church of York, Pennsylvania, as depicted in a watercolor by Lewis Miller, a local carpenter, who made many pictures between 1812 and 1880 (courtesy of Historical Society of York County, Pennsylvania).

4–2. Flagon (front and side views), dated 1734, America or England, H. 8¾″ (WM 64.705).

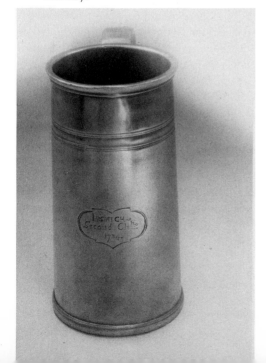
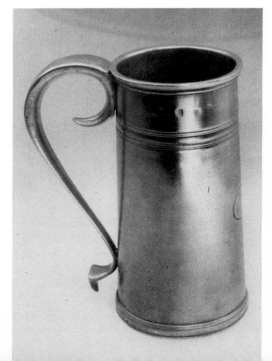

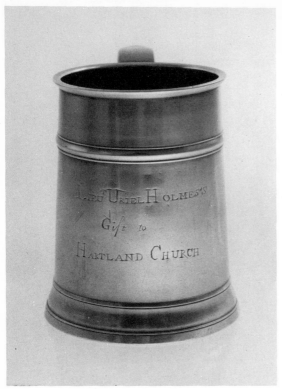

4–3. Pint mug, 1761–1800, by Frederick Bassett, New York City, H. 4¾″ (WM 65.2461).

4–4. Gadrooned cup with two handles, attributed to Robert Bonynge, w. 1731–63, Boston, W. (with handles) 7⅛″ (courtesy of Pocumtuck Valley Memorial Association; photo, courtesy Historic Deerfield, Deerfield, Mass.).

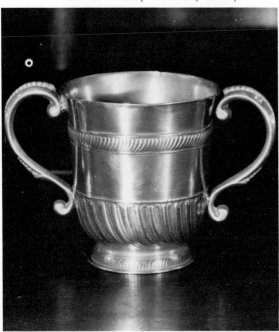

in the seventeenth and eighteenth centuries often acquired two, three, or four pieces of pewter or silver at a time through purchase or as gifts or bequests by members of the congregation. Usually a flagon, or sometimes two, was given along with an alms basin and one or two chalices, which often had covers. Sometimes a large paten was included in the gift.

Unless an object has a history of church ownership, is actually inscribed, or is now in a church's custody, it is almost impossible to know that it was made for church use. However, it seems safe to infer that most chalices and flagons made after 1750 originally served an ecclesiastical function. Prior to that time, flagons and beakers were used at table and are sometimes found in the inventories of individuals. For example, twenty-seven "flaggons" and twenty-four beakers are listed in personal inventories of Essex County, Massachusetts, between 1635 and 1680.[4]

Many tankards were also used in churches, as were some pint and quart mugs. A pewter pint mug, the gift of Lieutenant Uriel Holmes to the church in Hartland, Connecticut, is illustrated in Figure 4–3, and in the pewter communion service of the Rocky Hill Meeting House of Amesbury, Massachusetts, are seven tulip-shaped English pewter mugs.[5]

For sheer magnificence, few domestic forms match the splendor of the eighteenth-century pewter candlesticks, flagons, and chalices of Johann Christoph Heyne (Figs. 5–3, 4–37, 4–28), or the flagons of Henry Will or of his brother, William Will. Also among the noblest forms of American pewter are the chalices of Peter Young and Timothy Brigden of Albany.

Four large two-handled cups (Fig. 4-4) with gadrooned decoration may have been made for church use, as were similar silver ones. These cups, owned by the Pocumtuck Valley Memorial Association of Deer-

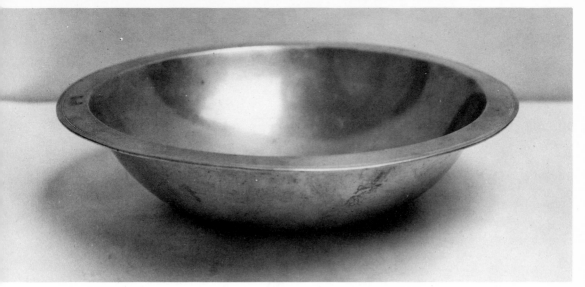

4–5. Basin, by Joseph Leddell, Sr., w. 1712–53, or Joseph Leddell, Jr. (w. ca. 1740–54), New York City, Diam. 13″ (The Metropolitan Museum of Art, Gift of Mrs. J. Insley Blair).

field, Massachusetts, bear the *R B* mark of a master pewterer who is now thought to be Robert Bonynge of Boston. Because of their design and large size, they are ranked among the great pieces of American pewter.[6]

Even more massive are William Will's footed cups made about fifty years later. But fitting each of them with a pair of his acanthus-leaf mug handles posed a problem of coordination too great even for that master pewterer to resolve.[7] They lack the refinement of the *R B* cups. Less imposing, but numbered among the distinctive forms produced by American pewterers, are the beakers of John Bassett, John Will, William Kirby, Peter Young, and Frederick Bassett of New York; *R B* of Boston; and the Danforths—Thomas III, Edward, Joseph, and Samuel.

In the unsold stock of Thomas Byles, offered for sale in 1775 by William Ball of Philadelphia, the "sacrament cups" may have been the "6 Chalices Pewr" valued at six shillings each in Byles's 1771 inventory.[8]

In the nineteenth century, as in the eighteenth, no clear line can be drawn between pewter made for church and home; but, unquestionably, the flagons, baptismal basins, and tall beakers of Samuel Danforth and Thomas and Sherman Boardman were all made for church use and are among the finest forms of the era.

Baptismal Basins

Ordinary pewter food or wash basins were undoubtedly used for baptismal purposes as well. And one famous silver basin, made by Philip Syng for Christ Church, Philadelphia, in 1712, was actually modeled on such pewter forms as those shown in Figure 8–10.

The earliest of American pewter basins, the splendid example made by one of the Leddells in New York City, may have been made for church use (Fig. 4–5). Ledlie Laughlin calls it a baptismal basin, though the writer thinks it was possibly once a "wash hand basin."[9] The basin can be definitely dated before 1754—the year in which both Leddells died.

Footed pewter basins of unusual contours (Fig. 4–6) were made by Samuel

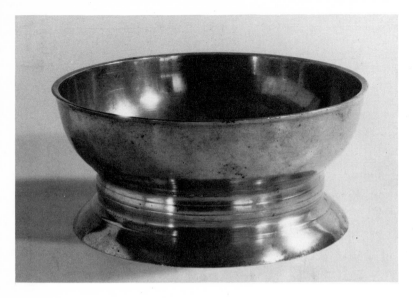

4–6.
Footed basin, 1795–1816, by Samuel Danforth, Hartford, Diam. 8″ (Yale University Art Gallery, The Mabel Brady Garvan Collection).

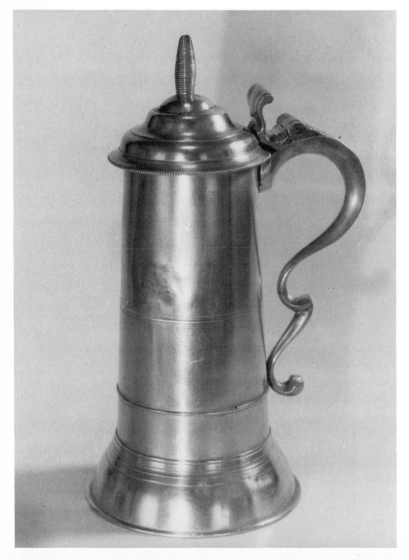

4–7.
Flagon, 1795–1816, by Samuel Danforth, Hartford, H. 13″ (Yale University Art Gallery, The Mabel Brady Garvan Collection).

Danforth, probably as early as 1795, and later by his Boardman nephews. They achieved this form by joining two bowls together bottom-to-bottom with an intervening neck. Usually half of the lower bowl was cut away, so that the base was smaller than the upper part. The Boardman brothers acquired many of their uncle Samuel's molds after his death in 1816 and continued to make this form as well as the basin-footed flagons (Fig. 4–7) and tall teapots (like Fig. 11–12). All three are ingeniously derived from unorthodox combinations of castings.

The earliest American footed basin, possibly a baptismal basin, is a unique flat-brimmed example made in Henry Will's shop (Fig. 4–9). Although appropriate for baptismal use, the initials "H * F" prominently engraved on the face of the

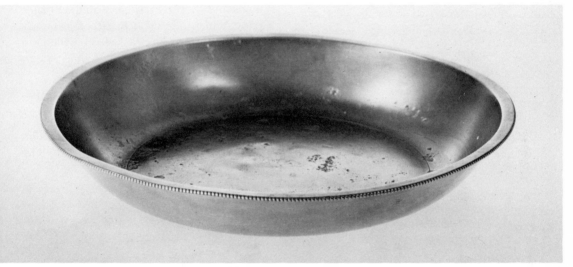

4–8. Baptismal basin, 1782–98, by William Will, Philadelphia, Diam. 10⅝" (WM 53.43).

4–9. Footed basin, 1761–93, by Henry Will, New York City or Albany, Diam. 11⅜" (WM 65.2462).

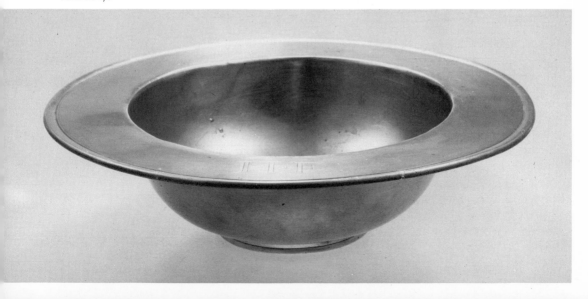

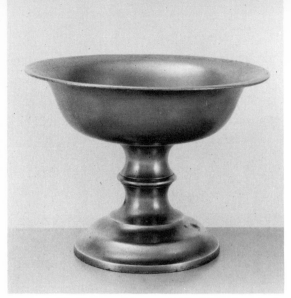

4–10. Baptismal basin, 1837–40, by Leonard, Reed & Barton, Taunton, Mass., Diam. 7¾″ (Gift of Charles K. Davis, WM 56.46.22).

brim suggest that this basin was privately owned and used for another purpose, possibly as a shaving basin. Circumstantial evidence points to church use for the shallow basin, shaped like a soup dish (Fig. 4–8). With beaded edge and William Will's large eagle mark, it was found with a communion flagon (like Fig. 4–38) which, though unmarked, was surely made by him.

Typical of nineteenth-century baptismal basins made after 1830 is one by Leonard, Reed and Barton (Fig. 4–10). This type was also made by the Boardmans and by the Meriden Britannia Company, which offered it in either britannia or plated ware in their 1855 catalogue (Fig. 4–11).

4–11. Communion service, no. 1390 from *Price List of Articles Manufactured by the Meriden Britannia Company* (West Meriden, Conn., 1855). (Winterthur Museum Libraries.)

COMMUNION SETS.

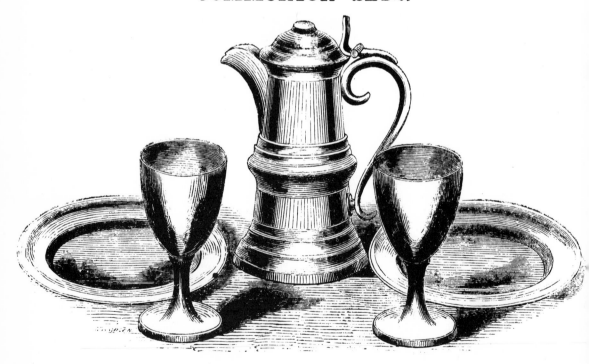

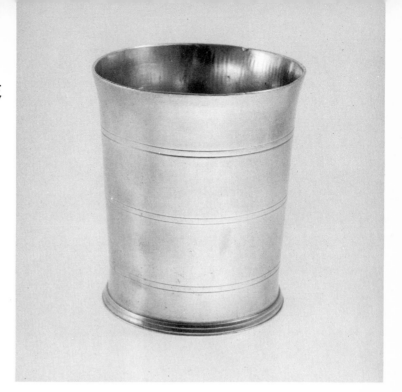

4–12.
Beaker, 1802–1820, by Ebenezer Southmayd, Castleton, Vt., H. 4⅜″ (WM 53.20).

Beakers

Beakers made of horn, pottery, glass, and silver have been used as drinking vessels since Egyptian, Greek, and Roman times. Beakers were never so popular in England as in Holland, where during the Reformation the beaker superseded the medieval chalice for the communion service. Innumerable seventeenth-century Dutch still-life paintings show pewter and silver beakers and testify to their widespread secular use. The beaker was also favored in Scotland for church use, although the English clung to the chalice.

The first beaker known to have been used in America is the "silver tunn: made in Amsterdam in 1637 and bequeathed to the First Church of Boston in 1652 by the celebrated John Cotton, the teacher of this church."[10] Of the 2,000 pieces of silver listed in Jones's survey of church silver, 577 were beakers—560 of them made by American silversmiths.[11] Like silver beakers, eighteenth-century pewter examples are usually of large diameter and

vary in height from 4 to 6¾ inches. Domestic examples as short as 1½ inches are known, but those less than 2½ inches tall are usually unmarked and of thin, light metal, a characteristic of later britannia ware.

A beaker is a simple form. Its qualities are basic—a flared cylinder on a molded base. It succeeds or fails according to its proportions, outline, and quality of metal. Early pewter beakers are strong, their walls are thick, and the color of their metal is soft and mellow in contrast to the hardness of those made after 1815. The taper of a beaker's body, the flare of its lip, and the moldings of its base were all determined initially by the designer of the molds. But three important elements of the form could be modified in the skimming: The base moldings could be simplified, made more complex, or reduced in size; the lip could be given more flare; and ornamental incised lines could be added and positioned at will as the pewterer finished skimming the body (Fig. 4–12).

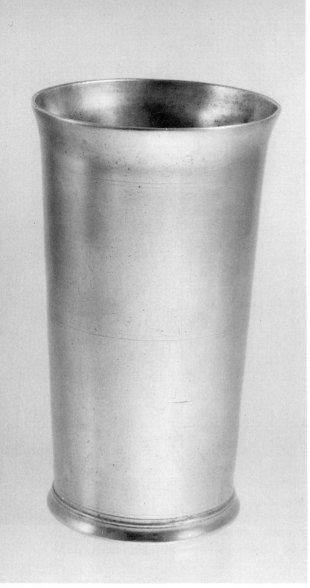

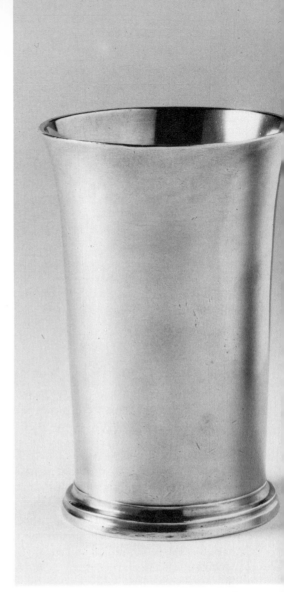

4–13. Tall beaker, 1752–74, by John Will, New York City, H. 6⁷⁄₁₆″ (WM 58.64).

4–14. Tall beaker, attributed to Robert Bonynge, w. 1731–63, Boston, H. 5¼″ (WM 72.438).

Among New York beakers, which are noted for their generous proportions, two beakers in the collection of Ledlie I. Laughlin (each 6¾ inches high) stand out. Made by John Bassett in New York before 1761, they are the tallest and possibly the earliest American pewter beakers known, and they approximate in size the tall New York silver beakers made in the Dutch tradition.[12] Other than these

two New York beakers and one by John Will (Fig. 4–13), the standard tall beaker was the 5¼-inch size made first in Boston either by Robert Bonynge (Fig. 4–14) or Jonathan Jackson, in whose inventory "long beakers" were listed in 1744. Later, several generations of Danforths and Boardmans made 5-inch beakers.

No form produced in pewter exemplifies so well the subtleties of proportion

found in beakers. John Will's large beaker (Fig. 4–13), for example, is well made of fine metal and is of excellent weight and workmanship but is less satisfying in silhouette than are most eighteenth-century New York examples. The sides are tightly vertical, and the flare of the lip is inadequate for the great height.

In contrast, the sides of the rare Heyne beaker (Fig. 4–15) taper sharply, and its thickened lip is without curve. The small base and straight taper are characteristic of eighteenth-century Dutch and German beakers of this size. Recently two other beakers—the only others known by Heyne—have been discovered in a York, Pennsylvania, church.

Careful examination of the insides of tall pewter beakers shows that they were made in two parts. An open cylinder or sleeve was designed to fit exactly into a circular slot in the base, which was cast separately.[13] After soldering, excess metal was cleaned away by skimming. This theory of manufacture is confirmed by surviving English molds and by Samuel

Pierce's soapstone mold for making a beaker base now in the Pewterer's Shop in Old Deerfield.[14]

Another large beaker (Fig. 4–12) of about the same size and contour as those made by Samuel Pierce of Greenfield, Massachusetts, is marked on the inner bottom with a full-rigged ship and the initials *E S*, which identify it as the work of another northern New England pewterer, Ebenezer Southmayd, one of Vermont's two known pewterers. Southmayd set up shop in Castleton about 1800, soon after completing his apprenticeship in Middletown, Connecticut. His beakers, of large diameter and usually enhanced by three pairs of closely incised lines, as in the Winterthur example, are among the most handsome made in America.

Not often did an eighteenth-century American pewterer go astray in his designs, and even less often can Frederick Bassett be criticized in this regard, but the base on Figure 4–16 seems much too broad, and the steps in the outer moldings soft and oversize. Far more satisfying is

4–15. Beaker, ca. 1756–80, by Johann Christoph Heyne, Lancaster, Pa., H. 4³⁄₁₆″ (WM 62.603).

4–16. Beaker, 1761–1800, by Frederick Bassett, New York City or Hartford, H. 4¹¹⁄₁₆″ (WM 63.534).

4-17. Beaker, 1761–1800, by Frederick Bassett, New York City or Hartford, H. 4⅝″ (WM 63.533).

4-19. Beaker, 1758–90, by Jacob Whitmore, Middletown, Conn., H. 3½″ (WM 66.1199).

4-18. Beaker, 1761–93, by Henry Will, New York City or Albany, H. 4¾″ (collection of Dr. Joseph H. Kler, photo, courtesy Smithsonian Institution, Washington, D.C.).

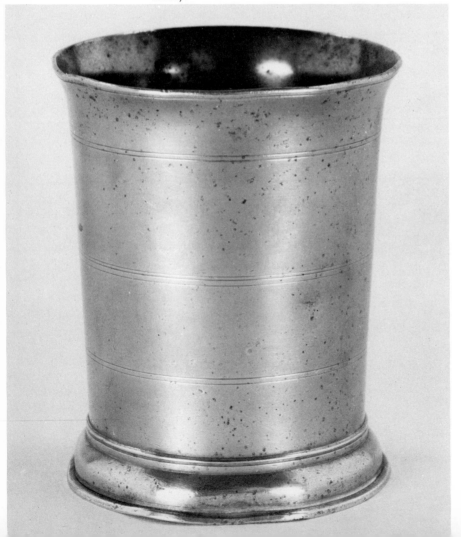

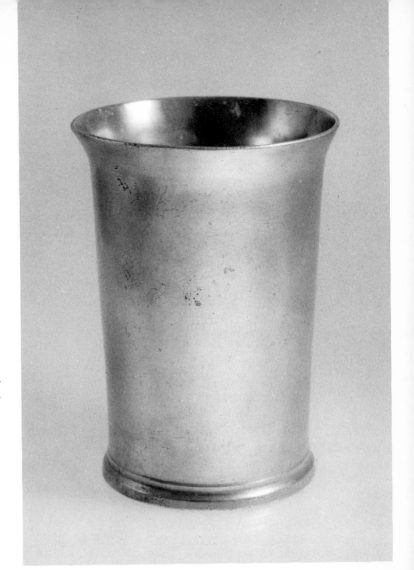

4–20.
Tall beaker, 1760–93, by William Kirby, New York City, H. 5⅜″ (WM 65.532).

the profile of the adroitly molded base of another of Bassett's beakers (Fig. 4–17).

Equally fine are beakers made in Albany between 1775 and 1795 by Peter Young and Henry Will. The bold quarter-round base molding on one of Will's beakers (Fig. 4–18) is suggestive of an inverted basin.[15] The Boardmans later copied this beaker form, sometimes adding two handles to make a church cup. Shown in Figure 4–19 is one of the few short beakers whose large diameter and heavy metal identify it as an eighteenth-century vessel. This example and two or three others also marked by Jacob Whitmore of Middletown, Connecticut, appear to have been made in the same mold as one with Joseph Danforth's touch (formerly in the collection of the author). Its lines approach perfection. From an ample and simple base, the sides rise in a smooth, outcurving line to the lip.

Equally simple is the base on a large beaker (Fig. 4–20) made by William Kirby of New York, which is larger than other American beakers except the 6-inch

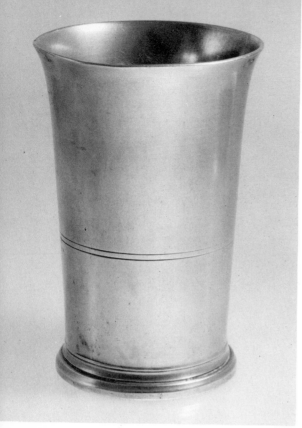

4-21. Tall beaker, one of a pair, 1822–25, Timothy Boardman & Co., Hartford or New York City, H. 5¼″ (WM 66.1186.1, .2).

examples by John Bassett and John Will (Fig. 4–13). Its lines, though excellent, do not match the sleek, outflowing contours that characterize the tall beakers (5¼ inches high) attributed to Robert Bonynge (Fig. 4–14), who appears to have been the first to use this distinctive and beautiful form. With heavier bases and thicker walls than similar models made later by several Danforths and Boardmans, the R B beakers are among the finest examples of American pewter.

The tall beakers of Thomas II, Edward, Joseph, and Samuel Danforth (Hartford) vary greatly in quality and are much rarer than those made by the Boardmans (Fig. 4–21) during the first third of the nineteenth century. Boardman beakers occur with various combinations of the T D and S B or eagle mark of the Boardman partners, and sometimes with the T B & Co. mark used by Timothy Boardman, the younger brother, who was for a short time in charge of the Boardmans' New York branch.

Small beakers were widely produced in the nineteenth century for domestic use.

4-22. "Tumblers," p. 169 from Price List of Articles Manufactured by the Meriden Britannia Company (West Meriden, Conn., 1867).

TUMBLERS.

No. 114.
Goblet. Per dozen, $4 25.

No. 116.
Per dozen, $3 25.

No. 115.
Per dozen, $2 50.

No. 112.
Per dozen, $2 75.

No. 113.
Per dozen, $2 75.

No. 111, with Handle.
Per dozen, $1 50.

No. 109.
Per dozen, $2 25.

No. 117.
Per dozen, $2 00.

No. 118.
Rolled Metal. Per dozen, $3 50.

No. 110.
Toy. Per dozen, $1 30.

4–23. Beaker, 1807–35, by Ashbil Griswold, Meriden, Conn., H. 3″ (WM 64.1160).

4–24. Japanned beaker, 1787–1811, by George Coldwell, New York City, H. 3½″ (formerly in collection of Lewis A. Walter).

4–25. Beaker, 1820–35, by James Weekes, New York City, H. 3½″ (WM 65.1536).

4–26. Beaker with handle, ca. 1830–56, by William Calder, Providence, H. 2¹³⁄₁₆″ (Gift of Charles K. Davis, WM 53.155.18).

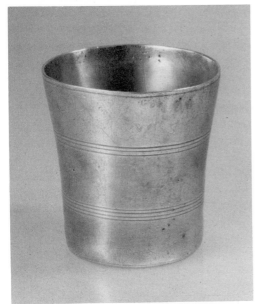

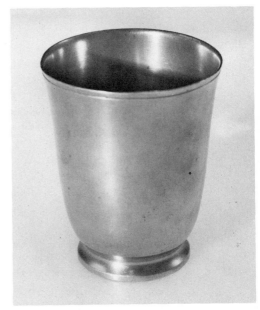

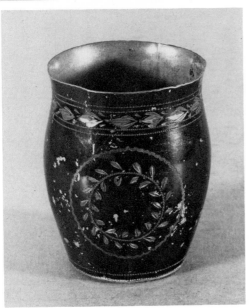

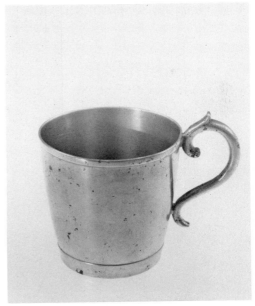

Many were made in Connecticut, and an indication of their shapes and wholesale cost is given in a Meriden Britannia Company price list of 1867 (Fig. 4–22). Called tumblers or cups, they were produced with curved as well as straight sides and were furnished in several sizes with or without handles. For the most part, beakers continued to be made by casting, but the addition of antimony to the alloy permitted them to be skimmed to minimal thickness and gave them a shiny finish of some permanence.

Typical of nineteenth-century straight-sided cups is one made by Ashbil Griswold in Meriden (Fig. 4–23). Stamped with his mark, A G, on the outside of the bottom and embellished with incised horizontal lines by skimming, these inexpensive cups were produced by Griswold in large numbers in the 1820's and 1830's. One of his New York agents, H. B. Hall, had sixty-five dozen on hand when he took inventory on January 1, 1836.[16] Less common today than Griswold's beakers are small Boardman examples, which are often of heavier metal and better workmanship.

Straight-sided beakers were the standard form, but some with curved sides were made, the most unusual being a unique small japanned beaker (Fig. 4–24) made by George Coldwell, according to tradition for George Washington.[17] Another fine bell-shaped, footed example is marked *J. Weekes, N.Y.* (Fig. 4–25). The quality of its metal and design is on a par with handsome candlesticks also stamped with Weekes's name. In contrast, his straight-sided beakers are often of thin metal. A marked example made by William Calder (Fig. 4–26) is characteristic of small unmarked cups with handles and curved sides often found in Rhode Island.

With the exception of a beaker by Israel Trask (Fig. 4–27) and one by Ashbil Griswold (Fig. 4–23), all of the beakers, tumblers, and cups in the Winterthur collection appear to have been cast. The Trask beaker, made between 1813 and 1856, is larger than other late beakers and is of rolled sheet metal with a seam down the side and an inset bottom soldered to the base of the incurving sides. The sheet metal seems to have been bent first about a form and then soldered along the seam. After that, it was given the flaring lip and rounded base by spinning. Griswold's beaker appears to have been spun on a lathe.

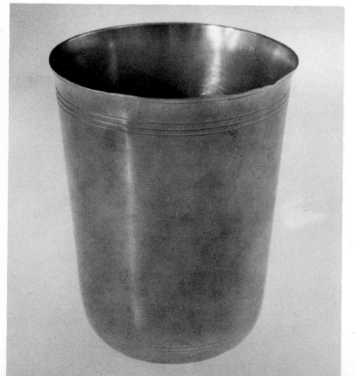

4–27. Beaker, ca. 1820–ca. 1856, by Israel Trask, Beverly, Mass., H. 4¹⁄₁₆″ (WM 52.117).

Chalices

The prestige of the standing cup in church ritual and its desirability in the hierarchy of communion vessels is reflected by Samuel Sewall's "humiliation" of December 6, 1724, when he noted in his diary:

> Lord's Supper . . . Deacon Checkley Deliver'd the Cup first to Madam Winthrop, and then gave me a Tankard. 'Twas humiliation to me and I think put me to the Blush, to have this injustice done me by a Justice. May all be sanctified.[18]

Perhaps because of the importance that communicants placed on chalices, silversmiths and pewterers gave great attention to their design. Church cups and chalices are among the finest forms created by the American silversmith and pewterer. Preeminent are silver examples made in Boston by the partners John Hull and Robert Sanderson (before 1683) and by Hull's apprentice, Jeremiah Dummer (before 1710). Equally fine are the great pewter chalices of Johann Christoph Heyne (Fig. 4–28), Peter Young (Fig. 4–29), and Timothy Brigden. These chalices stand in the forefront of American pewter design. Noble in their conception and proportions, the chalices of Young and Brigden approximate the size of the largest American-made silver cups; the covered Heyne examples tower above them.[19] Examples by Heyne with thick knops on the stems and "tumbler bottomed cups" enriched with architectonic bandings achieve a monumentality different from the smooth, sleek chalices of Peter Young. Another beautiful chalice (Fig. 4–30), with firm attribution to Henry Will, has a cup and base similar to those on Young's chalices and a simplified stem of pleasing proportions.

An important discovery in recent years is a New York chalice made by Joseph Leddell, Sr., for the Christ Church Parish, West Haven, Connecticut (Fig. 4–33)

Without cover this chalice, which stands 10¼ inches high, is the tallest and largest of American church cups in either pewter or silver. However, it appears top heavy and lacks the nobility and integration of form of Heyne's splendid chalices or the grace of Peter Young's examples. The chalice marked *I L* with two stars and inscribed "Drink ye All Of This 1744" is credited to the senior Leddell because a companion piece to the chalice, a plate owned by the same church, is clearly identified by Leddell's full name and ship mark and with his *I L from Old England* mark, which can be credited with confidence to the senior Leddell, who emigrated from England to America in 1711. The 1744 of the inscription places this chalice among the earliest surviving American pewter made for religious purposes. It is antedated only by the *I N* lidless flagon (Fig. 4–2) in the Winterthur collection dated 1734 but which may be English.[20]

Both "Church Cups" and "Goblets" appear in William Will's 1799 inventory. In his "Front Shop," "Five goblets" were valued at forty cents each, and "5 Church Cups with 2 Stands" were appraised at two dollars the lot.[21]

Whether goblet or cup, the example shown in Figure 4–31 is attributed to Will because it is similar in form to a documented vessel in the communion service (Fig. 4–39) of the Salem Lutheran Church of Aaronsburg, Pennsylvania.[22] Identified by its German inscription as the gift of "Catherine Elisabeth Morrin to the Glory of God," the similarity of engraving and the names of the donors on the Winterthur chalice and the flagon (formerly in the John F. Ruckman Collection) leave little doubt that the two pieces once were together and came from the same shop. The inscription on the flagon reads: "Zur ehre Gottes Gestifftet von Andreas Morrin Die Evangelisch-Lutherische Zion Kirche, in Penns-Township, Northumberland County, Den 29ten July, Anno Dom.

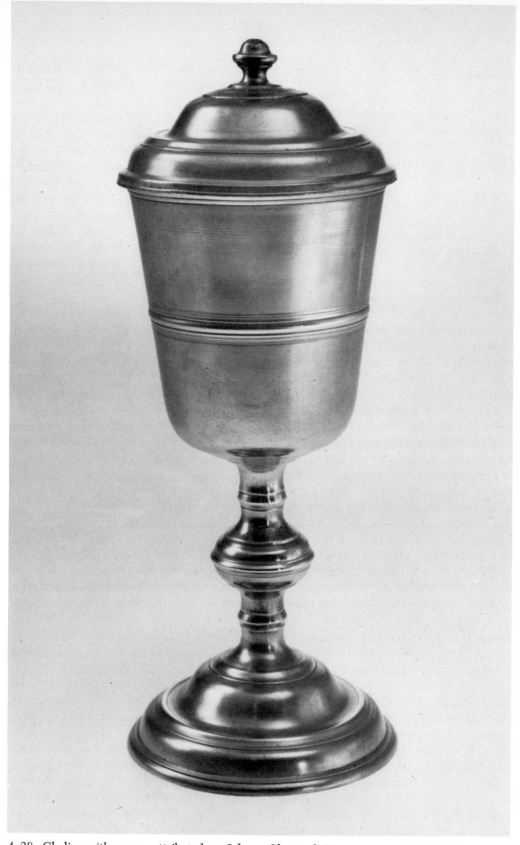

4-28. Chalice with cover, attributed to Johann Christoph Heyne, w. ca. 1756–80, Lancaster, Pa., H. 10^{11}/$_{16}$″ (Gift of Edgar Sittig, WM 53.97).

4–29. Chalice, 1775–95, by Peter Young, New York City or Albany, H. 8½″ (WM 65.2755).

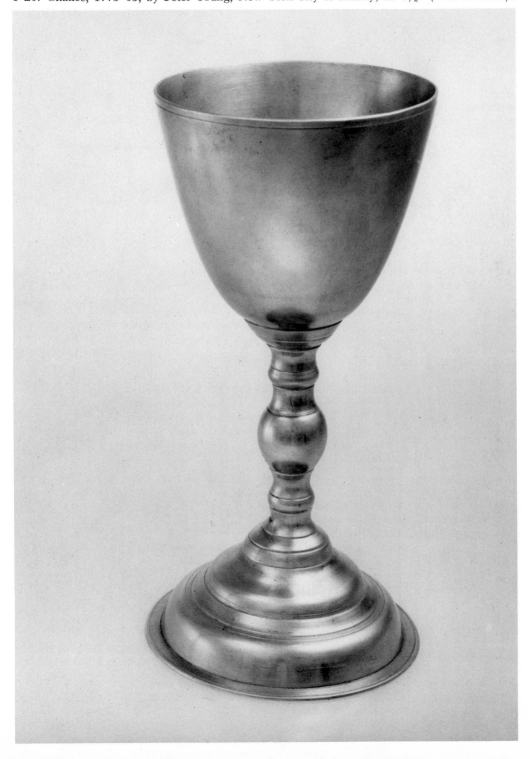

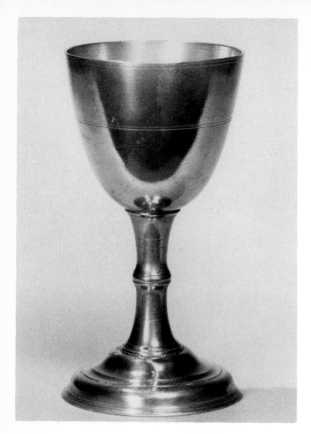

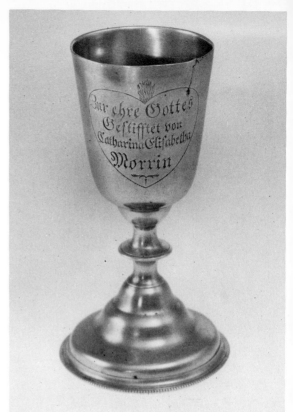

4–30. Chalice, attributed to Henry Will, w. 1761–93, New York City or Albany, H. 7½″ (collection of John H. McMurray).

4–31. Chalice, ca. 1795, attributed to William Will, Philadelphia, H. 7⅞″. Engraved inscription: "Zur ehre gottes/gestifftet von/Catharina Elisabetha/Morrin" [the gift of Catherine Elizabeth Morrin]. (Joseph France Fund, WM 58.24).

4–32. Trade card of Thomas D. and Sherman Boardman and Lucius Hart of Hartford and New York City, in partnership from 1827 until dissolution of the firm in 1847 (American Antiquarian Society, Worcester, Mass.).

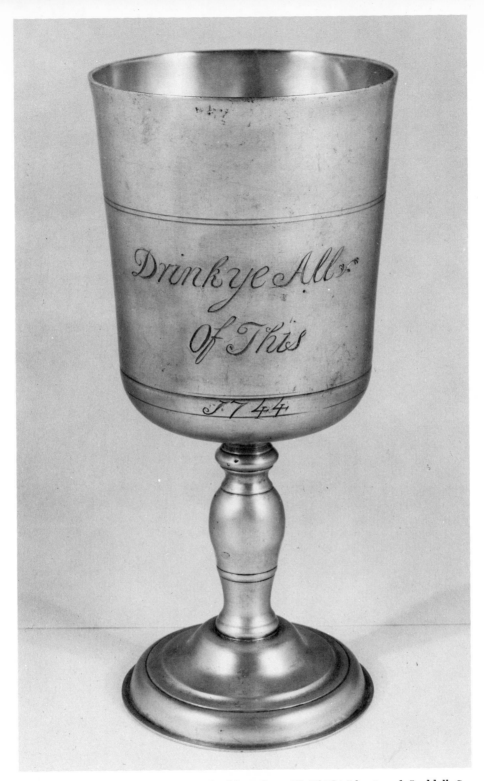

4–33. Chalice, dated 1744 and inscribed "Drink ye All Of This" by Joseph Leddell, Sr., New York City, H. 10¼″ (Christ Church Parish, West Haven, Conn.; photo, courtesy New Haven Colony Historical Society).

1795." (To the Glory of God, given by Andreas Morrin to the Evangelical Lutheran Zion Church, Penns-Township, Northumberland County, the 29th of July, Anno Domini 1795.) The fact that the name of the wife of Andreas Morrin was Elisabeth is a further link between the two pieces.

More typical of what came to be known as goblets in the nineteenth century is the footed cup (Fig. 4–22) titled "Goblet" and shown in the cut of "Tumblers" from the 1867 *Illustrated Catalogue and Price List* of the Meriden Britannia Company. Cups of related form are shown together with tall beakers and characteristic flagons on the trade card of Boardman and Hart (Fig. 4–32).

The makers of many unmarked variant chalices and goblets not illustrated here may never be known, but some can be identified on the basis of two well-illustrated articles by John F. Ruckman and by Charles V. Swain.[23] The late Mr. Ruckman and Mr. Swain of Doylestown, Pennsylvania, have collected and studied the form assiduously, and it is possible through their investigations to identify types made by the Boardmans; William Calder; Roswell Gleason; Leonard, Reed and Barton; J. H. Palethorp; Reed and Barton; Israel Trask; and H. Yale and Company. On the basis of these publications, the goblet in Figure 4–34 is attributed to the Boardmans of Hartford and that in Figure 4–35 to William Calder.

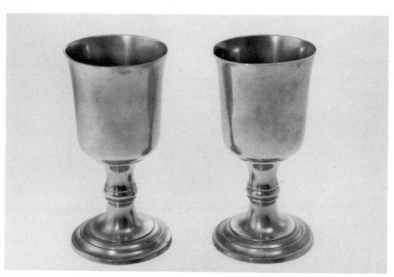

4–34.
Chalices, a pair, ca. 1830–60, attributed to the Boardmans, Hartford, H. 7⅛" (Gift of Charles K. Davis, WM 56.46.23, .24).

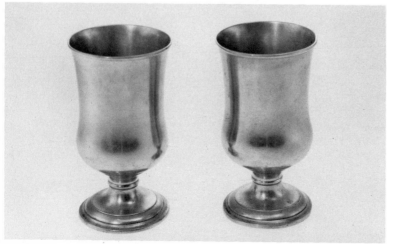

4–35.
Chalices, a pair, ca. 1830–56, attributed to William Calder, Providence, H. 6 1/16" (WM 64.994.1, .2).

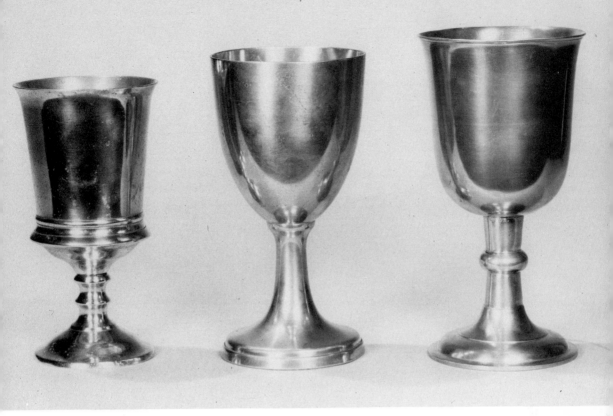

4–36. Chalices (*left to right*):
Early nineteenth century, probably New England, H. 6½"; Ca. 1840–50 by Reed and Barton, Taunton, Mass., H. 7⅛"; 1837–45, by J. H. Palethorp and Company, Philadelphia, H. 7½" (collection of Charles V. Swain).

Flagons

Pewter flagons are tall tankard-like vessels. Frequently listed in seventeenth-century inventories, they were presumably used in homes to bring beer or cider to the table, just as they were used in churches to bring unconsecrated wine to fill chalices or cups at the communion table. However, in the eighteenth century, their use seems to have been increasingly restricted to church purposes. English flagons were advertised in America, and it is probably no accident that many more English flagons with American histories of ownership are known than are examples identified as the work of eighteenth-century American pewterers. Few native pewterers appear to have owned the necessary molds to make these large vessels with limited sale. As a consequence, eighteenth-century American examples, except for those made by Johann Christoph Heyne, are very rare. However, several American forms depart from known European types and testify to the skill of their makers—Henry, Philip, and William Will, Samuel Danforth, and the Boardmans.

Two Heyne flagons in the Trinity Lutheran Church, Lancaster, Pennsylvania, are modeled closely on a German flagon owned by that church.[24] Both are of characteristic German form with flaring base, sharp-nosed spout, and cherub's-head feet. On these flagons, Heyne used a ball thumbpiece like that of the prototype. He

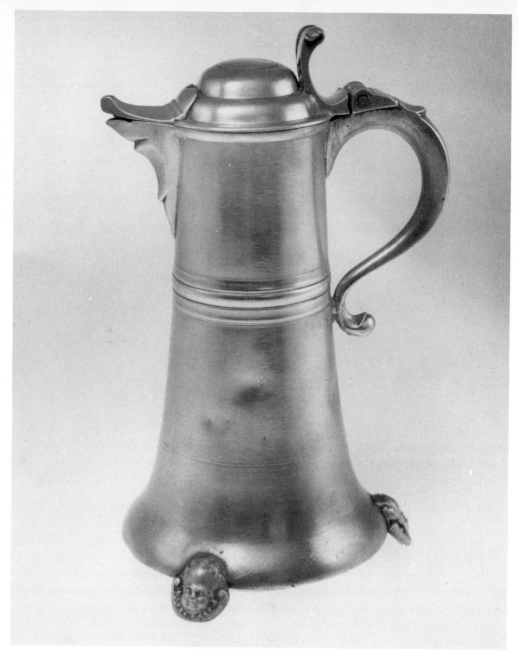

4–37. Flagon, ca. 1756–80, by Johann Christoph Heyne, Lancaster, Pa., H. 11¼″ (WM 62.607).

added a midband and substituted a cast hollow handle, such as those used on American and English tankards, for the Germanic strap handle. For the bottom of his flagon, he used a 6-inch plate. On all subsequent flagons, as in Winterthur's example (Fig. 4–37), Heyne used scrolled thumbpieces like those found on Philadelphia tankards. The result is an American version distinct from its German prototype and a monument of American pewter.

According to John H. Carter, Sr., there are nineteen flagons among the eighty

4–38. Flagon, attributed to William Will, w. 1764–98, Philadelphia, H. 13¾″. Engraved inscription: "Zur ehre gottes gestifftet/von Undreas Morr- /in die Evangelisch- /Lutherische-Zion/Kirche, in Penns-township/Northumberland County/Den 29ten July Anno Dom./1795″ [to the Glory of God, given by Andreas Morrin to the Evangelical Lutheran-Zion Church, Penns Township, Northumberland County, the 29th of July, Anno Domini 1795]. (Collection of Charles V. Swain).

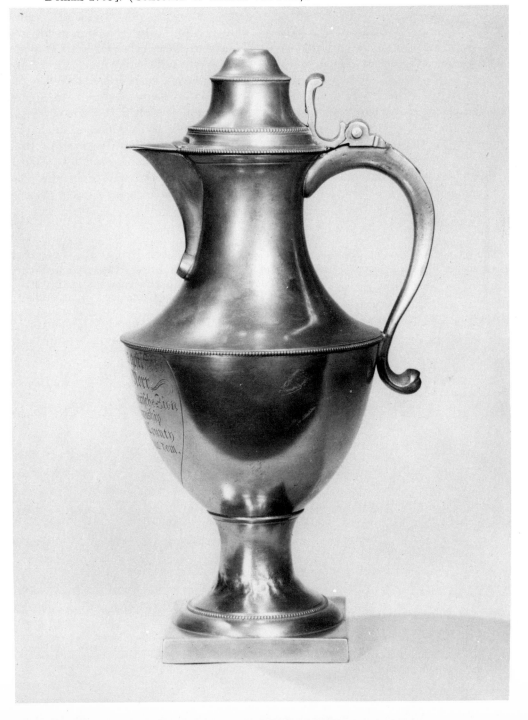

known examples of Heyne pewter, and many of them are still owned in the central Pennsylvania Lutheran churches for which they were made.[25]

Four unmarked flagons, similar to Figure 4–38, have been attributed to the shop of William Will on the basis of individual elements and their over-all style. They relate closely in shape to Will's marked coffeepots, and two are also linked by association—they were found with marked Will pieces. Such is the case with Winterthur's flagon, whose early history is unknown but which was offered to the museum with a basin (Fig. 4–8) bearing Will's large *Federal* eagle mark. In the four-piece Aaronsburg communion service (Fig. 4–39), only one piece is stamped with Will's marks, but all bear an original inscription made at the time of their donation by Aaron Levy about 1789, and all employ neoclassical beading.

The urn-shaped body favored by Will appears heavier on the flagon than that found on Will's marked coffeepots. The form of the pitcher is a highly original one. Will was one of the few American pewterers to produce neoclassical forms, and his drum teapots (Fig. 11–8), shaped like a section of a column and finished with beading, are triumphs of design. Perhaps less successful, the design of his large coffeepots with urn-shaped bodies (Figs. 11–15, 11–16) is unique, as his coffeepots are the only known survivals made by an eighteenth-century American or English pewterer. Closely related to Will's coffeepots is his flagon illustrated in Figure 4–38, its ample body in the form of an urn rests securely on a square plinth. The major divisions of this dynamic and dramatic form are emphasized by beading that accentuates the circular qualities. The curves of the hollow handle neatly balance

4–39. Communion service, 1789–94, by William Will, Philadelphia, H. of ewer 10¾"; of chalice 7¹⁵⁄₁₆"; of flagon 13¹¹⁄₁₆"; Diam. of baptismal bowl 10¹⁵⁄₁₆". Presented by Aaron Levy between 1789 and 1794 to the Salem Lutheran Church, Aaronsburg, Pa. Each piece is engraved "Das Geschenke/Zu Denen/Deutschen Gemeinden/in Arensburg/von Aron Levy" [the gift of Aaron Levy to the German congregations in Aaronsburg]. (Salem Lutheran Church, Aaronsburg, Pa.: photo courtesy Suzanne C. Hamilton).

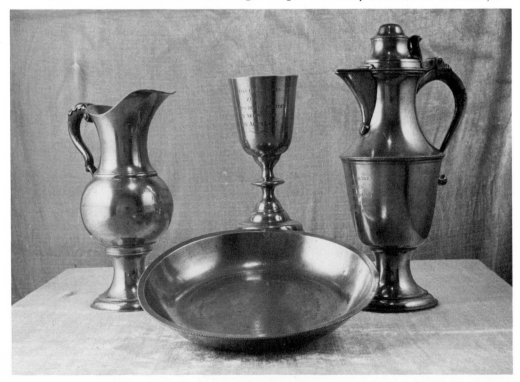

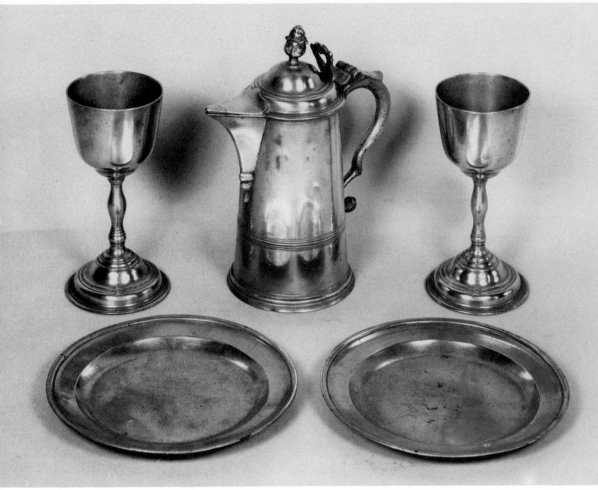

4–40. Communion service, by William Will, w. 1764–98, Philadelphia, H. of flagon 10½″, of chalices 8⅛″. (Presbyterian Church, Oxford, Pa.; photo, courtesy of the Department of History, General Assembly of the United Presbyterian Church in the United States of America, Philadelphia). The flagon bears William Will's touch, and the chalices may be attributed to him with confidence. The plates used as patens are English.

the outlines of the body and the sharp-tipped spout. One of Will's straight-sided flagons (Fig. 4–40) follows English design more closely and is far less interesting than his four flagons in the neoclassical taste.[26] Also illustrated in the communion service of the Presbyterian Church of Oxford, Pennsylvania (Fig. 4–40), are two chalices that are attributed to Will's shop.

Another flagon form, represented by a splendid example in the Garvan Collec-

tion at Yale University, was made by Henry Will (Fig. 4–41). Will added a heavy midband and extra base moldings to give stability to this double tankard—a tall form that might otherwise appear top heavy. Will's adaptation of castings from his quart-tankard mold to the requirements of a flagon demonstrates his competence as a designer. Such innovations are the supreme test of a craftsman's skill.

An extraordinary flagon (Fig. 4–42) made by Philip Will, son of John, was

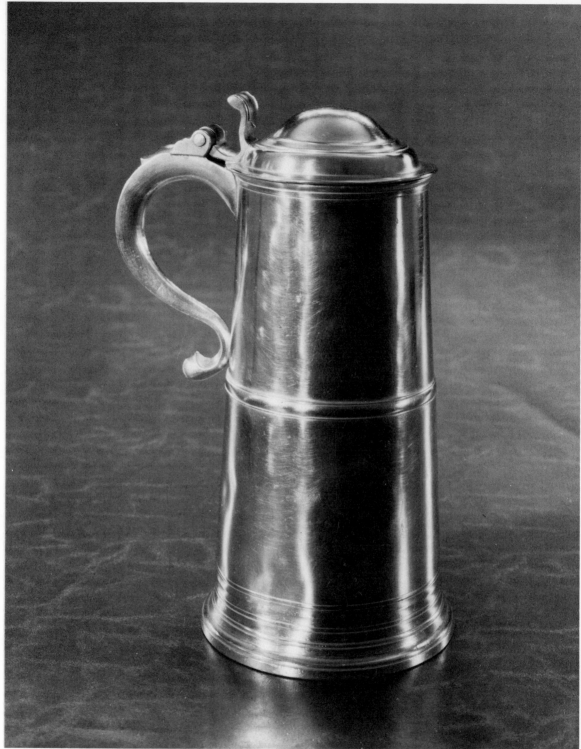

4–41. Flagon, 1761–93, by Henry Will, New York City or Albany, H. 11¼″ (Yale University Art Gallery, The Mabel Brady Garvan Collection).

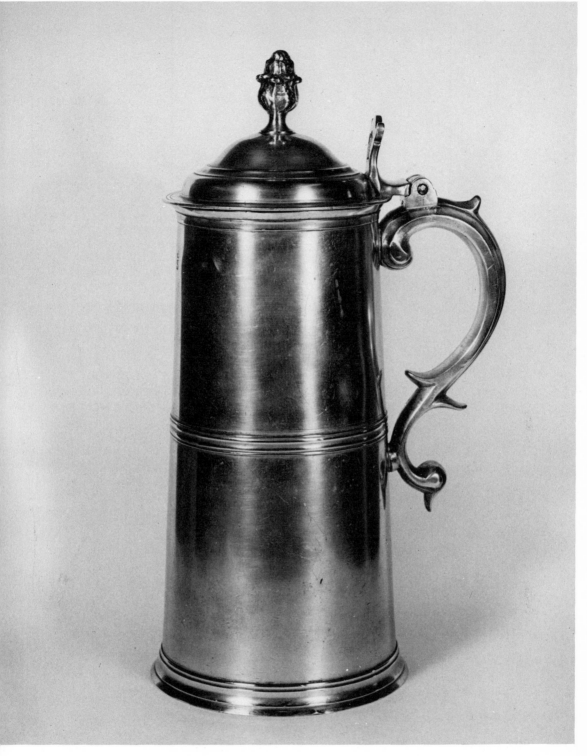

4–42. Flagon, 1763–87, by Philip Will, Philadelphia or New York City, H. 12¾″ (collection of Mr. and Mrs. Oliver W. Deming).

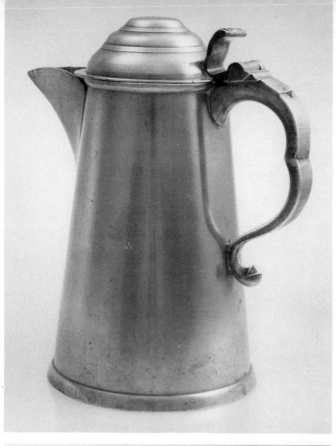

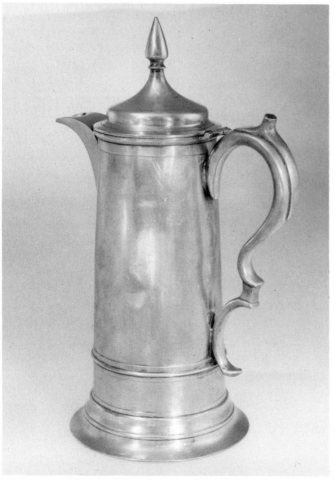

4–43. Flagon, 1816–19, by Timothy Brigden for the merchant Spencer Stafford, whose mark it bears, Albany, H. 10⅜″ (Gift of Charles K. Davis, WM 55.48.41).

4–44. Flagon, 1830–ca. 1855, by Thomas D. and Sherman Boardman, Hartford, H. 11¾″. (WM 64.1158).

4–45. Flagon, ca. 1830–50, by Roswell Gleason, Dorchester, Mass., H. 9⅞″ (WM 64.1162).

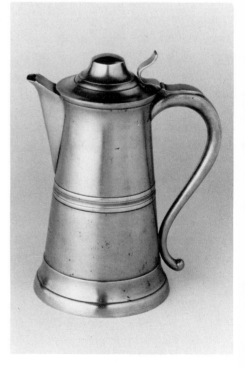

discovered in the fall of 1969 by Mr. and Mrs. Oliver W. Deming. This double-tankard form resembling the flagons made by Henry Will surpasses all others in the timeliness of the spurred rococo handle and bud finial. The finial and thumbpiece are of more than usual interest—the finial like one used by William Will, the thumbpiece like those used by William and Henry, brothers of Philip.[27] Did the brothers sell or trade parts to one another or, in the case of the finials, did they obtain them from William Ball, a Philadelphia silversmith, who used what appears to be an identical finial on a two-handled silver cup. Perhaps one of the Wills bought the molds from Ball's estate, which offered at auction in 1782 "a very large assortment of brass Moulds for Pewter dishes, plates, basons, tankards, mugs, porringers, &."[28]

Two other types of flagons produced before 1819 are also innovations. That illustrated in Figure 4–7 was probably first introduced by Samuel Danforth in the 1790's and later produced by Thomas and Sherman Boardman. With a base made in a 6-inch basin mold, it is crowned by a pewter cocoonlike finial similar to those found on certain Connecticut high chests, desks, and bookcases. Another unusual flagon of the same era (Fig. 4–43) was made by Timothy Brigden of Albany. Its overlarge spout, combined with an ineptly curved handle and weak, flabbily domed cover, is less successful.

Many more nineteenth- than eighteenth-century pewter flagons survive, the finest being those made by the Boardmans. That Hartford firm produced at least three patterns in addition to the Samuel Danforth type already mentioned. All are of excellent design and of fine, heavy metal that is properly called britannia, inasmuch as it originally had a high sheen and contains a fair percentage of anti-mony. One of these later Boardman designs is shown in Figure 4–44. On Boardman and Hart's trade card (Fig. 4–32), another type of flagon, a goblet, two beakers, a coffee urn, and a teapot are illustrated.

Israel Trask, Oliver Trask, and Eben Smith of Beverly, Massachusetts, produced britannia flagons in quantity, as did Roswell Gleason of Dorchester, William Calder of Providence, and Sheldon and Feltman of Albany. Of thin metal, some of these flagons are well designed, but many fall short, as does the popular model (Fig. 4–45) made by Roswell Gleason. A related example (Fig. 4–11) was offered in the Meriden Britannia Company catalogue of about 1855. After that time, the britannia trade steadily declined, and buyers increasingly chose the electroplated wares offered in the same catalogue.

Communion Tokens

Reminiscent of an all-but-forgotten religious custom are two curious bits of pewter—one oval, one square (Fig. 4–46).[29] Mary E. Norton points out that Presbyterian ministers in America continued to follow the Scottish custom and tradition of issuing—often months in advance—tokens of pewter, lead, tin, copper, brass, or paper as a ticket of admission to communion services. Cast on one token is *Scots Church Philad* and on the reverse *Wm Marshal 1775*. Mr. Marshall, "called as Pastor" in 1769, continued as minister until 1786.[30]

Cast in raised letters on the front and back of the other token are *N York 1799* and *Associate Church*, respectively. This church was located at that time in Nassau Street, between Maiden Lane and John Street. In the collection of the Presbyterian Historical Society in Philadelphia,

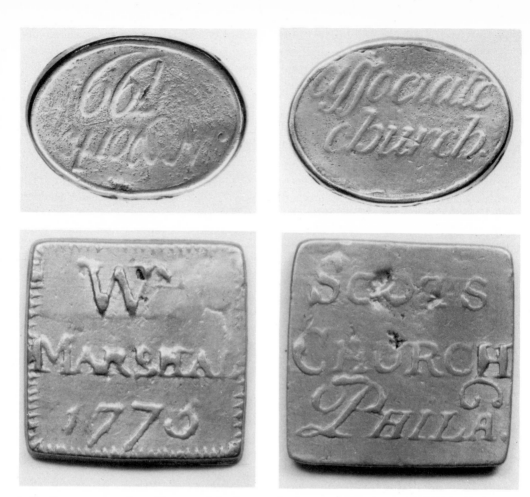

4-46. Communion token (front and back views), dated 1799, from Associate Church, New York City, H. 7 1/16″ (WM 62.65). Communion token (front and back views), dated 1775, from Scots Church, Philadelphia, H. 13/16″ (WM 62.64).

there are between three and four thousand of these pewter tokens, the larger portion of which are Scottish.

In *The Sabbath in Puritan New England,* Alice Morse Earle explains the need for such tokens at the semiannual assemblies called by the Scotch Presbyterians to celebrate the Lord's Supper:

After a protracted and solemn address upon the deep meaning of the celebration and the duties of the church-members, the oldest members of the congregation were seated at the table and partook of the sacrament. Thin cakes of unleavened bread were specially prepared for this sacred service. Again and again were the tables refilled with communicants, for often seven hundred church-members were present. Thus the services were prolonged from early morning until nightfall. When so many were to partake of the Lord's Supper, it seemed necessary to take means to prevent any unworthy or improper person from presenting himself. Hence the tables were fenced off, and each communicant was obliged to present a "token."[31]

Chapter Five

Lighting

In early America, men made the most of daylight. Work started at sunrise and ended at sundown. At night the candle and fireplace were the chief sources of light, but their light was poor (Fig. 5–1). Open lamps made of wrought iron similar to the pottery and stone examples of the Greeks and Romans were used, but their wicks were difficult to keep evenly trimmed and in place. Whether burning fat, grease, or tallow, they smoked and smelled badly and were not popular.

Tallow candles, which have changed little during the past thousand years, were made in every household. Sometimes the sweet-smelling bayberry was used. Edward Holyoke, president of Harvard College from 1737 to 1769, meticulously noted in his diary the making of candles. On March 22, 1743, he wrote, "Made 112 bayberry candles, 15 lbs. 12 oz.," and the following day "made 62 lbs. tallow candles, 29 small, 33½ great." On September 17, he added, "Candles all gone." Repeatedly, his diary makes explicit his interest in the problem of lighting. In 1761, he figured comparative costs per hour for light from four kinds of candles, including the then relatively new spermaceti candles made from whale oil.

Both homemade and store-bought, or "common sale," candles, ranging in size from nine to eighteen per pound, burned between five and six hours each at a cost of one to one and three-quarters pennies per hour.[1] Nevertheless, according to Holyoke, minimal light of four to five candles cost almost four pence per hour—at which rate, the light from a 100-candle-power light would have cost four hundred pence per hour—probably forty or fifty dollars per hour in present-day money purchasing power. It is not surprising that each household carefully saved its tallow, made its own candles, and went to bed early.

By the middle of the eighteenth century, commercial manufacturers were molding candles as well as dipping them. A little later, tin, pottery, and pewter candle molds of several sizes were advertised for sale. The mid-nineteenth-century advertisement of John Calverley of Philadelphia (Fig. 5–2) illustrates a mold for twenty-four candles. Though the advertisement stipulates the molds to be "Hard Britannia Metal," this would seem to have been an extravagance; in the interest of economy, lead was often added to cheapen the alloy from which they were made. Two examples similar to that illustrated are included in the Winterthur collection.

Candles, whether dipped, molded, or

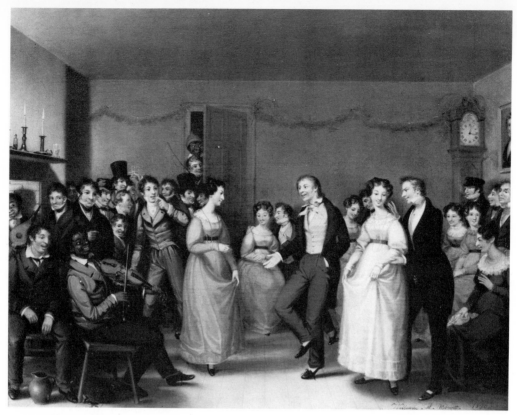

5–1. William Sidney Mount, *Rustic Dance After a Sleigh Ride*, 1830. Oil on canvas (courtesy of Museum of Fine Arts, Boston, M. and M. Karolik Collection).

made of bayberry, tallow, or spermaceti, burned not nearly so evenly as today's candles made of special wax or paraffin. Eighteenth-century candlewicks had to be trimmed from time to time with a snuffer to give a reasonably steady light. Unless they were extinguished with a snuffer (trimmer) or a douter (extinguisher), their smell was offensive.

Although candles did not change, the candleholder did. In England, candleholders of silver, brass, and pewter followed prevailing styles and were similar in design regardless of the metal. The same was true in America, where most surviving seventeenth- and eighteenth-century American silver candlesticks are in the English fashion. American pewterers produced candlesticks, but inventories indicate that the number in use before

1830 was small compared to the many English iron and brass ones that were imported. Why American pewter candlesticks, which were so popular after 1830, were little made before that time is not known, but eighteenth-century candlesticks are among the rarest of all surviving pewter objects, and only four marked ones by an American pewterer working before 1800 are known. They are the noble church candlesticks fashioned by Johann Christoph Heyne (Fig. 5–3).

Each of these candlesticks is engraved with the sacred monogram "I H S" over three nails, suggesting that they were created for a Roman Catholic church. An intensive search for the church where these candlesticks were originally owned reveals that they were the property of The Most Blessed Sacrament Church of

Bally, Pennsylvania, as late as 1930.[2] Bally, located in Berks County, is only a few miles from Tulpehocken, home of Heyne's wife's family and his place of residence for several years between 1750 and 1756, about which time he settled in Lancaster. Strongly baroque in their design, they closely follow seventeenth- and early eighteenth-century German and Italian models. It seems doubtful that Heyne owned bronze molds for such large and imposing high-church pieces for which there was probably little demand in an overwhelmingly Protestant community. More likely Heyne took plaster

impressions of each part of an imported example and fashioned plaster molds to execute a few examples. They are not only unique in form, they are also the largest known pieces of American-made pewter.

Few American pewterers' inventories list candlesticks, an exception being William Will's, taken in 1799, which enumerates "bretania metal candlesticks" valued at three dollars a pair.[3] The term "bretania metal" suggests that these were of fine quality hard metal. One may speculate that they were of the type shown in Figure 5–4, a late eighteenth-century style

5–2. Advertisement of Calverley and Holmes from George W. Colton's *Atlas of America, with Business Cards of the Prominent Houses in Philadelphia* (Philadelphia: Published by A. J. Perkins, 1856).

CALVERLEY & HOLMES,

MANUFACTURERS AND IMPORTERS OF

BRITANNIA WARE,

In all its Branches,

In part as follows, viz :

TEA SETTS,
ICE WATER PITCHERS,
MOLASSES PITCHERS,
CASTOR FRAMES,
COMMUNION SETTS,
GOBLET TUMBLERS,
CUPS OF ALL SIZES,
VINEGAR MEASURES,

VINEGAR FUNNELS,
FLUID LAMPS,
LARD do.
OIL do.
CANDLESTICKS,
SEGAR LAMPS,
SCREWS FOR LAMPS
OF ALL KINDS,

SOUP LADLES,
TABLE SPOONS,
TEA SPOONS,
COFFEE MILL HOPPERS,
BED PANS.
PLATED WARE,
SPITTOONS,
and many other articles.

JOHN CALVERLEY,

MANUFACTURER OF

Candle Moulds, Syringes, Surgical Instruments, &c.,

No. 109 Race Street, Philadelphia.

CANDLE

MOULDS

FOR

TALLOW CHANDLERS,

OF HARD

Britannia Metal.

CANDLE MOULDS,

4s, 5s, 6s, 7s, 8s, 9s, 10s,

12s, 14s, 16s, 18s, 20s,

24s, or

Any Other Size

THAT MAY BE

DESIRED.

Printed by HENRY B. ASHMEAD.

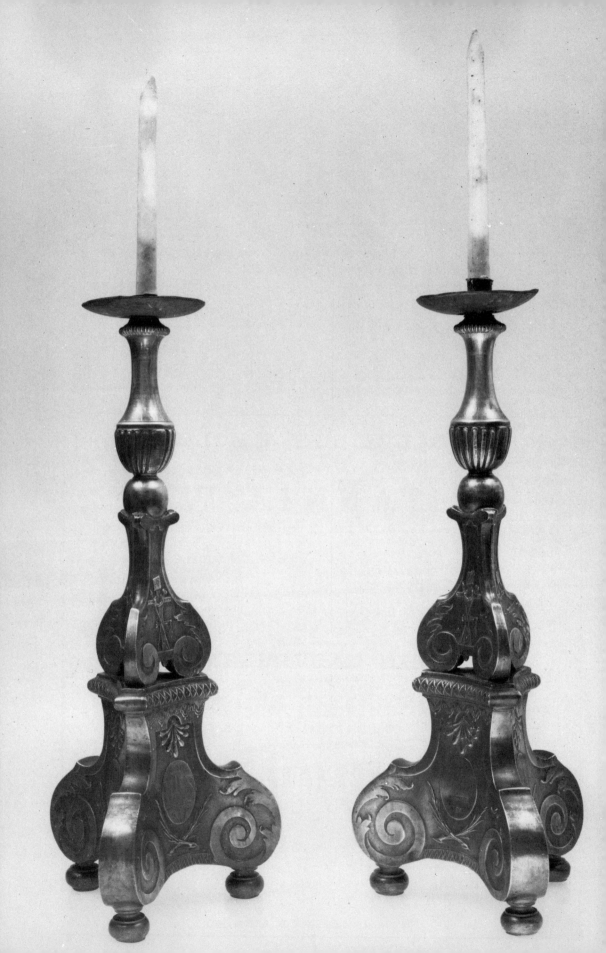

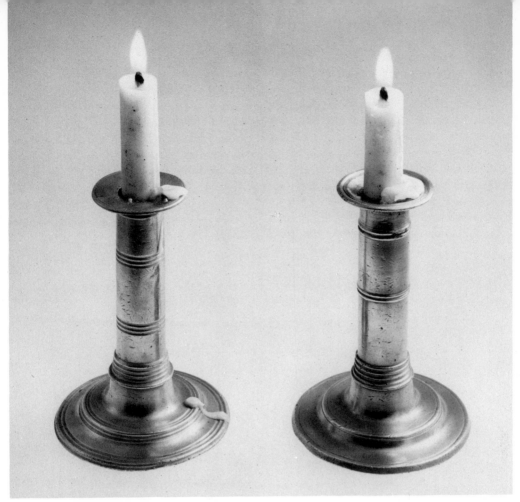

5–4. Candlesticks, 1790–1800, America, probably Philadelphia, H. (left) 5⅝″, (right) 5¹¹⁄₁₆″ (WM 56.60.1, .2).

of candlestick found occasionally in Pennsylvania. The columnar shape of these two sticks accords with William Will's drum teapots and urn-shaped coffeepots in late eighteenth-century neoclassical style. Others closely related in form are finished with beading, another decorative element favored by Will.

More numerous and less expensive than the candlesticks in Will's inventory is the rare mention of the "7 doz. 8 candlesticks" in the 1771 inventory of Philadelphia pewterer Thomas Byles.[4] Given a wholesale price of only seven shillings a dozen, they apparently sold at retail for little

more than a shilling a pair. A small quantity of English pewter candlesticks was imported, but seldom is more than a single pewter stick listed in an eighteenth-century American inventory (which often includes five or six brass or iron examples, usually located in the kitchen), and only two or three English examples with a history of American ownership are known.[5]

Despite the great advances in lighting technology made in the late eighteenth and early nineteenth centuries, candles continued to be used in most households from the 1830's through the 1860's. Dur-

5–3. Candlesticks, a pair, ca. 1756–80, by Johann Christoph Heyne, Lancaster, Pa., H. (left) 21¼″, (right) 22⅞″ (WM 65. 1602.1, .2).

ing this era, britannia makers produced candlesticks as well as oil lamps in many sizes and shapes. Two pages of the 1867 Catalogue and Price List of the Meriden Britannia Company give an idea of the variety produced and their wholesale cost. In that catalogue, nineteen candlesticks and forty-five lamps are illustrated of which eight candlesticks are shown in Figure 5–5 and twelve lamps in Figure 5–6. Wholesale prices ranged from four dollars a dozen for 3-inch candlesticks to eighteen dollars a dozen for those 13 inches high (not shown here). Lamps began at two dollars a dozen for the 2½-inch size with whale-oil burners and went as high as twenty-three dollars a dozen for "Double Swing" (ship's) lamps for "burning fluid" (a mixture of alcohol and turpentine patented in 1830).[6] Lamps, similar save for a different sort of wick holder and made for burning oil, cost

5–5. Candlesticks, p. 172 from *Price List of Articles Manufactured by the Meriden Britannia Company* (West Meriden, Conn., 1867).

seventy-five cents less per dozen.

Seven candlesticks illustrated in Figure 5–7 are typical American examples made between 1830 and 1860. The very tall lamp and candlestick on the left illustrate a common practice followed by lamp and candlestick makers. The bases and shafts were made in the same mold. Marked *TBM* on the bottom, they were made by the Taunton Britannia Company. These models of a lamp and candlesticks are the tallest nineteenth-century American ones known (12¼ inches high), but an equally fine design is shown next to the Taunton Britannia Company candlestick. One of a pair, it was made by Thomas Wildes of New York City. These 12-inch candlesticks are much rarer than identical examples and 10-inch ones in the same pattern made by Henry Hopper of the same city. Hopper's well-designed lamps are fairly common. His candlesticks and

5–6. Oil lamps, p. 175 from *Price List of Articles Manufactured by the Meriden Britannia Company* (West Meriden, Conn. 1867).

95

175

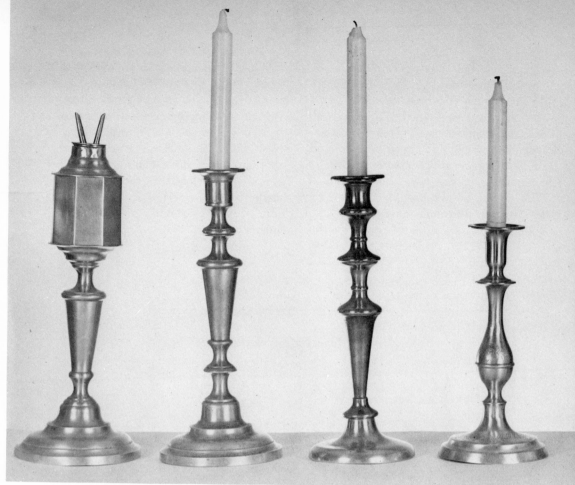

5–7. Britannia lamp and britannia candlesticks (*left to right*):
Lamp, 1830–34, by Taunton Britannia Manufacturing Company, Taunton, Mass., H. 14⅝″ (WM 56.515).
Candlestick, one of a pair, 1830–34, by Taunton Britannia Manufacturing Company, Tauton, Mass., H. 12¼″ (WM 64.1152.1).
Candlestick, one of a pair, 1833–40, by Thomas Wildes, New York City, H. 12″ (WM 65.1684.1).
Candlestick, 1830–60, attributed to Sellew and Company or Flagg and Homan, Cin-

lamps with vase turnings were favorites and among the prettiest. An unmarked candlestick (fourth from the left) is a rare engraved specimen of a popular form made in great numbers both by Sellew and Company and by Henry Homan or Homan and Company in Cincinnati. Candlesticks of this style were apparently made by those firms in 6-, 7-, 8-, and 10-inch sizes.

To make carrying easy, a few makers fitted their candlesticks with dish bases and ringlike handles with thumbpieces (as in the two on the right in Figure 5–7). Called "chamber candlesticks," their large dish bases gave better protection against grease running onto the table than did those fitted with loose *bobêches* (cups) to catch drippings and to make removal of the candle stub easy. For the latter purpose, some candlesticks were fitted with a push-up ejector.

At the end of the eighteenth century, three major developments took place that were to contribute to improvements in lighting: Ami Argand's invention of the

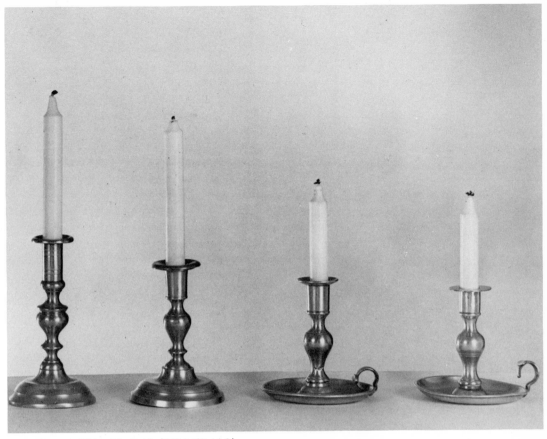

cinnati, Ohio, H. 9⅞" (WM 56.44.2).
Candlestick, 1830–60, America, H. 7" (WM 66.1201).
Candlestick, one of a pair, 1820–35, by James Weekes, New York City and Poughkeepsie, H. 6" (WM 55.48.40).
Candlestick, 1842–47, by Henry Hopper, New York City, H. 5⅛" (WM 66.1194).
Candlestick, 1848–50, by Charles Ostrander and George Norris, New York City, H. 4¾" (WM 66.1193).

Argand lamp; John Miles's patent oil lamp, which was to prove of particular interest to the pewter and britannia industry; and gas lighting, of great significance for city dwellers, first for street lighting and later for house lighting. In the Argand lamp, invented in 1783, a hollow cylindrical wick provided an updraft of air through the flame's center, giving a brilliant light. However, not all Americans took kindly to these bright lights.[7] In 1847, hostility to unusual brilliance was still expressed. The *Franklin Institute Journal*

in that year remarked that "the unpleasant, and to many sights, painful effects of the naked flame of a candle, lamp or gas-burner, have long been known and felt."[8] Argand lamps were made of tin, brass, bronze, and silverplate, but not normally of pewter. George Washington used standing urn-shaped silverplated Argand lamps at Mount Vernon, and Jefferson had both chandeliers and lamps that worked on this principle at Monticello.

An invention of more popular general use was the "agitable" lamp patented by

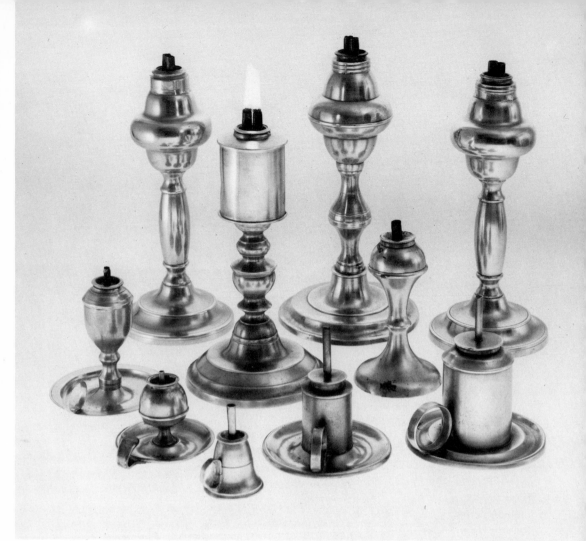

5–8. Whale-oil and burning-fluid pewter and britannia lamps.

Front row (left to right):

Lamp, 1830–34, by Taunton Britannia Manufacturing Company, Taunton, Mass., H. 2⅛″ (WM 64.1159).

Lamp, 1830–60, America, H. 2¼″ (WM 65.1559).

Lamp, 1848–54, by Ephraim Capen and George Molineux, New York City, H. 3½″ (WM 65.1471).

Lamp, 1846–51, by Edmund Endicott and William F. Sumner, New York City, H. 4⅛″ (WM 65.1558).

Middle row:

Lamp, 1830–55, by James H. Putnam, Malden, Mass., H. 3⅞″ (WM 65.1539).

Lamp, 1837–60, by Rufus Dunham, Westbrook, Me., H. 7¾″ (WM 58.674).

Lamp, 1830–60, America, H. 4¾″ (WM 56.78.2).

Back row:

Lamp, ca. 1830–38, by J. B. Woodbury, probably Philadelphia, H. 8½″ (Gift of Charles K. Davis, WM 56.46.5).

Lamp, ca. 1832–39, by Oliver Trask, Beverly, Mass., H. 9″ (WM 64.1153).

Lamp, 1830–38, by J. B. Woodbury, H. 8½″ (Gift of Charles K. Davis, WM 56.46.6).

the Englishman John Miles in 1787. Miles's lamp, which was small and inexpensive to buy and to burn, gave as good a light as a candle. Essentially it introduced the idea of an enclosed font with provision for one or more wicks. All of the britannia or pewter lamps illustrated in Figure 5–8 incorporate his patent, with a round wick encased in a metal tube extending down into a reservoir of whale oil or "burning fluid." Although "Miles" lamps made of pewter, tin, or glass may have been used in this country before 1800, the earliest reference the writer has seen to a pewter or britannia lamp of this kind is dated 1824 in William Calder's account book.[9]

The manufacture of lamps in America, which began in the 1820's, did not reach its peak until the 1840's and 1850's. Pewterers and britannia makers made lamps in a multitude of forms, sizes, and patterns. Some of the distinctive old names are easily recognized—"dishbottom" lamps, "bed" lamps, "nurse" lamps, "stand" lamps, "swing" lamps, and "ship" lamps. Bed and nurse lamps were those of small size; stand lamps were of larger size on a substantial stem. In one of William

Calder's account books, he refers to "egg" (Fig. 5–9) and "acorn" lamps, so named from the shapes of their fonts. Swing lamps (Fig. 5–10), sometimes called ship's lamps, were mounted on a single or double gimbal for stability.

Of the various forms of patent lamps produced, one made by Roswell Gleason called a bull's-eye lamp (Fig. 5–11), fitted with magnifying lenses with the intention of intensifying its light, is among the most interesting of the many forms of britannia patent lamps.

Most makers offered their customers two varieties of burner—with either one or two wicks—for whale oil or "burning fluid." Whale-oil burners (Fig. 5–12) had short tubes with a slot in the side through which a wick pick could be inserted to raise the wick. The brass burners for "burning fluid" were longer and set at an angle to flair outward. They were fitted with britannia extinguisher caps that were believed to reduce the ever-present danger of explosion.

Britannia and pewter candlesticks were produced in great numbers concurrently with lamps during the 1840's, 1850's, and 1860's. Chief among the twenty or thirty

5–9. Lamps, a pair, ca. 1830–56, by William Calder, Providence, H. 8½" (Gift of Joseph France, WM 56.75.2, .3).

5–10. Swing lamp, 1858–67, by Henry Yale and Stephen Curtis, New York City, H. 5½" (WM 64.1163).

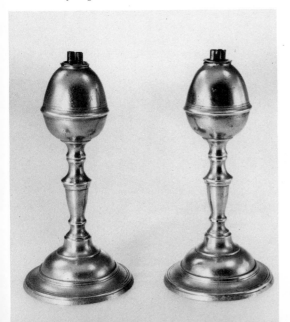

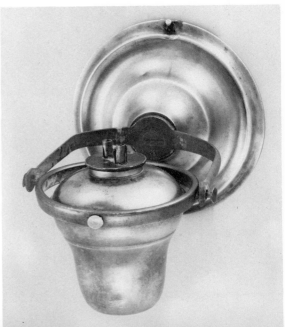

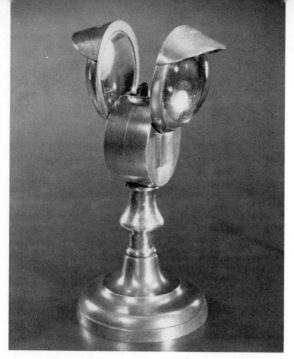

5–11. Double bull's-eye lamp, ca. 1840–60, by Roswell Gleason, Dorchester, Mass., H. 8¼″ (Yale University Art Gallery, The Mabel Brady Garvan Collection).

5–12. Burners, left for whale oil, right for fluid (drawing by James L. Garvin).

5–13. Sconce for two candles, with pewter reflectors, ca. 1825–45, America, H. 10″ (WM 67.1853).

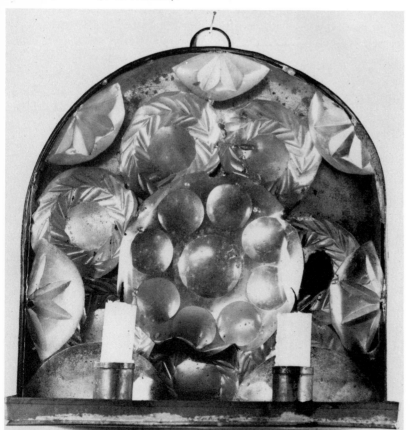

5-14. Sconce, diamond-shaped, with pewter reflecticks, 1800–1830, America, H. 13¼ " (WM 64.1220).

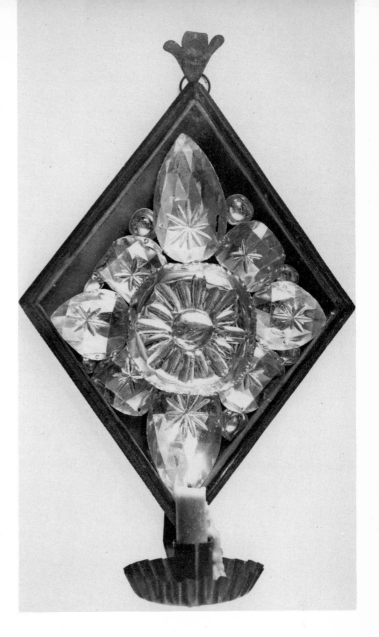

individuals or firms that manufactured both candlesticks and lamps were Roswell Gleason; Rufus Dunham of Westbrook, Maine; the Taunton Britannia Manufacturing Company; the Meriden Britannia Company; Henry Hopper of New York; and the Boardmans of Hartford, New York, and Philadelphia. Soon after 1870, the use of britannia whale-oil and fluid lamps declined rapidly, as did the production of candlesticks.

Chandeliers were not often used in America except in churches, taverns, and other places of public assembly. Recorded or surviving examples are usually made of brass, glass, or tin, tin being much the commonest. None made by an American pewterer is known, and the English or Continental pewter examples seen today are generally reproductions. Splendid brass chandeliers are to be found in the Touro Synagogue, Newport, Rhode Is-

land; the church in Marblehead, Massachusetts, and a few other American churches, where they have hung since the eighteenth century. However, tin chandeliers and sconces seem to have been widely made in the United States in the late eighteenth and first half of the nineteenth century.

Round-, rectangular-, and diamond-shaped sconces fitted with small, dazzling, faceted pewter reflectors are the most delightful and splendid lighting fixtures used in America (Figs. 5–13 through 5–15). Usually found in the United States, these sconces are assumed to have been made here—an assumption supported by a sconce (Fig. 5–15 left) in the Winterthur collection whose reflectors are cast in the shape of an eagle grasping an oval with the initials "TWD" in its talons. This form is the image of one on a bottle identified as having been made at Thomas W. Dyott's Kensington (Pennsylvania) Glass Works probably between 1822 and 1832.[10] This reflector was apparently cast over one of these bottles. The reflectors in the T. W. Dyott sconce differ so little from the reflectors in other pewter sconces that it seems reasonable to suppose that all were made about the same time—probably between 1820 and 1865. Another clue

that suggests a nineteenth-century date for these sconces is offered by old Christmas-tree reflectors, which are equally brilliant though they have no protective glass covers. They are occasionally found in the United States in context with tree ornaments and other material of the Civil War period. The frames of the round sconces are made of tin, and those of the rectangular and diamond-shaped ones are generally made of white pine painted black or red. Analysis shows reflectors of this kind to be composed of 55 per cent tin, about 40 per cent lead, and a trace of bismuth, a metal known for its slow tarnishing properties.[11]

Although much more is to be learned about these sconces, no other lighting fixtures made in the United States rival the brilliance of their pewter reflectors—jewels, swirls, flowers, and filigree.

Following the discovery of the Pennsylvania oil fields, kerosene lamps were used almost everywhere except in the back-country districts. *Gone with the Wind* lamps—with large showy reservoirs of glass, china, brass, or copper, and fitted with glass chimneys and broad, flat wicks that could be raised or lowered with a thumbscrew—adorned the tables and mantelpieces of an America soon to celebrate its centennial.

5–15. Sconces with pewter reflectors, ca. 1820–65, America, Diam. (left) 8¾", (right) 9⁵⁄₁₆" (WM 67.1196 and 67.1189).

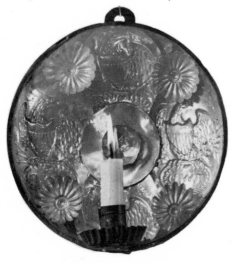

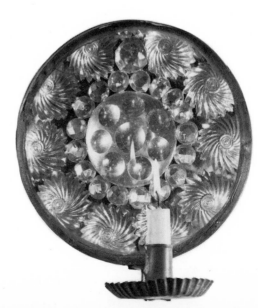

Chapter Six
Drinking Vessels

Mugs are usually larger in diameter at the base than at the lip, are taller than they are broad, and have handles but no covers. These drinking vessels were once also known as pots and cans. Eighteenth- and nineteenth-century American pewter mugs range in capacity from a half gill (two-ounce capacity) to a quart and are about two to six inches high.

Illustrated is the most common form of American pewter mug in four sizes (Fig. 6–7). Each has gently tapering straight sides, a molded base, and an S-shaped hollow handle with bud terminal and thumb grip at the top. Some eighteenth-century mugs are marked beside the handle near the lip; others, as in most of those shown here, are marked on the inside bottom. Some mugs have no fillet or band, but raised, broad bands are often found on New York and Pennsylvania examples, and New England ones usually have narrow bands.

The two pint mugs by Frederick Bassett (Figs. 6–2, 6–3) are typical of fine New York mugs. Both may have been made about the same time, although the fish-tail handle terminal on one (Fig.

6–2) is earlier stylistically and much rarer than the bud terminal on the other (Fig. 6–3). The metal in both mugs is bright, clear, and unpitted and, like that in other New York mugs, rather more substantial than that in New England mugs. Such excellent quality metal, of heavier than usual gauge, distinguishes most New York drinking vessels, as do broad fillets often located high on the body (Figs. 6–3, 6–4). The medium-size fillet (Fig. 6–3) is thick and echoes the strong curves of the handle and base molding. The straight lines of the angular lip and the flaring base repeat each other.

Mugs were the common eighteenth-century drinking vessel. A pint mug, being smaller, is less important than a quart mug, which, in turn, is less important than a tankard. On the basis of survivals, extant bills, inventories, and English orders placed by American merchants, pint mugs were about as popular as quart mugs, and both were more common and less costly than tankards.

The mark on Figure 6–3 is well documented as that of Frederick Bassett, who worked in New York from 1761 to 1800

BEER STREET.

Beer, happy Produce of our Isle
Can sinewy Strength impart,
And wearied with Fatigue and Toil
Can chear each manly Heart.

Labour and Art upheld by Thee
Successfully advance,
We quaff Thy balmy Juice with Glee
And Water leave to France.

Genius of Health, thy grateful Taste
Rivals the Cup of Jove.
And warms each English gcnerous Br.
With Liberty and Love.

Invent'd by W.Hogarth. Publish'd according to Act of Parliament Feb.1.1751.

6–1. William Hogarth, *Beer Street*, London, 1751 (Prints Division, The New York Public Library, Astor, Lenox and Tilden Foundations). Hogarth related beer to the good things in life in contrast to the evils of gin shown in his *Gin Lane*. The term *mugs* includes all of the drinking vessels shown here.

except for a five-year period. When the city was occupied by the British, he moved to Hartford.

Several surviving bills of the 1770's from Frederick Bassett to Hinman and Osborn of Woodbury, Connecticut, record his substantial wholesale trade with these merchants with charges for pint mugs at 2s. 2d. (28 cents), quart mugs at 3s. 6d. (47 cents), and tankards at 5s. (66 cents) each in an era when skilled craftsmen were paid 7s. 6d. (a dollar) a day.

The sturdiness, fine metal, and designs of Frederick Bassett are typical of early eighteenth-century pewter. English pewterers, for example, used fish-tail handle terminals from the late seventeenth century through the middle of the eighteenth century.

To the end, Frederick, last of the great New York pewterers and the last of the pewtering Bassetts, consistently worked in the early and best traditions of his craft. He merited, indeed, the huge trade

necessary to account for the large number of surviving pieces bearing his touch-mark.

There was much overlap in the names used for drinking vessels, and meanings were often blurred. For example, the writer of *The Compleat Appraiser* apparently included mugs, pots, and cans, and perhaps tankards and measures as well, under the headings of ale-house pots and wine pots. Ale pots, according to the author, ranged from one gallon to a half pint in capacity. He noted that "winepots are made much *stronger* than ale-pots" and sometimes have covers, sometimes not. The weight given for a one-quart wine pot is 2 pounds 11 ounces, versus 1 pound 12 ounces for an ale pot of the same size.[1]

Because of its strength and massiveness, the mug shown in Figure 6–4 made by John Will, and perhaps many other New York mugs, might be classified as a wine pot. Certain it is that New York mugs are normally heavier than mugs made else-

6–2. Pint mug, 1761–1800, by Frederick Bassett, New York City, H. 4¾″ (WM 65.2242).

6–3. Pint mug, 1761–1800, by Frederick Bassett, New York City, H. 4¾″ (WM 65.2461).

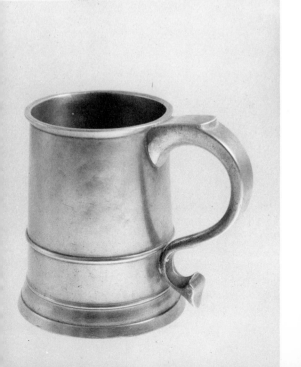

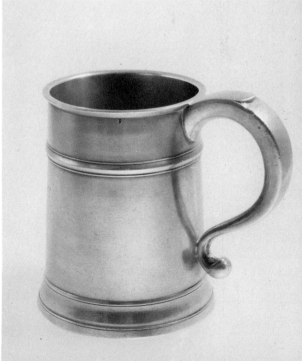

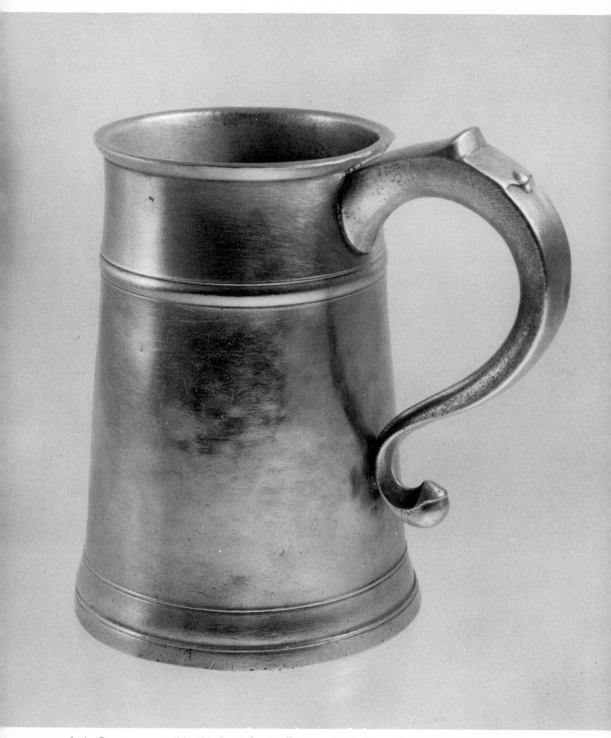

6–4. Quart mug, 1752–74, by John Will, New York City, H. 6⅝″ (WM 65.2759).

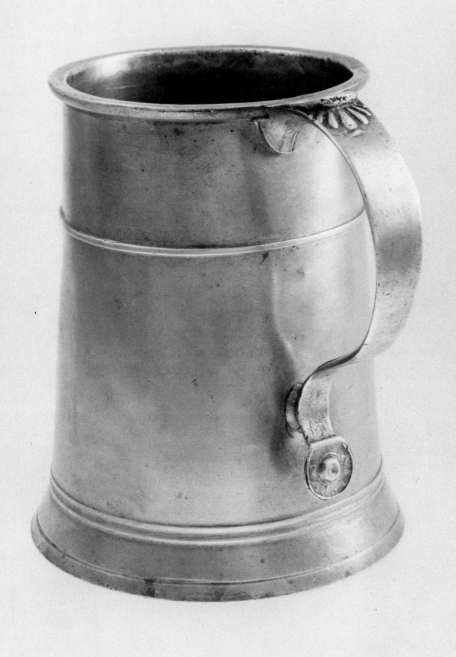

6–5. Quart mug, 1763–1807, by Nathaniel Austin, Charlestown, Mass., H. 5^{13}⁄$_{16}$″ (WM 60.944).

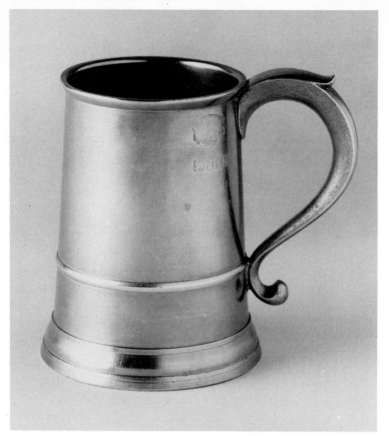

6–6. Quart mug, 1767–1801, by Samuel Hamlin, Hartford and Middletown, Conn., and Providence, H. 6¹⁄₁₆″ (WM 58.637).

6–7. Connecticut mugs (*left to right*):
Half-gill mug, ca. 1815–40, by Thomas D. Boardman, Hartford, H. 2¼″ (WM 65.1466).
Half-pint mug, 1828–53, by Boardman and Hart, New York City or Hartford, H. 3³⁄₁₆″ (WM 53.15).
Pint mug, 1795–1816, by Samuel Danforth, Hartford, H. 4⁷⁄₁₆″ (Gift of Charles K. Davis, WM 55.48.31).
Quart mug, 1795–1816, by Samuel Danforth, Hartford, H. 5¾″ (Gift of Charles K. Davis, WM 55.48.27).

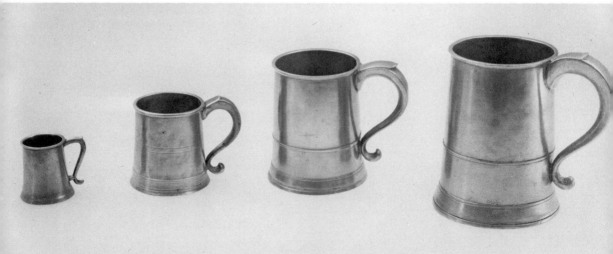

where. Two elements are typical of New York mugs: the broad, heavy fillet located high on the barrel and the tall, tapering shape.

Boston newspaper advertisements indicate that pots, cans, and tankards were clearly differentiated in the minds of pewterers and of the public. John Skinner in *The Boston News-Letter*, July 7, 1763, listed his "very neat Canns" and also advertised "Pint Basons, Porringers of five different sizes, . . . Rum-Measures, from Quart to Jill Pots."[2]

John Skinner's "very neat Canns" are most likely the tall, tapering mugs made exclusively by New England pewterers, such as the example by Nathaniel Austin shown in Figure 6–5, and sometimes referred to as strap-handle mugs. That particular example is marked in unique fashion with Austin's name cast on the handle tip. But similar mugs with solid strap handles and shell-like thumb grips were made and marked by other New England pewterers, including Gershom Jones, Richard Lee, David Melville, and John Skinner. Illustrative of other New England quart mugs is one made by Samuel Hamlin, stamped, as was his custom, with his full name and hallmarks beside the handle (Fig. 6–6). Quart mugs with thin, solid handles were made by William Billings and Gershom Jones, and this type of thin, round handle may be considered a Rhode Island characteristic.

Samuel Danforth made five sizes of mugs—quarts, pints, half pints, gills, and half gills. Quart and pint mugs were the standard sizes. Samuel's quart and pint mugs (Fig. 6–7) are typical of all Connecticut mugs made by various Danforths, Boardmans, Jacob Whitmore, and others. Some have no fillets; others have narrow fillets just above the lower handle juncture or high on the barrel. There appears to have been no rule for the presence or absence of fillets or for their placement.

Also shown in Figure 6–7 are a half-pint and a half-gill mug made by the Boardmans, who were apparently the only other American pewterers to make these small sizes.

One of the best of Connecticut mugs is the pint example in Figure 6–7 (second from right). It has a slightly flaring cylindrical body, thickened lip, and flat fillet located about one-third the way up the barrel resting upon an almost straight base molding above a thin, sloping foot. The S-shaped handle, with spurlike thumb grip at the top, ends in a flowing bud terminal. The metal is bright, although a little soft, with a suggestion of lead. Skimming marks show clearly on the pristine body. There is a crudely soldered repair to a crack, just above the base. Centered on the inside of the bottom is a clear impression of a small eagle mark flanked by the letters S D, which can readily be identified as the well-documented mark of Samuel Danforth, who worked in Hartford from 1795 to 1816. Samuel, son of Thomas Danforth II of Middletown, was one of five pewtering brothers. His pewter varies greatly in quality. Sometimes his metal is thinner and the workmanship less fine than that of earlier pewterers. This mug, though a standard form, is a particularly beautiful one, with a fine interplay among the curving outlines of the upper handle, the lower terminal, and the flat encircling fillet and skimming lines on the body. Many pots (mugs) were listed in Samuel Danforth's large estate, which was appraised February 16, 1816. There were

92 quart pots @ 62¢
106 pint " @ 38½¢
49 half pint pots @ 24¢
91 Gill Cups @ 15¢
60 Gill Cups @ 12¢

It seems more than coincidence that Danforth's is the only Connecticut pewterer's

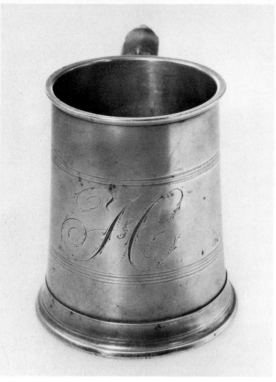

6–8. Pint mug with monogram, ca. 1821–ca. 1843, by Josiah Danforth, Middletown, Conn., H. 4⅜″ (WM 63.656).

inventory to list cups (mugs) of small sizes, and that half-pint, gill, and half-gill mugs are known only by him and his nephews, the Boardmans.[3] Probably the second entry in Samuel's inventory for "gill cups" is an oversight and should have read half-gill cups. Because of their fragility, these small vessels, which were perhaps used as whiskey measures, are extremely rare today.

Illustrated in Figure 6–8 is a mug made by Josiah Danforth, one of the last of this family to practice the pewterer's craft.[4] Probably made between 1825 and 1837, this mug displays features typical of late pewter vessels—incised fillets instead of raised ones and a wispy monogram characteristic of post-1820 practice. Like the small *T D B* mug (Fig. 6–7), this one is also marked on the outside of the bottom, as was customary after 1810.

6–9. Lidless tankard, 1775–95, by Peter Young, New York City, or Albany, H. 5⅝″ (WM 65.2760).

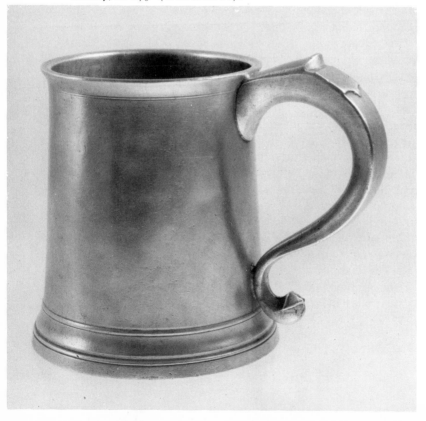

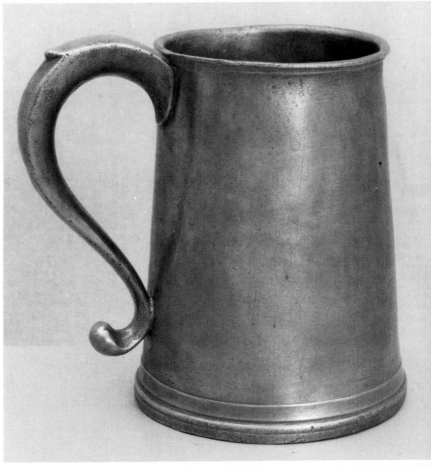

6–10. Quart mug, 1764–98, by William Will, Philadelphia, H. 5¹³⁄₁₆″ (WM 58.662).

If one accepts the definition of a tankard as a lidded drinking vessel, the reader may be confused by the term "lidless tankard" applied to one made by Peter Young (Fig. 6–9). The difference is that its construction is more massive and sturdier, its sides are more vertical, and its top diameter more nearly approximates that of the bottom than is normally true of mugs. Further, the handle is like a tankard handle with the hinge sliced away, leaving a sloping plateau.

Except for the mugs of William Will, few eighteenth-century Philadelphia mugs survive today. One might conclude that Philadelphians were not beer drinkers, but the evidence suggests otherwise. On

May 3, 1753, Cornelius Bradford offered in *The Pennsylvania Journal or Weekly Advertiser* "tankards, Quart and Pint Muggs, Basons, [and] Porringers";[5] however, more indicative of the large numbers of Philadelphia mugs made are more than five hundred quart mugs listed in inventories of Simon Edgell (1742) and Thomas Byles (1771).[6] In the former, 346 quart pots are listed, and in the latter 194 quarts of four varieties, including bellied examples, are detailed. In marked contrast is the modest stock of twenty-two quart mugs in William Will's inventory. Although their price of 67 cents may also seem modest, one must compare it with craftsmen's wages, which were standard

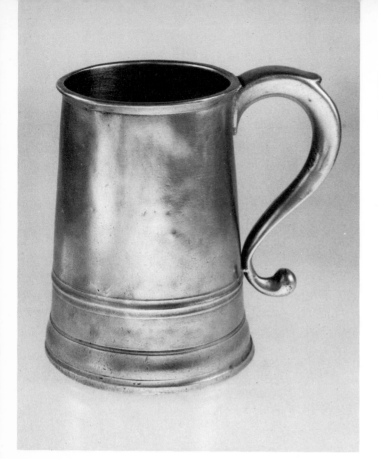

6–11.
Quart mug, 1764–98, by William Will, Philadelphia, H. 6¹⁄₁₆″ (WM 58.652).

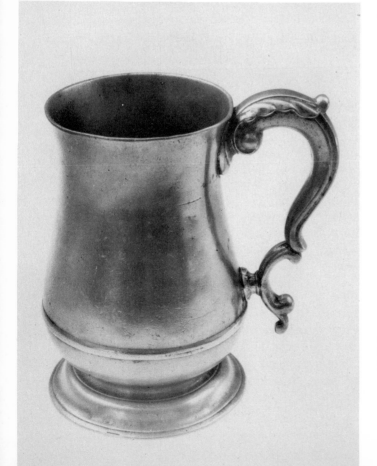

6–12.
Quart mug, tulip-shaped, 1764–98, by William Will, Philadelphia, 6⁷⁄₁₆″ (WM 53.27).

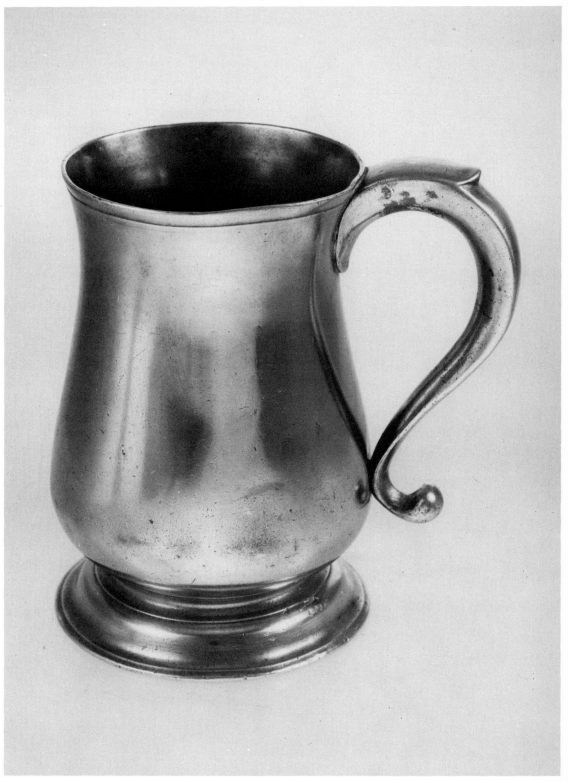

6–13. Quart mug, tulip-shaped, 1764–98, by William Will, Philadelphia, H. 6⁵⁄₁₆″ (WM 58.663).

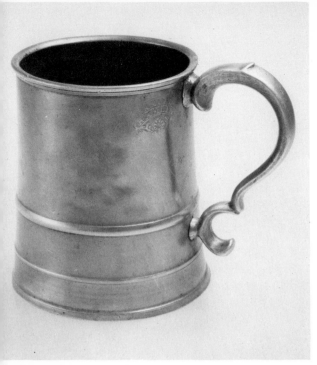

6–14. Pint mug, 1801–56, by Samuel E. Hamlin, Providence, H. 4¼″ (Gift of Charles K. Davis, WM 56.46.21).

6–15. Pint mug, barrel-shaped, 1817–22, by Robert Palethorp, Jr., Philadelphia, H. 4¼″ (WM 53.18).

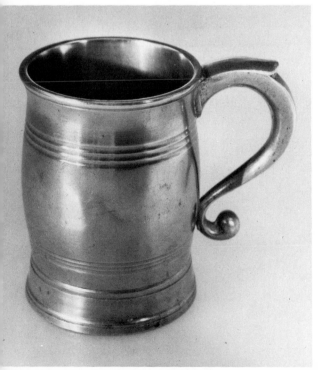

at one dollar per twelve-hour day at that time. It took eight hours' work to earn one of Will's mugs!

Illustrated in Figures 6–10 through 6–13 are four quart mugs, all marked by William Will. Each of these mugs is different from its fellows in terms of its base, handle, and the drum of the straight-sided ones (one has a fillet on the drum, the other does not). Similar variation is found in the bellied mugs of Will, who has left us more of this type than any other American pewterer. They are variously known as tulip-shaped, bulbous, or bellied.

William Will's unique interpretation of the double-C scroll handle with its acanthus-leaf thumb grip (Fig. 6–12) has already been noted. But it should be pointed out that despite the popularity of this type of handle in England, it is seldom found on American mugs. Will used it on his bellied quart mugs, and the younger Samuel Hamlin used nothing else on his straight-sided pints (Fig. 6–14).

Illustrated in Figure 6–15 is a pint barrel-shaped mug made by Robert Palethorp, Jr. This form may have been introduced by Parks Boyd, by whom a quart mug of the same shape was once owned by Philip Platt, a pewter dealer of Wallingford, Pennsylvania. Apparently the form was not popular, as only a few examples of the barrel form are known.

The making of pewter tankards ceased in the late eighteenth century. Mugs continued for a few years longer. The Boardmans and a few others continued to produce quart and pint mugs in the eighteenth-century manner until the 1830's, at which time their place was taken by britannia beakers and glass tumblers.

Tankards

A tankard is a drinking vessel with a handle and hinged cover. The cover distinguishes a tankard from a mug, pot, or can. Most American pewter tankards hold

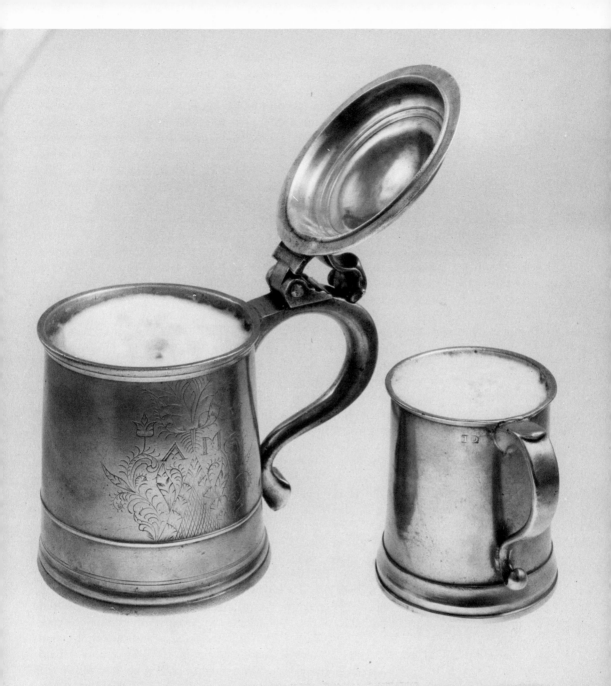

6–16. Tankard, 1713–42, by Simon Edgell, Philadelphia, H. 6⁹⁄₁₆″ (WM 65.553.). Pint mug, 1777-ca. 1818, by Thomas Danforth III, Stepney (Rocky Hill), Conn., or Philadelphia, H. 4″ (Gift of Charles K. Davis, WM 55.48.33).

about one quart. Two or three of pint size and perhaps a dozen giants that hold from three and a half pints to two quarts are known. A few pewter tankards survive in church communion sets, but for the most part they seem to have been privately owned.

Throughout the seventeenth and eighteenth centuries, Americans drank prodigious quantities of hard cider, beer, and malt liquors. But regional drinking habits are yet to be determined. Consider, for example, the supposition that there are probably far more surviving New England silver tankards than examples made in New York, Pennsylvania, or the South, but that not more than one in ten surviving American pewter tankards was made in New England.[8] Why pewter tankards were most popular with New Yorkers is not known, or why pewter mugs were favored in New England is still a mystery.

As already indicated, the pewter tankard was a popular drinking vessel in early America. But soon after the 1780's, as the vogue for silver tankards began to wane, pewter tankards also went out of fashion. With the demise of the last of the Wills and the end of the pewtermaking Bassetts about 1800, the day of the pewter tankard was over. Only for a few years after 1800 did the Boardmans of Connecticut, Parks Boyd of Philadelphia, and Peter Young and Timothy Brigden of Albany continue to fashion late versions of lidded drinking vessels.

The initials "A M" on the Edgell tankard in Figure 6–16 are believed to stand for Ann Michener, member of an early Philadelphia family. The free cutting and loose design of the floral-and-leaf ornament surrounding the monogram are inferior to the quality of the engraving on the Bradford tankard shown in Figure 3–6, but being less formal, it seems more appropriate for pewter than that on the New York tankard.

Edgell enjoyed a large business in his craft. Admitted a yeoman in the London Pewterer's Company in 1709, he came to Philadelphia in 1713, where he apparently worked until his death in 1742. At that time, among his stock of 8,001 pieces of pewter were twelve dozen quart tankards valued at five shillings each. Of these 8,001 pieces, and countless others made by Edgell, his now known work includes only two tankards, two 9-inch smooth-brim plates, and three large dishes.[9] The dishes are splendid. One 16 inches in diameter (in the Mabel Brady Garvan Collection at Yale) and another of 15 inches (given by Joseph France to the Metropolitan Museum) are hammered over their entire surface, but the 19-inch dish at Winterthur is hammered only on the booge.

Today marked American tankards are considered rare prizes by the collector. There is something so right and so beautiful about a flat-topped tankard with overhanging crenate lip and a fish-tail or splayed-handle terminal. The quality of the metal and the character of the form are in accord. The shape is bold; the metal has strength. The combination of form, function, and material is so natural that it catches the imagination of all pewter collectors.[10]

Pewter forms of the seventeenth and early eighteenth century were the noblest that the craft produced. Few surviving forms made by American pewterers date back to the seventeenth century in style. Among these are flat-topped tankards made mostly in New York and Albany; plain, straight-handled spoons with round bowls made in New York City (Figs. 10–3 l); three kinds of dishes (Figs. 8–2 through 8–4), one with multiple-reeded brim, another with flat, broad brim, and the rosewater bowl.

Tankards, composed of several castings (barrel, base, cover, thumbpiece, and handle) soldered together, are of course more complex than either the spoons or dishes. This unification of different ele-

ments makes the flat-topped tankard the glory of the American pewterer. No other form is so well suited to the material or more natural to the function it served. The section that follows begins with a group of flat-topped tankards made in New York and Albany in the eighteenth century but in the seventeenth-century style.

Each element of a tankard made by Joseph Leddell, Sr. or Jr., is typical of the finest English pewter tankards made soon after 1650. It combines a broad, low barrel, a cover with flat top only slightly elevated above a crenate overhanging lip, and an outsweeping S-shaped strap handle. One particular seventeenth-century attribute, the strong handle with splayed

6–17. Quart tankard 1712–54, attributed to Joseph Leddell, Sr., w ca. 1690–1754, or Joseph Leddell, Jr., w. ca. 1740–54, New York City, H. 7″ (WM 63.536).

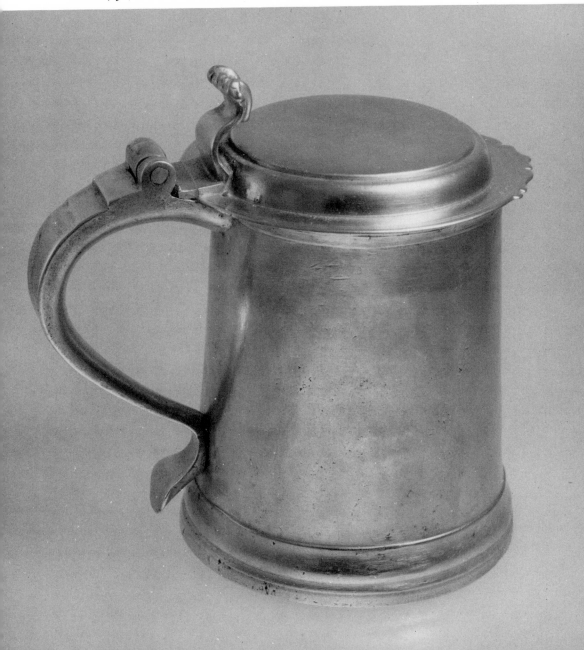

tip (Fig. 6–17), gives it and the tankard shown in Figure 3–6 great distinction. The upper part of the handle appears to be solid but is actually hollow. The broad curve between the lip and the flat top of the cover emulates that found on the earliest American silver tankards and is one seldom found on pewter examples. Other features of this tankard—the knurled thumbpiece, the flat top with crenate lip, and the robust ogee base moldings—are found on American tankards made throughout the eighteenth century.

Presumably when Joseph Leddell embarked for New York City from London in 1713, he brought with him brass molds. Although the silversmiths of Boston and New York were still fashioning tankards with flat tops, and some with covers of this kind continued to be made by colonial

6–18. Quart tankard, 1761–1800, by Frederick Bassett, New York City, H. 6⅞″ (WM 65.2240).

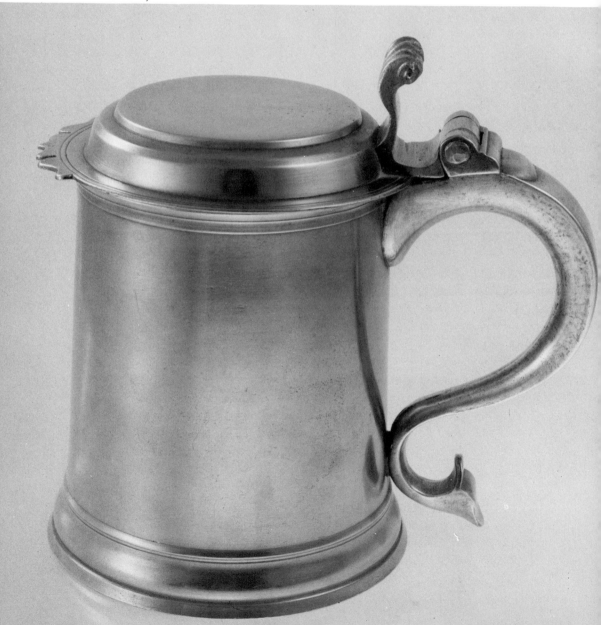

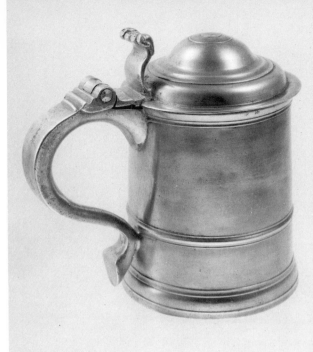

6–19. Quart tankard, 1752–74. by John Will, New York City, H. 7¹⁄₁₆″ (WM 55.75).

6–20. Quart tankard, 1723–60, by John Carnes, Boston, H. 6½″ (WM 65.2268).

silversmiths until the middle of the eighteenth century, flat-top tankards in this style were no longer *à la mode* in London. As yet we do not know whether the *I L* initial touch in this tankard is that of Joseph Leddell Sr. (w. 1712–53) or Jr. (w. ca. 1740–54), but it seems that if made by the son, he used molds once owned by his father.

Another tankard (Fig. 3–6) of essentially the same form, attributed to William Bradford, active in New York City from about 1719 to 1758, reveals elements that are stylistically identical. But comparison of the two reveals subtleties of design. Although both were made in the same era, ca. 1715–50, the composition of the example attributed to Bradford more closely approximates that of English and American silver tankards of 1660–90. Here the outflaring handle, combined with a barrel of approximately the same diameter but shorter than the Leddell example, gives a

silhouette that is horizontal rather than vertical—a silhouette that suggests greater stability.

Comparison with the superb tankard (Fig. 6–18) made between 1761 and 1800 by Frederick Bassett immediately reveals the dynamics of the inward sweep of the lower part of the handle of Figure 3–6, which seems to race straight toward the barrel, where it is firmly fixed instead of curving away, as does the handle of Figure 6–18 at the strutlike juncture. But not to be overlooked in the Bassett tankard is the larger scale (especially at the top) and the crisp lines of the hollow handle and robust fish-tail terminal.

The "H S 1777" neatly inscribed on the top of another flat-lidded, New York style tankard (Fig. 6–19) was believed by its former owners, to stand for Harvey Southard, an early owner of the property where the tankard was found in Long Island.

The open thumbpiece, like that used by

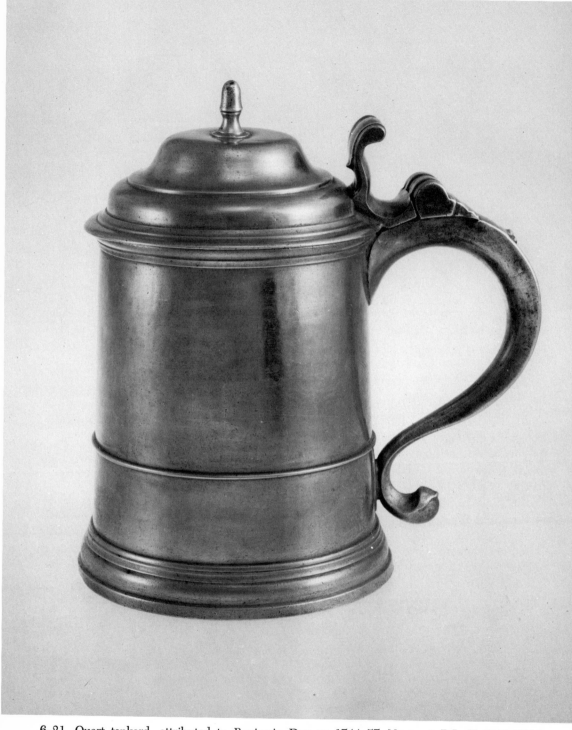

6–21. Quart tankard, attributed to Benjamin Day, w. 1744–57, Newport, R.I., H. 7½″ (WM 60.1133).

John Will on a pear-shaped tankard and also found on tankards made by Henry and William Will, is stylistically later than the knurled grip on all tankards illustrated so far in this book.[11]

New features introduced in English pewter tankards about 1700 were the flattened dome cover, the slush-cast hollow handle with boot-heel terminal, and an encircling band on the drum or barrel. Two tankards that look very much alike, one made by Simon Edgell (Fig. 6–16) and another by John Carnes of Boston (Fig. 6–20), incorporate these new features and may have been made before the preceding tankards of earlier style.

The width of bands used on tankards and their placement, high, low, or centered on the barrel, seems to have been a matter of the moldmaker's taste and should not be considered a regional characteristic. It is doubtful, for example, if any significance can be attached to the fact that the band on John Carnes's Boston tankard (Fig. 6–20) is broader and slightly higher on the barrel than on Simon Edgell's Philadelphia tankard (Fig. 6–16). John Carnes (w. 1723–60), a colonel in the Ancient and Honourable Artillery Company, was an important public figure and held many responsible positions in the local government. Of the many tankards undoubtedly made in Boston, Colonel Carnes's example is the only one known whose maker can be identified with certainty. It is also the earliest surviving piece of Boston hollowware, whose maker can be identified.

A few other, similar New England tankards, including one with an I C cast on the inner sides of the handle, were also probably made in Boston between 1725 and 1775. Of small size, their handles have a sloping plateau just back of the hinge. Some have an unusual barrel-shaped terminal, and others have finials on the cover.[12] At least one of this type of tankard, marked with the R B rose and crown

touch, attributed to Robert Bonynge, was surely made in Boston. The origin of three other fine New England tankards (Fig. 6–21), of heavy metal and ample proportions, is less certain. Marked with a large B D in octagon touch (as is a splendid solid-handle porringer and a lidless tankard), these were once attributed to Benjamin Day of Newport. Some of the tankards (like this one) have applied reinforcing plates at the base of the handle, and a finial, an ornament often used by New England, and especially Rhode Island, silversmiths. Although some of the B D pieces were found in Rhode Island, it is not known whether these pieces were made by Benjamin Day or by Benjamin Dolbeare of Boston.

A 3½-pint tankard, one of a pair (Fig. 6–22), dwarfs most other American examples. These tankards bear the F B fleur-de-lis touch of Frederick Bassett (w. 1761–1800) and are representative of about a dozen large tankards marked by one or another of the famous Bassett family. All appear to have come from the same set of molds, probably first owned by John Bassett (w. 1720–1761), father of Frederick. Each has a fully domed cover and midband, coupled with the earlier overhanging crenate lip, knurled thumbpiece, generous hollow handle with fish-tail terminal, and a high midband. Tankards with these features were probably made by English pewterers as early as 1710, about which time dome-topped tankards were first produced by American silversmiths. Perhaps unique as a pair, these tankards may once have served as flagons in a church because spouts were once added that have now been removed.

Connecticut Yankees, like New Englanders in general, seem to have preferred to drink from open mugs rather than from covered tankards—surely ten times as many Connecticut mugs survive as do tankards. Typical of Connecticut tankards

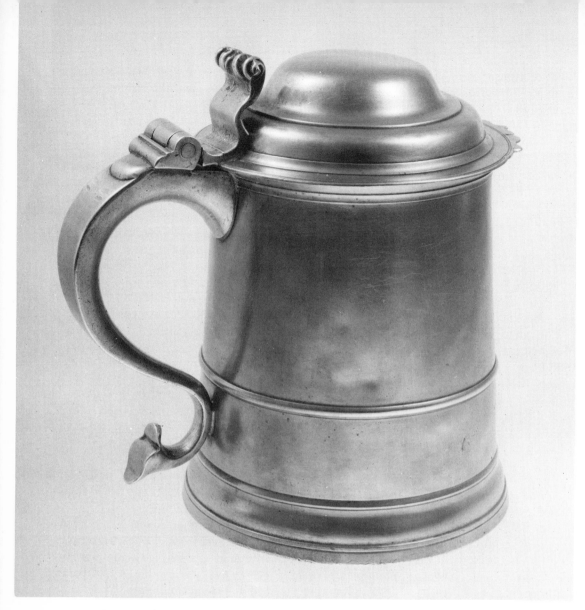

6–22. Three-and-one-half-pint tankard, 1761–1800, by Frederick Bassett, New York City, H. 7¹¹⁄₁₆″ (WM 65.2758).

6–23. Quart tankard, 1788–ca. 1795, by Edward Danforth, Middletown or Hartford, Conn., H. 6⅞″ (WM 58.648).

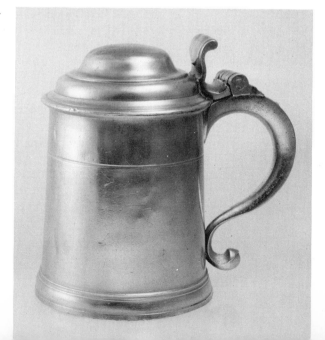

is that shown in Figure 6–23, one of two or three tankards known by Edward Danforth (w. 1786–95). Equally rare are tankards by Thomas Danforth II (Edward's father) and his brothers Thomas III and Samuel. All have domed covers, solid thumbpieces with a strengthening overlay on the upper surface, hinges with five leaves instead of the usual three, and often a thin band high on the barrel. Probably all of these were made after the Revolution and those of Samuel Danforth (w. 1795–1816) possibly even as late as the early years of the nineteenth century. The Boardmans continued to make tankards until about 1825.

Every collector wants to know who owned his prize and who made it. The fancy script "JJL 22 March 1766" and the "J M" engraved on Figure 6–24 suggest

6–24. Quart tankard, dated 1766, by John Will, New York City, H. 7″ (Gift of Charles K. Davis, WM 55.48.28).

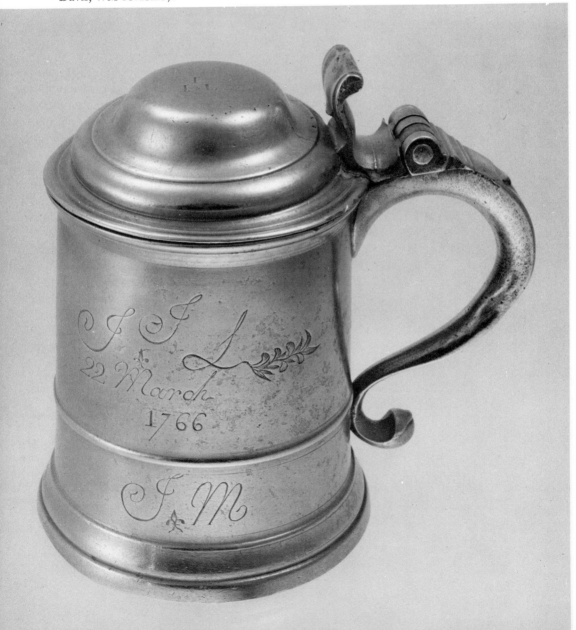

that much might be learned about the original ownership of this tankard. As yet it has been impossible to identify either the owners or the March 22, 1766, event that was commemorated. Nevertheless, the piece stands as a tribute to the skill of John Will (whose "angel" mark is centered inside the bottom) and to an unknown engraver who punctuated with fleurs-de-lis.

Although made up of elements similar to those of the preceding tankard, the form of the tankard (Fig. 6–25) marked by William Will is more vertical. The barrel is taller, smaller in diameter, and tapered; the thumbpiece is higher and thinner. The silhouette is neoclassical and reflects proportions introduced into England before the American Revolution but which did not come into vogue here until the 1780's. This tankard and the two tulip-shaped tankards that follow—differing

6–25. Quart tankard, 1764–98, by William Will, Philadelphia, H. 7⅝″ (Gift of Charles K. Davis, WM 55.48.30).

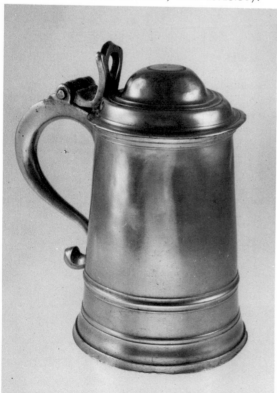

from one another only in thumbpieces and width and finish of midband—show the fine quality of finish and of metal that distinguish most of the surviving work of William Will. In an excellent study—the first published monograph on an American pewterer—Suzanne C. Hamilton listed 182 pieces by this versatile craftsman.[13] A cupboard at Winterthur (Fig. 1–1) containing thirty-eight examples of his work dramatically illustrates twenty-five different forms.

The tulip-shaped or bellied mug and tankard were introduced into England about 1720, but just when the form was brought to this country is not known. The earliest record of the form to come to the writer's attention is the date 1747 in the inscription on a pint mug given to the church in Southborough, Massachusetts. Marked *R B* and attributed to Robert Bonynge of Boston, the mug is in Ledlie Laughlin's collection. This form seems never to have been popular here except possibly in Philadelphia, where the inventory of Thomas Byles, taken in 1770, includes "31 Common Qt. Bellied Mugs." The forms of 163 other quart mugs and pots in this inventory are, alas, unidentified. Fifty-eight tankards are specified as "straight bodied," but the shape of sixty-six others is not designated.

Except for a single New York example made by John Will, all known American bellied tankards were made in Philadelphia—most of them the work of William Will in two variant forms (Figs. 6–26, 6–27).

At least six molds were required to make a tulip-shaped tankard—one each for the handle, thumbpiece, and cover, and three for the body. The parts of the latter were joined at the foot, and where the band occurs on Figure 6–27. At that point, both upper and lower castings had a thickened horizontal ridge. After the two parts were soldered together, the rough

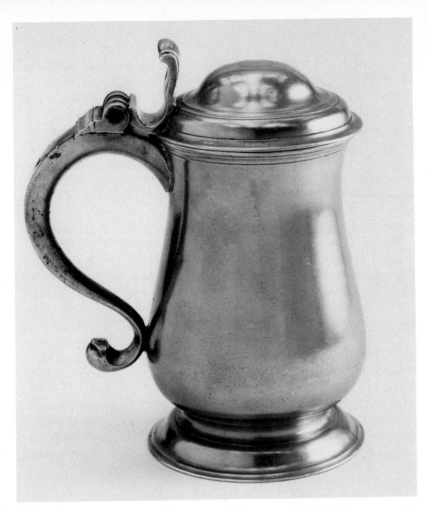

6–26. Quart tankard, tulip-shaped, 1764–98, by William Will, Philadelphia, H. 7¹⁵⁄₁₆″ (Gift of Charles K. Davis, WM 55.48.29).

6–27. Quart tankard, tulip-shaped, 1764–98, by William Will, Philadelphia, H. 7⅝″ (WM 58.653).

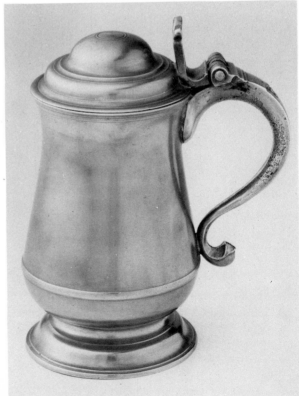

ridge could be either smoothed and left as a band or skimmed off, as in Figure 6–26. Today it is not known exactly how a piece of damp cloth was held in place on the inside of the barrel to form a tinker's dam where the upper and lower parts were soldered together, but the impression of the cloth is clearly seen as a horizontal stripe on the inner side of the barrel where the joint was made.

The high standards of eighteenth-century Philadelphia pewter made so abundantly evident in Simon Edgell's and William Will's work were carried on into the nineteenth century by Parks Boyd (w. 1795–1819). His metal is excellent and his forms, though less varied than those of Will, include a large covered water pitcher of the Liverpool-jug type made famous by Paul Revere (Fig. 7–5) and barrel-shaped mugs (Fig. 6–15) of which Boyd may have been the originator. Many of his hollowwares include neoclassical beaded edgings that were widely used about 1800 by Philadelphia craftsmen.

A tankard made by Boyd (Fig. 6–28)

is unorthodox by English and American standards. Strong Swedish influences are manifest in its flattened domed cover and heavy reeded bandings encircling the body. Circumstantial evidence suggests that Boyd acquired molds for his tankard from the local estate of the Swedish pewterer John Andrew Brunstrom, the son-in-law of Abraham Hasselberg (also a Swede), together with his pewterer's tools. At present none of Hasselberg's pewter is recognized, but it has been established that Hasselberg was a prominent Pennsylvania pewterer whose American career, begun about 1750 in the Moravian settlement at Bethlehem, continued in Wilmington and in Philadelphia, where he died in 1779. Hasselberg may have been one of the makers of the widely produced Pennsylvania pewter marked *Love*.

Though the Swedish strain in American pewter is less widespread than the German contribution of Heyne and the Wills, Parks Boyd's unorthodox tankard proves its presence.

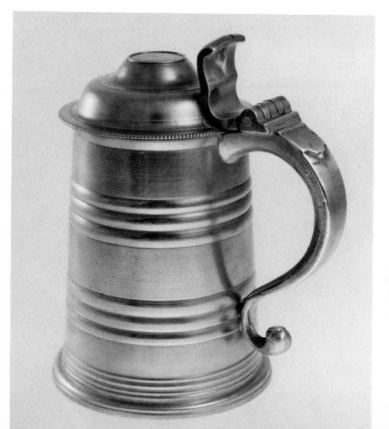

6–28.
Quart tankard, 1795–1819, b
Parks Boyd, Philadelphia, H. 7⅞
(Gift of Charles K. Davis, WM
52.293).

Chapter Seven

Pitchers

Surviving American pewter pitchers fall into several groups: the small eighteenth-century Queen Anne style cream pitchers with round, molded base or cabriole legs; unique, large eighteenth-century Germanic-looking pitchers made by William Will and probably of his own design;[1] a unique barrel-shaped pitcher made by Parks Boyd that approximates the design of Liverpool creamware jugs; a variety of nineteenth-century cream or syrup pitchers, and two- to six-quart globular water and cider pitchers made in large numbers between 1830 and 1870.

The earliest form of American pewter pitcher is a small Queen Anne style baluster-shaped cream pitcher (Fig. 7–1) with round, molded base, made and marked by John Will. Slightly later stylistically are his pitchers with three cabriole legs and pad feet. Few eighteenth-century pitchers of this form survive. In addition to those of John Will, only examples by William Will (Fig. 7–2) and Peter Young (Fig. 7–3) are known. Made at the earliest in the 1750's, these pitchers are modeled upon silver forms first fashioned by English goldsmiths during the reign of Queen Anne (1702–14).

In addition to pitchers with cabriole legs—sometimes with pad and sometimes with shell feet—William Will also made later-style pitchers of double-belly form (Fig. 7–2), with a round, beaded base made in his footed-salt mold. In Figure 7–3 is shown one of Peter Young's robust, three-footed, Queen Anne style cream pitchers of which five or six with shell feet and cabriole legs are known.

Several kinds of small open pitchers for cream, and covered ones for syrup, evolved in the nineteenth century. George Richardson of Cranston, Rhode Island, used castings from the base of a sugar bowl for his pitchers, and Lorenzo Williams of Philadelphia modified sugar-bowl designs to serve as creamers, thus saving the price of new molds.[2] Later in date and much handsomer is a cream pitcher made by the Taunton Britannia Manufacturing Company (Fig. 11–29) to match other pieces in a tea and coffee set.[3] Rare examples by Israel Trask (Fig. 7–4) attest to his early training as a silversmith. Composed of bulbous boat-shaped bodies resting on four ball feet, one is reeded, the other plain. Both are ornamented with bright-cut bands. Henry Hopper of New York made handsome cream pitchers that resemble lusterware jugs of the 1820's and

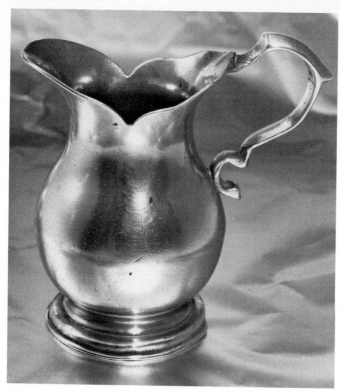

7–1. Cream pitcher with circular foot, 1752–74, by John Will, New York City, H. 3¾″ (WM 67.1368).

7–2. Cream pitchers, attributed to William Will, w. 1764–98, Philadelphia, H. (left) 3⅞″, (right) 5⅜″ (collection of Charles V. Swain).

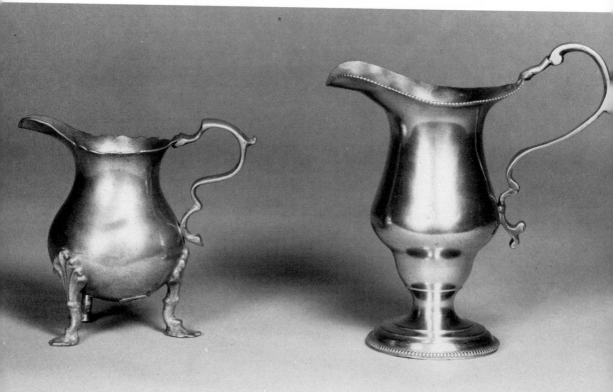

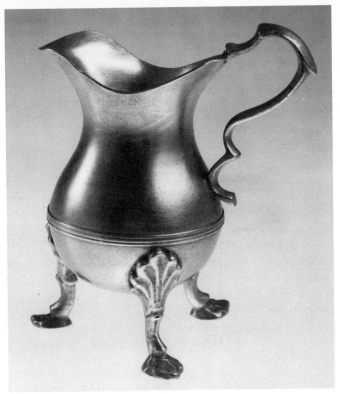

7–3. Cream pitcher with three shell feet, 1775–95, by Peter Young, New York City or Albany, H. 4½″ (WM 53.25).

7–4. Cream pitchers, ca. 1813–ca. 1856, by Israel Trask, Beverly, Mass., L. (left) 5⅜″, (right) 5½″ (left, collection of Mr. and Mrs. Paul M. Young; right, collection of Mr. and Mrs. Richard F. Upton).

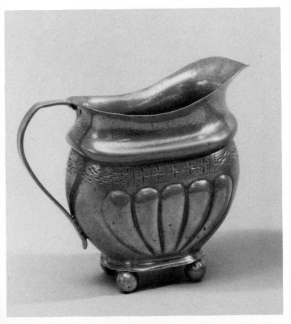 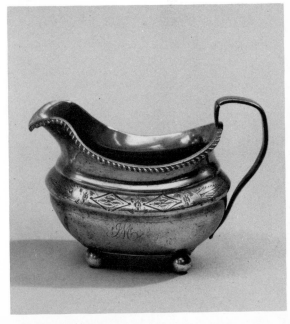

1830's, and several examples by Hall and Cotton of Middlefield, Connecticut, approximate the lighthouse coffeepot shape.

Probably the earliest pewter water pitcher known, and certainly the earliest in form, is the unique example made by Parks Boyd (Fig. 7–5). Its form follows the sleek lines of Paul Revere's well-known and widely copied silver pitcher. Whether Boyd's pitcher followed or preceded Revere's is not known. Both were first made about 1800 and derive from the same source—the Liverpool jugs of the early 1800's that were brought to America from England by so many ships' captains.

Certainly among the most successful forms of nineteenth-century britannia makers, are the water-pitcher designs of the Boardmans; Daniel Curtiss of Albany; Rufus Dunham and Freeman Porter of Portland and Westbrook, Maine, respectively; Roswell Gleason of Dorchester; the Meriden Britannia Company; and Timothy Sage of St. Louis. Water pitchers in the group illustrated in Figure 7–6 range

in size from Sage's half-pint pitchers to the six-quart examples made by Gleason and the Meriden Britannia Company. These pitchers are, for the most part, made of cast metal of excellent weight. More globular and curvaceous than the pitchers of Revere and Boyd, the shapes of these splendid nineteenth-century pitchers seem to derive from Staffordshire pottery pitchers imported in large numbers from 1815 to about 1825.

The high-shouldered, straight-necked ale jug is one of the most common English pewter forms of the late eighteenth and early nineteenth centuries, but Henry Hopper, who worked in New York, and George Richardson, seem to be the only American pewterers to have adopted it.[4] An equally rare form with flaring lip, a spout, and cast handle is the three-pint pitcher made by S. S. Hersey of Belfast, Maine, during the 1830's (Fig. 7–6).

In their 1867 catalogue, the Meriden Britannia Company advertised pitchers (Fig. 7–7) in one- to six-quart sizes, with

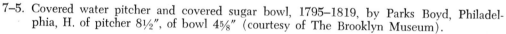

7–5. Covered water pitcher and covered sugar bowl, 1795–1819, by Parks Boyd, Philadelphia, H. of pitcher 8½", of bowl 4⅝" (courtesy of The Brooklyn Museum).

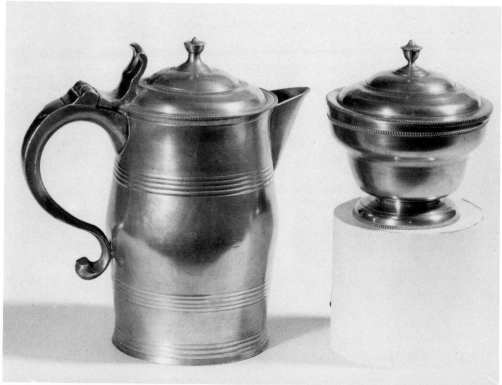

7–6. *Front row (left to right)*:
Covered pitcher, ca. 1840–60, by Elizur B. Forbes, probably Westbrook, Me., H. 8¹¹⁄₁₆″ (WM 52.112).
Pitcher, ca. 1845–49, by Timothy Sage, St. Louis, H. 4¾″ (Gift of Charles K. Davis, WM 55.48.25).
Cream pitcher with circular foot, 1752–74, by John Will, New York City, H. 3¾″ (WM 67.1368).
Middle row:
Pitcher, 1822–40, by Daniel Curtiss, Albany, H. 8⅜″ (WM 66.1177).
Pitcher, ca. 1830, by S. S. Hersey, Belfast, Me., H. 7″ (WM 63.666).
Pitcher, ca. 1835–1860, by Freeman Porter, Westbrook, Me., H. 6¹¹⁄₁₆″ (WM 63.662).
Pitcher, 1825–27, by Boardman and Company, Hartford or New York City, H. 8¹⁄₁₆″ (Gift of Charles K. Davis, WM 56.46.8).
Back row:
Covered pitcher, 1830–50, by Roswell Gleason, Dorchester, Mass., H. 12³⁄₁₆″ (WM 64.1157).
Covered pitcher, 1830–50, America, H. 10″ (WM 64.996).
Covered pitcher, 1844–45, by Boardman and Hall, Philadelphia, H. 9⅝″ (WM 65.1455).
Covered pitcher, 1839–53, by William McQuilkin, Philadelphia, H. 11⅞″ (Gift of Charles K. Davis, WM 56.46.9).

or without lids, at wholesale prices from fourteen dollars a dozen for the smallest to forty-five dollars a dozen for the six-quart size.[5] Although the examples in the top row and that on the left in the bottom row are in the styles of the first half of the nineteenth century, the remaining two examples with top-heavy spouts and weak handles point to the degeneration of this form after 1850.

PITCHERS.

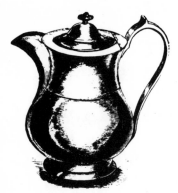

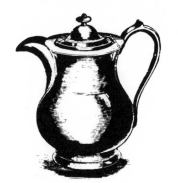

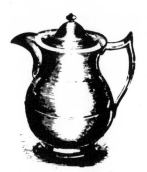

Covered.

6 quart. Per dozen, $42 00.
*Plain, 6 quart. Per dozen, $38 00.

Covered.

4 quart. Per dozen, $36 00.
Plain, 4 quart. Per dozen, $33 00.

Covered.

3 quart. Per dozen, $25 00.
Plain, 3 quart. Per dozen, $22 00.

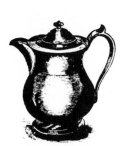

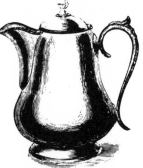

Covered.

2 quart. Per dozen, $20 00.

Plain, 2 quart. Per dozen, $18 00.

No. 1991, Covered.

Covered, Rolled Metal, 6 quart
Per dozen, $45 00.

Plain, Rolled Metal, 6 quart.
Per dozen, $41 00.

Covered, Rolled Metal, 4 quart.
Per dozen, $38 00.

Plain, Rolled Metal, 4 quart.
Per dozen $35 00.

Covered, Rolled Metal, 3 quart.
Per dozen, $26 50.

Plain, Rolled Metal, 3 quart.
Per dozen, $23 50.

Covered, Rolled Metal, 1 quart.
Per dozen $16 50.

Plain, Rolled Metal, 1 quart.
Per dozen, $14 00.

Patent Beer.

Per dozen, $45 00

*By Plain is understood without Covers.

7–7. Water pitchers, p. 168 from *Price List of Articles Manufactured by the Meriden Britannia Company* (West Meriden, Conn., 1867).

Chapter Eight

Plates, Dishes, and Basins

Plates, dishes, and basins were known during the pewtermaking era as "sadware," a term used in the seventeenth and eighteenth centuries to designate one-piece vessels cast in a two-part mold. Perhaps because of the simplicity of their manufacture, plates, dishes, and basins were made by most American pewterers and were sold by the pound (Fig. 8–1).

While these items may look very much alike, each varies within its class, in diameter, depth, size and contour of rim, relationship of weight to size, and quality of workmanship. Basins are deeper and have narrower brims than plates and dishes. Few are smaller than 6 inches or larger than 16⅜ inches in diameter. However, marked American examples as small as 4⅞ inches are known. Included in the Winterthur collection is a magnificent 19-inch dish with the marks of Simon Edgell. It was the largest American dish known until the recent discovery of a 20-inch dish with the English touch of Lawrence Langworthy, who worked in Newport after emigrating to this country in 1730. Whether Langworthy made this dish here or in England it is impossible to say.

Plates from which people ate, whether made by American or English pewterers, ranged from 7½ inches to 10 inches in diameter. Plates smaller than 6½ inches were known as saucers, and those larger than 10 inches as dishes. Deep plates in the 7½-inch to 10-inch range were called soup plates, then as now. Most dishes were used for serving food, though sometimes they were used as communion or collection plates in churches. Dishes—shallow, semideep, and deep—ranged from half an inch to about an inch and a half in depth. Both round and oval dishes larger than 13 inches across were often called platters or chargers. Dishes of 28 inches and even larger diameters were not uncommon in England. William Penn, for example, owned a great oval English platter 48 inches long by 33½ inches wide that was given by his son John to the Fort St. David's Fishing Company of the Schuylkill River.[1]

Six plate sizes—7¾, 8½, 8¾, 9¼, 9½, and 9¾ inches—weighing from 7 pounds 8 ounces to 16 pounds per dozen are specifically listed in *The Compleat Appraiser*.[2] In addition to these six sizes, plates 8 and 8¼ inches in diameter were also made in America. The same author lists eighteen sizes of round dishes from 10¾ inches, weighing 1 pound 12 ounces, to 28 inches, weighing 19 pounds 12 ounces.

8–1.
Pewter was sold by the pound.

Soup plates from 8 to 10 inches in diameter and about an inch deep were commonly made by English pewterers, but no eighteenth-century marked American ones are known. However, William Willett, "Pewterer, Living about two miles from Upper-Marlborough [Maryland] on the Bladensburg Road," advertised in 1756 that he

new Moulds [recasts] old Pewter at 9d. per pound, or will return one half good new Pewter for any quantity of old, and to be cast in whatever Form, the Employer pleases, either flat or soup Dishes, or flat or soup Plates. N.B. He will wait on any employer within 20 or 30 miles to receive their old, or return their new Pewter.[3]

The weights of plates and dishes varied somewhat even when new because, as the author of *The Compleat Appraiser* makes clear:

All Workmen have not their *Moulds,* of the same Diameter, so truly made as to contain exactly the same Quantity of Metal; and then, the same Mould may one Time (by its being screwed up *closer* or *looser*) contain more or less Metal than at another Time; And, besides these *Uncertainties* that may be occasioned by the Mould, there may be some Uncertainty as to the Weight, occasioned in the Turning, by the Turners taking off more or less Metal one Time than another.[4]

Nevertheless, he states that plates and dishes are "usually of *Diameters* and *Weights* set down in the [following] Tables if . . . New," noting that "the two smallest Sizes of Plates are chiefly made for *Exportation.*"[5]

As noted earlier, pewter of highest grade was called hard metal. Not only was the metal finer but the workmanship was better—usually hammered on the booge and commanding a premium price. Many English plates are marked with a special hard-metal touch, but only a few eighteenth-century American plates are so marked. The majority now known are from the shop of Samuel Hamlin of Providence, Rhode Island, and Henry Will of New York; for the most part, fine quality plates were simply marked with a crowned X, as were mugs, tankards, and other objects of the finest metal.

English pewter shipped to North America from London and from the West Country port of Bristol unquestionably set the standard for colonial pewterers, although local preferences were reflected in locally made pewterware. In the *Boston Gazette* of July 1, 1765, John Skinner advertised that "he continues to make hammer'd Plates the same as London, of different sizes"; and, in the same period, he emphasized that he "continues to make and sell all sorts of the best *New-England* Pewter."[6]

The shapes and rim styles of pewter plates and dishes changed with the pas-

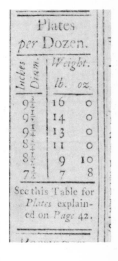

Dishes.		
Inches Diam.	Weight.	& oz.
28	19	12
27	18	12
26	16	8
25	15	8
24	13	0
23	12	4
22	11	0
21	9	0
20	7	12
19	6	12
18	5	8
17	5	0
16½	4	4
15	3	4
14	3	0
13½	2	12
12¼	2	4
10¼	1	12

See this Table for *Dishes* explained on *Page* 41.

Plates per Dozen.		
Inches Diam.	Weight.	lb. oz.
9¾	16	0
9½	14	0
9¼	13	0
8½	11	0
8½	9	10
7¾	7	8

See this Table for *Plates* explained on *Page* 42.

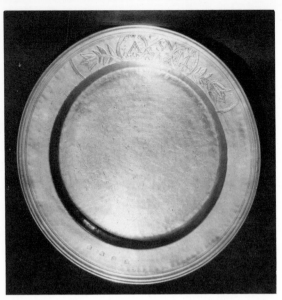

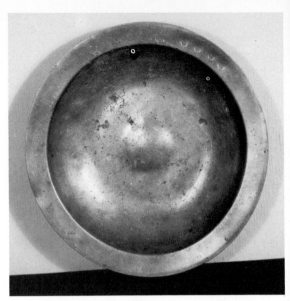

8–2. Dish with multiple-reeded brim, attributed to John Dolbeare, w. 1690–ca. 1740, Boston, Mass., Diam. 15″ (collection of Lloyd W. Fowles).

8–4. Rosewater bowl, attributed to Edmund Dolbeare, w. 1671–ca. 1711, Boston or Salem, Mass., Diam. 12¹¹⁄₁₆″ (collection of Mrs. Peter H. Alderwick).

sage of time. Among the styles of pewter plates and dishes made in England during the seventeenth century, the most common (now known as "multiple reeded") had a series of ridges and grooves on the upper outer surface of the face. The second most common form had a broad, smooth brim with a narrow reed on the back to strengthen it; the brim is broad in relation to the width of the hollow center and is sometimes hammered over the entire surface to strengthen the expanse of flat metal.

Eighteenth- and early nineteenth-cen-

8–3. Dish with broad, smooth brim, attributed to Edmund Dolbeare, w. 1671–ca. 1711, Boston or Salem, Mass., Diam., 16⅝″ (WM 55.60.2)

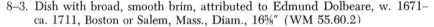

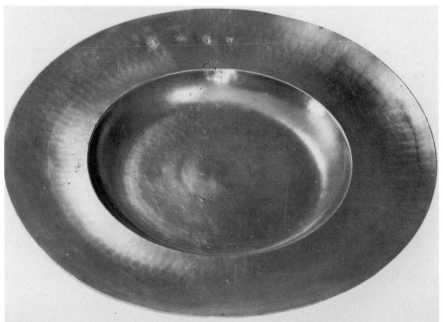

tury American plates and dishes are of two kinds: those with a single reed on the outer edge of the brim face; and those with a smooth-faced brim, about an inch and a half in width, with a single reed at the outer edge of the back.

American flatware was undoubtedly made in all these styles, but only one plate, eight dishes, and a rosewater bowl are now attributed with assurance to seventeenth-century American pewterers. All are marked on the face of the brim in accordance with English seventeenth-century practice. However, in contrast to normal English usage of four different pseudo hallmarks arranged in a line, on this pewter, an initial mark, *E D* in a shield, or *I D* in a heart is repeated four times. This pewter is in all likelihood the work of Boston's Dolbeare family of pewterers. The *E D* touch is attributed to Edmund, who arrived in Boston from Ashburton, England, in 1671 and worked there and in Salem until 1711. The *I D* mark may have been used by either of Edmund's sons, John or Joseph, though more likely the former because Joseph was poor and may never have had a shop of his own.

Illustrative of the multiple-reeded brim type, with molded contours similar to those found on seventeenth-century six-board blanket chests and interior house sheathing, is a large dish hammered over its entire surface (Fig. 8–2). The most beautiful piece of American flatware is the seventeenth-century dish with very broad flat brim, of a type sometimes called a cardinal's hat (Fig. 8–3). Three American examples known of this type are marked four times with the initial touch *E D* in a shield and attributed to Edmund Dolbeare. They are hammered over all their surface. Another form unique in American pewter, also attributed to Edmund Dolbeare, is a dish with a central boss, which in English usage is called a rosewater bowl (Fig. 8–4). One other seventeenth-

century dish marked four times on the brim with an *I B* touch may be even earlier than those cited above. It may have been made by John Baker, who worked in Boston from about 1676 to 1696.

Later, plates with single-beaded brims were the standard in most American families and were made by almost every established American pewterer working between 1700 and 1810 (Fig. 8–5). Careful examination of plate-brim profiles reveals the great care taken in their design, as shown in the thinning and thickening of the metal at strategic points (Fig. 8–6 *a, b, c*). The profile of equal thickness throughout (Fig. 8–6 *d*) is a fake. Several sizes were made and used in each locale, but the small sizes—7⅛ and 7¾ inches in diameter—were most popular in Boston; 8-inch plates were preferred by Connecticut residents; and larger sizes of 8½ and 8¾ inches were most favored in Newport and Philadelphia. New Yorkers and Albanyans preferred larger sizes—8½ to 9 inches in diameter. Most single-beaded plates were smaller, however, than those with smooth brims, which normally range from 9 to 9½ inches.

It should also be noted that plates made in Boston and Newport usually have narrower brims than New York, Connecticut, and Pennsylvania examples. Though Boston plates are not flimsy, the pewter in them is often thinner than that found in New York and Philadelphia plates.

Smooth-brimmed plates, made by many pewterers, seem to have been less popular than the single-reeded type. The earliest known maker of smooth-brimmed plates is Simon Edgell of Philadelphia, hence, their introduction in America can be dated before 1742, the year of his death.

Although the design of smooth-brimmed plates—a flat plateau surrounding a shallow basin—is simpler than that of the more common single-beaded plate, many people think them more beautiful, and there is a decided vogue for them among

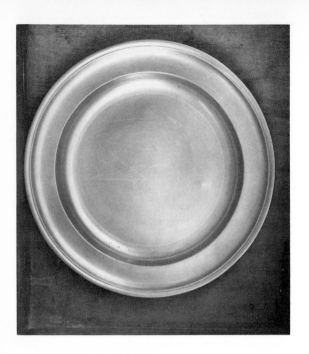
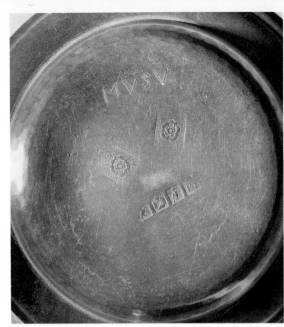
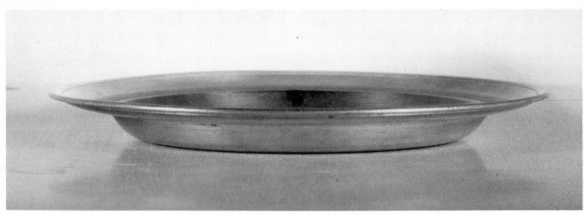

8–5. Plate (front, back, and profile views), 1775–95, by Peter Young, New York City or Albany, Diam. 8¹³⁄₁₆″ (WM 65.2494).

collectors. Invariably of good metal and well made, they are often expertly hammered on the booge to harden and strengthen the curved section between brim and bottom that was wont to crack.

Smooth-brimmed plates are known by the following American makers: Richard and Nathaniel Austin of Boston; Samuel Hamlin and Gershom Jones of Providence and David Melville of Newport, Rhode Island; Edward, Joseph Sr., and the various Thomas Danforths of Connecticut; Cornelius Bradford, Thomas Byles, Simon Edgell, Christian Hera, and William Will of Philadelphia; John Shoff, who may have worked in Pennsylvania; and the unidentified *E W* of Virginia.

Whereas many sizes of smooth-brimmed plates and platters, including soup plates, were made in England, surviving American examples are limited to dinner plates with the exceptions of a 15¼-inch oval

dish or platter made by Henry Will (in the Poole Collection of the Brooklyn Museum), a 5½-inch William Will saucer, and an 11-inch dish marked *I. Shoff* (both in the Winterthur collection). I. Shoff is thought to have worked in Lancaster County, Pennsylvania.

A few smooth-brimmed plates of a special kind illustrate one of the ingenious ways devised to keep food hot for fastidious eighteenth-century Americans and Englishmen. Plate warmers made to stand beside a fireplace in the eighteenth century are not uncommon. A more practical device was the plate with a hot-water reservoir, called water plates in the inventories of both Simon Edgell (1742) and Thomas Byles (1771). There is ample record of their American manufacture. Although among the 8,001 pieces of pewter in Edgell's inventory there is only one "Large Water Plate," Byles's inventory lists nineteen "water plates" at eight shil-

8–6. Profiles of plate brims: (*a*) seventeenth-century dish; (*b*) eighteenth-century shallow plate; (*c*) eighteenth-century deep plate; (*d*) twentieth-century fake with metal of uniform thickness.

8–7. Hot-water plate, 1764–98, by William Will, Philadelphia, W. (with handles) 10⅝" (WM 58.658).

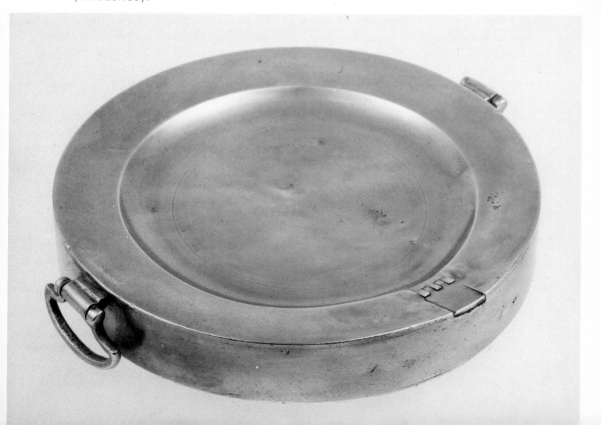

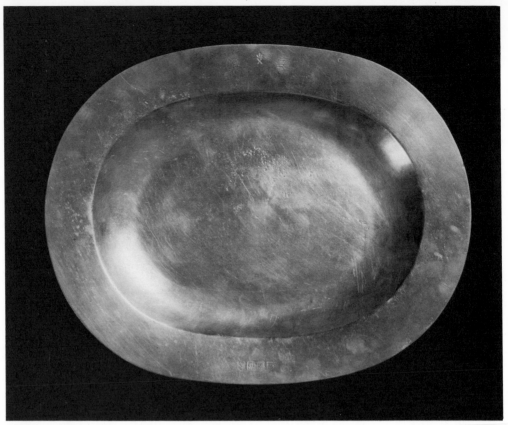

8–8. Oval dish, 1760–93, by Henry Will, New York City or Albany, L. 15¼″ (courtesy of The Brooklyn Museum).

lings each, expensive compared to the approximately one shilling each for more than 1,200 ordinary plates.

Expensive though hot-water plates obviously were, Americans bought them, and at least five American pewter examples have come down to us. Two at Winterthur (Fig. 8–7) and one other were made by William Will, and two others by his brother Henry. All of them have tabs hinged in the face of the smooth brim to admit approximately a quart of hot water. Similar porcelain plates were made in China for the export trade.

A unique American oval dish with a smooth brim is worthy of particular mention (Fig. 8–8). Probably fashioned by hammer instead of by casting, it bears the mark of the versatile Henry Will. Although only this one American oval dish

is known, many English ones were used in America. For example, Robert Beverley of Blandfield, Virginia, ordered from London in April, 1763, "A Service of oval Pewter Dishes and six Doz. shallow Plates but no deep ones, a Bull's Head, be[ing] my crest, to be engraved on 'em."[7]

Representative of known American plates and dishes are seventy-six plates and twenty-nine dishes in the Winterthur collection made by sixty-three pewterers who worked along the Atlantic coast from Boston to Augusta, Georgia. Twenty-three plates and dishes were made by pewterers who began to make pewter before the American Revolution; eighty-eight have single-reeded brims; fourteen have medium-width smooth brims; one has the seventeenth-century type of broad, smooth brim, and two have

seventeenth-century-style multiple-reeded brims. Four of these—among the earliest known eighteenth-century American plates —were made by Francis Bassett, John Bassett, William Bradford, Jr., and John Will. Fully as rare but comparatively unimportant are three late plates made by Plumly and Bidgood of Philadelphia (ca. 1825), Otis Williams of Buffalo (1826–31), and J. W. Olcott of Baltimore (ca. 1800). Their work is rare simply because their working careers coincided with the end of the platemaking era.

Because of Henry Francis du Pont's desire to have a representative showing of each size and form, the Winterthur Museum's holdings cannot be considered indicative of the ratio of survivals (see "Plates and Dishes in the Winterthur Museum," pp. 232–34). Winterthur's sixteen 6-inch plates or saucers are far rarer, for example, than their numbers suggest. They vary in diameter from 5½ to 6½ inches. Fifteen are edged with a single bead, while one by William Will is unique in that it has a smooth brim. All are shallow.

Forty-two plates in the Winterthur collection between 8 and 9 inches and five plates between 9 and 10 inches in diameter have a single-beaded edge. Eighteenth-century American plates in the latter size are decidedly rare, although nineteenth-century examples by the Boardmans are not uncommon. Winterthur's twelve smooth-brimmed plates suggest the range of sizes in this style and represent each of the major pewtermaking centers.

The people in each area also seem to have had decided preferences concerning the size and depth of dishes. Massachusetts and Rhode Island pewterers made only shallow dishes, while deep ones were favored by Connecticut pewterers. Connecticut-trained men favored 11- and 13-inch deep dishes, but no larger. They produced comparatively few 11- and 12-inch shallow dishes. In other centers, 15-inch dishes were the largest normally made,

though a dozen or more 16-inch dishes, sometimes deep, are known by Francis Bassett, Frederick Bassett, Simon Edgell, Joseph Leddell, John Skinner, Henry Will, and William Will. Also seventeenth-century-style, multiple-reeded examples attributed to Edmund Dolbeare and to Joseph Dolbeare are known. A unique American dish, 19 inches in diameter, made by Simon Edgell, is in the Winterthur collection.

Apparently, as was true of plates, deep dishes were known as soup dishes. Daniel Wister, in his December 6, 1763, letter to John Townsend of London, requested both "shallow dishes" and "soup dishes" of several sizes, which he ordered by weight rather than by diameter: *4-pound* (16-inch diameter), *3½-pound* (15¼-inch diameter), *3-pound* (14-inch diameter), *2½-pound* (13-inch diameter), *2-pound* (12-inch diameter), and *1½-pound* (11-inch diameter).[8]

Two remarkable dishes discovered in the 1950's are fluted; one, dated 1732, is clearly marked with the touch of Francis Bassett I. The other (Fig. 8–9), a similar dish, dated 1728, was probably also made in New York, though the mark has been obliterated. Instead of being cast, these dishes were formed in silversmith fashion by raising (hammering up) a flat piece of metal into a shallow vessel that, in turn, was fluted. The pewterer accomplished this by striking a chasing tool along radiating lines on the outer surface after filling the bowl with pitch. The fruit-and-floral decoration (also chased) featuring vines, pomegranates, and tulips is reminiscent of endpapers found in Dutch and German books or lining eighteenth-century trunks. Although the character of the featured initials "IZCZ" also is Continental in appearance, shallow fluted dishes of this form were made by London silversmiths in the 1720's. Today those English silver dessert dishes are conveniently called strawberry dishes.

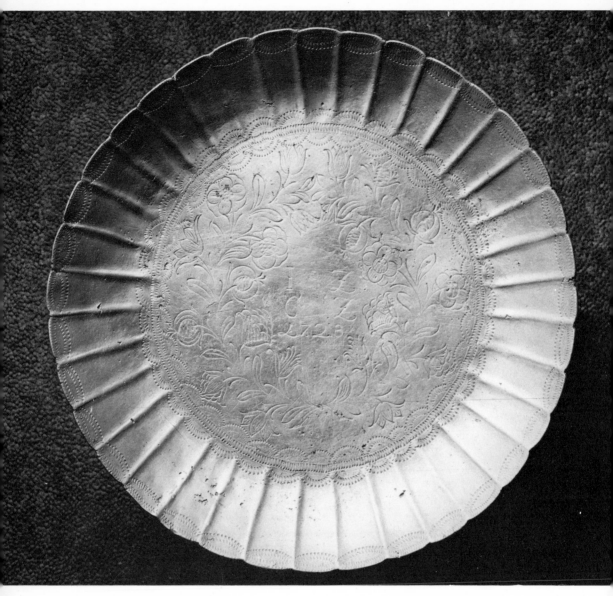

8–9. Presentation dish, dated 1728, probably New York City, Diam. 8¾″ (collection of William M. Goss, Jr.).

Basins

Most American pewter basins have narrow brims and are deeper than plates and dishes. The ordinary sizes vary from a pint to a gallon and from about 6 to 12 inches in diameter, with 8-inch, 9-inch, and 10½-inch sizes most common. Shown in Figure 8–10 are basins from pint size (6⁷⁄₁₆ inches in diameter), made by William Will, to a very large two-gallon example (14 inches in diameter) marked *Boardman Warranted*. The latter, called "a remarkable basin with domed cover" by J. B. Kerfoot,[9] is shown with its cover (Fig. 8–11).

Dishes with covers and "Turins [tureens] with covers" appeared occasionally in inventories and were sometimes advertised. However, no other American-made pewter basin cover is known. Equally remarkable is the broad-brimmed basin (Fig. 4–9). One might suppose it was a baptismal basin, but the "H F" prominently engraved on the brim suggests secular ownership. Marked *H W* in a serrated circle in the bottom, this unusual form is readily identified as the work of Henry Will. This basin and others from the same mold, though unmarked and without brim, are all presumably from Henry Will's shop. Possibly all of these are footed wash basins or barbers' basins, two of the five varieties of basins specified in *The Compleat Appraiser* as "Basons (wash) flat Bottomed" from 8½ to 12½ inches diameter; "Basons (*wash*) with a Foot" from 9¾ to 11 inches in diameter; "*Barbers* Basons, *Round*," 10½ inches in diameter; "*Barbers* Basons, *Oval*," 13 and 14 inches long; and "Basons, *Breakfast* or Slop" in quart, pint, half-pint, and "quartern" (quarter pint) sizes. This suggests that

8–10. A stack of basins.

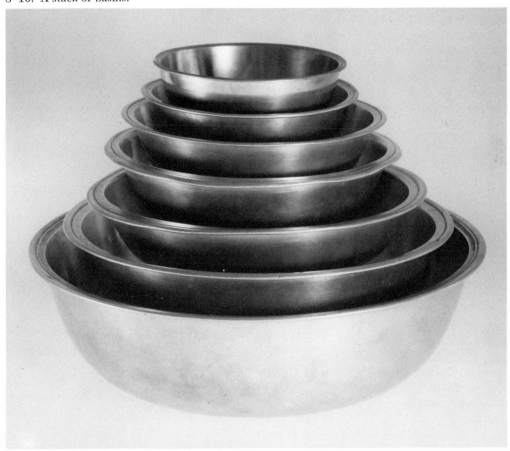

basins up to 8 inches in diameter (quart size) were used as breakfast bowls, or slop bowls with tea sets, and that the larger sizes were used as wash basins. Although even the 12½-inch (gallon) size may seem small for the purpose, readers are reminded that the openings for basins in most eighteenth-century high-style wash-basin stands are not more than 10 or 11 inches in diameter, and one walnut washstand in the Winterthur collection will accommodate only a pint basin.

The exact use or name for specific basins has been lost. The fact that Samuel Pierce charged forty-two cents for "wash" basins and forty cents for "quart" basins suggests that they were approximately the same size and weight, but we can only guess that Pierce called his footed basins "wash" basins and the ordinary flat-bottomed kind "basins." William Kirby's enumeration in his advertisements of "dishes, plates and basins" and "quart and pint bowls [and] wash-hand basons" makes it clear that a distinction existed (Fig. 2–3).[10]

The quart and pint bowls advertised by William Kirby may have been small flat-bottomed basins, but the writer believes

they were more likely the sort frequently advertised by importers as "hard metal breakfast bowls," which were a specialty of English pewterers and used with little change of shape as "mess bowls" in the English navy until the end of the nineteenth century.

Except for the hammering found on some English basins, there is little difference between those made in England and America. "Let them be hammer'd," wrote the Baltimore merchants Samuel and John Smith, of basins that they ordered in 1784 from the Bristol, England, firm of John Noble and Company.[11] And, indeed, some English basins are hammered over their entire bodies, but no known American basin is finished in this manner.

Only a few basins smaller than the pint size are known. One only 2¹³⁄₁₆ inches in diameter, marked by Samuel Hamlin, may have been used as a toy.[12]

Baptismal bowls, including the footed examples of the Boardmans and Samuel Danforth, have been discussed in connection with communion services and church pewter. Sugar bowls will be treated in the section on teapots and coffeepots.

8–11. *Left:* Pint basin, 1769–1856, by Samuel Hamlin or Samuel E. Hamlin, Providence, Diam. 5¹³⁄₁₆″ (WM 63.655). *Right:* Two-gallon basin with cover, ca. 1820–30, by Thomas D. and Sherman Boardman, Hartford, Diam. 14³⁄₁₆″ (WM 66.1147).

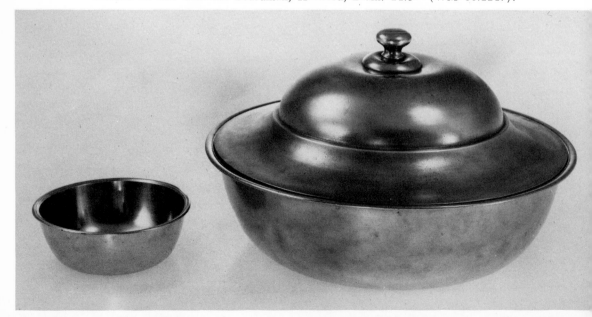

Chapter Nine

Porringers

Porringers are small bowls with flat handles used for eating and drinking. American pewterers made them in great quantity and variety throughout the colonial period, although the majority that survive were made after 1800. Like many other things, pewter porringers were popular in America long after they had gone out of fashion in England; 95 per cent of surviving American porringers were made after 1750, but hardly a porringer made in London after that date is known.

Porringers are sometimes called bleeding bowls, but that name, according to current English usage, should be restricted to examples with a series of rings on the inner surface much like those on a chemist's graduate. No American-made bleeding bowls are known. However, in the 1721 inventory of Richard Estabrooke of Boston, 105 "Blood porringers" were listed at only five and a half pence each—less than half the price of the cheapest porringer. Porringers in four sizes were priced at twelve to twenty pence each. Perhaps blood porringers were the diminutive 2¼-inch-diameter kind that the Richard Lees made.

The word "porringer" appeared first about the middle of the sixteenth century.

Percy Raymond has suggested that the name was derived from "pottenger" or "potenger," from the French word *potager* —"potage" being something cooked in a pot.[1] "Podingers," "eared dishes," and "counterfettes" are other early names used for porringers. Such names were not given up easily. In a shipment of pottery and other goods to John Banister of Newport in 1746, "3 doz white half pint pottingers" at 1s. 6d. per dozen and "2 doz white pottingers" at 1s. 10d. per dozen were listed.[2] Each of these, probably of delftware, cost less than one-fourth as much as the fifty dozen pewter porringers in three sizes in his shipment.

Six different sizes and several varieties of porringers were included in the new schedule of sizes adopted in 1673 by the London Pewterers' Company. There were "great pintes" to weigh 9 pounds per dozen and small pints to weigh 7½ pounds per dozen, "bosses" in six sizes from 7 pounds to 2 pounds per dozen, and "ordinary blood porringers."[3]

The supposition that English and American porringers were for drinking beer, wine, or cider, as well as for eating porridge, soup, or stew, is strengthened by some of their names—"beer pint," "wine

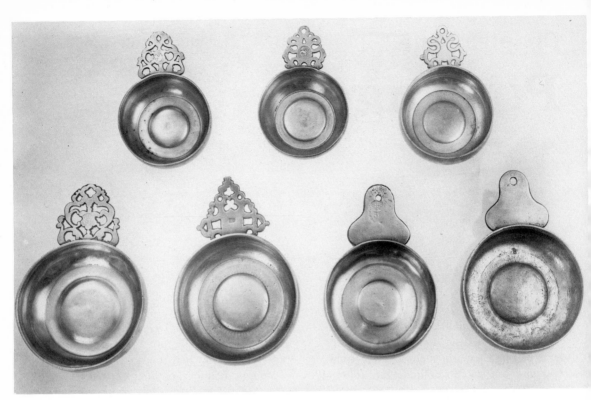

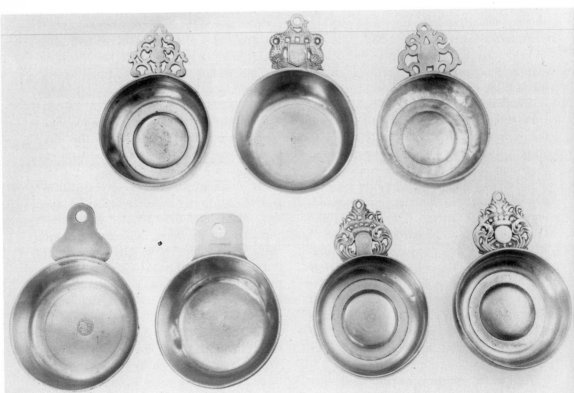

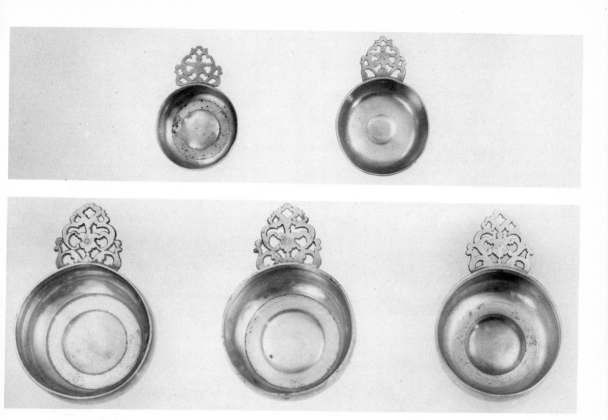

9–1. Porringers.

Opposite page, top (left to right): flowered handle, by William Calder, w. 1817–56, Providence (WM 65.1542); unnamed handle, by Samuel Hamlin, w. 1773–1801, or Samuel E. Hamlin, w. 1801–56, Providence (WM 65.1540); old English handle, by John Bassett, w. 1720–61, New York City (WM 67.1372); flowered handle, by Samuel Hamlin or Samuel E. Hamlin, Providence (WM 58.677); triangular handle, by David Melville, w. 1776–93, Newport, R.I. (WM 56.9.1); plain handle, 1793–96, probably by Thomas Melville for David Melville, Newport, R.I. (WM 67.1374); plain handle by Joseph Belcher, Sr., w. 1769–76, Newport, R.I., or Joseph Belcher, Jr., w. 1776–87, Newport, R.I., or New London, Conn. (WM 60.923).

Opposite page, bottom (left to right): flowered handle, by Josiah Danforth, w. 1821–ca. 1843, Middletown, Conn. (WM 65.2496); dolphin handle, by Samuel Danforth, w. 1795–1816, Hartford (WM 66.1191); old English handle, by Frederick Bassett, w. 1761–1800, New York City and Hartford (WM 65.2499); plain handle, by Thomas Danforth III, w. 1807–13, Philadelphia (WM 67.1373); tab handle, by Elisha Kirk, w. 1780–90, York, Pa. (WM 67.1371); crown handle, by Boardman and Company, w. 1825–27, Hartford and New York City (Gift of Charles K. Davis, WM 56.46.10); crown handle, by William Kirby, w. 1760–93, New York City (Joseph France Fund, WM 58.79).

Porringers with flowered handles.

Above, top (left to right): William Billings, w. 1791–1806, Providence (WM 65.1529); Samuel E. Hamlin, w. 1801–56, Providence (WM 65.1541); *bottom:* Samuel Hamlin, w. 1773–82, Providence (WM 67.1375); Josiah Keene, w. 1801–17, Providence (WM 58.142); William Calder, w. 1817–56, Providence (WM 65.1543).

Porringers/147

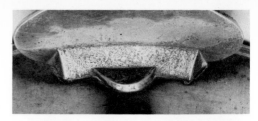

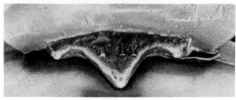

9–2. Porringer handle brackets.
Left (top to bottom): Richard Lee (WM 65.1530); David Melville (WM 56.9.1); Richard Lee (WM 53.16); Thomas Melville (WM 67.1374).
Right (top to bottom): Thomas Danforth (WM 67.1373); Josiah Danforth (WM 65.2496); Boardman and Company (WM 56.46.10); Samuel Hamlin or Samuel E. Hamlin (WM 58.677); Samuel Danforth, Hartford, Conn. (WM 66.1191).

pint," and "gill." Samuel Sewall documents the use of porringers as drinking vessels in his remarks on curing a cold. He wrote on September 11, 1704, "I was threaten'd with my sore Throat, but I went to bed early, . . . pin'd my Stocking about my Neck, drunk a porringer of Sage Tea, upon which I sweat very kindly."[4]

The variety of American porringers is illustrated in Figures 9–1 and 9–2. Their bowls are of two kinds: small basins (Fig. 9–3); and bellied bowls (Fig. 9–4) with a boss or slight dome in the center of a flat bottom. The latter type is normally, though not always, constricted about a quarter of an inch from the top and flares with a straight flange above that point. Both types of bowls were made with several types of handles.

Bowls with boss bottoms were fitted with Rhode Island, Old English, crown, and most other kinds of handles. Two Connecticut pewterers, Edward and Samuel Danforth, preferred basin forms for

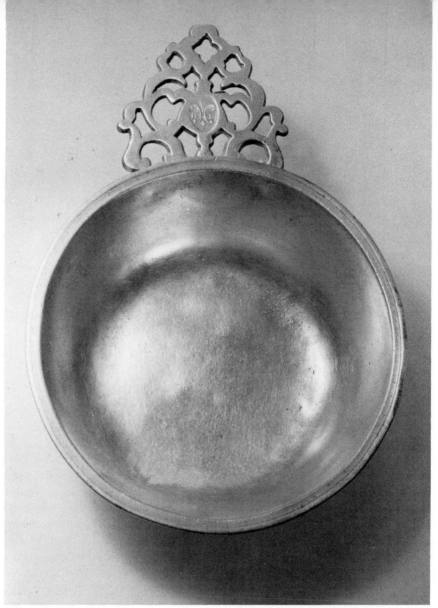

9–3.
Porringer, basin type, 1788–1820, by Richard Lee, Sr., or Richard Lee, Jr., Springfield, Vt., Diam. 5⅞″ (WM 53.16).

9–4.
Porringer with boss-bottom, 1788–1820, by Richard Lee, Sr. or Richard Lee, Jr., Springfield, Vt., Diam. 3⅜″ (WM 65.1530).

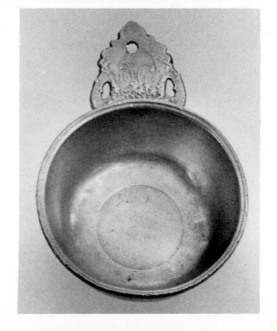

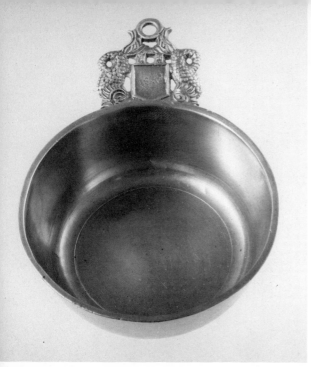

9–5. Porringer with dolphin handle, 1795–1823, by Samuel Danforth, Hartford, Diam. 5³⁄₁₆″ (WM 66.1191).

9–6. Porringer with crown handle, 1760–93, by William Kirby, New York City, Diam. 4⅞″ (Joseph France Fund, WM 58.79).

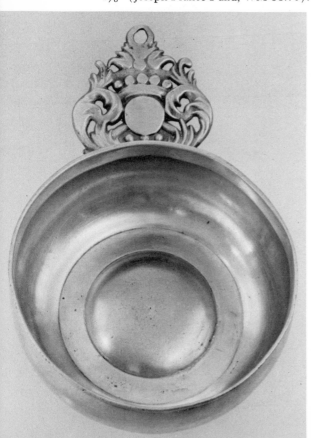

their smallest porringers, as did the Richard Lees. The distinctive, small porringers made by Edward and Samuel Danforth are fitted with Old English handles and are invariably stamped inside the bottom of the bowl, in contrast to the usual practice of marking porringers on the bottom of the handle, before about 1790, and on the top of the handle after that time.

In 1859, a late seventeenth-century English pewter porringer with a handle featuring dolphins was unearthed in Rhode Island from the grave of a seventeenth-century Indian princess.[5] Since that time, half a dozen marked Connecticut basin porringers with similar handles have been found. On their handles, lively dolphins standing on their heads frame a five-sided shield. Their scaly bodies and curled tails give texture and pattern to the design. Some porringers of this kind are marked *I D* with a rampant lion in a circle for John or Joseph Danforth; others bear the mark of Samuel Danforth of Hartford (Fig. 9–5). Still others are unmarked.

Crown-handled porringers also patterned on English models are known with marks of at least thirteen different pewterers working in Boston, Newport, Connecticut, New York, and Pennsylvania (Fig. 9–6). Apparently this was a popular style; but two groups of crown-handled porringers comprise most of the known examples. One large body of tantalizing, unidentified porringers is believed to have been made in Boston and is variously marked with the letters *I C*, *R G*, *S G*, or *W N* cast in relief on the backs of their crown handles. These porringers may have been cast in communally owned molds that passed from one generation of pewterers to another.

Less frequently found are crown-handled porringers made between 1810 and 1830 in the Connecticut shops of Josiah Danforth and by the highly successful brothers Sherman and Thomas

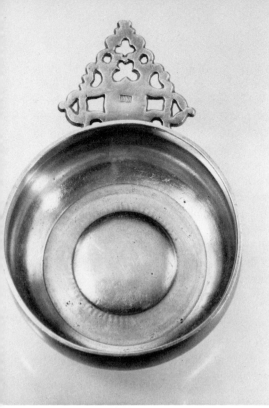

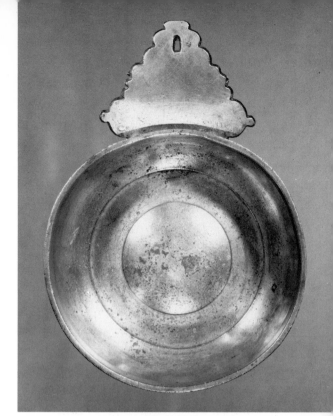

9–7. Porringer with triangular handle, 1779–93, by David Melville, Newport, R.I., Diam. 5⅜″ (WM 56.9.1).

9–8. Porringer with plain handle, attributed to Robert Bonynge, w. 1731–63, Boston, Diam. 5⅜″ (Yale University Art Gallery, The Mabel Brady Garvan Collection).

9–9. Porringer with "old English" type handle, 1720–61, by John Bassett, New York City, Diam. 4⅜″ (WM 67.1372).

9–10. Porringer with heart-shaped handle, probably New England, 1800–1830, Diam. 3⅜″ (Gift of Mrs. Waldron Phoenix Belknap, WM 67.963).

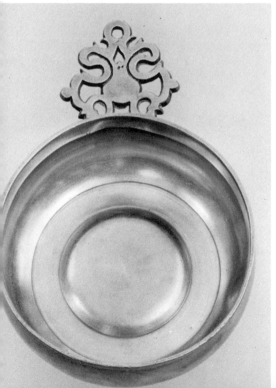

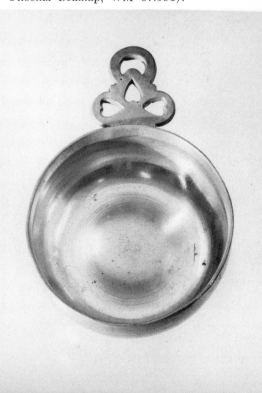

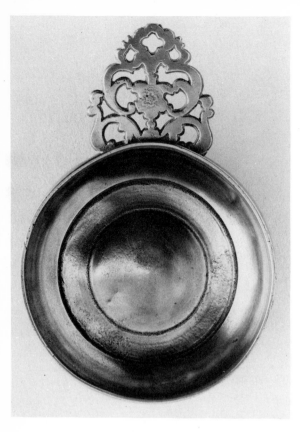

9–11. Porringer with flowered handle (top and side views), ca. 1771–82, by Samuel Hamlin, Providence, Diam. 5⁷⁄₁₆″ (WM 67.1375).

Danforth Boardman of Hartford. Those marked by Danforth were made in a mold owned earlier by Joseph Belcher of Newport and New London. A few with the *I D* and rampant-lion mark of John or Joseph Danforth are also known.

Probably less than half a dozen New York crown-handled porringers are recorded, most of them with the marks of the pre-Revolutionary pewterers Joseph Leddell, Sr. or Jr., and William Bradford. One made by William Kirby in the Leddell mold, possibly as late as the 1790's, is illustrated in Figure 9–6. A single Pennsylvania crown-handled porringer marked by Johann Christoph Heyne has been found.

One of the most popular early eighteenth-century handle styles for pewter porringers in England and for silver porringer styles in New England was the triangular handle containing a pierced trefoil and quatrefoil. Few identified American pewter porringers of this shape survive, one of those being the example by David Melville (Fig. 9–7). An early

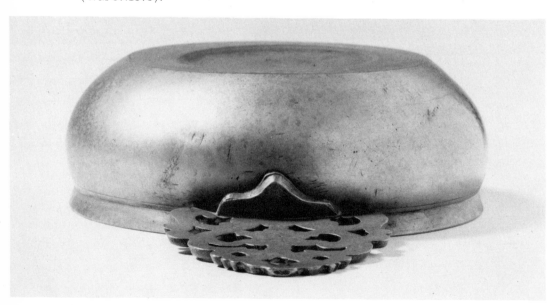

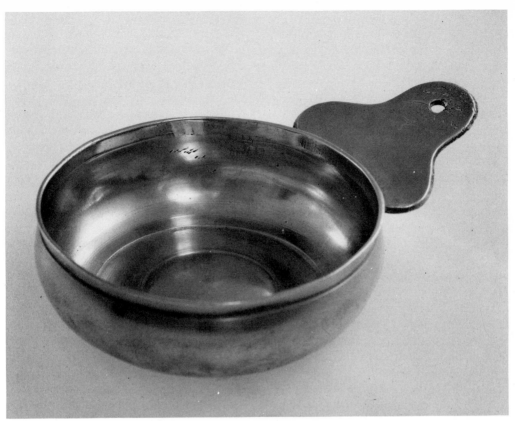

9–12. Porringer with Rhode Island type plain handle, 1793–96, probably by Thomas Melville for David Melville, Newport, Diam. 5″ (WM 67.1374).

unpierced example attributed to Robert Bonynge of Boston may be unique (Fig. 9–8). It vies with another plain-handled porringer marked *B D*, tentatively attributed to Benjamin Day, as the earliest American porringer with a plain handle.

Another type of handle found on American porringers is a close counterpart to English models. So close is one type of handle pierced with hearts and quatrefoil (Fig. 9–9) that Professor Percy E. Raymond named it "the old English handle." This handle style is occasionally found on unidentified porringers with cast initials (*C P* and *W P*) believed to have been made in Boston, Connecticut, and New York. A porringer of this type marked by John Bassett is shown in Figure 9–9. Others, by William Kirby, Peter Kirby, Henry Will, and the Danforths, are also known.

Porringers were made in great numbers in Rhode Island with handle styles so distinctive as to merit the name Rhode Island porringers. Usually, however, the term is reserved for those porringers with handles pierced with thirteen irregular-shaped openings of which the top one is a quatrefoil. These handles exhibit grace and movement with all the liveliness of the rococo that is found in the interlacing of Chippendale chair splats. The old name for these handles—flowered—was discovered by Ledlie Laughlin in the inventory

of David Melville of Newport. There he also found listed a mold for "plain" handles, another kind of Rhode Island handle produced by the Melvilles and Joseph Belcher (Fig. 9–12).

So many porringers survive with one of the Samuel Hamlin marks, used by either the father or the son, that Mr. Laughlin estimates that "there are more Hamlin porringers in existence today than the combined surviving total of marked porringers by all other American pewterers (the Boardmans of Hartford excepted) who dwelt outside the confines of Rhode Island."[6] William Calder was also a prolific maker of porringers. Less common are those of Gershom Jones, William Billings, and Josiah Keene, but all of these pewterers, as well as the Melvilles and the Belchers of Newport and some Connecticut pewterers, made porringers with flowered handles. It has been suggested that Jacob Whitmore of Middletown, Connecticut, was the possible originator of the Rhode Island style handle, and that Hamlin took the molds with him when he left Middletown for Providence in 1771. This may have been the case, but the close similarity of flowered handles found on all large Rhode Island porringers indicates that the molds were made by a single hand employing the same carved wooden forms to make brass castings from which several brass molds were finished. A logical person to have made them is the elder Samuel Hamlin, who advertised the completion of a set of molds in November, 1773.[7]

Regardless of who created the flowered handles, they are among the prettiest forms to be found in American pewter. Equally beautiful, however, are the Newport porringers with plain handles of trefoil outline made by Joseph Belcher and the Melvilles (Fig. 9–12). Although it is possible that the younger Belcher continued to make this style of porringer after he arrived in Connecticut from Newport in 1784, the form seems to have originated in Newport and to have been largely made there. Its lines are perfection and only the best of Queen Anne style chairs can equal the tension and interplay, the echo and re-echo of wavy handle outline and the circular bowl and boss. These most interesting and beautiful American pewter porringers may have been made not only by David Melville and his younger brothers, Samuel and Thomas, but also by his three sons, Thomas, William, and Andrew. All of these men worked as pewterers in Newport—David as early as 1776, the others continuing into the early nineteenth century.

The David Melville triangular-handled porringer (Fig. 9–7) has a 20-ounce capacity—an eighteenth-century "beer pint" —and was probably made in the "beer pint porringer" mold listed in his 1801 inventory.[8]

The combination of makers' marks on the plain-handled porringer (Fig. 9–12) suggests the problems of identification encountered by pewter collectors. Marked with David Melville's beehive-and-star mark, as well as the initials *T M* cast on the handle bracket, this porringer could have been made after David's death by either of the Thomas Melvilles, brother or son of David, who may have continued to use his die stamps. More likely, both Thomas and Samuel, brothers of David, used a mold of their own while they were working as journeymen in David's shop.

A similar plain-handled porringer (not shown) made by Joseph Belcher, or possibly by his son Joseph Jr. before he left Newport for New London, is marked *J:B*, with the initials separated by two dots, a characteristic of the initial marks of Newport pewterers and silversmiths, for whom all dies were probably made by one Newport diemaker.

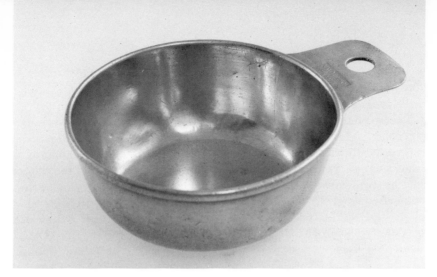

9–13. Porringer with Pennsylvania type tab handle, ca. 1785, by Elisha Kirk, York, Pa., Diam. 5⅜″ (WM 67.1371).

9–14. Pennsylvania type tab-handle porringer mold and castings. The mold was used about 1800 by Samuel or Simon Pennock, Chester Co., Pa. One half is in the collection of the Chester County Historical Society, West Chester, Pa.; the other at The Henry Francis du Pont Winterthur Museum (WM 62.202).

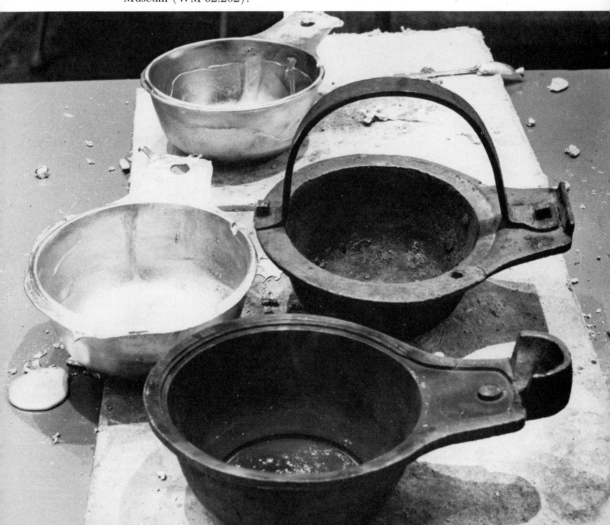

Many plain-handled porringers found in southeastern Pennsylvania are referred to by collectors as tab-handle porringers. Although most of these are unmarked, a high percentage of them are similar to ones marked by Elisha Kirk of York (Fig. 9–13) and Samuel Pennock of Chester County. The two halves of a porringer mold originally used by Samuel or Simon Pennock of East Marlborough Township, Chester County, Pennsylvania, are reunited here (Fig. 9–14).

At first glance, the Pennsylvania tab-handle porringer seems to be related to the Newport type. It appears to have been produced in Pennsylvania by, and perhaps for, Quakers, but its background and method of making are Continental.

In addition to the American porringers detailed here, there are numerous variant American designs, the most innovative of which are several made by the Richard Lees. All of their porringers are appealing, but with the exception of the 6-inch basin porringer, most of the Lee production lacks the finesse and finish of Rhode Island and New York work. Just what the ¼-gill porringers (the smallest porringers normally found) were used for is not known. Several of these only 2¼ inches in diameter have survived that were made by Richard Lee, father or son, who wandered over much of New England before settling in North Springfield, Vermont.

Despite ample evidence of their importation, English porringers are seldom found today in the United States; but when one is found, it usually was made in Bristol after 1750 and bears the mark of Robert Bush, Sr. or Jr., or one of the Bush partnerships. Other Bristol pewterers active in the American trade were Burgum and Catcott and P. Edgar and Son; the latter, under the firm name of Edgar and Curtis, continued in business into the nineteenth century.

Although a few recent imports of English and Continental porringers have been made, it is estimated that at least 90 per cent of the two or three thousand pewter porringers now in American collections were made here. Half of these may be unmarked, but their American makers can often be identified by criteria set forth in a series of tables published in the *American Collector*.[9]

Every old American-made porringer, unless it has been repaired at the handle or is of the tab-handle type, has a linen mark (Fig. 2–15). As described on page 37, this mark of the tinker's dam proves how a porringer handle was fastened to its bowl, and it offers excellent evidence for determining whether a porringer is old or new. The handles of modern pewter porringers—both reproduction and fake—are soldered to the bowl. The soldered edge of the bracket has a soft line, and no linen mark is found.

Other differences in the appearance of antique porringers and modern ones are the result of work on the lathe. Modern porringer bowls are usually spun from flat sheet metal and have a hard, tinny, "metallic feel," as opposed to the sturdier cast bowls of antique porringers whose lips were flared and surfaces smoothed by skimming. As a result, the bottoms of antique porringer bowls often show coarse, spiraled skimming marks and chatter marks that appear as radii when one looks across the bottom toward a light source. Modern porringers, skimmed or spun on metal lathes with precision bearings, show chatter marks that are finer, closer together, and more regular.

Chapter Ten

Spoons and Ladles

Before 1800, large numbers of Americans ate with pewter spoons; however, not more than twenty eighteenth-century pewter spoons by identified makers are known today. This is true partly because spoons are fragile and easily broken and partly because they were seldom marked. Spoons could be easily cast in comparatively inexpensive brass molds from old or worn-out pewter (Figs. 2–9, 10–2). As a result, many spoons were made by tinkers and handy householders, who failed to mark their products or, at most, left now unidentified cast initials. Hence their work, in addition to being short-lived, is anonymous. Further, spoons, being cheap, were not cherished or preserved as were larger or more interesting objects.

Harder to explain is the discrepancy in numbers between the millions of the stronger britannia spoons made commercially each year, in the 1850's and 1860's, and the few hundred that survive today. No answer comes to mind except the fragility and short life of spoons fashioned of tin alloy, whether pewter or britannia.

More clearly than in any other pewter or silver form, the shapes and designs of spoons changed with time and illustrate two maxims of the arts: (1) Each new year and each new era bring new shapes and fashions, and (2) old styles linger on after the introduction of new forms. Hence, at any given time, both new- and old-style spoons were produced.

Stylistically, the forms of American pewter spoons followed the lead of silver spoons, but the decoration of pewter spoons is often highly individual and frequently topical. Many of the handles (Fig. 10–3) are ornamented with a variety of devices such as an American eagle, a liberty cap centered between crossed American flags, or a vine, shells, or a rooster. V-shaped tongues, called rat-tails, extend the line of the handles over the backs of the bowls of the earliest spoons. Rounded drops and shells take the place of the rat-tails on the backs of later spoons (1750–1800).

Flat-stem spoons, called Puritan spoons, with round bowls and straight handles were introduced in England, Holland, and America before 1650 and were the earliest type made in the British colonies. Silver spoons of this form lost their popularity before 1700, but pewter ones were made for another hundred years both in Holland and in New York City, where John Bassett (w. ca. 1720–61) made the tablespoon, now exhibited by the New Hampshire Historical Society (Concord).

10–1. *Hard Metal Spoons to Sell or Change*, plate 20 from John Thomas Smith, *The Cries of London: Exhibiting Several of the Itinerant Traders of Ancient and Modern Times* (London, 1839). (Prints Division, The New York Public Library, Astor, Lenox and Tilden Foundations.)

Two others, almost identical but marked by William J. Elsworth (w. 1767–98) are at Winterthur (Fig. 10–3 *l*), and still another at the Brooklyn Museum bears the mark of William Kirby, who repeatedly offered "soup, table and teaspoons, round-bowl spoons [and] soup ladles" in his advertisements between 1774 and 1788 (Fig. 2–3).[1]

To American pewter collectors, fragments of two pewter spoons, hallowed by centuries of burial at Jamestown, Virginia, are relics in the strictest sense (Fig. 10–5). One of the earliest survivals of American-made pewter is stamped with the maker's name *J*[oseph] *Copeland*, the date he began to make pewter, *1675*, and his place of work, *Chuckatuck*, Virginia.[2] With circular end and ears, it closely resembles mid-seventeenth-century Scottish spoons and a silver death's-head spoon made in York, England, in 1670, a type presented at funerals.[3]

Brass molds for making rat-tail spoons with trifid-end, wavy-end, and mid-rib handles—types introduced, respectively, about 1690, 1700, and 1720—are relatively common, but American marked pewter spoons of these types are almost nonexistent. A trifid-end spoon marked *I B* in a rectangle (Fig. 10–3 *k*) may be American, but the pewterer's name is now lost. Of the mid-rib type, no identified example with rat-tail is known, and the maker of but a single, small mid-rib teaspoon with lacy shell on the back of the bowl is established by a cast flourish on the handle that reads *R. Lee* (Fig. 10–6 *a*). Presumably, this is the work of the senior Richard Lee, peripatetic pewterer of Massachusetts, New Hampshire, and Vermont. Except for this example and one reported to have been made by William Will, seventeenth- and eighteenth-century teaspoons are known only by molds and by unidentified specimens. These, however, show that the earliest pewter teaspoons, like their silver counterparts, were

smaller than nineteenth-century examples. Another small spoon with simulated bright-cut edging and tiny flowers on the handle. (Fig. 10–6 *b*) is also marked *R. Lee*. Whether made by the father or the son is not known, but certainly these two spoons and the William Will teaspoon cited above are the earliest identified American pewter teaspoons. All were probably made before 1810.

Six other extraordinary survivals made in William Will's Philadelphia shop are preserved in the Winterthur collection (Fig. 10–7). Only four are stamped with his mark, but all have the same owner's initials, "H * S" or "S * H," engraved with wriggled lines in Continental fashion, and each is finished on the back with the same shell-like rococo scroll.

Another eighteenth-century tablespoon marked by Thomas Danforth III was found under the ell of the Buttolph-

10–2. Brass spoon molds (*clockwise, from bottom left*):

Seventeenth-century style mold for spoon with straight flat handle and round bowl, used from ca. 1700 until the 1790's in America and possibly England, L. 7⁷⁄₁₆″ (WM 55.58.4).

Two-part mold for spoon with mid-rib handle and shell on back of oval bowl, 1750–1800, probably America, L. 4¾″ (WM 58.675).

Mold with wooden handles for spoon with fiddle-back handle and oval drop on back of pointed bowl, stamped "1841", L. 9⅛″ (WM 55.621).

Two-part mold with wooden handles for spoon with wavy-end handle and oval bowl, 1700–1740, probably America, L. 7⅞″ (WM 55.620).

Brass spoon mold, 1760–1800, America, L. 5⅜″ (WM 65.1832).

Seventeenth-century style brass spoon mold, probably used until the 1790's, England or America, L. 7″ (WM 56.51.7).

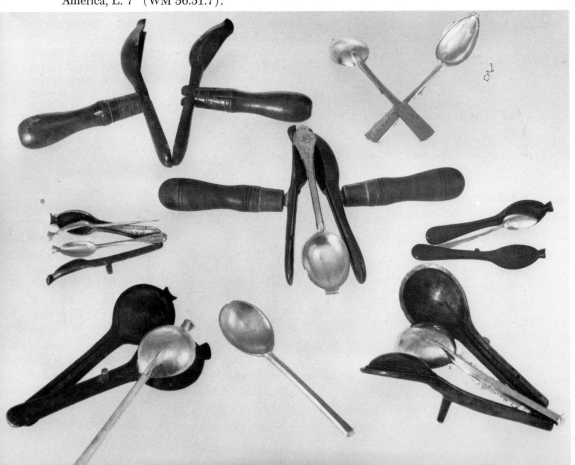

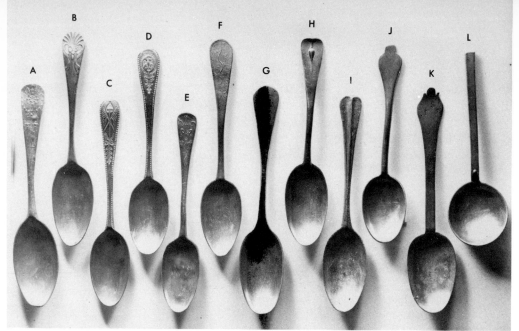

10–3. Tablespoons *(left to right)*:

(*a*) Neoclassical type with sunburst-like design and rooster cast in relief on face of flat back-turning handle, 1780–1800, probably America, L. 8�5/16″ (WM 53.90). (*b*) Neoclassical type with flat back-turning handle. 1780–1800, possibly America, L. 7¹⁵/16″ (WM 63.121). (*c*) Neoclassical type, inscribed "Peace & Amity" on face of flat back-turning handle, 1787–1811, by George Coldwell, New York City, L. 7¾″ (WM 65.2491). (*d*) Neoclassical type, inscribed "Federal Constitution, Liberty, and Peace" on face of flat back-turning handle, 1787–1811, by George Coldwell, New York City, L. 7⁹/16″ (WM 63.55). (*e*) Neoclassical type with flat back-turning handle, large shell-like motif on back of bowl, 1780–1810, probably America, L. 7½″ (WM 53.89). (*f*) Neoclassical type, square drop on back of bowl, 1780–1810, probably America, L. 8″ (WM 53.14). (*g*) Neoclassical type with flat back-turning handle, rococo scroll on back of bowl, 1782–98, one of six by William Will, Philadelphia, L. 8½″ (WM 58.666). (*h*) Hanoverian mid-rib type, double drop on back of bowl, 1750–70. America or England. L. 7⁵/16″ (WM 65.2466). (*i*) Hanoverian mid-rib type, "rat-tail" on back of bowl, 1710–50, America or England, L. 8¹/16″ (WM 65.2490). (*j*) Wavy-end type, 1700–1740, America or England, L. 7¼″ (WM 65.2463). (*k*) Trifid-end, late seventeenth-century type, 1690–1720, marked "I B," America or England, L. 8⅝″ (WM 65.2464). (*l*) Puritan or "round bowl" type, 1767–98, by William J. Elsworth, New York City, L. 7¹/16″ (Joseph France Fund, WM 61.113).

10–4. Backs of spoons in Figure 10–3.

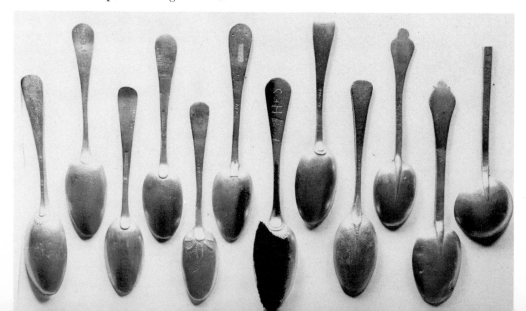

Williams House in Wethersfield, Connecticut, when the house was restored by the Antiquarian and Landmarks Society.[4]

The most elegant American pewter spoons were made by George Coldwell, listed in the 1789 directory of New York, where he probably worked until his death in 1811. Spoons of two different designs by him feature handles outlined with simulated bright-cut engraving that frames historical motifs at the upper end of the handle. On one with the motto "Peace and Amity," a liberty cap is handsomely displayed between crossed thirteen-star American flags (Fig. 10–3 c). On the other an American eagle with the words

About that time, Liverpool potters ornamented their jugs with American patriotic and historical transfer prints, and later (1820–50) Staffordshire potteries produced millions of plates, dishes, and platters in many different colors and of every conceivable sort, some with state seals and national figures and hundreds of others with local scenes, such as the Pittsfield elm, the Boston Common, and the Erie Canal. Between 1820 and 1840, when the marketing of these historical wares reached a peak, English britannia makers produced great numbers of fiddleback tablespoons and teaspoons (Figs. 10–8 a, b, c; 10–6 g, h, i, j, k) deco-

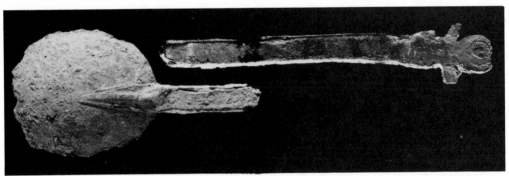

10–5. Parts of two identical spoons, 1675–91, by Joseph Copeland, Chuckatuck, Va., Diam. of bowl 2⅛", L. of handle 5½" (courtesy Worth Bailey and the National Park Service).

"Federal Constitution" expresses national pride and satisfaction in the adoption of the Constitution (Fig. 10–3 d). In addition, "Liberty" and "Peace" further reflect the aspirations of the American people.

Though Coldwell may have been the first pewterer to attempt to increase his sales with a nationalistic appeal, he followed the tradition of artists and printmakers. Shortly after the Revolution, English and French textile manufacturers printed cottons also for the American market glorifying Washington, Franklin, and other national figures.

rated with oversized eagles on their handles. Until recently many of these spoons could be found in Pennsylvania antique shops with the marks of John Yates, a Birmingham, England, britannia maker.

As with earlier spoons, few American fiddle-back spoons of 1810–30 survive; therefore, a spoon mold in the Winterthur collection and a fiddle-back spoon cast long ago are of special interest—both are inscribed "P. Derr" (Fig. 10–8 d). The spoon mold, dated "1841," was made for spoons of similar style a generation

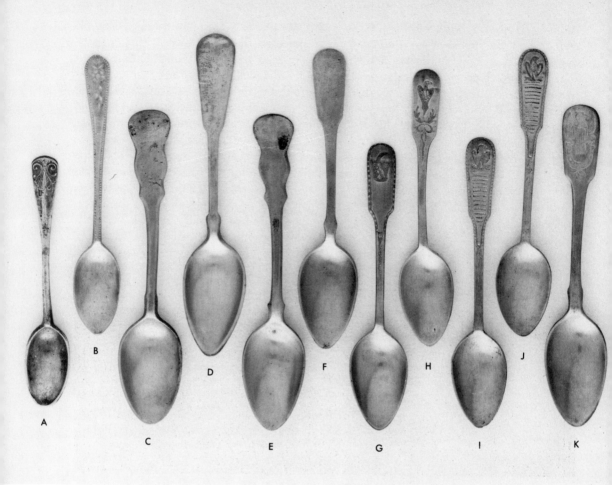

10–6. Mid-to-late eighteenth- and early nineteenth-century teaspoons (*left to right*):

(*a*) Mid-to-late eighteenth-century type, Springfield, Vt., L. 4¼". "R. Lee" cast in relief on back of forward-turning handle (WM 56.11.3).

(*b*) Neoclassical, late eighteenth-century type, with cast "bright cut" and floral decoration, marked "R. Lee," L. 4¾" (WM 60.101).

(*c*) Fiddle-back, 1820–40 type, with incised "J. Weekes" mark, New York City, L. 5⁵⁄₁₆" (WM 65.2790).

(*d*) Fiddle-back, 1820–40 type, with "John Yates" mark, Birmingham, England, L. 5½" (WM 65.2787).

(*e*) Fiddle-back, 1820–40 type with "Jⁿᵒ Yates" hallmark-like mark, Birmingham, L. 5⁵⁄₁₆" (WM 65.2791).

(*f*) Fiddle-back, 1820–40 type, with "I Yates" mark, Birmingham, L. 4¹³⁄₁₆" (·WM 65.2772).

(*g*) Fiddle-back, 1820–40 type, with intaglio eagle on face, "Jⁿᵒ Yates" mark, Birmingham, L. 4⅞" (WM 65.2766).

(*h*) Fiddle-back, 1820–40 type, with intaglio eagle on face, "Jⁿᵒ Yates" mark, Birmingham, L. 4¹¹⁄₁₆" (WM 65.2764).

(*i*) Fiddle-back, 1820–40 type, with intaglio eagle on face, marked "Whitehouse," America[?], L. 4¹⁵⁄₁₆" (WM 65.2793).

(*j*) Fiddle-back, 1820–40 type, with intaglio eagle on face, "I Yates" mark, Birmingham, L. 5⅛" (WM 65.2792).

(*k*) Fiddle-back, 1820–40 type, with intaglio eagle on face, probably Birmingham, L. 5⅝" (WM 65.2785).

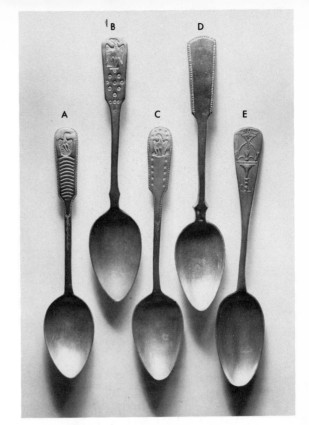

10–7. Tablespoons, 1782–98, by William Will, Philadelphia, L. 8⅜″ (WM 58.665-670). Rack, painted tulip wood, probably Hudson Valley, ca. 1750–80 (WM 59.2813).

10–8. Tablespoons *(left to right)*:
(*a*) One of six, with punched or cast decoration on fiddle-back handle, ca. 1800–1830, by E. Whitehouse, England, L. 8″ (WM 65.1688.4).
(*b*) One of three, with punched or cast decoration on fiddle-back handle, ca. 1800–1840, probably by James or John Yates, Birmingham, England, L. 8⅜″ (WM 65.1690.1).
(*c*) One of two, with punched or cast decoration on fiddle-back handle, 1800–1840, by T. Hill, England, L. 8¹⁄₁₆″ (WM 65.1689.2).
(*d*) Fiddle-back handle with "P/Derr/1820" on back, probably Berks County, Pa., L. 8⁷⁄₁₆″ (WM 65.1695).
(*e*) Neoclassical type, with cast urn on face of handle, ca. 1800–1850, America, L. 8¼″ (WM 65.1694).

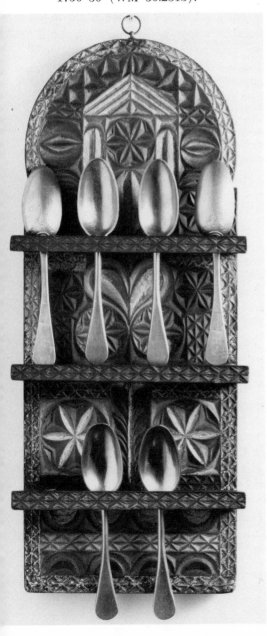

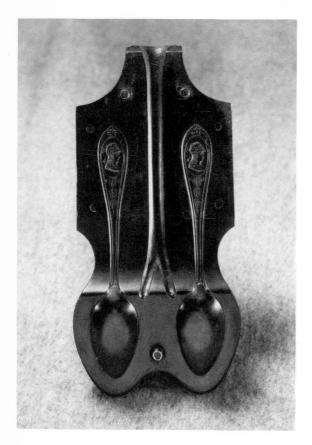

later. Both came from descendants of Peter Derr, who was a well-known nineteenth-century coppersmith in Reading, Pennsylvania, and the maker of highly prized copper betty lamps and other lighting devices.

Beginning in the late 1820's and continuing into the 1870's, the making of britannia spoons became a big business. During these fifty years, great improvements were made and patents issued for stronger spoons of many designs. Brass molds were supplanted by ingenious iron molds permitting the inclusion of a piece of hard iron wire to strengthen the thin handle. Such spoons were usually stamped *wired* and were advertised in the 1867 catalogue of the Meriden Britannia Company, where other spoons, of unknown treatment, were listed as "metallic strengthened." In that catalogue, at least fourteen spoon patterns "warranted to be of a finer and firmer metal, and better finished than anything of the kind produced in this country," were offered at prices from $6.25 to $21.00 per gross, depending upon the intricacy of design and whether they were small teaspoons or large tablespoons. Most designs offered in silver plate cost approximately twice as much. A "metallic strengthened" Grecian pattern teaspoon, for example, cost $11.13 per gross, if of britannia, versus $21.00 per gross in silver plate. The "wired" Olive pattern was advanced from $22.13 for britannia to $38.00 for plate (about twenty-seven cents each).

Among the Connecticut leaders in the manufacture of britannia spoons was William Mix, who in 1827 started what was to become a large manufactory in Prospect. Later his nephews William and Gary I. Mix also became prominent manufacturers, as did his one-time apprentices Robert Wallace and Charles Parker.

According to the 1860 census, another Charles Parker was then producing 26,000 gross of britannia spoons per year in

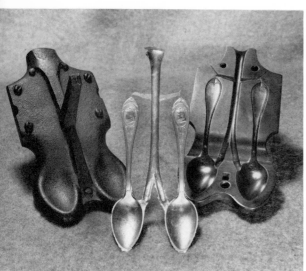

10–9. Iron spoon mold for casting two spoons at the same time, patented in 1870 by Luther and Norman S. Boardman, East Haddam, Conn., L. of spoons, 5¾" (collection of William F. Kayhoe).

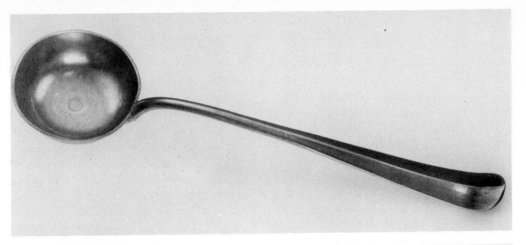

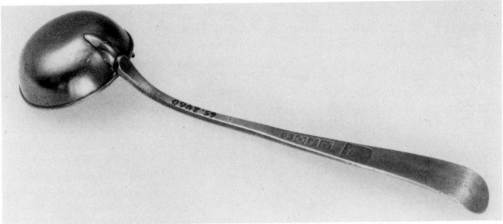

10–10. Ladle (front and back views), 1775–
95, by Peter Young, New York City
or Albany, L. 16″ (WM 65.2460).

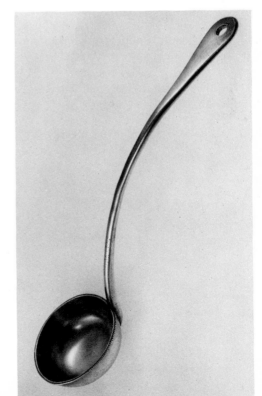

10–11. Ladle, 1785–98, by William Will,
Philadelphia, L. 15″ (WM 58.664).

Spoons/165

Meriden, exceeding the 18,000 gross output of Luther Boardman located in East Haddam at that time. Illustrated in Figure 10–9 is an iron spoon mold patented in 1870 by Luther Boardman and his brother Norman that enabled the maker to double production by casting two spoons at a time. It is the writer's supposition that a large portion of these more than 6 million spoons, as well as those made by many companies in the Meriden-Wallingford area, were marketed through the agents and the catalogues of the Meriden Britannia Company, which eventually emerged as the International Silver Company. This development points up the increasing sophistication and finesse of broad-scale marketing that matched the great advances in American industrialization, more often thought of in terms of improved production techniques.

As might be expected, the designs of ladle handles followed those of spoons. However, the earliest known ladle design in American silver or pewter is the type introduced about 1710 with a mid-rib on the forward-turning handle and a rat-tail on the back of the bowl. The only known pewter example of this type is an extraordinary specimen in fine condition with six different marks (four of them hallmarks) of Peter Young (w. 1785–95) (Fig. 10–10 *a, b*). Stylistic successors to Young's handsome ladle are a few of late eighteenth-century form with back-turning handles marked by William Will (Fig. 10–11) and the Boardmans. Whereas eighteenth-century ladles, like pewter spoons, are rare, nineteenth-century ladles with fiddle-back handles are known by at least seven makers, the most common being the ladles of Lewis Kruiger and J. H. Palethorp (Fig. 10–12), both of Philadelphia, and Josiah Danforth of Middletown, Connecticut.[5]

The well-turned wooden handles of a half dozen ladles with basin-shaped bowls stamped with the mark *R. Lee* (Fig. 10–13) are reminiscent of eighteenth-century design and, although proof is lacking, may be the work of the senior Richard Lee. Equally attractive, but somewhat

10–12. Ladle, 1820–45, by John Harrison Palethorp, Philadelphia, L. 13½" (WM 60.1081).

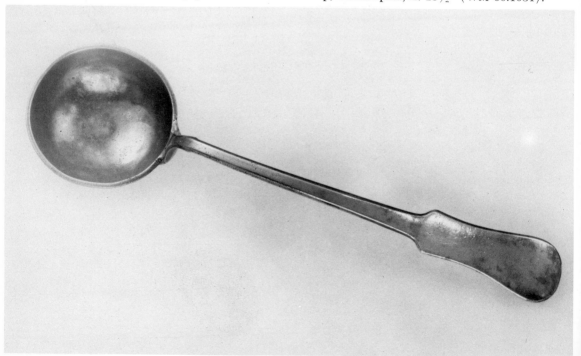

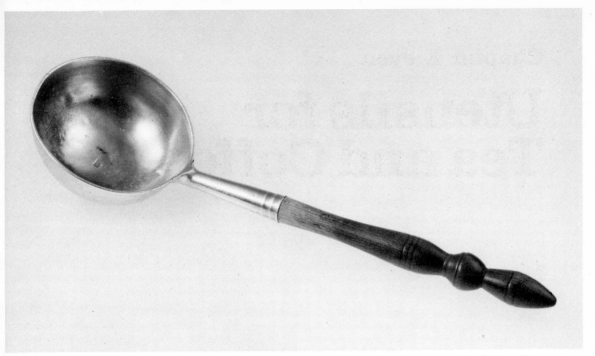

10–13. Ladle with wooden handle, 1788–1820, by Richard Lee, Sr., or Richard Lee, Jr., Springfield, Vt., L. 12″ (WM 66.1189).

10–14. Ladle with wooden handle, ca. 1818–ca. 1825, by S. Stedman, Hartford, L. 14⅛″ (WM 65.1462).

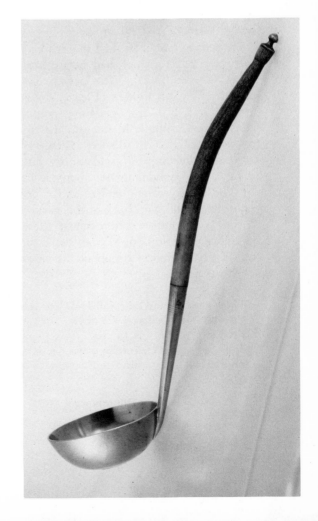

later in style, are brass ladles and skimmers that were made by the younger Richard Lee, though possibly by his father as well.

Many handsome later ladles with curved, turned wooden handles survive and were probably produced in large numbers. Some, distinguished with an urn-shaped turning at the end of the handle, are stamped *S. Stedman* (Fig. 10–14) on the handle, where it fits into the pewter socket. These were patented in 1818 by Simeon Stedman, brother-in-law of the Boardmans, and a cabinetmaker by trade. Presumably he made his ladles in Hartford from that time until 1825, when he moved to Springfield, where he is believed to have remained until his death in 1842.

Chapter Eleven

Utensils for Tea and Coffee

After 1825, the manufacture of teapots and coffeepots became a major activity of the American pewterer and britannia maker. Pots of many sizes and shapes from half-gallon capacity to toy tea models were offered by at least twenty-five American producers, and the drinking of tea and coffee, which had begun long before, became the rage. The large teapot made by William Calder (Fig. 11–1) is a form that J. B. Kerfoot calls the "pouter pigeon" shape. Similar in shape is the toy tea set attributed to Roswell Gleason's shop in Dorchester, Massachusetts, and given to his granddaughter about 1850.

The history of tea, coffee, and chocolate in England goes back to the middle of the seventeenth century when these beverages were introduced from the East. John Evelyn, reminiscing about his years at Oxford, notes:

There came in my time [1637–41] to the College one Nathaniel Conopios, out of Greece. . . . He was the first I ever saw drink coffee; which custom came not into England till thirty years after.[1]

Twenty years later (September 25, 1660), Samuel Pepys commented in his dairy: "I did send for a cup of tee (a China drink) of which I had never drunk before."[2]

Introduced with these new drinking customs were utensils for their preparation—tea cups or dishes, as they were sometimes called, coffee cups, sugar bowls, milk jugs, teapots, coffeepots, chocolate pots, and tea canisters, and soon thereafter, tables made especially for the service and ceremony of tea drinking.

According to J. H. Buck in *Old Plate, Its Makers and Marks*, "These beverages were not long in reaching New England, for in 1670 'Mrs. Dorothy Jones is approved of to keepe a house of publique Entertainment for the selling of Coffee and Chuchaletto.' "[3] Tea was also specified in the franchise of Benjamin Harris and Daniel Vernon of Boston when they were licensed to sell "Coffee, Tea and Chucaletto" in 1690,[4] and it appears that these drinks were served in public houses before their adoption in the home.

According to Alice Morse Earle, "Green and bohea teas were sold at the Boston apothecaries in 1712,"[5] and for many years thereafter tea was dispensed like medicines. On May 24, 1714, Edward

Mill of Sudbury Street, Boston, advertised coffee in addition to "very fine green tea, the best for color and taste."[6]

The drinking of these beverages grew steadily in favor, and by 1750 Israel Acrelius, author of the *History of New Sweden* (Delaware), observed that "Tea, coffee, and chocolate are so general as to be found in the most remote cabins, if not for daily use, yet for visitors, mixed with Muscovado, or raw sugar."[7]

One anonymous writer suggested that coffee was not always made in coffeepots but was only served in them. He says that after roasting the beans over a charcoal fire in a "chaffendish," grinding them, and boiling the coffee in water for four or five minutes,

> There are nice people who . . . pour it clear from its grounds into a silver, or other coffee pot. And taking red-hot tongs from the fire, melt between them, over the liquor of coffee, two or three large nobs of sugar, which drop from the tongs into it; then they extinguish the tongs themselves in it afterwards. This ceremony gives it, it must be confessed, an admirable flavour and most agreeable taste.[8]

11–1. Teapot, ca. 1830–50, by William Calder, Providence, H. 9⅛″ (WM 53.30). Child's tea set, 1830–50, attributed to Roswell Gleason, w. 1821–71, Dorchester, Mass. H. of sugar bowl 2⅞″; of milk pot 9⁹⁄₁₆″; of slop bowl 1⅞″; of teapot 3⅞″; Diam. of teacup 1⅜″; of saucer 2″ (WM 65.1679–.1683).

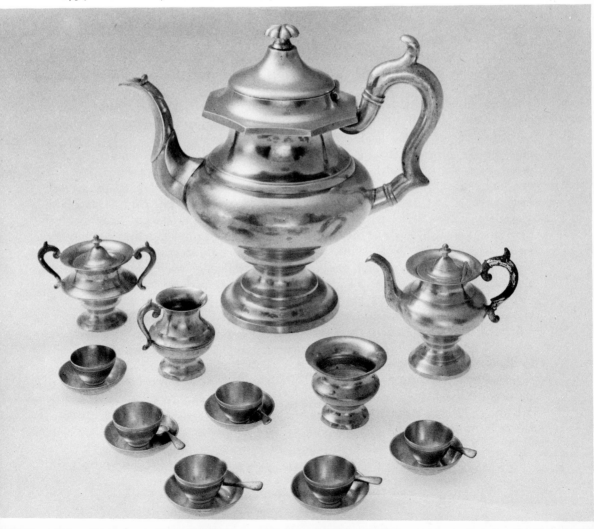

At first porcelain and pottery teapots, either made in China or modeled after Chinese ones, were used; but before 1700, English silversmiths were making them, and cabinetmakers followed suit with special tables. American tea tables of the 1730's and 1740's in the Queen Anne style are fairly common, and one Winterthur table in the William and Mary style was possibly made before 1725.

At his death in 1729, William Burnet, Royal Governor of Massachusetts, owned two tea tables—a "plain" one valued at twenty-five shillings and a "japanned" one listed at forty shillings.[9] The governor's paraphernalia for serving tea and coffee was extraordinary for that date in America: two silver coffeepots and one teapot, a pair of tea tongs, six "Gilt" teaspoons, a pair of tongs and a strainer, a "Red China Teapot & Oval stand" at thirty shillings each, "6 cups & 5 Saucers Blue & White China" at twenty shillings each, "12 Saucers & 12 Cups burnt China," two teapots, one with a silver spout, two stands, two milk pots, a sugar dish and cover.[10]

Pewter tea kettles, although commonly made in France, Holland, and Germany, are rarely found in England and were probably not made in America. Instead, most Americans used locally made cast-iron and copper tea kettles. However, at least three eighteenth-century American silver tea kettles are known: One by Cornelius Kierstede for the de Peyster family was probably made before 1725; another tea kettle with stand by Jacob Hurd for the Lowell family, about 1730; and a third, a rococo-style kettle and stand of the 1760's, made by Joseph Richardson of Philadelphia. An early Virginia reference to tea-kettle ownership is found in the June, 1719, inventory of Edmund Berkeley for "one silver Tea Kettle, 1 silver Tea Pot and Lamp."

Early eighteenth-century silver chocolate pots made by John Coney and Edward Winslow of Boston are among their handsomest products, but no pewter chocolate pots, either English or American, have been recognized, and references to either their manufacture or use are unknown.

Unquestionably, teapots were made in America prior to 1742, the date of Simon Edgell's inventory, which included 125 pewter teapots at four shillings each. Pewter vessels usually followed silver forms in the eighteenth century, just as European and English silver tea vessels followed Oriental ceramic forms. Hence, it is not surprising that the earliest American pewter teapots are closely related to English and American silver and to Chinese porcelain teapots.

The fine round or ball-shaped teapot (Fig. 11–2) and another from the same mold are probably the earliest American pewter teapots.[11] The round, spherical form, unknown in English pewter, approximates that of the earliest known American silver teapot made in New York City between 1705 and 1710 by Jacob Boelen and engraved with the arms of the Philipse family (in the Metropolitan Museum of Art). A fine teapot of this shape (probably of silver) appears in the picture of Susanna Truax painted about 1730 by a Hudson Valley limner.[12]

The history of the round pewter teapot suggests New York City as its place of origin, and the thicker-than-usual metal and the broad band that ornaments the neck are in accord with New York practice. Although such broad bands are frequently found on New York mugs and tankards, they are not exclusive to New York pewter. This pot was found in the 1940's in the possession of a New Jersey family that had long owned it and a John Bassett New York porringer. This may be the form of teapot mentioned in a 1745 invoice to the Newport merchant John Banister as two "old shaped" teapots. In the same bill, Banister was also charged

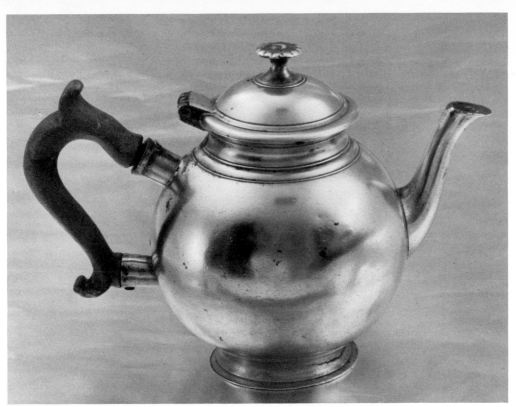

11–2. Round teapot, ca. 1740–60, probably New York, H. 6¼″ (WM 67.1370).

11–3. Teapot, 1752–85, by Cornelius Bradford, New York City or Philadelphia, H. 7¼″ (WM 65.2500).

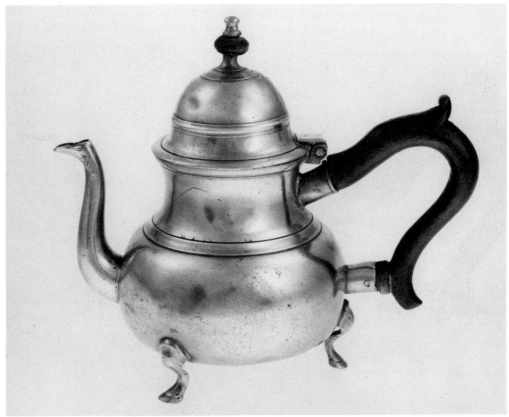

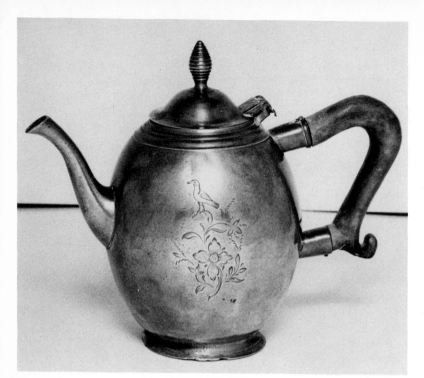

11–4. Teapot, 1761–1800, by Frederick Bassett, New York City, H. 7″
(from the collection of the New Haven Colony Historical Society).

11–5. Teapot, 1764–98, by William Will, Philadelphia, H. 6¾₁₆″ (WM
61.1680).

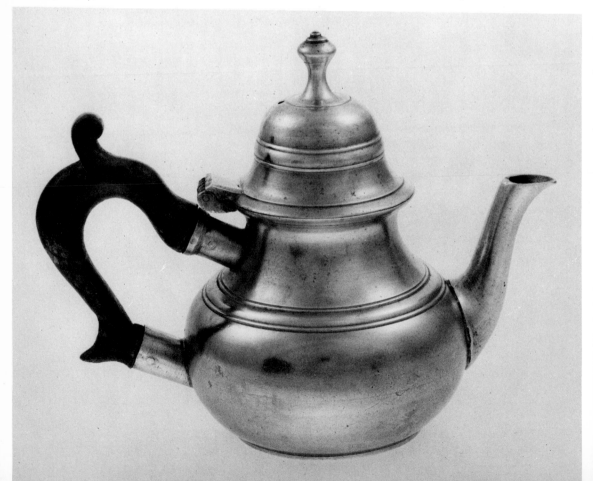

for two otherwise unidentified "turnip shaped" pottery teapots, which accurately describes the exquisite pear-shaped teapots produced in New York as early as 1715 by Peter Van Dyke and others. Pear-shaped teapots, and similar pitchers, rival flat-top tankards in harmony of design. The outlines of the former follow the S curve, the basic line of the Queen Anne style lauded in William Hogarth's *The Analysis of Beauty*. But long before that publication (1753), silver pear-shaped teapots and cream pitchers were introduced and widely made in England and America. So popular was the style that it remained in vogue for a long time thereafter. For example, Myer Myers of New York made silver pots of this kind through the 1760's, and American pewterers and britannia makers continued the style through the early years of the nineteenth century.

Shown in Figure 11–3 is probably the earliest marked American pewter teapot.[13] With the mark of Cornelius Bradford, it was in all likelihood made in his Philadelphia shop between 1753 and 1770. In 1770, he left Philadelphia for New York, where he was to achieve distinction as a "steady patriot during the arduous contest for American liberty."[14] The S-shaped cabriole legs and pad feet, reminiscent of those found on furniture in the Queen Anne style, might suggest that pewter teapots with legs were popular, but the Philadelphia merchant, Daniel Wister, repeatedly stipulated in his orders of the 1760's to John Townsend of London to send teapots without legs.[15]

English eighteenth-century pewter teapots are scarce, and only about thirty-five marked American examples are known. In addition to the two unmarked round teapots mentioned above and three by Cornelius Bradford (of which two are unmarked), there are single pear-shaped examples by Thomas Danforth III of Stepney, Connecticut, and William Kirby of New York, and twenty-one from William Will's shop in Philadelphia. Of the latter, fourteen are pear-shaped in two sizes, five with cabriole legs and claw-and-ball feet, nine in three sizes without feet (Figs. 11–5, 11–7), and seven are drum-shaped in three sizes (Fig. 11–8 left). Other eighteenth-century teapots currently known include at least three oval ones of unique form made by Frederick Bassett (Fig. 11–4) or, in one case, possibly by the younger Francis Bassett. Two or three drum-shaped pots, like those made by Colonel Will but bearing Parks Boyd's mark, are known. Presumably Boyd acquired Will's molds after the colonel's death in 1798.

William Will made at least three different models of teapots during his career, the pint example (Fig. 11–5) being in his earliest style. Its broad bands, high-domed cover, and ball-shaped finial are early features found on at least two sizes of this version, both of which occur with and without cabriole legs and claw-and-ball feet (Fig. 11–6). Especially to be noted are the pewter finials that Will used instead of the wooden ones normally found on eighteenth-century teapots. The disc shape of the finial in Figure 11–7 and the beading on both finial and cover indicate a date after 1785 for this teapot of one-quart capacity. Beading, like the urn and the drum shape, is part of the neoclassical vocabulary widely used in England on all kinds of objects after about 1770. It is found not only on English pewter teapots but also on Philadelphia- and Connecticut-made objects as well, being easily accomplished by rolling a knurling tool around exposed edges.[16]

Just when William Will introduced his drum-shaped teapots (Fig. 11–8 left) and urn-shaped coffeepots and flagons is not known, but it is assumed that these new-fashioned vessels were introduced about

1787, when William Kirby advertised "straight and round" teapots in quart and 1½-pint sizes, and concurrent with the introduction of federal or neoclassical furniture styles.[17]

Study of the drum-shaped teapot (Fig. 11–8) reveals several subtle relationships. Its silhouette is like that of Chinese export porcelain teapots brought back to the United States with tea sets in the 1790's and the early 1800's. The simi- larity of its beaded disc finial to that on the quart teapot (Fig. 11–7) and the sugar bowl (Fig. 11–9) suggests that all were made about the same time, but the style of Will's drum teapot is entirely new and neoclassical in contrast to the sugar bowl, whose bulging contours re- mind us of silver made in the 1760's and 1770's by such celebrated Philadelphia silversmiths as Joseph Richardson and Philip Syng. Its form is rococo, but its

11–6. Teapot, ca. 1764–98, by William Will, Philadelphia, H. 8″ (courtesy of The Brooklyn Museum).

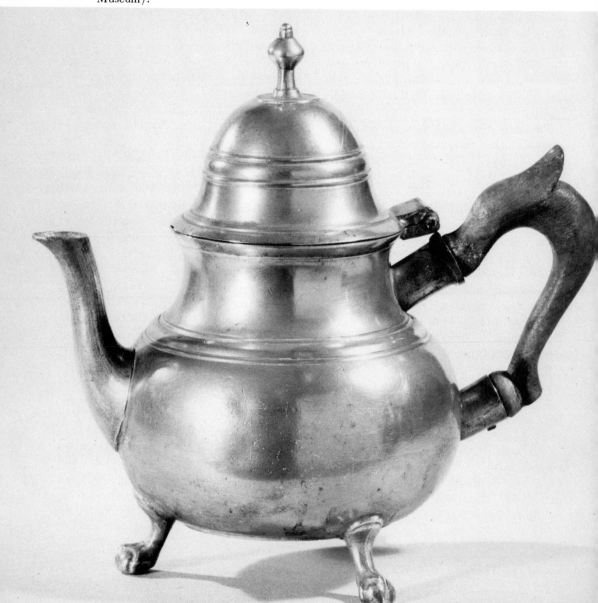

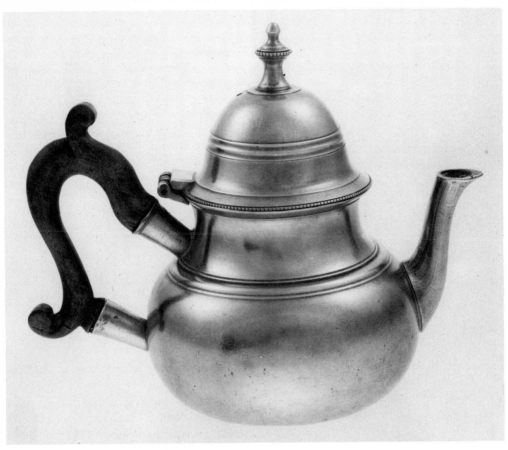

11-7. Teapot, 1785–98, by William Will, Philadelphia, H. 7¼″ (WM 58.657).

11-8. Drum-shaped teapots. Left, ca. 1785–98, by William Will, H. 6⅜₆″ (WM 58.656). Right, ca. 1813–ca. 1856, by Israel Trask, Beverly, Mass. (formerly in collection of Mrs. Stephen S. FitzGerald).

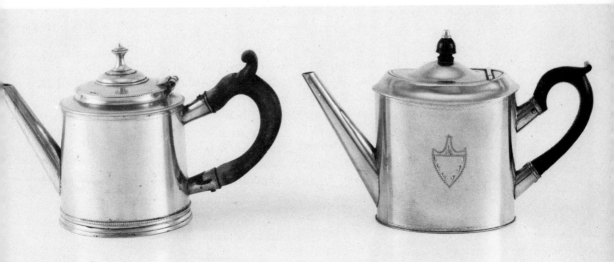

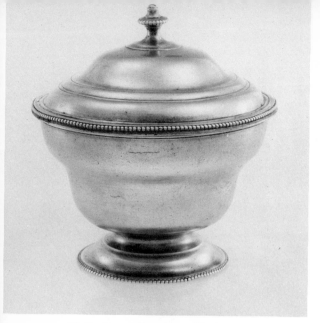

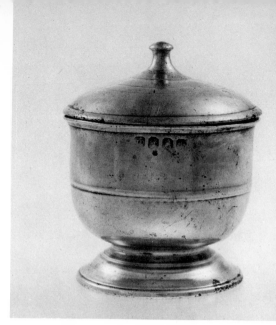

11–9. Covered sugar bowl, attributed to William Will, w. 1764–98, Philadelphia, H. 4¹³⁄₁₆″ (WM 58.999).

11–10. Sugar bowl, ca. 1777–90, by Thomas Danforth III, Stepney, Conn., H. 3¹⁵⁄₁₆″ (WM 65.1622).

ornament is neoclassical. In its own time, this form was called "double bellied." By 1790, it was old-fashioned. It is even more surprising to find that the Queen Anne style teapot (Fig. 11–7) also has neoclassical ornament. This sugar bowl and the teapot illustrate the conservative strain in Americans who clung to traditional forms but gave them a touch of fashion with new-style ornament.

Comparison of the two teapots in Figure 11–8 reveals further contrasts between the old and the new. The sturdy Will teapot on the left is the new drum-shaped form with new ornament made in the traditional way by casting. The teapot on the right is an oval version of the drum teapot made of thin rolled sheet metal shaped around a form with a vertical join. In its bright-cut decoration, use of sheet metal, and seamed construction, it is related to silver teapots of the 1790's. As yet the relationships between its maker, Israel Trask, the silversmith-trained britannia maker of Beverly, Massachusetts, and Philip Lee and an unidentified Mr. Creesy

of the same town are not known, but they were undoubtedly close.

Earlier in form is a handsome small sugar bowl that Thomas Danforth III made in two sizes from 1777 to about 1790. The smaller version is illustrated in Figure 11–10. Invariably these bowls are marked on the side with Danforth's small hallmarks. The earliest surviving American pewter sugar bowls were made by Johann Christoph Heyne, and one of his finest examples is to be seen in the Brooklyn Museum collection. Other early sugar bowls are known by the Pennsylvania pewterer or pewterers who used the *Love* touch.

Many pear-shaped teapots continued to be made in the early 1800's and are easily recognized as late versions of the Queen Anne style. Although made in the traditional pear shape, their lines are looser and their metal is harder and thinner. They are always fitted with metal handles and disc finials, and some have a concave foot. Such pots were made by Thomas Danforth III (Fig. 11–11), Thomas D.

Boardman, William Calder, Eben Smith, Bailey and Putnam, George Richardson, Samuel Pierce, Peter Young, Timothy Brigden, and others.

Although many Queen Anne and drum teapots can be recognized as American by their details, their dependence on English design is clearly apparent. However, about 1800 an American innovation in teapot design was introduced. The ingenious double-pear or reversed shaped pots (Fig. 11–12) were probably first made by Samuel Danforth. Sometimes called extended base teapots, these were made by substituting an upper section for the bulbous base normally used in pear-

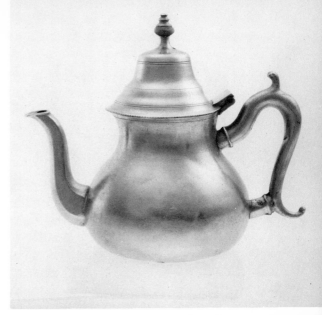

11–11. Teapot, ca. 1790–1818, by Thomas Danforth III, Stepney, Conn., H. 7″ (Gift of Charles K. Davis, WM 55.48.42).

11–12. Teapot, 1805–30, by Thomas D. Boardman, Hartford, H. 9¼″ (collection of Ledlie I. Laughlin).

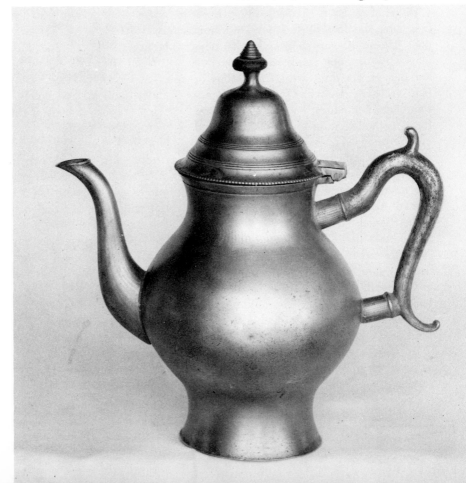

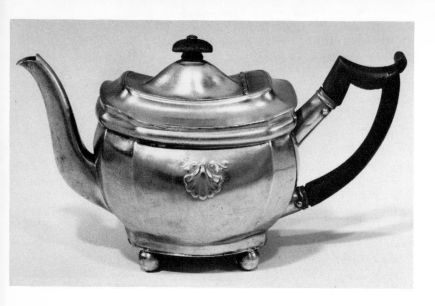

11–13.
Teapot, boat-shaped, 1787–1811 by George Coldwell, New York City, H. 6⅛″ (courtesy of The New-York Historical Society, New York City, and Mr. and Mrs. Thomas D. Williams).

shaped teapots. Later the Boardmans and Samuel Kilbourn also produced the form.

The highly sophisticated boat-shaped teapot (Fig. 11–13) may have been fashioned in a press or over a wooden form, but the boat-shaped teapot made by George Coldwell of New York appears to have been made of sheet metal and, along with one by Israel Trask (Fig. 11–8), is among the first of the new britannia pots. The lighthouse shape was also popular with britannia makers, and several variants of the form with flared tops or bottoms were devised. One of the handsomest of nineteenth-century britannia forms is the teapot or coffeepot illustrated in Figure 11–14. Made of thin rolled metal and fashioned around a form, it was seamed along a vertical line where the handle is fastened. Its bright-cut ornament reflects the early training of its maker, Israel Trask, as a silversmith. The four horizontal bands near the top strengthened the body and permitted the use of lighter-gauge metal. Trask, as well as Coldwell, made straight-sided oval and boat-shaped pots that were often fitted with small ball feet and ornamented with bright-cut engraving.

In the nineteenth century, matching sugar bowls, pitchers, and teapots became increasingly common. Among the first made were the bright-cut examples by Israel Trask (Fig. 7–4) and his brother Oliver. Perhaps because of the fragility of their bases, which might crack under the blow of the stamping die, marked examples made before 1820 are not often found. More likely, tea sets did not become common until the 1840's and 1850's, and complete sets of any era are rare today.

Soon after 1800, English britannia makers such as James Dixon, John Vickers, and Joseph Wolstenholme offered underslung teapots of boat or duck shapes that were close parallels to pottery forms. Not long thereafter, they followed with reeded, fluted, and paneled variants of taller, globular pots. Americans copied the new English designs to a limited degree, but only a few of the many teapot makers, such as Babbitt, Crossman and Company and its successor firms of Crossman, West and Leonard, Taunton Britannia Company, and Reed and Barton, and Roswell Gleason, had the equipment before 1840 to stamp out these complex forms. Instead, American pewter and britannia manufacturers produced a vast number (probably in the millions) of teapots and coffeepots in a variety of cast

11–14. Tall teapot or coffeepot, lighthouse-shaped, 1812–ca. 1830, by Israel Trask, Beverly, Mass. H. 11⁷⁄₁₆″ (WM 58.673).

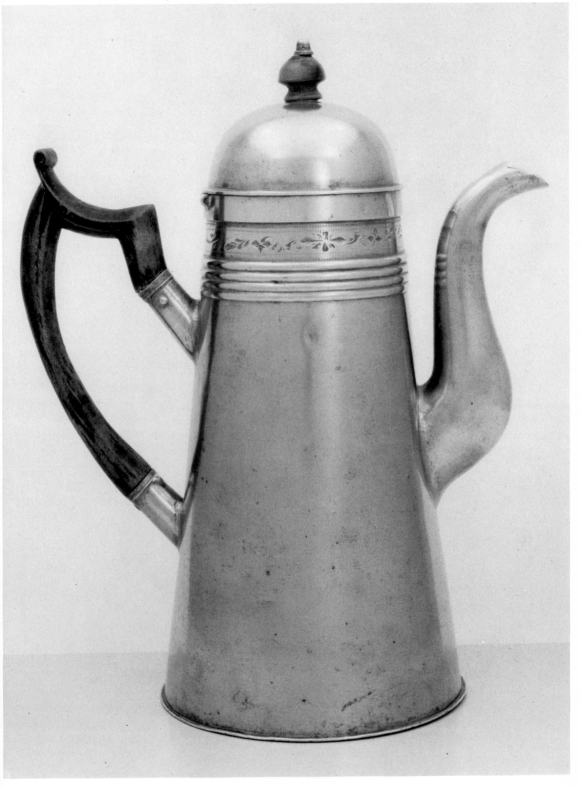

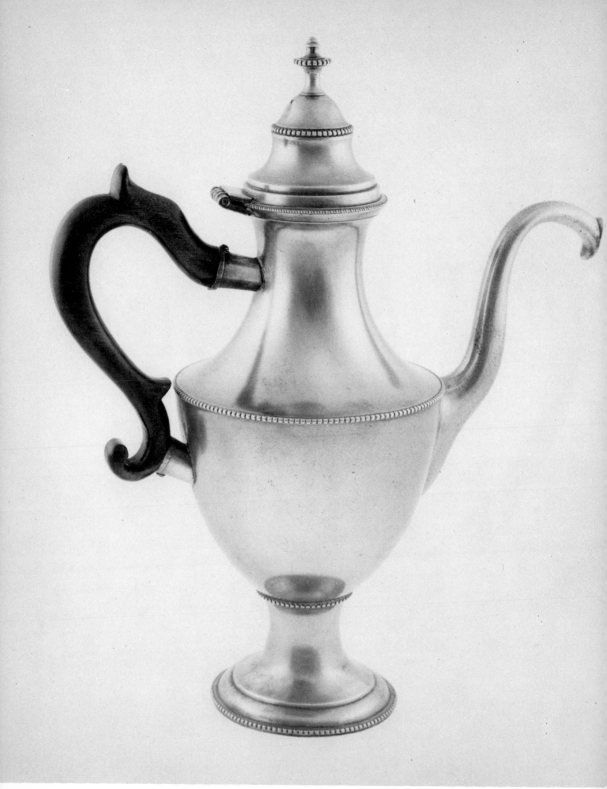

11–15. Coffeepot, 1785–98, by William Will, Philadelphia, H. 15½″ (WM 55.624).

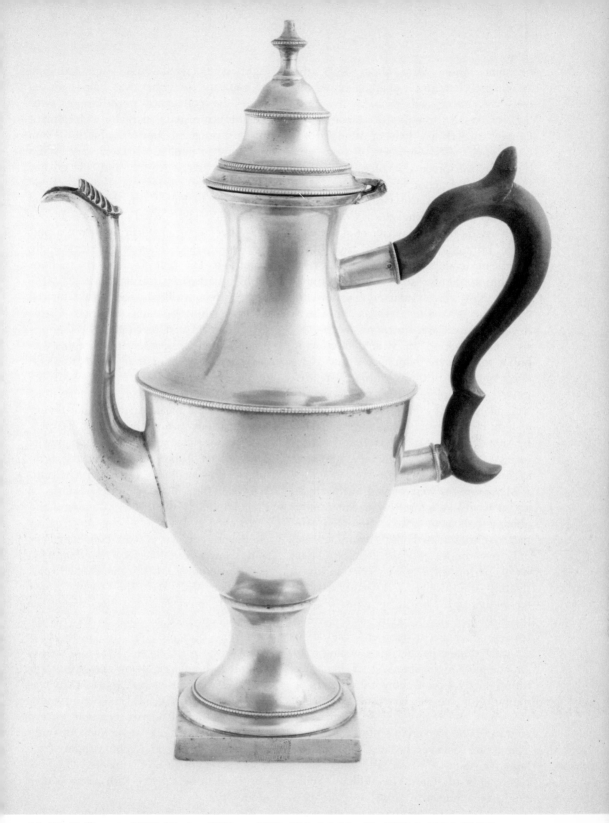

11–16. Coffeepot, 1785–98, by William Will, Philadelphia, H. 15¹³⁄₁₆″ (WM 54.33).

or spun forms. After about 1825, the spinning technique for shaping round objects was introduced, probably by English workmen brought to America by Charles and Hiram Yale of Wallingford, Connecticut. The number of pots produced by this process was for many years but a small fraction of those made by casting. As far as the writer can ascertain, there are no English or Continental counterparts to the majority of American-made britannia teapots. Although some American teapots show a general relationship to Staffordshire transfer-printed wares, most were fundamentally new designs that the writer sees as innovative developments closely attuned to the design of a period in which large-scale bulky forms were popular. A few years ago, American britannia forms were dismissed or deplored but not generally studied, except by Professor Raymond in a light-hearted essay categorizing them by shape.[18] His names, which cover most forms and are self-explanatory, are used in the captions in this book.

Many designs were copied in the trade, and it would be interesting to know more about the men who originated the patterns designated by manufacturers only by number and size. Nancy Goyne Evans performed a great service in investigating the history and manufacturing techniques of the britannia industry,[19] but the history of the designing of the American product needs further exploration. As yet we have neither a chronology nor an adequate understanding of manufacturing methods and how they relate to design. Nor are the differences between coffeepots and teapots clear. Figures 11–15 and 11–16 are surely coffeepots. Why? The writer believes because they are of large capacity and are tall. Each holds two quarts of liquid. In William Will's 1799 shop inventory, twelve coffeepots were listed at two dollars each, whereas forty teapots were appraised at only

eighty cents (six shillings) each. Although no capacity for either was listed, we assume the coffeepots were larger, since weight was usually a major determinant in the price of pewter objects. From surviving examples, we know that Will's coffeepots were larger and of greater capacity than his teapots. But size alone seems not to have been the determining factor. Coffeepots listed in Thomas Byles's 1771 inventory ranged in size from a pint to two quarts.[20] They were surprisingly expensive. The pint size cost six shillings each; quarts, ten shillings each; three pints, fifteen shillings each; two quarts, eighteen shillings each; whereas thirty-seven teapots cost less than five shillings each. Although the size of the teapots was not given, teapots normally held from one to three pints, and for comparative purposes it should be noted that forty-four covered sugar basins in the same inventory cost only two shillings each. Teapots were about twice as large as sugar bowls. The subject is perplexing, and the little information available is not very helpful. For example, in 1736 Aaron Smith of Philadelphia advertised London-made coffeepots and teapots, but no English eighteenth-century pewter coffeepots are now known. And the only American surviving examples are the urn-shaped ones of William Will. With the exception of a tall, lighthouse-shaped silver teapot of 1670 documented as such in its inscription and presented to the East India Company by George Lord Berkeley, seventeenth- and eighteenth-century silver coffeepots are taller and larger than teapots.[21] Modeled closely on late seventeenth-century Chinese ceramic forms, teapots were small, sometimes of only half-pint capacity and seldom more than a quart or three-pint capacity. Teapots also tend to be squatty with a low center of gravity.

The 1867 illustrated catalogue of the Meriden Britannia Company drew the

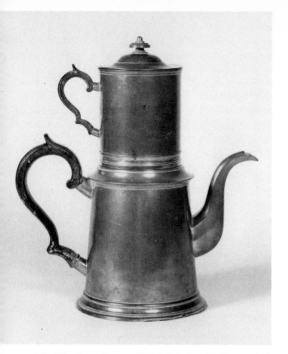

loose opening of Figure 11–15. The bases of the spouts also differ, and the beading on Figure 11–16 is larger and less refined. The latter, of course, is a minor variation, since Will owned knurling tools of different gauges that could be run around the edges of the various moldings on body and lid somewhat like a pie crimper. The wooden handles are probably the kind billed by Joshua Delaplaine to New York City silversmiths in the 1750's as "kink't handles."[23]

An interesting and unusual britannia utensil for brewing coffee is illustrated in Figure 11–17. Hot water, poured into the upper reservoir, seeped through a bed of coffee grounds segregated between finely pierced britannia sieves. Made by Wil-

11–17. Percolator, 1817–56, by William Calder, Providence, H. 9¼″ (collection of Dr. Joseph H. Kler, photo, courtesy Smithsonian Institution, Washington, D.C.).

11–18. Coffee urn, 1837–40, by Leonard, Reed & Barton, Taunton, Mass., H. 14″ (collection of Mr. and Mrs. Thomas D. Williams).

line between coffeepots and teapots at five pints' capacity. Larger vessels were termed coffeepots; smaller ones, even of the same shape, were called teapots. Professor Raymond insisted that the presence or absence of a strainer at the base of the spout was the differentiating factor between teapots and coffeepots. He wrote that teapots had strainers and coffeepots did not.[22] And indeed two William Will coffeepots at Winterthur have no strainers! But all other teapots or coffeepots in the Winterthur and other collections which the writer has examined do have strainers, and we are led to ask what has happened to all the nineteenth-century coffeepots which were advertised.

To return to William Will's coffeepots: They vary in detail but are essentially alike. Figure 11–16 has an extra square member added to the foot, and the spout has a comb as opposed to the broad,

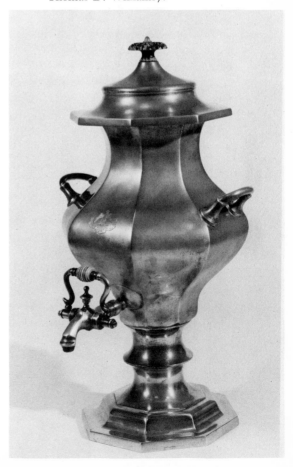

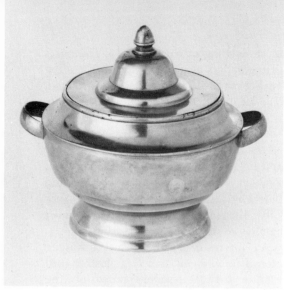

11–19. Sugar bowl, 1830–45, by George Richardson, Cranston, R.I., H. 5¹⁄₁₆″ (WM 63.660).

liam Calder, whose mark it bears, between 1817 and 1856, it seems as modern as the dripolator.

The large urns are for the dispensing of coffee rather than for making it. One might speculate on who owned such coffee vessels—the parish church, local school district, lodge or fraternity, or a large family? In the case of the handsome octagonal example (Fig. 11–18) marked by Leonard, Reed and Barton (w. 1835–40), the Boston Sears family crest just above the spout suggests private ownership, as does the inscription on the opposite side, "MBS from LBH." Approximately a dozen surviving britannia coffee urns are about evenly divided among Roswell Gleason, the Taunton

11–20. William Sidney Mount, *Dregs in the Cup, or Fortune Telling*, 1838. Oil on canvas. (courtesy of The New-York Historical Society, New York City).

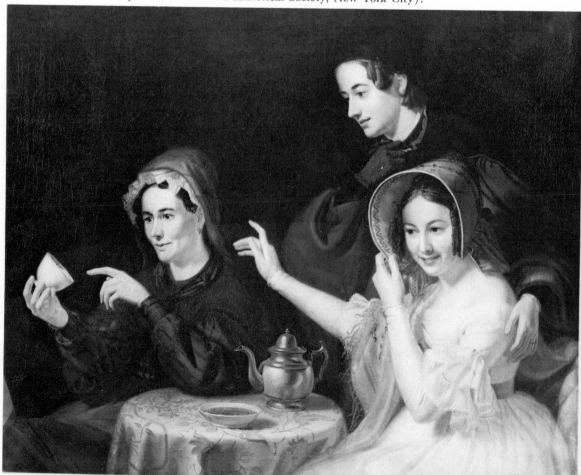

Britannia Manufacturing Company, and Leonard, Reed and Barton.

Britannia teapots are comparatively common, but cream pitchers and sugar bowls are scarce. Their very rarity may influence our reaction to them. But who among us brought up on the enthusiasm of John Barrett Kerfoot can look at the sugar bowls of George Richardson without remembering their place of honor as frontispiece in *American Pewter* (Fig. 11–19). Most elegant of nineteenth-century sugar bowls, it documents its maker's flair for design. Richardson was also able to incorporate castings of this bowl into his milk pitchers. However, both of these designs are far more successful than his other sugar bowl or his teapots incorporating castings of that bowl as their bases.

As if life revolved around the teapot and tea drinking, William Sidney Mount, famous for his scenes of daily life, painted a globular britannia teapot at the center of his gay portrait of three pensive young women in *Dregs in the Cup, or Fortune Telling* (Fig. 11–20). Such pots were made by Charles Yale, Daniel Curtiss, and others a few years before 1838, the signed date on the painting.

The body of the teapot or coffeepot (Fig. 11–22) appears to have been cast in the half-gallon-measure mold used by the Boardmans. Although of lighter-weight metal and lacking the sturdiness of a measure, it illustrates once again the multiple uses of castings. Alas, this does not seem to have been a popular model, and the writer has not seen another pot like it.

The tall teapot made by Sage and Beebe about 1850 (Fig. 11–21) was called tulip-shaped by Percy Raymond. Its kinked or broken-C scroll handle, which follows eighteenth-century rococo design, may properly be termed a Victorian revival. The handle of Figure 11–23, marked Boardman and Company, is simpler in outline, but the body has the double-bellied contours associated with rococo silver forms. In contrast to these vessels, the center of gravity here is comparatively low. This style was termed "nodose" because of its nodes or protuberances.

Flat-banded was Percy Raymond's name for Daniel Curtiss's teapot (Fig. 11–24). A popular shape introduced soon after 1825, its form seems to anticipate James H. Putnam's pot of the 1830's (Fig. 11–25). Another variation, called the annular style by Raymond, was favored by Philadelphia manufacturers. The example illustrated (Fig. 11–26) is marked *Hall, Boardman & Co. Philad.*, a firm which, according to the report of Edwin T. Freedley, used modern improvements to the fullest in the production of britannia wares. In *Leading Pursuits and Leading Men*, Freedley observed:

> Messrs. Hall & Boardman, who have been engaged in the manufacture of Britannia-ware since 1843, are now the leading manufacturers in Philadelphia. Their manufactory, at 93 Arch Street, is provided with every modern improvement in machinery that can facilitate the manufacture, embracing rolls of great size and exquisite finish, constructed for the United States Mint, heavy drop-hammers for fluting, &c., with steam to heat the building as well as drive the machinery, and many conveniences for the comfort of employees. In the composition of their metal they use certain proportions, peculiar to themselves, which Mr. Hall, who is noted for his skill in the selection of metals, after many patient experiments discovered to be the best, and which give to their ordinary ware a silvery appearance, and render the whiteness more durable than is usual.[24]

The tall pot (Fig. 11–27), a coarse variant of the lighthouse style, can be closely dated between 1834 and 1836, the period

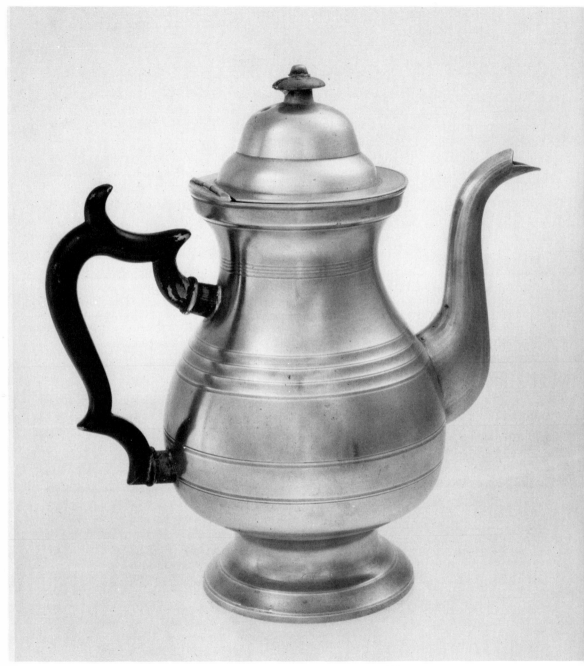

11–21. Teapot or coffeepot, ca. 1849–50, by Timothy Sage & [?] Beebe, St. Louis, H. 10⅞″. (Gift of John J. Evans, Jr., WM 55.53).

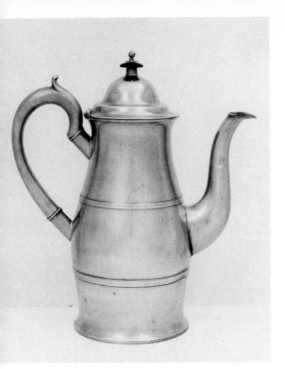

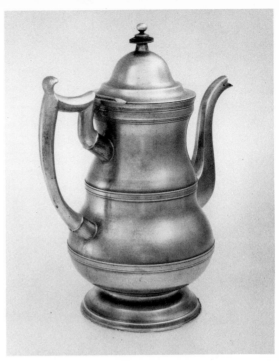

11–22. Teapot or coffeepot, 1827–53, by Thomas D. and Sherman Boardman and Lucius Hart, Hartford or New York City, H. 10¾″ (WM 66.1146).

11–23. Teapot or coffeepot, 1825–27, by Boardman and Company, New York City, H. 11¹³⁄₁₆″ (WM 64.1155).

11–24. Teapot, ca. 1830–40, by Daniel Curtiss, Albany, H. 8¹³⁄₁₆″ (WM 65.1456).

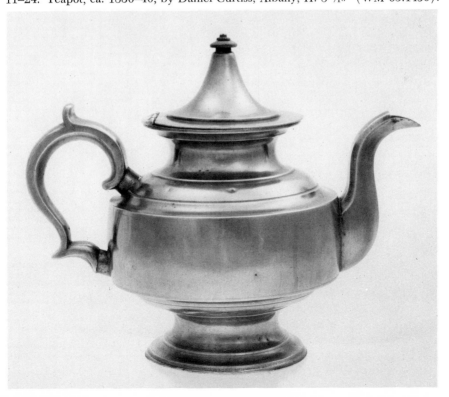

11–25. Teapot, 1830–55, by James H. Putnam, Malden, Mass., H. 7¹⁵⁄₁₆″ (WM 65.1457).

11–26. Teapot, 1846–48, by Hall, Boardman and Company, Philadelphia, H. 8³⁄₁₆″ (WM 64.1154).

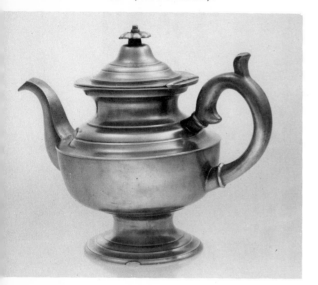

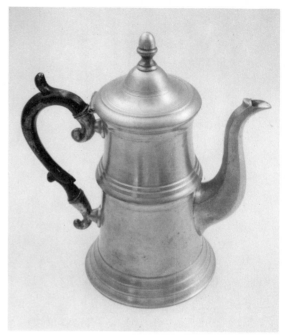

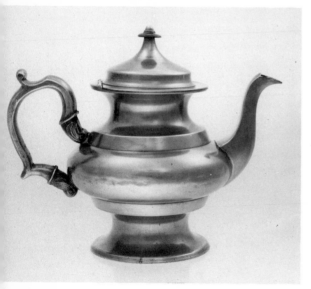

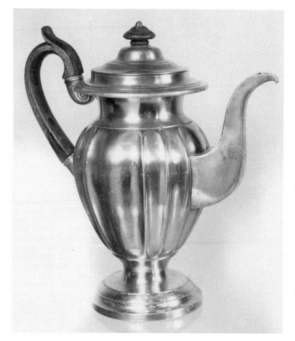

11–27. Teapot or coffeepot, 1847–56, by John H. Whitlock, Troy, N.Y., H. 11¼″ (WM 68.240).

11–28. Teapot or coffeepot with fluted body, 1830–34, by the Taunton Britannia Manufacturing Company, Taunton, Mass., H. 10½″ (collection of Mrs. Ralph B. Post).

of the partnership of its makers, Isaac C. Lewis and George C. Cowles. They worked in Meriden, Connecticut, five miles from Yalesville and ten miles from Middletown, a center for the manufacture of pewter and britannia for almost a century. In 1852, Lewis was named president of the Meriden Britannia Company, a merger of the principal firms in the area, and by 1855 the new company began to issue annual catalogues offering a variety of goods, including electroplated wares. Indicative of the interchange of designs among britannia manufacturers is their offering of five styles of "black japanned handles" at eight to fifteen dollars a gross and twenty-five varieties of "knobs" (finials), black, white, or plain at eighty cents to $1.75 a gross.

The three-piece set (Fig. 11–30) is one of the later and less successful britannia

designs of Roswell Gleason of Dorchester, Massachusetts. His life is a Horatio Alger story of britannia. Born in Putney, Vermont, Gleason journeyed to Boston in 1818 and learned the pewterer's trade. He took over his master's business in 1822 and was awarded the highest diploma and a medal for his "fine specimens of block tin" exhibited at the fair of the Massachusetts Charitible Mechanics Association in 1837. So good were his teapots in 1840 that a Philadelphia Quaker was moved to write him, "It gives us great pleasure to say that we have never seen anything in American Goods that can compare with them." In a britannia-ware advertisement of 1848, Gleason puffed, "These goods received the Diploma of the Fair of Massachusetts Mechanics Association in 1841 since which great improvements have been constantly making in patterns,

11–29. Tea or coffee service, 1830–34, by the Taunton Britannia Manufacturing Company, Taunton, Mass., H. of left teapot 8¾"; of right teapot 10⅞"; of sugar bowl 7½"; of creamer 5⅜" (formerly in collection of the Hon. and Mrs. George V. Smith).

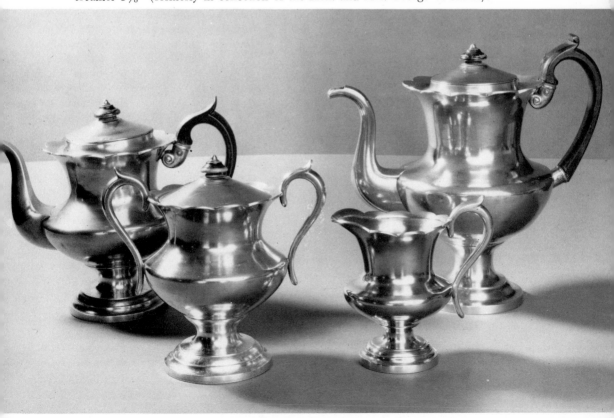

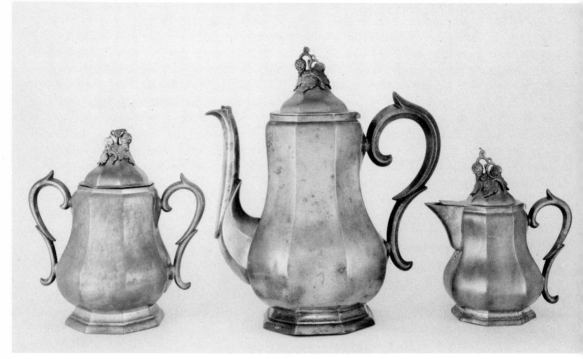

11–30. Tea or coffee service, 1850–65, by Roswell Gleason, Dorchester, Mass., H. of sugar bowl 7¹³⁄₁₆″; of coffeepot 11x¹³⁄₁₆″; of cream pot 6¾″ (WM 64.86.1-.3).

styles, and finish." Among the "great improvements" may have been the coffee or tea set illustrated in Figure 11–30. In keeping with the rococo-revival style of the 1850's, its design appears unsatisfactory to our eyes. The paneled bodies soldered along vertical seams are neat and clean, but alas, the scrolled handles and fruit-and-leaf finials are fussy and out of scale.

Soon thereafter, Gleason's plant in Dorchester was to become one of the first in the United States to introduce electroplating. For the most part, Gleason's designs for pitchers, lamps, and teapots had the traditional virtues of pewter's simple, bold forms and enjoyed wide sales all over the eastern United States. In 1851, Gleason was characterized in *The Rich Men in Massachusetts* as worth $100,000 and one who

came to Dorchester from the country a poor boy. Commenced business without any other capital than a determination to do *something* and be *somebody*. Went to work; and all the noise he made was in his tinshop, where there was an incessant din, from day-light in the morning to a late hour of the night. He succeeded. Such a man *must* succeed; and it was but a short time before there might daily be seen an army of honest tin-peddlers departing from his factory to furnish the "*real* tin," and to bring back in return "rags" and the "pewter." He gives employment to a large number of laborers, and gives support to many poor persons; is a bank director, enjoys the confidence of the community, and is highly respected as a citizen.[25]

In 1871, Roswell Gleason closed his factory and retired to a life of ease; the era of britannia was over.

Chapter Twelve

"Any Uncommon Thing in Pewter"

American pewterers were active and energetic as makers of pewter, brass, and tinware, as merchants of imported pewter and as repairmen. They offered their goods on "the most reasonable terms" and promised that their customers would be "faithfully and honestly dealt with."

Simon Wyer, at the Sign of the Globe in Market Street, Philadelphia, met competition with the announcement that "all sorts of old, pewter dishes and plates... that by long use or neglect of servants are battered, bruised, melted or damaged, shall be mended (if possible) neat and cheap."[1] Colonel Will advertised that "he practices the pewterer's craft in all its forms, and makes and sells all kinds of tin ware by the large and small quantity." After his death his widow continued "to carry on the pewtering business in all its branches."[2] Joseph Leddell, Jr., concluded a long list of objects he offered for sale with "... and any uncommon Thing in Pewter in any Shape or Form as shall be order'd."[3] Robert Boyle continued to use the same wording in his own advertising after Leddell's death with the addition of "Likewise all kinds of Leadwork for ships or houses with due care and expedition."[4]

William Kirby's advertisement concluded with "... many other articles in the Pewter way too tedious to mention. Old Pewter will be taken in exchange for new," and he added that he had "several lots of Ground to dispose of, lying near the North River." (Fig. 2–3).[5]

Of the unconventional objects made and sold by pewterers, baby bottles are among the most unexpected. Pewter nipples must have been hard for babies to take, but their use was widespread. As early as 1764, William Ball, a Philadelphia pewterer, advertised "sucking bottles for children,"[6] and "15 sucking bottles" at 3s. 6d. each were detailed in Thomas Byles's 1771 inventory.[7] In 1803, George Coldwell advertised "Suckling Bottles for infants."[8] Somewhat earlier and smaller than the Boardman bottle at Winterthur (Fig. 12–1) is a Frederick Bassett example that was made between 1761 and 1800.

Eighteenth-century pewterers' advertisements offer cranes (syphons) for bottles and hogsheads. Those listed in William Will's inventory were expensive at six dollars each, a price matched only by that of his ice-cream molds, which were equally costly.[9] Neither of these forms is known today. In Will's inventory, the next

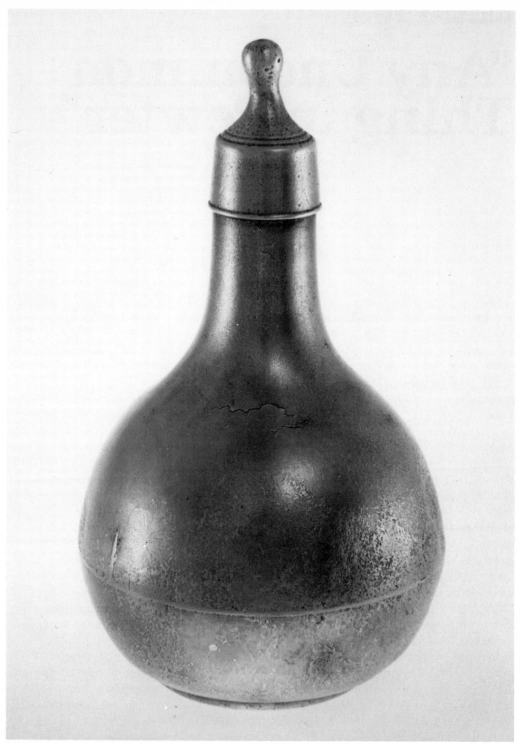

12–1. Baby bottle, 1828–53, by Thomas D. and Sherman Boardman and Lucius Hart, New York City, H. 6½″ (WM 65.1469).

most expensive objects were three bedpans appraised at $3.50 each, which may be compared to the price of his coffeepots at two dollars each. Of Will's bedpans, that illustrated in Figure 12–2 is probably typical.

Although bedpans were apparently difficult to make, most pewterers made them by soldering together two brimless dishes and then cutting the bottom out of one of them. The edges of the hole were pushed down in the skimming process. The handle, which was fitted to a threaded pewter pipe, could be unscrewed and removed.

Thomas Byles's large bedpans were valued at fifteen shillings each; the same figure was placed on three-pint coffeepots and gallon wine measures—only slightly less than the most expensive individual objects, which were two-quart coffeepots at eighteen shillings each. Simon Edgell's bedpans at fourteen shillings were his most expensive items and cost almost

three times as much as quart tankards.[10]

An indoor convenience and predecessor of the watercloset was the close stool. As bedroom furniture, most easy chairs (called wing chairs today) were fitted with tall tapering vessels variously called chair pans, stool pans, close stool pans, and commode forms. Sometimes these were made of pottery or porcelain, but more often pewter served the purpose. William Will's "chair pans" were valued at $1.50 each, and those of Simon Edgell

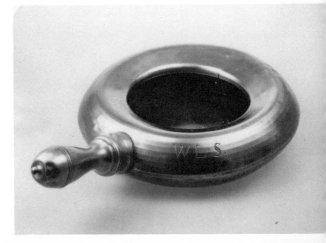

12–2.
Bedpan, 1764–98, by William Will, Philadelphia, Diam. 11½" (WM 61.103).

12–3.
Commode, 1761–1800, by Frederick Bassett, Hartford and New York City, H. 8" (Yale University Art Gallery, The Mabel Brady Garvan Collection).

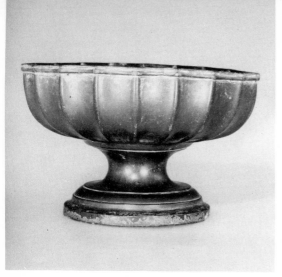

12–4. Bowl with fluted sides, 1829–30, by Crossman, West & Leonard, Taunton, Mass., Diam. 6⅞″ (WM 64.130).

12–5. Caster frame with glass bottles, ca. 1814–56, by Eben Smith, Beverly, Mass., H. 8½″ (WM 71.35).

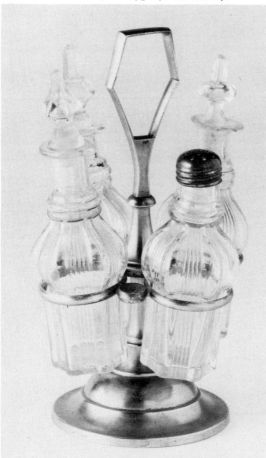

at ten shillings.[11] Only three or four American pewter commode forms by American pewterers are now known—all by Frederick Bassett (Fig. 12–3) except for the one in the Winterthur collection marked *I F*, possibly the touchmark of John Fryers of Newport (w. 1749–68).

In 1827, Babbitt and Crossman began to make stamped britannia wares and developed in Taunton the technological facilities to fashion reeded and fluted forms in the manner of those produced in Birmingham, England, by James Dixon and Sons. Illustrated in Figure 12–4 is a fine fluted bowl by Crossman, West and Leonard, successors to the earlier firm. Now blackened and shabby, it was once gay in blue and green paint with gilding. It may have been a mantel ornament.

Shown in Figure 12–5 is a britannia caster frame by Eben Smith of Beverly, Massachusetts, fitted with glass bottles made in a New England glass factory, perhaps in Sandwich. The manufacture of such frames, begun in the 1830's, increased steadily through the 1840's and 1850's. Such frames held four, five, or six bottles for vinegar, oil and hot sauce, mustard, pepper, and sometimes salt.[12] The salt and pepper bottles were fitted with britannia caps; the others had glass stoppers.

In 1814, John Love of Baltimore advertised "METALLIC CUPS AND SAUCERS," explaining "that he has obtained a patent for . . . Manufacturing the Mineral Tin (or what is commonly called the Block or Pig Tin) into Tea and Coffee Cups and Saucers." "Great advantages," he said, were "to be derived . . . from the purity and durability of the Metal, combined with a moderate price."[13] Analysis of Winterthur's cup and saucer marked *I Love Balt* (Fig. 12–6) confirms Love's claim of purity of metal. They average 94 per cent tin and 4 per cent antimony.

Round bottle-shaped vessels with screw caps have long been called dram (small

drink) bottles by pewterers. Cornelius Bradford of Philadelphia used that name when he advertised pint and half-pint dram bottles in 1765. One might speculate that the round pint container (Fig. 12–7) was used as a canteen, but it remained for the survival of an extraordinary record to prove it. The office of "the commissioner of purchases in Lancaster" lists a payment of £9 13 s. 10d. on October 27, 1775, to "Christopher Hayne" and others "for making canteens, etc. for riflemen."[14] The date of payment suggests that the Lancaster militia were being fitted out in preparation for the impending Revolutionary War. Although we have no proof that this bottle was one of those referred to above, it bears Heyne's *I C H* and *Lancaster* marks.

A specialty with Continental pewterers were flat, oval-shaped pewter bottles fitted with large screw caps. When filled with hot water, they served as foot warmers. Comparable in function is a unique pewter foot warmer (Fig. 12–8). Made by Henry Will, it approximates in shape a quarter section of a cylinder and has a screw cap to contain the hot water. Whether Will invented this form is not known. Such foot warmers would have served equally well in church or in sleigh.

A pewter frame with a label of Babbitt and Crossman pasted on the cardboard backing was illustrated by Dr. Adelbert C. Abbott in the *Pewter Collectors' Club of*

12–6. Cup and saucer, ca. 1814, by John Love, Baltimore, Diam. of cup 4", of saucer 5⅞" (WM 65.1527).

12–7. Round pint container, ca. 1756–80, by Johann Christoph Heyne, Lancaster, Pa., H. 5½" (WM 55.623).

12–8. Foot warmer, 1761–93, by Henry Will, New York City or Albany, H. 11⅜" (Yale University Art Gallery, The Mabel Brady Garvan Collection).

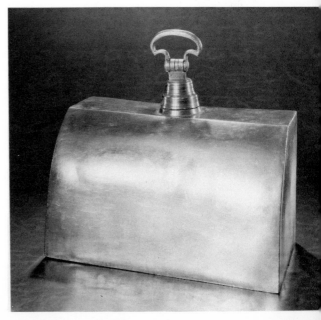

"Any Uncommon Thing in Pewter"/195

12–9. Silhouette and frame, 1825–30, New England, Diam. 3⅝₁₆″ (WM 61.70).

America Bulletin for September, 1962. That rare frame with a silhouette of President Martin Van Buren had a finely milled face edging, whereas most pewter frames have smooth surfaces. Some have beveled liners like that illustrated in Figure 12–9. Others have rounded profiles. Pewter frames range in size from 1⅝ inches in diameter, enclosing a small print of Washington with a looking glass on the reverse, to 4⅛ inches, the size of the one made by Babbitt and Crossman. Some others have been attributed to Samuel Pierce.[15] Proof may be lacking for this attribution, but many such frames have been found in the Greenfield, Massachusetts area.

Enough pewter funnels, sometimes

12–10. Funnel, 1720–61, by John Bassett, New York City, L. 7⅟₁₆″ (WM 65.2241).

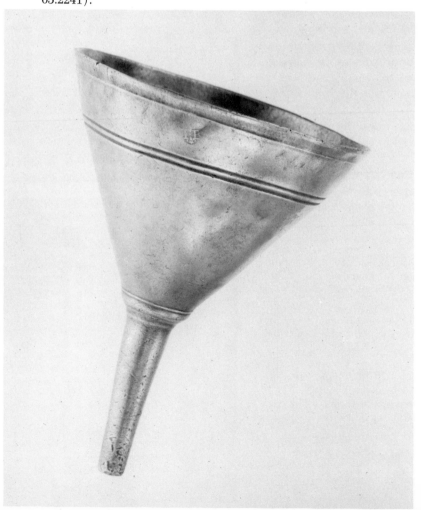

12–11. Standish, 1761–93, by Henry Will, New York City or Albany, L. 7⅞″ (courtesy of The Brooklyn Museum).

descriptively called "tunnels" in early references, have survived in several sizes, indicating that they were widely made and used. However, the only identified American examples are a few made by Frederick Bassett and a unique specimen (Fig. 12–10) made by his father, John Bassett of New York. Bassett funnels differ from others in that their sides taper in a straight line to form an inverted cone-shaped receptacle, instead of being curved to form the usual hemisphere. Like most of John Bassett's pewter, this example is of splendid metal.

Remedies for the common cold were as eagerly sought in the eighteenth century and as elusive to find as today. Apparently hot steam was considered an effective decongestant, and infusion pots (Fig. 12–12), fitted with a flexible tube to convey the steam to the nostrils, were frequently advertised. As early as 1752, Joseph Leddell, Jr., New York pewterer, advertised "infusion-Pots, so-much approved of in colds." Two years later Robert Boyle, another New York maker, offered "infusion pots so much made use of in colds." And in 1787, William Kirby went even further in claims for his "infus-

ing pots, approved of in cold and consumptions."[16]

The pewter standish often appears as a symbol of the merchant or man of business in the paintings of John Singleton Copley and other colonial artists. Nevertheless, surviving pewter standishes are surprisingly rare, and only a single American example is known (Fig. 12–11). That unique example is marked with Henry Will's rose-and-crown full-name touch on

12–12. Infusion pot, 1817–22, by Robert Palethorp, Jr., Philadelphia, H. of pot 4¾″ (Yale University Art Gallery, The Mabel Brady Garvan Collection).

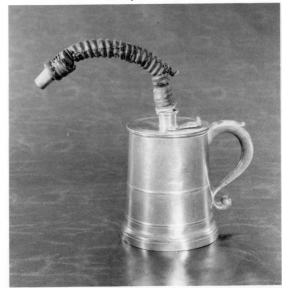

the top of each lid. The prominent display of the pewterer's name suggests that this may have been his personal writing box. On one side was storage space for pens and on the other a pen holder, sander, and container for ink. Nine large "Chest Standishes" in the 1771 inventory of Thomas Byles were valued at twelve shillings each.

Typical of eighteenth-century round, capstan-shaped inkwells is a single example by William Will, complete with original blown-glass liner (Fig. 12–13 c). That Will's contemporaries called such objects inkstands is clearly indicated by the appraiser's two entries in Will's shop inventory, which read, "2 Ink Stands . . . [$].25 each." Also listed were "2 doz. Ink Stand Glasses."[17]

Early nineteenth-century pewter inkstands are almost as rare as eighteenth-century examples and are limited to an occasional piece by the Boardmans, Hall and Cotton, and a few others. About 1831, Gaius and Jason Fenn of New York City began to produce small, weighty (not eas-

12–13. *Left to right:*
 (a) Sander, ca. 1830–40, by W. Potter, probably New England, H. 2⅞" (WM 52.116).
 (b) Sander, ca. 1813–56, by Israel Trask, Beverly, Mass., H. 2⅜" (WM 52.115).
 (c) Inkstand, 1764–98, by William Will, Philadelphia, H. 1¹⁵⁄₁₆" (WM 52.19).
 (d) Inkwell, 1831–43, by Gaius and Jason Fenn, New York City, H. 1¾" (Gift of Charles K. Davis, WM 53.155.17).
 (e) Inkwell, 1831–43, by Gaius and Jason Fenn, H. 1½" (WM 65.1467).

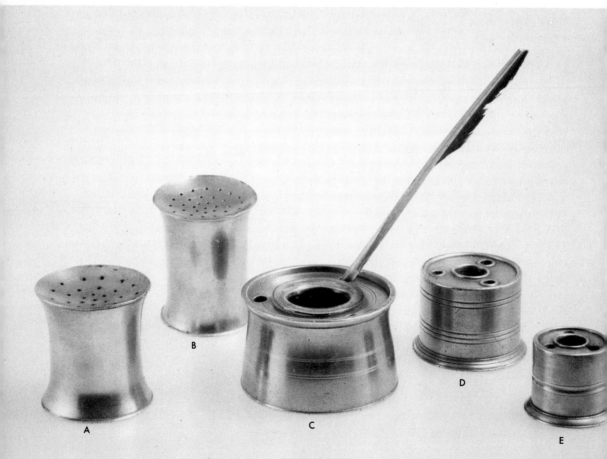

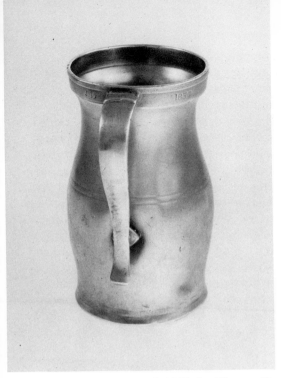

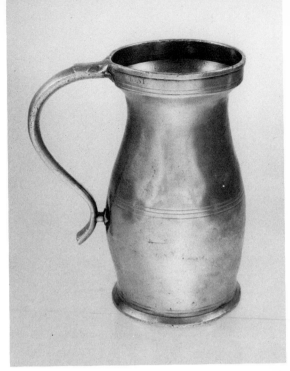

12–14. Measure, dated 1837, by Thomas D. and Sherman Boardman and Lucius Hart, Hartford or New York City, H. 5⅜" (WM 66.1185).

12–15. Measure, dated 1831, by Thomas D. and Sherman Boardman and Lucius Hart, H. 7" (WM 60.555).

ily overturned) inkwells in two or three sizes. A dozen or more examples (marked on the bottom) are known today (two at the right, Fig. 12–13 d, e). The Fenns also produced pewter faucets and molasses gates.

Before 1850, pounce (pulverized gum sandarac or cuttlefish shell) was rubbed over unsized paper before writing to prevent the ink from spreading. After writing, fine sand was commonly sifted over the wet ink.[18] Containers for storing and sifting sand or sandarac are appropriately called sanders. Less frequently made of pewter or britannia than of turned wood or painted tin, the two britannia examples (Fig. 12–13 a, b) are unusual. Capstan-shaped and of excellent design, they are marked by Israel Trask (Fig. 12–13 b) and W. Potter (a), respectively. Both pieces are believed to have been shaped

by spinning and to have been made between 1825 and 1850. As yet, Potter has not been identified.

"Sealed measures from a gallon to a gill" were listed among the effects of Philadelphia pewterer Thomas Byles in 1775.[19] In a most explicit advertisement, Henry Will in 1786 offered:

Pewter Wine Measures of all sizes, containing the exact quantity as is directed by a law of this State, passed the 10th day of April, 1784; are made and sold by Henry Will, No. 3 Water-street, near the Old-slip, New-York, who has the new standard Measures for the State agreeable to which the above Measures are made.[20]

Indeed, wine measures were advertised by many eighteenth-century American pewterers and were occasionally listed among their unsold stock after death. But

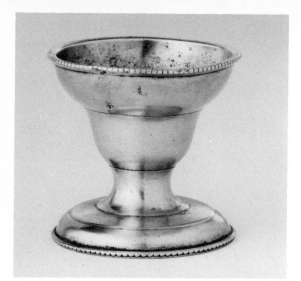

12–16. Salt cellar, 1785–1810, probably Philadelphia, H. 2⅜″ (Gift of Mr. and Mrs. Charles F. Montgomery, WM 72.43).

the only known American baluster measures are a few nineteenth-century examples made by the Boardmans and a recently found example attributed to Lawrence Langworthy of Newport. Lidless measures made and marked by the Boardmans are not appreciably different from eighteenth-century English measures, and it is assumed that some of the many unmarked (and presumably earlier) measures of the same shape bearing American sealer's stamps, such as *C P* for Commonwealth of Pennsylvania, are American made. There is some mystery regarding the stamping of measures with makers' marks. Although half-pint, pint (Fig. 12–14), and quart (Fig. 12–15) measures stamped with one of the Boardman marks may be

12–17. *Left to right:*
Shaker, attributed to Thomas Danforth III, w. 1777–1818, Stepney, Conn. or Philadelphia, H. 5¹⁵⁄₁₆″ (WM 56.38.32).
Shaker, attributed to Thomas Danforth III, H. 5¹¹⁄₁₆″ (WM 56.38.30).
Shaker, attributed to Homan and Company, w. 1847–90, Cincinnati, H. 4½″ (WM 66.1181).
Shaker, attributed to Homan and Company, H. 4½″ (WM 66.1182).

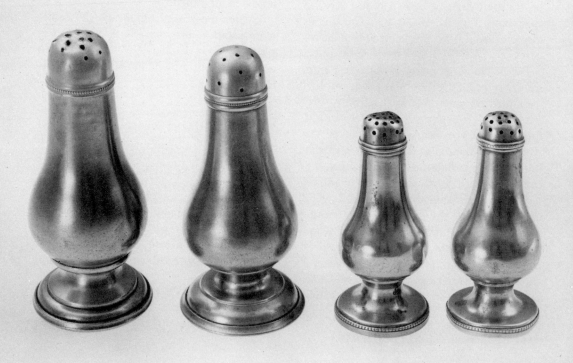

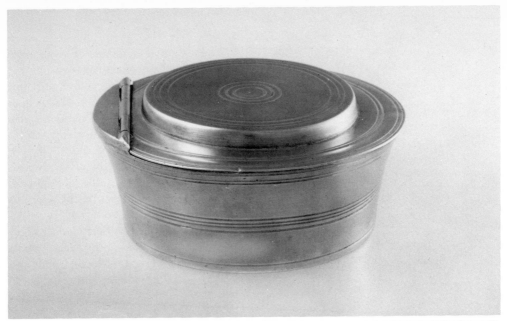

12–18.
Shaving box, 1807–35, by Ashbil Griswold, Meriden, Conn., Diam. $4\frac{7}{16}''$ (WM 55.3.2); shaving brush, 1770–1810, probably England, L. $3\frac{5}{8}''$ (WM 58.2366).

found in a set of five or more measures that appear to be from the same shop, the larger and smaller sizes are always unmarked. Why they were not marked is not known, but one can speculate that the American pewterer avoided arguments concerning the capacity of the vessels by omitting to mark them with his name.

Open salts were probably made by most American pewterers, but only a few late eighteenth-century American salts are known. Generally attributed to William Will, certain double-bellied salts (Fig. 12–16) are presumably like the "18 pr. salts" listed in his inventory at thirty-one cents a pair. No other eighteenth-century or earlier salts can be attributed to a particular maker or even be cited with assurance as of American origin. Simon Edgell's 1742 inventory listed "5 doz. 9 salt sellers" at sixteen pence each. Thomas Byles owned "86 pewr. salts" at ten pence each. John

12–19. Box, 1827–29, by Isaac Babbitt and William W. Crossman, Taunton, Mass., Diam. 4″ (Joseph France Fund, WM 60.334).

Andrew Brunstrom had "15 salt Sellars" at approximately six and a half pence each. In each case, the salts were the least, or nearly the least, expensive items in the inventory. The similarity of form and outline of Will's coffeepot covers and the salts attributed to his shop has often been cited, and it is of interest that in Brunstrom's inventory (the only inventory cited above in which molds are detailed) there is "1 Coffee Pot Mould complete" but no saltcellar mold is mentioned.

A substantial number of eighteenth-century American silver sugar casters with elaborately pierced tops, as well as pepper shakers with several small round holes in their covers, are known. But neither survivals nor inventory entries suggest that shakers or casters were often made by American pewterers before 1800. None of the inventories listing salts, already cited, contained shakers. Perhaps three or four dozen examples are known in two sizes, similar to the shakers illustrated in Figure 12–17 (group). Two large shakers of this form with smooth, flowing lines and beaded decoration are known with the marks of Thomas Danforth III and of Homan and Company of Cincinnati.[21] The marked Homan example has a beaded base above a straight, vertical foot, like the smaller shakers in Figure 12–17, whereas the Danforth example has no beading on a well-articulated, molded base with a bold ovolo, or quarter-round, molding above a straight, sloping foot like that on the two larger shakers illustrated. Others, as well, may have made similar shakers between 1790 and 1850.

Shaving dishes and lather boxes were offered by various britannia makers. Some

12–20.
Spittoon, ca. 1835–56, by Eben Smith, Beverly, Mass., H. 3″ (WM 65.1535).

12–21. Brass sundial mold and casting, 1750–1800, probably New England, Diam. 3½″ (WM 52.118).

marked *A G* (Fig. 12–18) were made by Ashbil Griswold in Meriden. They were offered with and without dividers, and some had mirrors on the inside in the raised portion of the lid.

Figure 12–19 illustrates a fine britannia box with slip-on cover made by Babbitt and Crossman of Taunton between 1827 and 1829, probably one of the shaving boxes mentioned in their advertisements.

Equally useful were shaving brushes with pewter handles of which a few examples are known.

In America, "the spitting was incessant," wrote Mrs. Trollope, and Mrs. Basil Hall commented that in the corners of the Lebanon, New York, Shaker Church with the "most beautiful polished floors I have seen in this country are spitting boxes that the floors may be preserved from such

12–22. Sundial, 1725–75, by Josiah Miller, New England, Diam. 4⁹⁄₁₆″ (collection of Mr. and Mrs. Thomas D. Williams).

12–23. Sundial, ca. 1800–1821, by Goldsmith Chandlee, Winchester, Va., 5⅛″ square. (WM 61.250).

contamination."²² The chewing of tobacco and the need for spittoons went hand in hand. Mrs. Trollope, when visiting Congress, noted the "vile and universal habit of chewing tobacco," and on another occasion acidly remarked on the "loathsome spitting, from the contamination of which it was absolutely impossible to protect our dresses."

Many britannia makers produced spittoons, and they were made at Bennington and other potteries as well. The 1855 Catalogue and Price List of the Meriden Britannia Company shows three versions priced from eighty cents for the handy "ring" design to $1.20 for the genteel "parlor" model. "Ring" examples with removable funnel-shaped tops were spun in the shops of Josiah Danforth and Eben Smith. An example from the Smith shop is illustrated in Figure 12–20.

The most common American pewter sundials are those with the name Josiah Miller (Fig. 12–22) or the initials *I M* or *N M* appearing in relief on the face of the dial. Reginald French has suggested that Josiah Miller was the maker of spoon, button, and other molds marked with an incised *I M* (and sometimes accompanied with an early eighteenth-century date).²³ He speculates on the possibility that the moldmaker *N M* was a relative, possibly a son, of Josiah Miller. Miller's dials are marked *42* for the forty-second parallel, which passes near Plymouth, Massachusetts, along the Connecticut-Massachusetts border and through Kingston, New York. Miller may have worked in Connecticut or western Massachusetts, where these dials have often been found. Josiah Miller's mold for making sundials was offered for sale around 1969 by Joan Morris, collector and antiques dealer, in Stamford, Connecticut.

Time pieces were expensive before the advent of cheap clocks with wooden movements in the early nineteenth century. For a large part of the population, the town crier, the church bell, and the sundial filled the needs of a people less time-conscious than we are today. Pewter dials were readily cast in brass molds (Fig. 12–21). (To pour a dial, a flat piece of iron was clamped against the open face of the mold and molten pewter poured in through the spout on the right.) Although this mold was found in New England, neither the latitude for which it was calibrated nor the date of the mold is known, but such molds were in early use. According to the *Boston Gazette* of April 8, 1742, "Spoon and dial molds & other tinker's tools" were found in the possession of a runaway servant.²⁴ Most pewter sundials range from two to four inches across and were made to be nailed on window sills.

Two pewter sundials of Goldsmith Chandlee (Fig. 12–23) are larger than usual and characterized by the careful detailing of the mold in which they were cast. Goldsmith Chandlee, son of Benjamin Chandlee, Jr., clockmaker of Nottingham Township, Chester County, Pennsylvania, moved to Winchester, Virginia, about 1800, where he carried on the brazier's business for several years.

In their search for "orders from town or country," pewterers and britannia makers went further and further afield in the nineteenth century. Connecticut pewterers increased their sales via the peddler, and the Connecticut Boardmans established branch outlets and manufactories in New York City and Philadelphia. One conglomerate, the Meriden Britannia Company, offered in its annual catalogue the widest possible variety of goods made of fine alloys produced by several britannia makers. This company, like many others, began to silver plate some of its britannia wares in the 1850's and within a few decades had completed the cycle from the hand-craft methods of earlier pewterers to the industrialization of the International Silver Company of the modern era.

Chapter Thirteen

The Collecting of American Pewter Before 1950

Americans began to collect pewter even before the craft died and while pewter was still being made: exactly when is not known, but probably in the 1850's, although possibly earlier. At first, collecting pewter, like other antiques collecting, was simply the gathering of bygones with historical interest. Cummings E. Davis, collector and colorful character of Concord, Massachusetts, began

> In the middle of the eighteen hundreds [to gather in] . . . everything that came his way: furniture, textiles, glassware, china, brass and pewter, historic relics—anything that had a Concord tradition or satisfied his strange feeling for historic values . . . with little knowledge of periods or styles and no preconceived ideas of what a collection . . . should be.[1]

In 1887 Davis's collections provided the foundation of the Concord Antiquarian Society, one of the best of the smaller historical museums in the country.

The interest in pewter just before and after 1900 is indicated by such articles as R. Davis Benne's "Some Rare Old Pewter," which appeared in two installments in the *Art Journal* of 1899, and "Pewter Ware" by Randolph L. Geare, published in *Scientific American* in 1903. A. L. Liberty contributed "Pewter and the Revival of Its Use" to the 1904 *Annual Report* of the Smithsonian Institution.[2]

During the next few years, a steady stream of contributions appeared in *American Homes and Gardens, House Beautiful,* and *Harper's Bazaar.* "Art in Pewter," a nine-part series, ran in *Keramic Studio* from November, 1906, through September, 1908. Information in N. Hudson (Hannah) Moore's "The Collector's Manual, Old Pewter," published in the *Delineator* of March, 1905, was expanded for her book *Old Pewter, Brass, Copper, and Sheffield Plate.*[3] In it, she devoted 83 pages to "English and American Pewter," with only 26 pages on "Foreign Pewter." The names of 33 American pewterers were included in an appendix.

Several marks and a longer list of pewterers (some with addresses determined from early city directories) appeared in *Pewter and the Amateur Collector* by Edwards J. Gale. Gale's chapter seven, entitled "The Collection," contains one of

the earliest general statements on the philosophy of collecting and display. Such lively interest in old pewter also stimulated counterfeiting, and he suggested:

It is probable that more porringers were made between 1900 and 1905 than in the preceding one hundred and fifty years, and [reproduction] jugs, flagons, and, more latterly, plates, pepper-pots and spoons are all on the market, and these may be found not only for sale by dealers, but well distributed in households far distant from any railway.[4]

Virginia Robie in "Pewter and Its Marks," published in *House Beautiful* in September, 1903, had commented, "It is painful to chronicle, but unfortunately true, that there is a great deal of sham pewter for sale . . . new pewter is made like the old, and is so clever a representation that it has justly aroused the wrath of collectors."[5] Porringers are particularly mentioned as something to be examined carefully before purchase.

Walter Alden Dyer in an essay, "The Pewter on the Dresser," in his book *The Lure of the Antique,* published in 1910, emphasized monetary aspects of collecting.

Ecclesiastical ware is rare in this country, and hence valuable, but the simple pieces that adorned the Colonial dresser stand highest in the collector's favor. . . . Such pieces have a money value, but that value is hard to determine. One writer sets the following values, . . . plates, eight to eleven inches in diameter, $1.25 to $2.50; plates and trenchers, twelve to sixteen inches, $3 to $6; 20-inch plates, $6 to $10. . . . Roughly speaking, plain tankards are worth from $10 to $15, teapots from $10 to $20, whale-oil lamps from $5 to $10, sugar-bowls from $4 to $5, plain plates of medium size from $5 to $10, and so on. [In comparison, he tells the reader:] Reproductions sell for prices something like these: flagons and tankards, $5 to $12

each; mugs, $1.50 to $3; candlesticks, $1.50 to $3; plates, about $2; more elaborate pieces, up to $16 and $18.[6]

The Hudson-Fulton Exhibition, held at The Metropolitan Museum of Art, New York, in 1909, was the first to include American pewter. Eight plates and two tankards marked by American pewterers were exhibited, and Dr. Edwin Atlee Barber explained briefly in the catalogue how pewter was made in colonial America.[7] He also commented on its widespread use and listed several of the prominent pewterers of New York and Philadelphia, including William Will, the maker of one of the tankards in the exhibition. Two years later, in 1911, the Copley Society Retrospective Exhibition of the Decorative Arts held at Copley Hall in Boston included 48 pieces of pewter lent by 10 different individuals. English, Swiss, German, Chinese, and Japanese pieces and one snuff box marked *P. Revere* were listed in the catalogue, but no others were identified as American made.[8]

The 1916 loan exhibition of pewter at the Museum of Fine Arts in Boston was the largest up to that time. "Over five hundred pieces including American, English, and Continental pewter, dating from the early seventeenth to the middle of the nineteenth century" were displayed. As reported in the museum *Bulletin,* "an effort was made to obtain as many marked American pieces as possible in order that the shapes produced by our craftsmen might be better known and their names and marks recorded." A small pamphlet "containing a bibliography, list of American pewterers and a short introduction on pewter" was prepared and sold by the museum.[9] Further recognition of the importance of pewter came in 1923 when another major art museum, the Wadsworth Atheneum in Hartford, Connecticut, arranged a "Loan Exposition of Pewter."

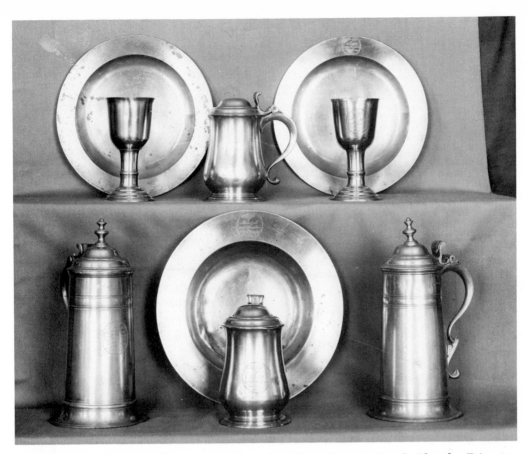

13–1. An English communion service from the First Congregational Church, Princeton, Mass. Shown in the 1916 exhibition at the Museum of Fine Arts, Boston.

Two lectures were given on the exhibition and in a supplement to the Atheneum's *Bulletin* were listed the names of 151 men or firms believed to have made pewter in America.[10]

An "Exhibit of American Marked Pewter" was held at the Twentieth Century Club in Boston during January of 1925. According to the report in *Antiques,* "The nucleus of the show . . . was provided from the comprehensive collection of J. B. Kerfoot, who sent not only a full series of eight-inch plates, but a number of his most important possessions in the way of bowls, coffee-pots, tankards and porringers."[11] Other lenders were Herbert Lawton, S. Prescott Fay, Mary Sampson,

George C. Greener, Dwight Blaney, and Henry Ford.

Kerfoot's book, *American Pewter,* had been published the previous November (1924). As a former editor of *Life* (1900– 18) and the author of *Broadway* and *How to Read,* Kerfoot was a skilled writer and a first-rate judge of human nature. The psychology of the collector interested him, and he wrote: "Two urges, then, meet in every collector—that of competitive rivalry and that of personal taste; and the desire to beat the other fellow, and the desire to follow one's own inclination."[12] As an antiques dealer he wrote on the pleasures of the game and the fine qualities of pewter:

There is no American pewter—not even the latest and most negligible—that is not rare enough to be collectible; . . . the lover of fine line, of pure form, or beautiful texture, does not have to deny his taste for the sake of competitive enjoyment. . . . The lover of craftsmanship cannot go wrong, competitively, while following his own bent here. Nor the student of our national past and of our social development. Nor the sentimental patriot, hunting eagles.[13]

Kerfoot suggested:

The ideal collection of American pewter would, therefore, probably consist of chosen specimens showing, not only all types of the ware made here, but each of the marks of each of the makers whose work survives. It would be a small collection . . . [and, as he pointed out elsewhere] expressive of the man [collector].[14]

Kerfoot's book was enthusiastically received. "Much of the narrative . . . is as absorbing as a detective tale," wrote the reviewer in *Antiques*. He called the book "the most contagiously zestful piece of writing for collectors, actual and potential, which has yet been published."[15]

Kerfoot in his advertisements, as in his book, challenged the collector's competitive instincts. He acted with style and bravado. In the June, 1926, issue of *Antiques* a brief announcement in his own handwriting centered on a full page of white space proclaimed:

The man who's been through The House with the Brick Wall [Kerfoot's shop], but hasn't seen the Metropolitan's new American Wing, is only half educated. J. B. Kerfoot.[16]

On another occasion, he advertised a splendid solid-handle porringer by David Melville with the statement: "Marked porringers by the rarer makers are des-

tined before long to take their place among the unobtainable rarities of American pewter. Remember that 'the good die young' because the wise buy early."[17] In his advertisement, "The American Pewter Mug," he challenged collectors to buy now:

Mugs, whether of quart or of pint size, marked by the earlier makers, are rare survivals in American pewter. The assembling of anything approaching a complete collection of these pieces is already extremely difficult and will soon be impossible.[18]

The idea of rarity was central to Kerfoot's scheme of collecting. He rated pewterers in four grades of comparative rarity: (1) those men by whom he had seen but a single plate; (2) those makers by whom he had seen two or three plates; (3) those makers by whom he had seen not more than ten or twelve plates; and (4) the rest of the pewterers.

In the last eight pages of his book Kerfoot provided the names of all the known American pewterers (with spaces for a few yet to be discovered) and a column for each of the forms known at that time. The resulting 15,360 squares gave the collector ample opportunity to check off every form that he owned or saw.

In December, 1926, Kerfoot did what no antiques dealer had done before. He published a priced checklist of marked American pewter in the belief that "it would be of service to collectors and dealers alike to have a measurably valid criterion of American pewter values established." His claim of having "handled nearly two thousand pieces of American pewter" lent validity to his price list, which he proposed to continue "until an American pewter equivalent of the Scott stamp and coin catalogue shall be available to all who wish to be guided by it either in buying or selling."[19]

The prices in his first checklist ranged from $17.50 for an 8-inch plate by B. Barns to $275 for a 15-inch dish by Frederick Bassett. His May, 1927, installment included basins, porringers, and mugs, ranging in price from $25 for an 8-inch basin with an unidentified eagle mark to $160 for a 12-inch basin by George Lightner of Baltimore; a crown-handle porringer marked *I G* was listed as low as $25; and three different versions of porringers by the Melvilles of Newport were valued at $150 each. Mugs by Boardman and Hall were offered at $40, whereas a quart mug by Frederick Bassett commanded the princely sum of $350.[20] During the 1930's and 1940's these prices seemed very expensive, whereas today they appear to be extremely modest.

A few days before the May, 1927, list appeared in print, Kerfoot died while traveling abroad. A flamboyant figure, his enthusiasm for American arts was unbounded, and few others have left a greater impression upon the collecting public than John Barrett Kerfoot.[21]

The buying of pewter declined after Kerfoot's death and the 1929 stock market crash, but interest remained keen, and on March 21, 1934, The Pewter Collectors' Club of America was organized in the Old Boston State House at the suggestion of William Germain Dooley, the antiques-page editor of *The Boston Evening Transcript*.

The goals of the club, as stated in the first *Bulletin*, were: "To foster study and research in the field of American pewter and to cooperate in the studies of those interested in English and Continental pewter." Members agreed that:

> Collections of antique pewter in all forms will be encouraged. Membership will be extended to all students and collectors of pewter in this country and one of the chief functions of the Club will be to act as a clearing house of information on pewter and pewterers. Touch marks will be recorded and every effort will be made to acquire knowledge of hitherto unknown pewterers and their marks, and to expose spurious touch marks and all forms of faked pieces and faked marks.[22]

In 1935 the club held an impressive exhibition at the Boston Public Library and published an illustrated catalogue with a

13–2. An overall view of the exhibition held by The Pewter Collectors' Club of America at the Boston Public Library in 1935. Courtesy Paul J. and Edna T. Franklin Archive; Charles Darling, photographer.

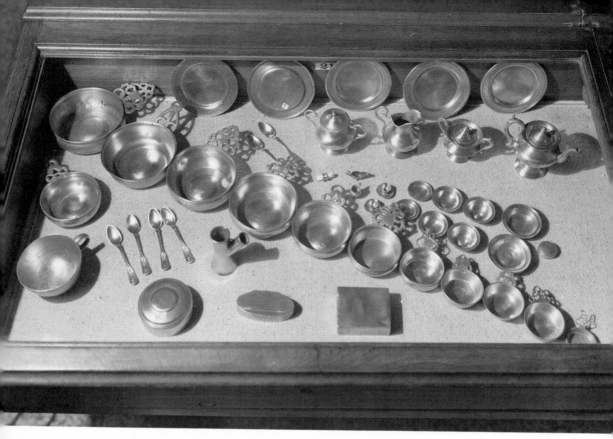

13–3. American pewter on exhibition, The Pewter Collectors' Club of America, Boston Public Library, 1935. Courtesy Paul J. and Edna T. Franklin Archive; Charles Darling, photographer.

fine bibliography. Dr. Percy E. Raymond, Harvard professor of paleontology, was a mainstay of the club and longtime editor of the *Bulletin*. He wrote many articles and bedeviled others to contribute to the two or three issues published annually.

Bound together, the copies of the *Bulletin* make three thick books that provide a running account of pewter discoveries—both of objects and information—during the years since the club's founding.

Although during the 1930's there was little trade in old American pewter, at least two dealers had substantial stocks. Several hundred pieces were owned and offered for sale by Mrs. Kerfoot, who continued her husband's shop after his death. Phillip G. Platt of Wallingford, Pennsylvania, also had fine pewter. But both dealers were dispirited and unable to bring

themselves to make the drastic price reductions necessary to encourage buying. During the middle 1930's John W. Poole, a traveling representative of the Lion Oil Company, and the present writer, at that time a member of the Education Department of the *New York Herald Tribune,* were among the few people actively seeking early American pewter. In 1935 and 1936 Poole wrote seven excellent articles for the antiques page of the *New York Sun.*[23] These scholarly, well-illustrated articles carried by a large metropolitan daily newspaper stimulated interest in pewter. Yet the prices realized at the 1938 New York auction of Albert C. Bowman's collection were depressingly low, despite favorable auspices for the success of the sale. The collection was the lifetime accumulation of Mr. Bowman, owner of a

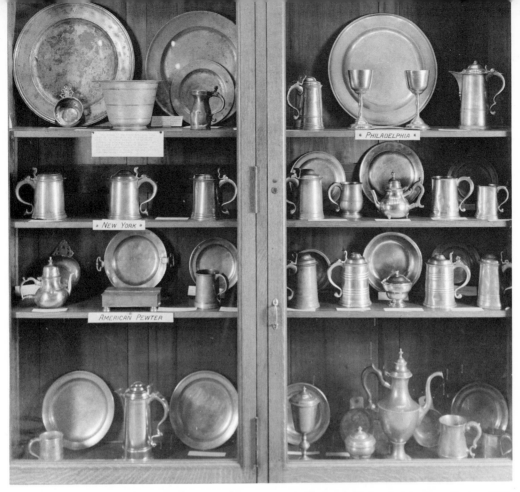

13–4. American pewter on exhibition, The Pewter Collectors' Club of America, Boston Public Library, 1935. Courtesy Paul J. and Edna T. Franklin Archive; Charles Darling, photographer.

13–5. Great rarities of American pewter on exhibition, The Pewter Collectors' Club of America, Boston Public Library, 1935. Courtesy Paul J. and Edna T. Franklin Archive; T. F. Hartley, photographer.

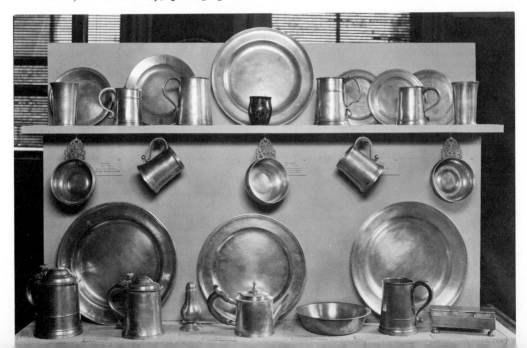

13–6. A display of the pewter of P. G. Platt, Wallingford, Pa., at the Boston Antiques Exposition, 1930.

13–7. The John W. Poole Collection of American pewter as it appeared in 1974 at The Brooklyn Museum, New York.

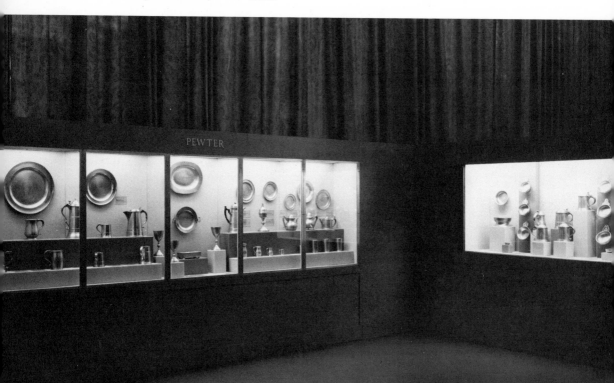

shoddy mill in Springfield, Vermont.[24] A meeting of The Pewter Collectors' Club of America, held the day before the auction, brought many members to New York for the dispersal at the American Art Association, Anderson Galleries. Nevertheless, the more than 400 marked pieces, sold in 218 lots, realized only modest prices: $235 for a small flat-top tankard made by Frederick Bassett and $245 for another by Henry Will. The price of $160 for a pair of Peter Young chalices seemed high to this writer, who had purchased P. G. Platt's pair for $110 two days before. When a year later 161 pieces of pewter, the remainder of Platt's collection, were sold at the same New York auction house, a highlight was a unique solid-handle porringer made by Thomas Danforth III during his Philadelphia period.[25] Knocked down at $250, the highest price of the sale, it was bought for Charles K. Davis from whose collection it passed to the Winterthur Museum in 1967.

Among early pewter collectors the name of Louis Guerineau Myers stands high as a man of wit and learning interested in form and maker. The history of the pewter craft in America fascinated him. Having begun to collect in 1904, he had acquired a splendid collection by the mid-1920's. In 1926 he published a delightful book, *Some Notes on American Pewterers*, but soon after he sold much, perhaps all, of his pewter collection to Francis P. Garvan of New York.[26] Although the latter's interest in pewter was second to his passion for American silver and furniture, it was nevertheless strong, and he gave more than 200 pieces to Yale University in 1930 and 1931 in honor of his wife, Mabel Brady Garvan. Mr. Garvan appears to have made the first large gift of American pewter to a public institution. Similarly, the printed catalogue of his collection, which comprises the major

part of Yale's holdings, when published in 1965, was the first major museum catalogue of pewter.[27] Highlights of the Yale collection are eighteenth-century tankards, mugs, and beakers, a flagon and covered chalice by Johann Christoph Heyne, a unique foot warmer and a superb flagon by Henry Will, a 16-inch completely hammered dish by Simon Edgell, and a Queen Anne style teapot by Thomas Danforth II or III.

As early as the 1890's Mr. and Mrs. Stephen S. FitzGerald were seeking antiques in the Massachusetts countryside with which to furnish their Weston house, but it was not until the middle 1930's that Mrs. FitzGerald began to collect American pewter. Extremely generous, she gave Connecticut Valley pewter to the Governor Pynchon Memorial in Springfield and several unique pieces to the American Wing of The Metropolitan Museum of Art, including quart, pint, half-pint, gill, and half-gill mugs marked by Samuel Danforth. Most of her well-rounded collection she bequeathed to the Museum of Fine Arts, Boston, in 1963.[28]

Beginning in the late 1920's, Dr. Madelaine R. Brown of Cambridge, Massachusetts, was singularly successful in finding pewter made in Providence and Newport. When she bequeathed her collection to the Newport Historical Society in 1968, it included almost all the known forms of Rhode Island pewter, several of which are unique.[29]

During the 1920's and 1930's Mrs. J. Insley Blair of Tuxedo Park, New York, actively collected early American decorative arts of all kinds. The quality of her donations of furniture—especially of early painted and decorated examples—and of pewter to The Metropolitan Museum of Art mark her as one of the most discriminating of American collectors. Among her gifts of pewter are the well-known John Will tankard with wriggle-work decora-

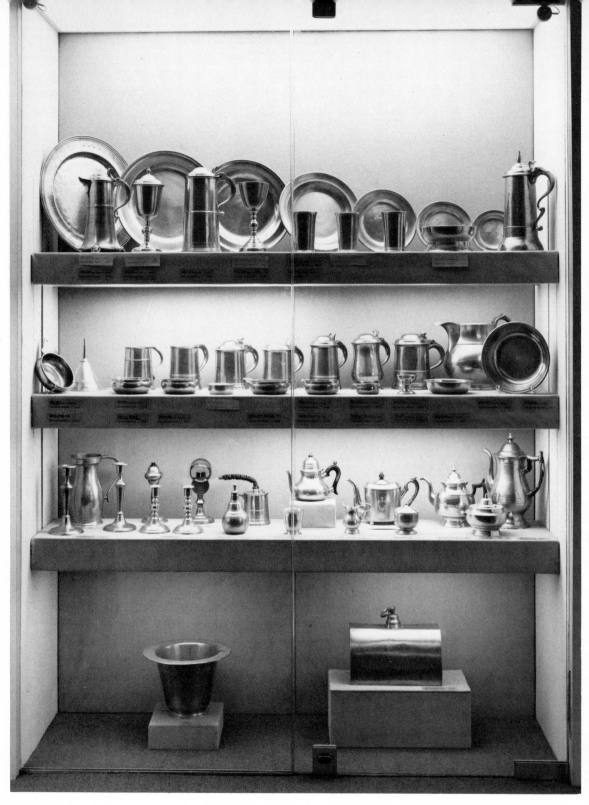

13–8. A case of pewter in the Mabel Brady Garvan Galleries, Yale University Art Gallery. Most of this pewter was collected and given to Yale by Francis P. Garvan before 1931.

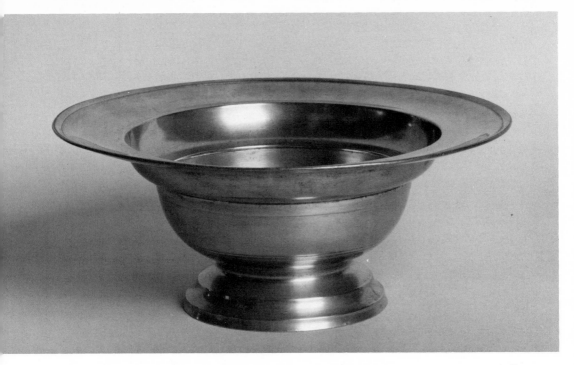

13-9. Footed baptismal basin, ca. 1835, by Israel Trask, Beverly, Mass., H. 4⅛″. Collection of Agnes FitzGerald. (Museum of Fine Arts, Boston)

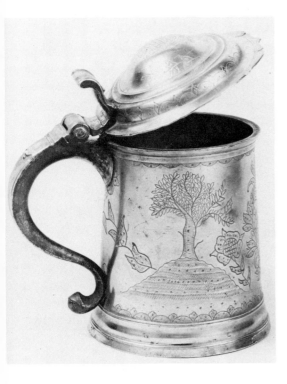

13-10. Tankard, ca. 1750–60, by John Will, New York City, H. 7⅛″. (The Metropolitan Museum of Art, New York: Gift of Mrs. J. Insley Blair)

The Collecting of American Pewter Before 1950/215

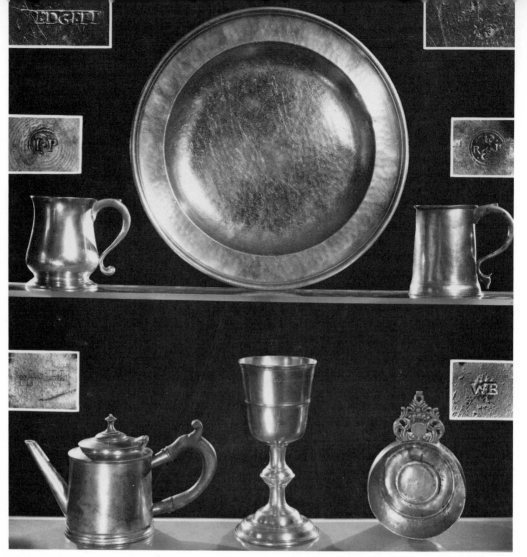

13–11. Choice pewter in the collection of Joseph France. The great hammered, single-bead dish in the center is by Simon Edgell, w. 1713–42, Philadelphia, Diam. 14¾". Most of the France pewter was given to The Metropolitan Museum of Art about 1940. Holmes I. Mettee, photographer.

tion and the unique Joseph Leddell basin (Figs. 13-10 and 4-5). About 1940 she also presented to the Cooper Union Museum several rare pewter reflector sconces as a part of her lighting collection.[30]

In 1944, Joseph France, another collector of the late 1920's and 1930's, magnanimously offered The Metropolitan Museum of Art the heart of his collection—the choice of whatever Joseph Downs, then curator, deemed important for the American Wing (excepting only porringers from

his offer). This gift of 44 pieces included a marked Heyne chalice, a 15-inch hammered Simon Edgell dish, and two William Will teapots.[31] In 1957, Mr. France gave to the Winterthur Museum many plates and dishes, and in 1965, he presented to the William Penn Memorial Museum in Harrisburg, Pennsylvania (formerly the Pennsylvania State Museum), 96 American porringers, the most comprehensive collection ever brought together.

Many, but not all, pewter collectors chose to give their collections away. And some museums seized the opportunity to buy a private collection. In 1938, The Currier Gallery of Art, Manchester, New Hampshire, purchased about 200 pieces from the Edward Pushee estate of Weston, Massachusetts, and in 1945, The Brooklyn Museum bought the outstanding 246-piece collection of John W. Poole. Especially rich in the work of eighteenth-century craftsmen, the Poole collection included a unique 15½-inch oval platter and inkstand made by Henry Will, a rare sugar bowl made by Johann Christoph Heyne, eighteenth-century teapots made by William Will, Parks Boyd, and the pewterer of the "love bird" touch. On this foundation, the museum, under the curatorship of John Graham, continued to build a very fine collection.

Some collections were widely dispersed. Consider, for example, the pewter and britannia owned by Charles F. Hutchins, president of the Standard Foundry in Worcester, Massachusetts. Hutchins, who began to collect American antiques before 1910, acquired more than 600 pieces of American pewter and britannia before his death about 1950. Of these he bequeathed a small number of outstanding pieces—among them a hot-water plate by Henry Will and a fine tankard by Cornelius Bradford—to the Worcester Art Museum. A dozen pieces from his collection went to the Winterthur Museum, among them a splendid 19-inch dish made by Simon Edgell. The balance, acquired by Carl Jacobs, was sold to more than 50 collectors and dealers. Another collector, Mitchell Van Winkle of Litchfield, Connecticut, and Rye, New York, who started

13–12. Collection of Charles F. Hutchins, Worcester, Mass., about 1940. Courtesy Paul J. and Edna T. Franklin Archive.

almost as early as Hutchins, chose to dispose of his collection while he was still alive. Among the 93 pieces sold at auction at the Anderson Galleries in New York in 1938 were a fine pair of 6-inch plates marked *N. England* by one of the Melvilles and an extraordinary pair of large two-handled beakers by T. D. and S. Boardman.

13–13. This largest-known single-bead American dish was made by Simon Edgell, w. 1713–42, Philadelphia, Diam. 19″. (WM 53.28)

13–14. Collection of Mrs. John B. Jameson, Concord, N.H., about 1940. Courtesy Paul J. and Edna T. Franklin Archive.

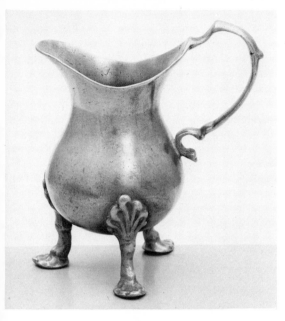

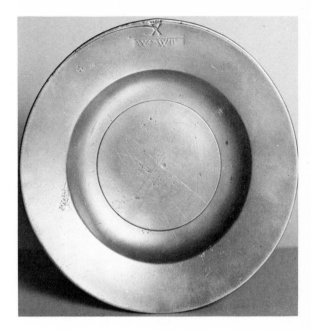

13–15. Cream pitcher, ca. 1750–70, by John Will, New York City, H. 4″. Acquired from the collection of the Honorable Richard S. and Mrs. Quigley by Henry Francis du Pont about 1960. (WM 65.2756)

13–16. Small plate made by William Will, w. 1764–98, Philadelphia, Diam. 5⅝″. Acquired from the collection of the Honorable Richard S. and Mrs. Quigley by Henry Francis du Pont about 1960. (WM 58.650)

Another early collector, Mrs. John B. Jameson of Concord, New Hampshire, and one of the first members of The Pewter Collectors' Club of America, sought 8-inch plates. Between 1920 and the time of her death in 1952 she found examples by approximately 50 different pewterers.

In his extensive travels back and forth from Washington to his native Ohio, Albert H. Good, an employee of the National Park Service, found many pewter prizes. Among them was the great "Captain Ickes" quart mug (later acquired by Charles K. Davis and now at Winterthur), a pair of Peter Young chalices, and two 14-inch *Boardman Warranted* basins.

Between 1920 and 1936, the Honorable and Mrs. Richard E. Quigley of Lock Haven, Pennsylvania, collected about 150 pieces of American pewter. Among many pieces in their outstanding collection was

a small cream pitcher made by John Will and six pieces from the shop of his son, William Will. Made by that notable Philadelphian were a superb coffeepot, two teapots (Figs. 11-5 and 11-8), quart and pint mugs, and a 5½-inch smooth-rimmed plate. Henry Francis du Pont was delighted when the Senator and Mrs. Quigley offered their collection to him in 1955 and readily agreed to its purchase.

The finest exhibit of American pewter ever brought together was held at The Metropolitan Museum of Art in 1939. Joseph Downs, curator of the American Wing, wrote in the museum *Bulletin* of the twofold purpose of the exhibition:

First to show the diversity of form which the earlier pewterers gave to their work, with attention paid to both the sleekness of the contours and the quiet beauty of the metal, and second to show the widest

13–17. Installation view of the special exhibition "American Pewter" at The Metropolitan Museum of Art, 1939. A plaster cast of the mark on each piece of pewter was shown with it.

variety of clear and complete touches, or makers' marks.[32]

Collectors were especially delighted to find plaster casts of the touch mark placed beside each piece, which enabled the visitor to see at a glance the nature of the original mark. Although the exhibition did not include the work of every known maker, it still stands as the most comprehensive collection ever assembled, comprising about 370 marked pieces, chosen for their form and variety, and dating from the seventeenth, eighteenth, and nineteenth centuries. This exhibition gave new impetus to pewter collecting, especially to John W. Poole and Edward E. Minor, who had begun collecting in 1934.

In Minor's old farmhouse in Mount Carmel, Connecticut, a mantel shelf and corner cupboard were already filled by 1939 with excellent dishes, plates, porringers, mugs, tankards, and beakers. Drinking vessels were his chief interest. As illustrations in *Pewter in America* suggest, Minor's pewter, which he lovingly cleaned and polished, was outstanding for its quality and its condition. In 1943, when no more tankards were to be found not already represented in his collection, he reluctantly exchanged his pewter, a piece at a time, for silver. When he died in 1951, his pewter had been transformed into a small but superb collection of American silver, some of which can now be seen at Historic Deerfield, Deerfield, Massachusetts, and at Bayou Bend in Houston, Texas.

Other enthusiastic new collectors were Melville T. Nichols of Medford, Massachusetts, and Charles K. Davis of Fairfield, Connecticut. Between the late 1930's

and 1950, Mr. Nichols assembled the largest collection of American pewter ever brought together. When sold in 1950, it numbered almost 1,000 pieces, with representative examples of most known marks and all important forms. His scientific filing system and specially built cabinets enabled him to locate any desired example in a matter of minutes.

The collection of Mr. Davis, former president of Remington Arms, was more personal. It never totaled more than 300 pieces, but probably included as many superb and extraordinary pieces as any private collection. Among them were a Heyne flagon, some 15 marked American tankards, the "Captain Ickes" (Fig. 3-1), and other quart mugs, chalices by Peter Young and Timothy Brigden, Queen Anne style teapots by William Will, and outstanding porringers and dishes. Mr. Davis gave a representative collection of Massa-

13–18. A mantel shelf with American pewter in the Mount Carmel, Conn., farmhouse of Edward E. Minor about 1939.

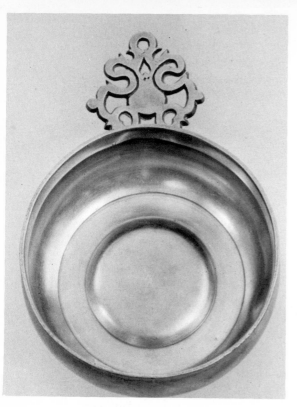

13–19. A rare New York porringer with "Old English" handle by John Bassett, w. 1720–60, New York City, Diam. 4⅜". From the collection of Charles K. Davis now at the Henry Francis du Pont Winterthur Museum. (WM 67.1372)

13–20. Master Members badge, The Pewter Collectors' Club of America. Designed by Paul J. Franklin about 1940 to be given to members of five-years' standing.

chusetts and other New England pewter to the Society for the Preservation of New England Antiquities and 64 pieces of Connecticut pewter to the New Haven Colony Historical Society.[33] Beginning in 1953 he also presented pewter, britannia, and some of his finest American silver to the Winterthur Museum. Prior to his death in 1967 Charles Davis had given away the bulk of his pewter collection, retaining only a small number of pieces which were especially meaningful to him. Of these, Henry Francis du Pont bought 12 for the Winterthur collection.

Mr. du Pont began to collect pewter in 1923, and by 1939 had an excellent small collection from which 11 pieces were selected for inclusion in the 1939 Metropoli-

tan Museum exhibition: a flat-topped tankard with strap handle attributed to Joseph Leddell, Sr. or Jr. (Fig. 6-17); a quart tankard and mug by John Will (Fig. 6-4); beakers by Ebenezer Southmayd (Fig. 4-12) and Boardman and Hart; plates by Blakeslee Barns and Plumly and Bidgood; spoons by Whitehouse and T. Hill; a pitcher by F. Porter (Fig. 7-6); and a Boardman and Hart two-gallon basin with cover (Fig. 8-11). One of Mr. du Pont's early purchases was a great 16⅜-inch dish made by William Will, formerly in the collection of Maurice Brix of Philadelphia. Later, when it was suggested to Mr. du Pont that it might be possible to acquire a whole cupboard of pewter showing the full range of forms

made by the talented Philadelphian, he entered upon the chase with enthusiasm and over a 25-year period acquired 37 pieces representing 27 different or variant forms. These, now displayed in a corner cupboard and an adjacent spoon rack in the Fraktur Room at Winterthur (Fig. 1-1), testify to Colonel Will's versatility. Some pieces came by gift and others by purchase from the Quigley, Davis, France, Hutchins, Minor, and Nichols collections, as well as from Mrs. Harry Horton Benkard of Oyster Bay, Ivan Culbertson of Wilmington, Delaware, and Charles A. Calder, a descendant of William Calder and a pioneer Providence, Rhode Island, collector, who was actively collecting before 1920. An equal number of pieces (37) marked by the Richard Lees (father and son) were bequeathed by Mark C. La-Fountain to the Art and Historical Society, Springfield, Vermont. However, the Lees, who worked in rural New England and made several different sizes and styles of porringers, had far fewer molds than Colonel Will and no molds for the large, impressive forms that he produced.

Since 1950 at least 50 new collectors have brought together interesting groups of pewter—some of which follow a specific theme such as Connecticut pewter, New England pewter, Pennsylvania pewter, Cincinnati pewter, britannia, drinking vessels, and so forth. Increased interest has meant larger, more lively, and scholarly meetings of The Pewter Collectors' Club of America, and attendance by more than 100 members is not unusual. At a recent meeting in Lancaster, Pennsylvania, many pieces of church pewter made by Johann Christoph Heyne and William Will, several of hitherto unknown form, were assembled for the delight and edification of collectors who had come from as far away as North Carolina, Michigan, and Illinois.

Today, fine collections of American pewter are on permanent display in almost 50 American museums. With few exceptions, the cornerstones and foundations of those collections were gifts or bequests from serious collectors who prized the metal and the objects made from it. Their names belong on a roll of honor, and insofar as I am able to discover them, they are listed at the back of this book. I am grateful to those collectors and so is the growing number of noncollectors who are discovering the beauty of old American pewter.

Collecting American Pewter Today

In response to the questions, "How do you collect pewter? How do I become a pewter collector?," I can best answer that I began when I saw a 13-inch deep dish in mint condition. Caught by its beauty I bought it for $5.00. It changed my life. I didn't start out with the idea of being a collector, and I doubt that most people do. They just drift into it and before they know it they are haunting antiques shops and art galleries, going to auctions, and visiting museums. Life takes on a new luster. When you have bought ten or more pieces of pewter, I suggest that you stop and think about the idea of collecting and the kinds of things that appeal to you most or seem to have some special significance to you. Today there is a good deal of pewter on the market, and you have latitude in the choices you make. Consider the idea of selection and selectivity. You have options, and the way you exercise them will influence the nature of your collection and the pleasure you derive from it. Almost every month, several auctions feature a few pieces of britannia and pewter; dealers advertise pewter regularly in antiques magazines; one or more booths in most antiques shows have displays of pewter; and at least three dealers have stocks of from 50 to 300 pieces. Those three dealers, all in Connecticut,

are Celia Jacobs Stevenson of Granby, John Carl Thomas of Jewett City, and Thomas D. and Constance R. Williams of Litchfield. Hence, you as a pewter buyer have more latitude than the collector of furniture or painting in that pewter takes less space, and, unlike a chair, need not fit a particular place.

During the past 30 years, prices of American pewter have risen ten times or more. The competition has been intense and there are good reasons for the very active market. Because so many pieces of pewter are marked, identification by mark or form and ornament is readily possible, hence buyer and seller know what is being bought and sold and can compare the price with established values. There is enough pewter available to provide the basis for a market. There are reliable and good books and much literature on the subject. The *Bulletin* of The Pewter Collectors' Club of America provides a clearinghouse for new information. Collectors are urged to share new discoveries through its pages and at the frequent meetings of the club. Those meetings are also social affairs where lasting friendships are formed. All in all, collecting American pewter is a great game that for the knowing has provided a fine investment and beautiful things in the home.

Dr. Raymond, upon his retirement in 1948 as president of The Pewter Collectors' Club of America, recounted appealing reasons for collecting in his address entitled "Why Collect Pewter." Because of the insights it offers, I quote from it with pleasure. He began:

We are sometimes asked to give a reason for the faith that is in us. What follows is not a disquisition upon collecting in general, or propaganda for collecting pewter in particular. It is, rather, an apologia for what some may deem a useless pastime, a statement of the satisfaction to be obtained, and the advantages to be derived, from the pursuit of the humble grey metal. It is, perhaps, more a summary of the writer's own experience than a treatise on the subject. Hence, the personal pronoun probably will appear too often.

A HOBBY

Nothing is more discouraging than middle or old age without a hobby. . . . There are hundreds of possible hobbies, but collecting pewter is a good one. There is enough of it still extant to enable everyone to get some, it is cheap enough and expensive enough to satisfy every purse. . . . Since comparatively few people collect it, most of one's friends and acquaintances are curious about it. It gives opportunities to talk for hours, with a distinct sense of superiority. It is not necessary to know all about it; no one does. The careful choice of a small collection may occupy as many years as the acquirement of a large one, gathered in a haphazard fashion.[34]

For the person who would decorate his house with pewter, there is a wide choice of plates, dishes, mugs, canisters, and other things. Pieces may be English, Dutch, French, Chinese, or American. Unquestionably they will make your home more interesting, but they do not constitute a collection in the true sense of the word.

As you go about acquiring pewter, a piece here and another piece there, you will become aware of the rules of the game. Certain ideas, conventions, and traditions seem to govern the prices by which pewter changes hands. Many of these go back a long time and were first determined by the master collector-dealer, John Barrett Kerfoot. Every collector ought to read his book, *American Pewter*, from cover to cover. It is delightful, but keep in mind what he is doing to you as you read about the eight-inch-plate men and the four degrees of rarity. He is

sharpening your appreciation of rarity and your spirit of competition. He is setting forth a set of values that to a large degree influence the pewter market to this day. For Kerfoot, the epitome of American pewter was the flat-lidded tankard, and he describes one by Frederick Bassett as being "as beautiful an example of the work of the American pewterer as I have ever seen." Rarity and age were the major criteria for the prices he published in *The Antiquarian* and *Antiques* in 1926 and 1927. Undoubtedly his publication of prices in an era when there was much secrecy about values did much to establish confidence in the minds of such collectors as Mrs. J. Insley Blair, Henry Francis du Pont, Francis P. Garvan, and Louis Guerineau Myers.

In his lists Kerfoot made no mention of how he valued quality of metal or the clarity of a mark. However, as early as 1939 this writer prized condition of both metal and mark and took both into consideration in establishing the price to be asked. Kerfoot's prices were highest for tankards. Because of their rarity, by the same token, six-inch plates commanded about the same prices as large dishes. Further, their small size made them easier to display and consequently easier to sell. The aura given the Bassetts and the Wills by Kerfoot lingered on, and any object made by them was in demand.

In 1935 and 1936 in a series of excellent articles in the *New York Sun*, John W. Poole stressed quality of workmanship and the desirability of particular forms. An active collector himself, Poole was the first to praise early teapots and argued that as collectors' items the Queen Anne style teapots of William Will "cannot be surpassed."

In 1946 when Aurie Johnson, a gentle and thoughtful beginning collector, asked "what pieces of pewter do you recommend? What ought a collection be?," my wife and I compiled a representative list entitled "A Fifty-Piece Basic Collection of American Pewter." In a short introductory essay we called attention to the fact that most people "know little about pewter or the part it played in the lives of the common man during that century of emergence, 1750–1850," and that a collection for teaching and suitable for display in a local museum "doesn't mean a hodgepodge of odds and ends. It means a well-rounded, good-looking collection complete in itself, and ready to tell the whole story of American pewter." Our 1946 list follows.

A Fifty-Piece Basic Collection of American Pewter
Suitable as a Gift to a Museum or a Historical Society

1 6" Plate	
6 8" Plates	Boston, narrow brim, eagle mark
	Connecticut Revolutionary period
	Rhode Island, narrow rim
	New York, hammered if possible, or Albany hammered
	Baltimore, eagle marked, or Connecticut, or Southern, eagle marked
1 9" Plate	Smooth rim, hammered if possible
1 10" Plate	Church collection plate
1 11" Dish	Deep type, or shallow type
1 12" Dish	Shallow type
3 13" Dishes	Deep type
	Semi-deep Rhode Island type
	Shallow, New York or Boston type, or a 14" Newport dish
1 15" Platter	Boston, New York, or Philadelphia
2 Basins	6" (pint)
	8" (quart)

6 Porringers	Taster, 2¼″ R. Lee type Basin type, 3″ EC, R. Lee, or Samuel Danforth type Geometric handle 4″ Boardman or Danforth type, or Geometric handle 5″ Samuel Danforth or Bassett type Crown handle 4″ or 5″ SG, RG, IG, or New Yorkers Flowered handle 5″ Hamlin type Solid handle 5″ Newport type, or Pennsylvania type		1 Sugar bowl		
			2 Candlesticks	Pair	
			4 Lamps	Sparking lamp Saucer-base lamp 1 pair tall lamps	
			1 Sundial or inkwell		
			1 Baby bottle, or pap boat, or dram bottle		

5 Spoons & Ladles	ca. 1710 wavy- end rat-tail type ca. 1750 mid-rib rat-tail type ca. 1770 mid-rib shell drop on bowl ca. 1790 pointed handle, spoon or ladle ca. 1800 fiddle-shape spoon or ladle	Probably all unmarked or with cast initials

2 Mugs	Pint straight sided with S-shaped handle Quart straight sided with S-shaped handle
1 Tankard	Straight sided or bulbous American tankard with bud or fish-tail handle terminal
2 Beakers	3″ straight sided 5¼″ tall church beaker, Connecticut
1 Chalice	The taller the better
1 Flagon	The Boardmans and Samuel Danforth made beautiful flagons
3 Pitchers	2-quart open type 3- or 4-quart lidded type Small cream pitcher (marked ones are hard to find)
3 Teapots and Coffeepots	1 small round pear shape 1 lighthouse 1 tall bulbous, or a medium height, round type

Although we arrived at a specific list and obviously had many guidelines in mind, we failed to state them or to be explicit about the principles we were following. Beginning with a discussion and definition of the idea of a collection, I propose to do this in the pages that follow.

Webster centers the definition of the word *collection* around the idea of "gathering" but notes specifically that collection usually implies some order, arrangement, or unity of effect. Clearly, to most of us a collection means something more than a mere aggregation or accumulation. Inasmuch as a great deal of thought is usually given to the selection of furniture, prints, paintings, silver, and other objects whose primary purpose is to furnish and beautify a home, the furnishings of some houses are often thought of as a collection and, indeed, often constitute a group of related and beautiful, rare objects. To the degree that the furnishings are beautiful and harmonious, they may or may not constitute a collection. For a museum collection the goal must be broad. The collection must instruct as well as delight.

A young book collector, William Reese, describes a collection in these words:

A mass of objects becomes more than an accumulation and moves into the realm of a collection when the whole is greater than the sum of the parts. When each object finds a reflection in some other

piece; when groups suggest patterns of development that are indistinguishable in only one or two specimens, and when the whole serves to accentuate a diversity or a similarity of thought, then the goal of a collector begins to be reached. No randomly or blindly chosen accumulation can do this. In the best collections the accenting each piece lends to the others is so subtle that the highlighting of certain characteristics occurs naturally and without effort. The best collections are not merely aggregations of valuable objects; they are statements of a powerful and extraordinary intellect. Such a collection stands as a luminous chronology of the occurrence of things.

An intellectual quality does indeed mark the great collection. In its ordering and selectivity it will make its points and at the same time be all-inclusive. It will illustrate the craft of the pewterer and the taste of the society for which the pewter was made. The first-rate collection should provide an overview of pewter making in America and illustrate insofar as possible the beginning and the end and a fair representation of the classics of American pewter. Some collectors may choose more limited fields such as those suggested by the chapter titles of this book—church pewter, lighting, drinking vessels, etc. Others may seek only the work of New York, Connecticut, or Pennsylvania pewterers, or the products of one family such as the Bassetts, the Danforths, or the Wills. Some may opt for britannia. Others may prefer the monuments of the eighteenth century. Whatever the area chosen, there are certain guidelines that apply.

Condition. Condition is important. Pitted pewter or that from which the pitting has been removed by buffing usually turns out to be a poor acquisition. Neither the effects of pocking nor the hard shiny surface of buffed metal can be eliminated. A buffed piece will never approximate the beauty of old pewter in pristine condition.

Fine Marks. A fine and complete mark is a beautiful thing and makes a good piece of pewter better. However, I would never pass by a wonderful form in good condition for want of a fine mark. Indeed, many advanced collectors regularly buy unmarked pieces that they can or hope to identify on the basis of form.

Hammered Wares. Plates and dishes with hammered booges are preferred, and those dishes by John Edgell and Edmund Dolbeare (Figs. 8-2, 8-3), hammered all over their surface, are a collector's delight. Greatly to be desired, also, are those rare tankards with hammered barrels attributed to Benjamin Day (Fig. 6-21).

Range of Size. Flatware, from a five- or six-inch plate to a 16-inch dish, and basins, from one pint to two gallons, serve to dramatize the range of size and variety of plates and dishes, which may include shallow, semi-deep, and deep forms.

Chronological Series. Marks representative of the various periods—rose and crown, and lion marks of the earlier pewterers, eagle marks for those of the Federal period, and simple straight line touches of the later makers as in Figure 3-4—and a series of spoons showing the stylistic changes that took place from the seventeenth to the mid-nineteenth century would be most interesting (Figs. 10-3, 10-6). Although spoons are extremely rare, old spoons should be acquired whenever possible, otherwise recent castings from old molds will suffice.

Regional and Personal Expressions. The New England strap-handled mug (Fig. 6-5) is a regional expression. The mugs of Connecticut (Fig. 6-7) are modeled on English prototypes, and the strong, tall, high-banded New York examples (Figs. 6-3, 6-4) are probably personal statements of the Bassetts and the Wills. Similar relationships appear in porringers. The crown and geometric handles are modeled on English examples, whereas

the plain (Fig. 9-12) and the flowered (Fig. 9-11) handles of Rhode Island and the imaginative designs of the Richard Lees (Fig. 9-4) are American innovations. Because the rose-marked examples by Samuel Hamlin (Fig. 9-11) are probably the first of their style, they are of greatest interest.

Fabrication Techniques. Pewter and britannia objects offer contrasts of form and of fabrication techniques employed— casting and skimming for pewter and stamping, spinning, and seaming for britannia.

Inscriptions, Engraving, Provenance. The facts and the symbols of earlier ownership lend an aura and a prestige to an object that is difficult to evaluate, but which is of much importance. Inscriptions may indicate date, ownership, or commemorate the early use of an object. Consider, for instance, the pewter chalice (Fig. 4-33) of Christ Church Parish, West Haven, Connecticut, made by Joseph Leddell of New York and inscribed "Drink ye All of this 1744," or the Frederick Bassett mugs (Fig. 4-3) inscribed "Lieut Uriel Holmes's Gift to Hartland Church," or the mug (Fig. 3-1) inscribed "Liberty or Death Huzza for Capt. Ickes" above the engraved portrait of the captain astride a spirited horse, or the John Will tankard (Fig. 13-10) in the collection of The Metropolitan Museum of Art with engraving covering its entire barrel. The richness of its ornament is comparable to that of two fluted New York dishes, one which is dated 1728 (Fig. 8-9) and the other which bears the mark of Francis Bassett and is dated 1732 (Fig. 8-9). Their ornament and inscriptions put them in a class by themselves among the classics of American pewter. And even such simple inscriptions as a triad of stamped

<center>M</center>

initials like c ✦ f give special character to the objects on which they appear. They refer to the original owners and may one day lead to their identification. Modern ownership by a famous collector like Kerfoot or Louis Guerineau Myers adds interest to an object, as does the fact that it was included in a great loan exhibition such as the 1939 Metropolitan Museum pewter exhibit or The Yale University Art Gallery—Victoria and Albert Museum Bicentennial exhibition.

Classic Forms. Certain objects come to be recognized as classic forms or classics. Book collectors refer to them as cornerstones of a collection. Such special recognition is given for a variety of reasons, but often it results from the approbation of recognized authorities. Kerfoot identified a Richardson sugar bowl, like Figure 11-19, as a classic by illustrating it as the frontispiece of *American Pewter*. Ledlie Laughlin did the same for the 15-inch hammered dish of Simon Edgell (Fig. 13-11) now in The Metropolitan Museum of Art. This is accomplished to a greater or a lesser degree whenever an author illustrates an object in a large illustration or in a color plate.

On the subject of rarity collectors need be cautious because of a curious anomaly. For example, beakers, basins, and porringers of the Boardmans were formerly held in low regard because they were common. However, their commonness is due to their original popularity and the fact that large numbers were made and sold. It seems likely that it was their beauty and special qualities that resulted in their numbers. If that be true, then should not their commonness make them more important, rather than less? Indeed, it appears to this writer that the 5-inch beakers of the Boardmans rank high and only slightly behind the classic 5-inch beakers of brilliant form and metal introduced by RB of Boston.

When we chose the 31 pieces of pewter

for the Yale–Victoria and Albert exhibition, "American Art, 1750–1800: Towards Independence," [35] we were choosing classics of American pewter. However, that exhibition did not include pieces made prior to 1750, among which are some of the most important, nor did it include nineteenth-century britannia of which many exciting forms were fashioned. [36]

By this time I hope you are ready to start collecting American pewter. Eventually, you will be able to compile your own list of 100 pieces that make your heart skip a beat when you see them. Choose those pieces that light up your eyes, pieces that you will want to take off the shelf first when you see them in a collection for the first time. In this game you will miss the pleasure of visiting shops and holding objects in your hands, but you won't need money, or the courage and conviction that mark the advanced collector. You will need only knowledge

and taste and a sense of quality to enable you to make the right decisions. The hurdle will be the 100-piece limit. That limit, rather than money, will force you to choose one thing and to bypass ten others. Our choices may vary a great deal, but as Ledlie Laughlin autographed my copy of his book in 1940, "Happy Hunting."

I have tabulated below the 100 pieces that I feel best cover the range of forms and quality of craftsmanship attained by the American pewterer. To show the reasons for my choices, I have included brief comments with the checklist. The objects are listed in the order of the preceding chapters. Within a group such as tankards, the objects are listed according to chronology of form. In others, such as oil lamps, all made at approximately the same time, they are listed according to size.

One Hundred Great Examples of American Pewter

Chosen for Their Quality, Originality, and Variety of Form.

	ORIGINALITY OF FORM OR TECHNIQUE	ILLUSTRATED*	EARLY DATE	STYLISTIC ATTRIBUTES	PERFECTION OF FORM	HISTORICAL ASSOCIATION	INSCRIPTION OR ENGRAVING	
CHURCH PEWTER (*continued*)								
		M4-9		X	X		X	Henry Will (w. 1761–93), New York City and Albany; Winterthur Museum — Baptismal Basin, Diam. 11⅜"
		M4-6		X				Samuel Danforth (w. 1795–1816), Hartford, Conn.; Yale University Art Gallery: Mabel Brady Garvan Collection — Baptismal Basin, Diam. 8"
		M4-8		X				William Will (w. 1764–98), Philadelphia; Winterthur Museum — Baptismal Basin, Diam. 10⅝"

	Notes	Illustrated/Ref			Description
		M4–10	X	X	Baptismal Basin Diam. 7¾" Leonard, Reed and Barton (w. 1837–40), Taunton, Mass.; Winterthur Museum: Gift of Charles K. Davis
	Fine late form	M13–9	X		Footed Baptismal Basin H. 4⅛" Israel Trask (ca. 1835), Beverly, Mass.; Museum of Fine Arts, Boston
	Largest size	X L–159			Beaker H. 6¾" John Bassett (w. 1720–61), New York City; Collection of Ledlie I. Laughlin
	The first of this New England form	X M4–14		X	Beaker H. 5¼" Attributed to Robert Bonynge (w. 1731–63), Boston; Winterthur Museum

* NOTE: In the column labeled "Illustrated" the letter *M* denotes Charles F. Montgomery: *A History of American Pewter*; the letter *L* denotes Ledlie Irwin Laughlin: *Pewter in America: Its Makers and Their Marks*; *Y* denotes *American Pewter: Garvan and Other Collections at Yale*; and *C* denotes *An Exhibition of Connecticut Pewter*, the New Haven Colony Historical Society.

CHURCH PEWTER (continued)	William Kirby (w. 1760–93), New York City; Winterthur Museum	Ebenezer Southmayd (w. 1802–20), Castleton, Vt.; Winterthur Museum	Johann Christoph Heyne (w. 1756–80), Lancaster, Pa.; Winterthur Museum
Originality of Form or Technique			German form
Illustrated	M4–20	M4–12	M4–15
Early Date			
Stylistic Attributes	X		
Perfection of Form	X	X	X
Historical Association			
Inscription or Engraving			
	Beaker H. 5⅜″	Beaker H. 4⅜″	Beaker H. 4³⁄₁₆″

An American innovation		
M4–29	M4–30	L–818
X	X	X
Peter Young (w. 1775–95), New York City or Albany; Winterthur Museum	Attributed to Henry Will, ca. 1780–90, New York City or Albany; Collection of John H. McMurray	Unidentified maker, ca. 1760–1800, probably Pennsylvania; Collection of Charles V. Swain
Chalice H. 8½"	Chalice H. 7½"	Chalice with cover H. 11½"

CHURCH PEWTER (continued)

	Originality of Form or Technique	Illustrated	Early Date	Stylistic Attributes	Perfection of Form	Historical Association	Inscription or Engraving
Chalice H. 7⅛" Reed and Barton, ca. 1840 or later, Taunton, Mass.; Collection of Charles V. Swain		M4-36			X		
Standing cup with cover H. 11¹¹⁄₁₆" Johann Christoph Heyne (w. 1756–80), Lancaster, Pa.; Yale University Art Gallery: Mabel Brady Garvan Collection	Magnificent Germanic form			X			
Standing cup H. 10¼" Joseph Leddell, Sr. (dated 1744), New York City; Christ Church Parish, West Haven, Conn.	Extraordinary documentation	X M4-33	X				X

Extraordinary documentation			
	Y4–186	M4–42	M4–38
	X	X	X
	X		
	Flagon	Flagon	Flagon
	Johann Christoph Heyne, 1771, Lancaster, Pa. Inscribed: "for/The Peters Kirche/ in Mount Joy Town Ship/ von John Dirr/ 1771." Yale University Art Gallery: Mabel Brady Garvan Collection	Philip Will (w. 1763–87), Philadelphia or New York City; Collection of Mr. and Mrs. Oliver W. Deming	Attributed to William Will (w. 1764–98), dated 1795, Philadelphia; Collection of Charles V. Swain
	H. 11¼″	H. 12¾″	H. 13¾″

CHURCH PEWTER (continued)	Originality of Form or Technique	Illustrated	Early Date	Stylistic Attributes	Perfection of Form	Historical Association	Inscription or Engraving
Flagon H. 13" Samuel Danforth (1795–1816), Hartford, Conn.; Yale University Art Gallery: Mabel Brady Garvan Collection	Ingenious combination of elements	M4–7		X			
Flagon H. 12³⁄₁₆" Boardman and Company (ca. 1825), Hartford, Conn.; Yale University Art Gallery: Mabel Brady Garvan Collection		Y4–106		X			

Object	Note	Ref.	Marks	Maker / Provenance
Two-handled church cup — W. 7⅛″	Complex early form	M4–4	X X X	Attributed to Robert Bonynge (w. 1731–63), Boston; Pocumtuck Valley Memorial Association, Deerfield, Mass.
Two-handled church cup — H. 5″	Impressive size	L–228	X	Thomas D. Boardman, 1805–30, Hartford, Conn.; Formerly in collection of Dr. and Mrs. Irving H. Berg
Ciborium or sugar bowl — H. 5½″	Unique combination of elements	L–789	X	Johann Christoph Heyne (w. 1756–80), Lancaster, Pa.; William Penn Memorial Museum, Harrisburg, Pa.

LIGHTING: CANDLESTICKS, LAMPS, AND SCONCES

CANDLESTICKS

	ORIGINALITY OF FORM OR TECHNIQUE	ILLUSTRATED	EARLY DATE	STYLISTIC ATTRIBUTES	PERFECTION OF FORM	HISTORICAL ASSOCIATION	INSCRIPTION OR ENGRAVING
Johann Christoph Heyne (w. 1756–80), Lancaster, Pa.; Winterthur Museum German baroque H. 21¼"	Monumental forms	X M5-3	X	X			
Taunton Britannia Manufacturing (1830–34), Taunton, Mass.; Winterthur Museum American baluster H. 12¼"	Fine American form	M5-7 2nd from left		X	X		

M5-7 3rd from right	M5-9	M5-10
X X	X X	X X
Candlestick H. 6"	Lamp H. 8½"	Swing lamp H. 5½"
James Weekes (w. 1820–35), New York City and Poughkeepsie, N.Y.; Winterthur Museum	William Calder, ca. 1830–56, Providence, R.I.; Winterthur Museum: Gift of Joseph France	Henry Yale and Stephen Curtis (1858–67), New York City; Winterthur Museum

LAMPS

LIGHTING: CANDLESTICKS, LAMPS, AND SCONCES

LAMPS (continued)

	Inscription or Engraving	Historical Association	Perfection of Form	Stylistic Attributes	Early Date	Illustrated	Originality of Form or Technique	Image
Lamp H. 9″ Oliver Trask, 1832–39, Beverly, Mass.; Winterthur Museum			X	X		M5-8 Back row: middle		
Nursing lamp H. 2⅛″ Taunton Britannia Manufacturing (1830–34), Taunton, Mass.; Winterthur Museum						M5-8 Left front	Smallest size	
Double bull's-eye H. 8¼″ Roswell Gleason, 1840–60, Dorchester, Mass.; Yale University Art Gallery: Mabel Brady Garvan Collection						M5-11	Ingenious attempt to magnify light	

SCONCES				
Round	Anonymous maker, 1825–45; Winterthur Museum	M5–15 Right	For sparkling effect	
H. 9⁵⁄₁₆″				
Diamond-shaped	Anonymous maker, 1800–30; Winterthur Museum	M5–14	Rare form, sparkling effect	
H. 13¼″				
DRINKING VESSELS: MUGS AND TANKARDS				
MUGS				
Quart	John Will (w. 1752–74), New York City; Winterthur Museum	M6–4	X	X
H. 6⅝″				

	ORIGINALITY OF FORM OR TECHNIQUE	ILLUSTRATED	EARLY DATE	STYLISTIC ATTRIBUTES	PERFECTION OF FORM	HISTORICAL ASSOCIATION	INSCRIPTION OR ENGRAVING
DRINKING VESSELS: MUGS AND TANKARDS **MUGS** (*continued*)							
Quart H. 5¾″ — Anonymous maker, 1775–80, Philadelphia, Pa.; Winterthur Museum		M3–1				X	X
Quart H. 5¹³⁄₁₆″ — Nathaniel Austin, 1763–1807, Charlestown, Mass.; Winterthur Museum	Fine American type	M6–5		X			
Quart, tulip-shaped H. 6⁹⁄₁₆″ — William Will (w. 1764–98), Philadelphia; Winterthur Museum		M6–13		X	X		

Pint	TANKARDS	Dome top, crenate lip
H. 4¾"	Flat top, strap handle	H. 7 11/16"
Frederick Bassett (w. 1761–1799), New York City and Hartford, Conn.; Winterthur Museum	H. 6½"	Frederick Bassett (w. 1761–1799), New York City; Winterthur Museum
	Attributed to William Bradford, Jr. (w. 1719–58), New York City; Winterthur Museum	
M4–3	M3–6	M6–22
X X	X X X	Large size, 3½ pints

DRINKING VESSELS: MUGS AND TANKARDS (continued)

	Originality of Form or Technique	Illustrated	Early Date	Stylistic Attributes	Perfection of Form	Historical Association	Inscription or Engraving
Simon Edgell (w. 1713–42), Philadelphia; Winterthur Museum Dome top H. 6 9/16″		M6–16	X				X
John Will (w. 1752–74), New York City; The Metropolitan Museum of Art: Gift of Mrs. J. Insley Blair Dome top H. 6 5/8″	Splendid engraving	M13–10					X

Hammered barrel	Circular foot, the earliest type	Early form	
M6–21	M7–1	M13–15	M7–2 Right
X	X X	X	X
Dome top with finial H. 7½"	**PITCHERS** Cream pitcher H. 3¾"	Cream pitcher H. 4"	Cream pitcher H. 5⅜"
Attributed to Benjamin Day (w. 1744–57), Newport, R.I.; Winterthur Museum	John Will (w. 1752–74), New York City; Winterthur Museum	John Will (w. 1752–74), New York City; Winterthur Museum	William Will (w. 1764–98), Philadelphia; Collection of Charles V. Swain

PITCHERS (continued)	ORIGINALITY OF FORM OR TECHNIQUE	ILLUSTRATED	EARLY DATE	STYLISTIC ATTRIBUTES	PERFECTION OF FORM	HISTORICAL ASSOCIATION	INSCRIPTION OR ENGRAVING
Parks Boyd (w. 1795–1819), Philadelphia; The Brooklyn Museum — Covered water pitcher H. 8½″	Earliest American pewter water pitcher	M7–5	X				
Roswell Gleason, ca. 1830–50, Dorchester, Mass.; Winterthur Museum — Covered water pitcher H. 12³⁄₁₆″	Magnificent form	M7–6		X			
Freeman Porter, ca. 1835–60, Westbrook, Me.; Winterthur Museum — Open water pitcher H. 6¹¹⁄₁₆″		M7–6 Middle row			X		

Open water pitcher H. 4¾"	Timothy Sage, ca. 1845–49, St. Louis, Mo.; Winterthur Museum: Gift of Charles K. Davis	M7–6 Front row	Small size	X

PLATES, DISHES, AND BASINS

Smooth brim Diam. 5⅝"	William Will (w. 1764–98), Philadelphia; Winterthur Museum	M13–16	
Single bead Diam. 8"	Henry Will (w. 1761–93), New York City and Albany; Winterthur Museum	L–478–480	The common 18th-century plate
Single bead Diam. 9"	John Will (w. 1752–1774), New York City; Yale University Art Gallery: Mabel Brady Garvan Collection	L–478–480	German immigrant, extraordinary mark

PLATES, DISHES, AND BASINS (continued)

	ORIGINALITY OF FORM OR TECHNIQUE	ILLUSTRATED	EARLY DATE	STYLISTIC ATTRIBUTES	PERFECTION OF FORM	HISTORICAL ASSOCIATION	INSCRIPTION OR ENGRAVING
Simon Edgell (w. 1713–42), Philadelphia; Museum of Fine Arts, Boston: Gift of Mrs. Stephen S. FitzGerald — Smooth brim — Diam. 9″	Early example smooth-brim plate		X				
Thomas Danforth II (w. 1755–82), Middletown, Conn.; New Haven Colony Historical Society — Deep dish — Diam. 13″	Early instance of Conn. preference for deep dishes	C-11	X		X		
Simon Edgell (w. 1713–42), Philadelphia; The Metropolitan Museum of Art: Gift of Joseph France — Single bead — Diam. 15″	Hammered all over	M13-11	X		X		

17th-century type	Superb example of 17th-century type	Largest known American dish	
X M8-2	M8-3	M1-7 Top, far right	M8-7
	X X		X
	X		
Multiple reeded brim	Smooth brim	Single bead	Hot-water plate
Diam. 15"	Diam. 16⅝"	Diam. 19"	W. 10⅝"
Attributed to Edmund Dolbeare (w. 1671–ca. 1711), Boston or Salem, Mass.; Collection of Lloyd W. Fowles	Attributed to Edmund Dolbeare (w. 1671–ca. 1711), Boston or Salem, Mass.; Winterthur Museum	Simon Edgell (w. 1713–42), Philadelphia; Winterthur Museum	William Will (w. 1764–98), Philadelphia; Winterthur Museum

PLATES, DISHES, AND BASINS *(continued)*

	Image	Originality of Form or Technique	Illustrated	Early Date	Stylistic Attributes	Perfection of Form	Historical Association	Inscription or Engraving	
Fluted presentation dish Diam. 8¾″			M8–9 X	X	X	X	X	X	Anonymous maker, dated 1728, probably New York City; Collection of William M. Goss, Jr.
BASINS									
"Rosewater bowl" Diam. 12¹¹⁄₁₆″		Unique American example of this early form	M8–4 X	X	X				Edmund Dolbeare (w. 1671–ca. 1711), Boston or Salem, Mass.; Collection of Mrs. Peter H. Alderwick
Basin Diam. 13″		Earliest form of American basin	M4–5 X	X	X	X			Joseph Leddell, Sr., or Jr. (w. 1712–54), New York City; The Metropolitan Museum of Art: Gift of Mrs. J. Insley Blair

	Description	Note	No.				
	Covered basin Diam. 14 3/16" Thomas D. and Sherman Board-man, ca. 1820–30, Hartford, Conn.; Winterthur Museum	Largest size American basin	M8–11				
PORRINGERS							
	Plain handle Diam. 5 3/8" Attributed to Robert Bonynge (w. 1731–63), Boston; Yale University Art Gallery; Mabel Brady Garvan Collection	Early handle type	M9–8	X	X	X	
	"Old English" handle Diam. 4 3/8" John Bassett (w. 1720–61), New York City; Winterthur Museum	Early English type	M9–9	X			
	Flowered handle Diam. 5 7/16" Samuel Hamlin, ca. 1771–82, Providence, R.I.; Winterthur Museum		M9–11	X	X	X	

PORRINGERS (continued)	ORIGINALITY OF FORM OR TECHNIQUE	ILLUSTRATED	EARLY DATE	STYLISTIC ATTRIBUTES	PERFECTION OF FORM	HISTORICAL ASSOCIATION	INSCRIPTION OR ENGRAVING
Plain handle Diam. 5″ David Melville (w. 1776–93), Newport, R.I.; Winterthur Museum	Superb design	M9–12		X	X		
Tab handle Diam. 5⅜″ Elisha Kirk (w. 1780–90), York, Pa.; Winterthur Museum	A rare Pa. type	M9–13		X			
Dolphin handle Diam. 5 5/16″ Samuel Danforth, 1795–1823, Hartford, Conn.; Winterthur Museum	A 17th-century English form	M9–5		X			
Plain handle Diam. 3⅜″ Richard Lee, Sr., or Jr., 1788–1820, Springfield, Vt.; Winterthur Museum	Very small size	M9–4		X	X		

Description	Notes	Catalog			
Richard Lee, Sr., or Jr., w. 1788–1820, Springfield, Vt.; Winterthur Museum Flowered handle Diam. 5⅞"	Very large size	M9–3	X	X	

SPOONS AND LADLES

Description	Notes	Catalog			
Joseph Copeland, 1675–91, Chuckatuck, Va.; National Park Service York, England, 17th-century type L. 5½"	Earliest documented piece of American pewter	M10–5			
John Bassett (w. 1720–61), New York City; New Hampshire Historical Society "Puritan" or round bowl L. 6½"		X L–171	X	X	
William Will, 1782–98, Philadelphia; Winterthur Museum Neoclassical type L. 8⅜"		M10–7			X

SPOONS AND LADLES (continued)

	Originality of Form or Technique	Illustrated	Early Date	Stylistic Attributes	Perfection of Form	Historical Association	Inscription or Engraving
George Coldwell (w. 1787–1811), New York City; Winterthur Museum. Neoclassical bright-cut effect L. 7¾"	Rare ornament	M10–3c				X	X
Richard Lee, Sr., or Jr., 1788–1820, New England; Winterthur Museum. Neoclassical bright-cut effect L. 4¾"		M10–6b			X		
Peter Young (w. 1775–95), New York City; Winterthur Museum. Mid-rib ladle L. 16"		M10–10		X	X		

Neoclassical ladle
L. 15"

William Will, 1785–98, Philadelphia; Winterthur Museum

M10–11

X

UTENSILS FOR TEA AND COFFEE

Coffeepot
H. 15¾"

William Will, 1785–98, Philadelphia; Collection of Dr. and Mrs. Robert Mallory III

L–760

X X

X

Coffee- or teapot, lighthouse shaped
H. 11⁷/₁₆"

Israel Trask, 1812–ca. 1830, Beverly, Mass.; Winterthur Museum

M11–14

X

X

UTENSILS FOR TEA AND COFFEE (continued)

Description	Illustrated	Early Date	Stylistic Attributes	Perfection of Form	Historical Association	Inscription or Engraving	Originality of Form or Technique	Notes
Tea or coffee service — H. of tallest pot 10⅞″	M11–29		X					Taunton Britannia Manufacturing Co., 1830–34, Taunton, Mass., Ex Collection of the Hon. and Mrs. George V. Smith
Tea- or coffeepot — H. 10½″	M11–28		X					Taunton Britannia Manufacturing Co. (1830–34), Taunton, Mass.; Collection of Mrs. Ralph B. Post
Round teapot — H. 6¼″	M11–2	X						Anonymous maker, 1740–60, probably New York City; Winterthur Museum

		Fine classical form	
M11–3	L–190	M11–8	M11–8
X X	X X	X X	X X
	X	X	X
Cornelius Bradford (w. 1752–85), New York City or Philadelphia; Winterthur Museum	William Will, 1764–85, Philadelphia; Collection of Dr. and Mrs. Robert Mallory III	William Will, 1785–98, Philadelphia; Winterthur Museum	Israel Trask, ca. 1813–ca. 1856, Beverly, Mass.; Museum of Fine Arts, Boston: Bequest of Mrs. Stephen S. FitzGerald
Pear-shaped teapot with feet H. 7¼"	Pear-shaped teapot with feet H. 7"	Drum teapot H. 6³⁄₁₆"	Drum teapot H. about 7"

UTENSILS FOR TEA AND COFFEE (continued)

	ORIGINALITY OF FORM OR TECHNIQUE	ILLUSTRATED	EARLY DATE	STYLISTIC ATTRIBUTES	PERFECTION OF FORM	HISTORICAL ASSOCIATION	INSCRIPTION OR ENGRAVING
Coffee urn H. 14" — Leonard, Reed and Barton (w. 1837–40), Taunton, Mass.; Collection of Mr. and Mrs. Thomas D. Williams	An extraordinary form in pewter	M11–18					
Double-ended teapot H. 9" — Samuel Danforth, 1795–1820, Hartford, Conn.; New Haven Colony Historical Society	An ingenious solution	C-32		X			
Sugar bowl H. 4 13/16" — Attributed to William Will (w. 1764-98), Philadelphia; Winterthur Museum		M11–9		X	X		

Item	Maker / Details	Height	Columns	Reference	Note
Sugar bowl	Thomas Danforth III, 1777–90, Stepney, Conn.; Winterthur Museum	H. 3 15/16″	X X	M11–10	
Sugar bowl	George Richardson, 1830–45, Cranston, R.I.; Winterthur Museum	H. 5 1/16″	X	M11–19	Fine late form

"ANY UNCOMMON THING IN PEWTER"

Item	Maker / Details	Height	Columns	Reference	Note
Circular box	Attributed to Joseph Leddell, Sr., or Jr. (w. 1712–54); The Metropolitan Museum of Art	H. 3 1/4″	X X	L–255	
Commode	Frederick Bassett (w. 1761–1799), New York City and Hartford, Conn.; Yale University Art Gallery: Mabel Brady Garvan Collection	H. 8″		M12–3	Very large form

"ANY UNCOMMON THING IN PEWTER" (continued)	ORIGINALITY OF FORM OR TECHNIQUE	ILLUSTRATED	EARLY DATE	STYLISTIC ATTRIBUTES	PERFECTION OF FORM	HISTORICAL ASSOCIATION	INSCRIPTION OR ENGRAVING
Foot warmer H. 11⅜″ Henry Will (w. 1761–93), New York City and Albany; Yale University Art Gallery: Mabel Brady Garvan Collection	Unique and practical form	M12–8					
Funnel L. 7⁷⁄₁₆″ John Bassett (w. 1720–61), New York City; Winterthur Museum	Very unusual design	M12–10					
Standish L. 7⅞″ Henry Will (w. 1761–93), New York City and Albany; The Brooklyn Museum	Unique in American pewter	M12–11					

| Tea caddy
H. 5½" | George Coldwell (w. 1787–1811), New York City; Collection of Mr. and Mrs. Thomas D. Williams | | | X | L–823 | Fine ornament | |

Notes

Chapter 1

1. Arthur Lasenby Liberty, "Pewter and the Revival of Its Use" (Paper delivered before the Applied Art Section of the Society for the Encouragement of Arts, Manufactures, and Commerce, London, May 17, 1904, reprinted from *Journal of the Society of Arts*, June 10, 1904), *Smithsonian Annual Report* (1904), p. 694.
2. Liberty, "Pewter and the Revival of Its Use," p. 695.
3. Watson, *Annals of Philadelphia and Pennsylvania*, 3 vols. (1830; reprint ed., Philadelphia: Leary, Stuart Co., 1927), 1:205.
4. Dean A. Fales, Jr., "T.D.B. [Thomas Danforth Boardman] Tells All," *Pewter Collectors' Club of America Bulletin*, no. 46 (Feb., 1962), p. 109. This article is based on an undated autobiographical account of the life and business career of Thomas Danforth Boardman. Connecticut State Library, Hartford, Connecticut, Business papers of Thomas Danforth Boardman.
5. Symonds, "The English Export Trade in Furniture to Colonial America, II," *Antiques* 28, no. 4 (Oct., 1935): 156–59.
6. Eight-inch plates weigh about 8 pounds per dozen; quart mugs, 2 pounds each; tankards, 2½ pounds each; 15-inch dishes, 3 pounds each.
7. Charles F. Montgomery, "John Townsend, English Quaker with American Connections," *Pewter Collectors' Club of America Bulletin*, no. 51 (Dec., 1964), p. 23.
8. Salmon, *L'Art du Potier d'Etain* (Paris: Académie Royale des Sciences, 1788), p. 23. (Author's translation.)
9. As quoted in a broadside, "The Case of the Pewterers of England" (London: The Worshipful Company of Pewterers, Feb. 20, 1710/11), photostat in Joseph Downs Manuscript and Microfilm Collection, Winterthur Museum Libraries (hereafter DMMC). The broadside was printed to accompany a petition to the House of Commons to procure a reduction or abolishment of the duty on exported pewter (then 2 shillings per hundredweight). See Charles Welch, *History of the Worshipful Company of Pewterers of the City of London*, 2 vols. (London: Blades, East & Blades, 1902), 2:179.
10. William Fergus, Osborne, Virginia, to James Glassford, merchant, Norfolk, Virginia, April 11, 1772, from the Neil Jamieson Papers (Washington, D.C.: Library of Congress), vol. 15 (Feb. 12–Aug. 15, 1772, no. 3359. *Maryland Gazette*, Jan. 8, 1756, as quoted in Alfred Coxe Prime, ed., *The Arts and Crafts in Philadelphia, Maryland, and South Carolina, 1721–1785* (Topsfield, Mass.: Published for the Walpole Society, 1929), p. 111.
11. *Staatsbote* (Philadelphia), Sept. 19, 1763, as quoted in Prime, *Arts and Crafts*, pp. 110–11.
12. Broadside, "The Case of the Pewterers of England." See footnote 9.
13. William H. Whitmore, ed., *Boston Town Records, 1660–1700*, in *Report of the Record Commissioners of the City of Boston*, vol. 7 (Boston: Published by the City of Boston, 1881), p. 134. Although the Town Meeting requested the representatives to get such an act passed, I am not aware that the Court, which was the representative body of the Colony, did so.
14. *Boston News-Letter*, Nov. 3, 1768, as quoted in George Francis Dow, ed., *The Arts and Crafts in New England, 1704–1775* (Topsfield, Mass.: Wayside Press, 1927), p. 73.
15. Fales, "T.D.B. Tells All," p. 110.
16. Howard Herschel Cotterell, *Old Pewter, Its Makers and Marks in England, Scotland and Ireland* (New York: Charles Scribner's Sons; London: B. T. Batsford Ltd., 1929 or reprint Rutland, Vt. and Tokyo: Charles Tuttle, 1964), pp. 20–51.
17. The study of many American merchants' accounts and pewterers' records show that between 1650 and 1800 the price of pewter articles varied from 1s. 4d. to 2s. (sterling) per pound. Hence, dishes weighing from 2 to 5 pounds, tankards (about 2½ pounds), and flagons (about 3 to 4 pounds), ranged in price from 2s. 8d. to 10s. (sterling). For most of this era, the average daily wage for a skilled artisan was from 2s. 6d. to 3s. 6d. (sterling). After the Revolution, wages advanced until by the 1790's the daily rate was the equivalent of 7s. 6d. (sterling).
18. Diary of Samuel Sewall, III, 1714–29, Collections of the Massachusetts Historical Society, 5th ser., vol. 7 (Boston, 1882).
19. Abram English Brown, *John Hancock, His Book* (Boston: Lee and Shepard, 1898), p. 240.

20. Westman, *The Spoon* (London: Wiley & Putnam, 1845), p. 247.

21. Carl Bridenbaugh, ed., *Gentleman's Progress: The Itinerarium of Dr. Alexander Hamilton* (Chapel Hill, N.C.: Published for the Institute of Early American History and Culture by the University of North Carolina Press, 1948), pp. 54–55.

22. "Invoice of Sundry Goods Shipped by Robert Cary and Company . . . on account and risque of Col. George Washington," Mount Vernon Archives.

23. Ellis's fame is indicated in a letter of Feb. 22, 1765, from Robert and T. Portues, London merchants, to Caleb Blanchard, partner of John Hancock, merchant of Boston. The letter is printed in Nancy A. Goyne, "An Eighteenth-Century Document," *Pewter Collectors' Club of America Bulletin*, no. 59 (Dec., 1968), pp. 218–19. It reads in part: "We are very much affraid our Trade to America is rather upon the decline owing to the vast improvements you are making every Year in all your Manufactorys—M Ellis the Pewterer has left off Business, & is going to retire in ye Country, he has been famous for many Years in dealing in the Article of Pewter, & I dont doubt but you have heard of him."

24. A "sett of letters" for marking utensils is often found in pewterers' shops. Those owned by the Boston pewterer John Comer were valued at three shillings upon his death in 1706. Suffolk County, Mass., Probate Records.

25. Westman, *The Spoon*, p. 242.

26. Inventory of the Estate of Edmond Haines, Evesham, Burlington County, New Jersey, taken Feb. 14, 1766, Richardson Papers, Box 11, Friends Historical Library of Swarthmore College. Benjamin Chase, *History of Old Chester from 1719–1869* (Auburn, N.H., 1869), p. 413.

27. Watson, *Historic Tales of Olden Time* (New York: Collins and Hannay, 1832), p. 160.

28. Samuel Eliot Morison, *Three Centuries of Harvard, 1636–1936* (Cambridge, Mass.: Harvard University Press, 1936), pp. 27–28.

29. *Publications of the Colonial Society of Massachusetts*, 15 (Boston, 1925): 61–62.

30. *Publications of the Colonial Society of Massachusetts*, 15:149.

31. In 1705, Mr. Jackson was paid 19s. 3d. "for a Pewter Dish lost att Commencement." Entry dated July 10, 1705, Andrew Bordman (II) Ledger, 1703–31. Stewards' Journals and Ledgers, I.70.15.70 & 75, Harvard University Archives, Widener Library.

32. Henry Howe, *Historical Collections of Ohio* (Cincinnati: Bradley & Anthony, 1849), pp. 65–66.

33. *The Diary of Matthew Patten of Bedford, New Hampshire, 1754–1788* (Concord, N.H.: Published by the Town, 1903), pp. 12–13.

34. See C. Malcolm Watkins and Ivor Noël Hume, "The 'Poor Potter' of Yorktown," *The United States National Museum Bulletin* 249. *Contributions from The Museum of History and Technology*, Paper 54 (Washington, D.C.: Smithsonian Institution Press, 1967), pp. 73–112.

35. Leonard W. Labaree, ed., *The Autobiography of Benjamin Franklin* (New Haven, Conn.: Yale University Press, 1964), p. 145.

36. Howe, *Historical Collections of Ohio*, p. 63. In all likelihood, the Townsend referred to was John Townsend, the Quaker pewterer (w. 1748–1801) whose house was a frequent meeting place for American Quakers in London and who spent most of 1785 and 1786 traveling and preaching in America from Philadelphia to Halifax. See footnote 7 for article on Townsend.

37. Receipt dated Feb. 28, 1818. Girard Papers, ser. 2, reel no. 209 (Bills and Receipts), American Philosophical Society, Philadelphia.

38. Hall's inventory included 779 teapots and coffeepots in seven different styles, 96 spittoons, 120 pint mugs, 372 shaving boxes, 128 slop bowls, 111 sugar bowls, 36 creamers, 780 tumblers, and 432 castor frames equally divided among four-, five-, and six-bottle sizes, 310 gross of teaspoons in three styles, and 270 gross of tablespoons in two styles. An entry of Jan. 1, 1836, for H. B. Hall in the Daybook of (Ashbil) Griswold and (Ira) Couch, Meriden, Conn., 1834–1839 (DMMC, microfilm 744). Original manuscript in the archives of The International Silver Company, Meriden, Conn. Some items in this archive are filed chronologically and others alphabetically by maker.

39. Letter to the author, March 9, 1967.

Chapter 2

1. Sarah H. J. Simpson, "The Federal Procession in the City of New York," *New-York Historical Society Quarterly Bulletin* 9, no. 2 (July, 1925): 50.

2. George Francis Dow, "Notes on the Use of Pewter in Massachusetts During the Seventeenth Century," *Old-Time New England* 14, no. 1 (July, 1923): 31–32, as quoted in J. B. Kerfoot, *American Pewter* (Boston: Houghton Mifflin, 1924), p. 32.

3. For this and much other historical information on American pewterers, I am deeply indebted to Ledlie Irwin Laughlin's *Pewter in America: Its Makers and Their Marks*, 2 vols. (Boston: Houghton Mifflin, 1940). Reprinted in 1969 in one volume (Barre, Mass.: Barre Publishers, 1969). A third volume of the same title was published in 1971 by Barre Pub-

lishers. Subsequent reference to this work will refer to the editions published by Barre.

4. *New Hampshire Gazette and Historical Chronicle* (Concord, N.H.), June 24, 1780. The author thanks Charles S. Parsons for calling this reference to his attention.

5. John Norsworthy, who opened shop in Norfolk, Virginia, in 1771, advertised that "he makes and sells different Sizes of Dishes, Basons, and Plates, either hammered or turned. . . . Any Persons may be supplied by Wholesale much cheaper than they can import from England." Alexander Purdie and John Dixon, Virginia Gazette, Norfolk and Petersburg, March 21, 1771, p. 3, col. 2; July 13, 1776, p. 2, col. 1.

6. *Providence Gazette* (Rhode Island), January 10, 1784. *Boston News-Letter*, Oct. 1, 1761, as quoted in George Francis Dow, *The Arts and Crafts in New England, 1704–1775* (Topsfield, Mass.: Wayside Press, 1927), p. 74. *Boston Gazette*, July 1, 1765, as quoted in Dow, *Arts and Crafts*, p. 74.

7. Records of the Suffolk County, Mass., Court of Common Pleas, unnumbered volume dated 1724, pp. 130–33.

8. Suffolk County Probate Records, vol. 5, pp. 15–30.

9. Petition of Edward Kneeland, the gift of Carl Jacobs to the DMMC, Winterthur Museum Libraries, 53.158.1.

10. Inventory of Roger Kirk, DMMC, Ph390.

11. *New-York Gazette and the Weekly Mercury*, July 2, 1770, as quoted in Rita Susswein Gottesman, *The Arts and Crafts in New York, 1726–1776* (New York: New-York Historical Society, 1938), p. 107.

12. Except for emigrants the system of apprenticeship based on English practice provided the work force of skilled artisans for all trades in early America. Indentures of apprenticeship were legal documents and as such were signed by local government officials.

13. Indenture of Luther Boardman, Meriden, Conn., Dec. 6, 1829, International Silver Company Archives.

14. Princess Anne County Minute Book, vol. 7 (1753–62), p. 371, Virginia State Archives.

15. *The Compleat Appraiser*, 4th ed. (London, 1770), p. 46.

16. "Antiques in the American Wing, 1725–50," *Antiques* 50, no. 4 (Oct., 1946): 250, fig. 12, shows the Edgell example in the collection of the Metropolitan Museum of Art. The second example is illustrated in Graham Hood, "American Pewter: Garvan and Other Collections at Yale," *Yale University Art Gallery Bulletin* 30, no. 3 (Fall, 1965): 50, no. 185.

17. Hammered plates and dishes have been identified from the following shops: the Dolbeares and John Skinner of Boston; Thomas Danforth of the Connecticut lion-and-gateway touch; Francis Bassett, Frederick Bassett, Robert Boyle, William Kirby, and Duncan and Malcolm McEuen of New York; Henry Will and Peter Young of Albany; and Simon Edgell and William Will of Philadelphia.

18. Laughlin, *Pewter in America*, 3: 50–51. Although this mark, may very tentatively be attributed to Benjamin Dolbeare, it seems more likely to have been used by Benjamin Day of Newport, R.I.

19. *Compleat Appraiser*, p. 46.

20. Pierre Auguste Salmon, *L'Art du Potier d'Etain* (Paris: L. F. Delatour, 1788), p. 32. Salmon explains that the cavity in a piece of pewter made of "sweet" new tin, fresh from the mines, would be clear and brilliant in color. Tin with the addition of an alloy of 4 per cent zinc, and sometimes 8 ounces of bismuth per hundredweight, produced a slightly brighter cavity. The presence of antimony produced a blacker, pitted spot. Tin alloyed with copper, zinc, and bismuth produced a cavity of even greater brilliance than pure tin; whereas an alloy with a small amount of iron (useful for making kitchen utensils) resulted in a blacker, textured *mouche*. All of these variations and mixtures were considered first-quality pewter by Salmon.

21. Salmon, *L'Art du Potier d'Etain*, p. 32, freely translated reads: "A *mouche* with a clear-cut cavity on all of its surfaces, with only its center broken up by two or three particles, distinguishes pewter which contains about two to three pounds of lead per hundredweight. . . . But when the central point extends and is encircled with a larger quantity of white spots, looking like the center of a rose which is beginning to lose its bloom, and when the sheen of the rest of the cavity is also a little whiter, then the lead alloyed with it is in the proportion of seven or eight pounds per hundredweight. It is more fusible and cannot be polished. Because of these little white spots arranged around the center of the cavity, craftsmen call it pewter *à la rose*, alluding to that English pewter which, among other marks, carries a rose. This pewter should be put in a second pile and rejected from the fine metal."

22. Suffolk County Probate Records, 115, pp. 231–32; 370–71. In Richard Austin's 1817 inventory (Boston), four unspecified stone molds were valued at three dollars. Austin also owned three dish molds, two plate molds, one basin mold, and porringer molds. The latter group, weighing 359 pounds, was valued at twenty-five cents a pound and was probably made of brass. Also, two soapstone molds—one for the base of a beaker, the other for a teapot finial—are among Samuel Pierce's molds in Deerfield, Mass., in the Heritage Foundation Collections.

23. Salmon, *L'Art du Potier d'Etain*, p. 93.
24. Salmon, *L'Art du Potier d'Etain*, p. 93.
25. Salmon, *L'Art du Potier d'Etain*, p. 94.
26. In a manuscript account book (1772–1834) begun by William Proud (d. 1779) and continued by his sons Samuel and Daniel, and in the records of Job Danforth, another Providence, R.I. cabinetmaker, many transactions are listed with Gershom Jones, William Billings and with Billings and Danforth (Job, Jr., son of the cabinetmaker) as well as with Samuel Hamlin. The woodworkers made numerous molds, "flasks to cast in," and "patterns to cast by" as well as coffeepot handles (1775) and teapot handles (1790's). The most frequent entries, however, are for "turning a mold piece." All of these manuscript records are in the Rhode Island Historical Society.
27. The patterns that Daniel Proud, the woodworker, had supplied in August, September, and October, 1773, had been transformed by Hamlin, the brazier and brassfounder, into a set of brass molds by November. I am indebted to Ledlie I. Laughlin for bringing Samuel Hamlin's advertisement to my attention. Fortuitously, this occurred just after my discovery of the charges in Proud's account books.
28. For information on mold making we must rely on brass founding practice. Apparently Salmon intended to write on the subject because in *L'Art du Potier d'Etain*, page 155, the reviewer for the French Academy Register of Books states: "Nothing more is needed to complete The Art of the Pewterer than that part which concerns the Model-maker and the Mold-maker, and M. Salmon promises to publish it forthwith." The writer has been unable to locate the promised work.
29. Salmon, *L'Art du Potier d'Etain*, p. 38.
30. Charles Welch, *History of the Worshipful Company of Pewterers of the City of London*, 2 vols. (London: Blades, East & Blades, 1902), Vol. 2, p. 155.
31. This drawing is based on pewterer's tongs once owned by Samuel Pierce, who worked in Greenfield, Mass., in the early 1800's. They are illustrated in Laughlin, *Pewter in America*, 1: pl. 4.
32. Curiously, Salmon does not mention copper as an ingredient to be used with antimony and tin, a combination which Thomas Danforth Boardman later found to be the ideal one.
33. Dean A. Fales, Jr., "T.D.B. [Thomas Danforth Boardman] Tells All," *Pewter Collectors' Club of America Bulletin*, no. 46 (Feb., 1962), pp. 109–10.
34. Illustrated Catalogue and Price List of The Meriden Britannia Company (West Meriden, Conn., 1867).

35. Laughlin, *Pewter in America*, 2: 159.
36. As quoted in Nancy A. Goyne, "Britannia in America: The Introduction of a New Alloy and a New Industry," in *Winterthur Portfolio 2*, ed. Milo M. Naeve (Winterthur, Del.: The Henry Francis du Pont Winterthur Museum, 1965), p. 161. The manufacturing methods and the many improvements that followed after 1810 are described in detail in this authoritative article.
37. William Calder, Daybook, Providence, R.I., 1826–38, DMMC, 65 x 570.1.
38. William Calder, Ledger, Providence, R.I., ca. 1823–47, p. 8, DMMC, 65 x 570.2. At this time Calder was buying, as he had in the past, small amounts of old pewter—usually 20 or 30 pounds at a time—at 15 cents a pound, but the bulk of the metal he used was new. On Nov. 21, 1827, three weeks before his entry for the britannia tumblers, he received a larger shipment than usual from Phelps and Peck, a Providence importing firm, of English tin, India tin, and Spanish tin, the first two at 19 cents, and the latter at 14½ cents a pound. Twenty-six pigs of English tin weighed 531 pounds, and 5 pigs of Spanish tin weighed 308 pounds. In the same shipment, "6 Blocks Antimony" weighing 102 pounds were priced at 27 cents per pound, 8 cents more than the most expensive tin.
39. Goyne, "Britannia in America," pp. 160–96.
40. This estimate is based on my personal examination of thousands of so-called pewter objects made in the britannia period.
41. John P. Garfield, "Taunton Britannia Makers," *Pewter Collectors' Club of America Bulletin*, no. 10 (July, 1942), p. 5.
42. Ashbil Griswold Accounts, International Silver Company Archives.

Chapter 3

1. Perhaps the single most important book on connoisseurship and, incidentally, the first on the subject in the English language, is Jonathan Richardson's *Two Discourses . . . ,* published in London in 1719 and republished in 1792 under the title *The Works of Jonathan Richardson*. His remarks on the judging of the goodness of pictures and drawings are particularly pertinent as an approach to connoisseurship in any field. The writer thanks the Walpole Society for permission to include here material that first appeared as *Some Remarks on the Practice and Science of Connoisseurship* in *The Walpole Society Notebook 1961*. General ideas first presented there on the study of decorative-arts objects are restated in more specific terms as they relate to American pewter.

2. Edwin M. Stone, *Mechanics' Festival: An Account of the Seventy-Fifth Anniversary of the Providence Association of Mechanics and Manufacturers* (Providence, R.I.: Knowles, Anthony & Co., 1860), p. 103.

3. This suggestion is made on the basis of the form of each piece and the early working dates of the makers. The writer believes another teapot illustrated in Laughlin, *Pewter in America*, 3: pl. 112, no. 761, is more likely the work of Frederick rather· than one of the Francis Bassetts and a 1770's form modeled upon English creamware teapots of that era.

4. Suzanne Hamilton, "The Pewter of William Will: A Checklist," *Winterthur Portfolio 7*, ed. Ian M. G. Quimby (Charlottesville: University Press of Virginia for The Henry Francis du Pont Winterthur Museum, 1972), pp. 129–60.

5. *The Encyclopaedia Britannica*, Fourteenth Edition (London, New York: Encyclopaedia Britannica Company, Ltd., 1929) vol. 22, p. 234.

Chapter 4

1. As yet, no study has been made of pewter comparable to the survey of more than 2,000 pieces of silver listed and described in E. Alfred Jones's monumental, pioneering study, *The Old Silver of American Churches* (Letchworth, England: National Society of the Colonial Dames of America, 1913).

2. Alice Morse Earle, *The Sabbath in Puritan New England*, 5th ed. (New York: Charles Scribner's Sons, 1892), p. 115.

3. The writer will use throughout this book the name of Johann Christoph Heyne, the name given at birth to the gifted Pennsylvania pewterer who marked his wares *I. C. H.* He was born in Funtschen, Saxony, Germany, on December 3, 1715. The writer uses his given name because of the lack of consistency in Pennsylvania-German orthography. For example, soon after Heyne's arrival in America, his name was listed on June 25, 1742, with other single men in the Bethlehem, Pennsylvania, Moravian settlement as John Christopher Heyne. Thereafter, he signed his name variously as Christ, Chris'r, Christ'r, Hayne, or Heyne. An advertisement in the English-language *Pennsylvania Gazette* of November 25, 1772, was headed John Christopher Hayne. The changes in his name surely reflect the influences of the prevailing English culture, but just as most of Heyne's pewter has a German look about it, so even to the end of his life his name had a German sound to it. The inventory of his possessions was recorded after his death on January 11, 1781, in the name of Christopher Hiney, an English rendition of the Germanic Heyne. For information on pewter communion sets of New England churches see [Jane C. Giffin and Ida F. Taggart], *Pewter in the Collections of the New Hampshire Historical Society* (Concord, N.H.: New Hampshire Historical Society, 1968).

4. *The Probate Records of Essex County, Massachusetts, 1635–1680*. 3 vols. (Salem, Mass.: Essex Institute, 1916–20).

5. See William O. Blaney, "Pewter Communion Service of the Rocky Hill Meetinghouse," *Old-Time New England* 58 (Winter, 1968): 82–84.

6. Laughlin, *Pewter in America*, 1: pl. 35, no. 232.

7. Laughlin, *Pewter in America*, 3: pl. 97, no. 798.

8. *Pennsylvania Packet*, May 29, 1775, as quoted in Alfred Coxe Prime, *The Arts and Crafts in Philadelphia, Maryland, and South Carolina, 1721–1785* (Topsfield, Mass.: Wayside Press, 1929), pp. 107–8. See also, Laughlin, *Pewter in America*, 2: 156.

9. Laughlin, *Pewter in America*, 1: pl. 38, no. 247.

10. Francis Hill Bigelow, *Historic Silver of the American Colonies* (New York: Macmillan, 1931), p. 55.

11. E. Alfred Jones, *Old Silver of American Churches* (this writer's computation).

12. Laughlin, *Pewter in America*, 1: 36; pl. 23, no. 159.

13. The present-day English pewtermaking firms of Gaskell and Chambers of Birmingham, and Englehart and Company of London, both own several early beaker and mug molds that prove these objects were cast in parts and fitted together as outlined.

14. Given by Ledlie I. Laughlin, with other tools used by Samuel Pierce of Greenfield, Mass., to the Heritage Foundation.

15. The present location of these beakers is unknown. From the communion service of the Baptist Church of Cheshire, Mass., they were once in the collection of Dr. and Mrs. L. H. Berg of East Hartland, Conn., but they were sold with the rest of that collection in the 1940's.

16. Daybook of Ashbil Griswold, 1825–52, Archives of the International Silver Company, Meriden, Conn.

17. *Catalogue of Harvard Tercentenary Exhibition, July 25 to September 21, 1936*, (Cambridge, Mass.: Harvard College, 1936), p. 67, no. 312a.

18. *The Diary of Samuel Sewall, III, 1714–29*, in *Collections of the Massachusetts Historical Society* 7, 5th ser. (Boston, 1882): 345.

19. Comparative heights of representative chalices (standing cups): Heyne pewter covered chalice, 10 11/16 inches; Heyne pewter chalice

without cover, 8⅝ inches; Jeremiah Dummer silver standing cup with gadrooned ornament, without cover, 8⅜ inches; Peter Young pewter chalice without cover, 8½ inches; Hull and Sanderson silver standing cup without cover, 7¼ inches.

20. See *Pewter Collectors' Club of America Bulletin.* no. 4 (Oct., 1937), p. 8, for the exciting discovery of this chalice and plate now on loan to the New Haven Colony Historical Society.

21. Laughlin, *Pewter in America*, 2: 159.

22. Paul M. Auman, "New Finds in Old Pewter by William Will: The Aaronsburg Communion Service," *Antiques* 57, no. 4 (April, 1950): 274–75.

23. "Nineteenth Century Chalices," *Pewter Collectors' Club of America Bulletin*, no. 48 (March, 1963), pp. 148–50. "Interchangeable Parts in Early American Pewter," *Antiques* 83, no. 2 (Feb., 1963): 212–13; see also J. Carl Thomas, "A Marked Boardman Chalice," *Pewter Collectors' Club of America Bulletin*, no. 49 (Sept., 1963), pp. 187–88.

24. As first pointed out by John J. Evans, Jr., "I.C.H., Lancaster, Pewterer," *Antiques* 20, no. 2 (Feb., 1931): 150–53. Heyne sold English pewter as well as that of his own make and advertised in the *Pennsylvania Gazette* of November 25, 1772, that

he has again imported a large assortment of the best London Pewter ware, made by the best masters in that metropolis, viz. deep soup dishes, and other deep and flat dishes, soup and flat plates, many sorts of spoons, quart and pint tankards, pewter measures for liquids, ink-stands, porringers, chamber pots, and vessels for close-stools, with articles used in families. He also makes himself many sorts of Pewterers' work, such as small butter-plates, dishes, porringers, salt cellars, toys or children's playthings, etc. He likewise mends pewter vessels, in the best manner; and changes old for new pewter or gives the highest price for it. All sorts of Tin ware that may be wanted, he makes and sells; he also sells hair brooms, and glassware; all at the most reasonable rates.

Heyne advertised with pride the work of the best masters of London, but his own work ranks among the finest produced anywhere in the eighteenth century.

25. *Pewter Collectors' Club of America Bulletin*, no. 43 (Sept., 1960), pp. 53–57.

26. Laughlin, *Pewter in America*, 1: pl. 31, no. 218, illustrates one straight-sided example. Another is owned by the Presbyterian Historical Society, Philadelphia. See Suzanne Hamilton, "The Pewter of William Will: A Checklist," *Winterthur Portfolio 7*, ed. Ian M. G. Quimby (Charlottesville, Va.: University Press of Virginia for The Henry Francis du Pont

Winterthur Museum, 1972), pp. 129–60.

27. See Laughlin, *Pewter in America*, 3: pl. 97, no. 792, for the William Will flagon in the Presbyterian Church of Oxford, Penn., and Figure 4–40.

28. Alfred Coxe Prime, *The Arts and Crafts in Philadelphia, Maryland, and South Carolina, 1721–1785* (Topsfield, Mass.: Walpole Society, 1929), pp. 4–5.

29. Mary E. Norton, "Pewter Communion Tokens at Winterthur," *Winterthur Portfolio 1*, ed. Milo M. Naeve (Winterthur, Del.: The Henry Francis du Pont Winterthur Museum, 1964), p. 182.

30. Norton, "Pewter Communion Tokens," pp. 184, 186.

31. Earle, *Sabbath in Puritan New England*, p. 122.

Chapter 5

1. *The Holyoke Diaries, 1709–1856*, ed. George Francis Dow (Salem: The Essex Institute, 1911), pp. 7, 11, 15, 24, 25, 27.

2. Letter dated Oct. 4, 1970, from the Rev. Monsignor Charles L. Allwein, Pastor of The Most Blessed Sacrament Church, founded in 1741. At that time, Rev. Allwein wrote to me concerning the Heyne candlesticks now at Winterthur, "There is no question in my mind about them coming from here. I was acting pastor of this parish in 1930–31 and remember seeing at least two of them stored in the up-stairs room. One was in good condition while the other had been fixed. It looked as if they had tried to solder it where it was broken. I might mention that it did not look like a very good job." And such, indeed, is the condition of one of the candlesticks at Winterthur, the upper section had been completely broken off before the museum acquired it.

3. Laughlin, *Pewter in America*, 2: 159.

4. Laughlin, *Pewter in America*, 2: 157.

5. A clustered column example thought to have been owned by Governor Pyncheon is preserved in the Governor Pyncheon Memorial in Springfield, Mass. Another seventeenth-century example of the same kind is in the Wadsworth Atheneum, Hartford, Conn.

6. Leroy Thwing, *Flickering Flames* (Rutland, Vt.: Charles E. Tuttle, 1958), pp. 58, 59.

7. According to C. Malcolm Watkins, quoting an 1804 source, "as the light emitted from them is frequently too vivid for weak or irritable eyes, we would recommend the use of a small screen." Presumably the Argand lamp, with its unprecedented candlepower, was the basis for this caution. Mease, *The Domestic Encyclopedia* (1804), vol. 3, p. 432, as quoted

in Watkins, "Artificial Lighting in America, 1830–1860," *The Smithsonian Report for 1951* (Washington, D.C.: U.S. Government Printing Office, 1952), p. 395.

8. *Franklin Institute Journal*, ser. 3, vol. 14, p. 410, as quoted in Watkins, "Artificial Lighting in America, 1830–1860," p. 395.
9. William Calder, Daybook, Providence, R.I., 1826–38, DMMC, 65x570.1.
10. Helen McKearin, *The Story of American Historical Flasks* (Corning, N.Y.: Corning Museum of Glass, 1953), pp. 21–23.
11. As has been demonstrated in a recent experiment conducted by Victor Hanson at the Winterthur Museum, this composition, combined with the process of casting over glass, produced a mirror finish.

Chapter 6

1. *The Compleat Appraiser*, 4th ed. (London, 1770) p. 44.
2. George Francis Dow, *The Arts and Crafts in New England, 1704–1775* (Topsfield, Mass.: Wayside Press, 1927), p. 74.
3. Louis G. Myers, *Some Notes on American Pewter* (Garden City, N.Y.: Country Life Press, 1926), p. 29.
4. *Pewter Collectors' Club of America Bulletin*, no. 36 (July, 1956), pp. 109–10.
5. Alfred Coxe Prime, *The Arts and Crafts in Philadelphia, Maryland, and South Carolina, 1721–1785* (Topsfield, Mass.: Wayside Press, 1929), p. 108.
6. Laughlin, *Pewter in America*, 2: 155, 156–58.
7. Laughlin, *Pewter in America*, 2: 159.
8. The writer estimates that not more than twenty of perhaps two hundred surviving American pewter tankards were made in New England (six or seven in Massachusetts, three in Rhode Island, and a dozen at most in Connecticut) or more than thirty or forty in Philadelphia. The rest, perhaps 150, were made in New York City and Albany.
9. Laughlin, *Pewter in America*, 2: 155.
10. A well-marked eighteenth-century tankard of good metal commands a price of six to eight thousand dollars or more—almost as much as an eighteenth-century teapot of which not more than a dozen examples are known.
11. Laughlin, *Pewter in America*, 3: pl. 85, no. 715.
12. Laughlin, *Pewter in America*, 1: pl. 16, no. 93.
13. Suzanne Hamilton, "The Pewter of William Will: A Checklist," *Winterthur Portfolio 7*, ed. Ian M. G. Quimby (Charlottesville, Va.: University Press of Virginia for The Henry Francis du Pont Winterthur Museum, 1972), pp. 129–60.

Chapter 7

1. See Figure 4–39 for one, another is owned by the Art Institute of Chicago. See Charles V. Swain, "Interchangeable Parts in Early American Pewter," *Antiques* 83, no. 2 (Feb., 1962): 212–13.
2. Laughlin, *Pewter in America*, 2: pl. 72, no. 617. J. B. Kerfoot, *American Pewter* (Boston: Houghton Mifflin, 1924), p. 332.
3. Laughlin, *Pewter in America*, 2: pl. 72, no. 620.
4. Kerfoot, *American Pewter*, p. 278.
5. Catalogue and Price List, Meriden Britannia Company (West Meriden, Conn., ca. 1855), pp. 53–54.

Chapter 8

1. Edna T. Franklin, "William Penn Platter," *Pewter Collectors' Club of America Bulletin*, no. 11 (Jan., 1943), p. 4. Subsequently, the platter passed to The State in Schuylkill (founded in 1732), the oldest social organization in continuous existence in the United States.
2. *The Compleat Appraiser*, 4th ed. (London, 1770), pp. 42, 70.
3. *Maryland Gazette*, Jan. 6, 1756, as quoted in Alfred Coxe Prime, *The Arts and Crafts in Philadelphia, Maryland, and South Carolina, 1721–1785* (Topsfield, Mass.: The Wayside Press, 1929), p. 111.
4. *Compleat Appraiser*, pp. 42–43.
5. *Compleat Appraiser*, p. 70.
6. *Boston News-Letter*, Oct. 1, 1761, as quoted in George Francis Dow, *The Arts and Crafts in New England, 1704–1775* (Topsfield, Mass.: The Wayside Press, 1927), p. 74.
7. *Robert Beverley Letter Book, 1761–75*. Library of Congress.
8. Order book, Daniel Wister, Philadelphia, Dec. 6, 1762, to June 20, 1768, Historical Society of Pennsylvania, 56x17.8 (under date of Dec. 6, 1763), DMMC, Winterthur Museum Libraries.
9. J. B. Kerfoot, *American Pewter* (Boston: Houghton Mifflin, 1924), fig. 2.
10. *New York Gazette and The Weekly Mercury*, September 26, 1774, as quoted in Rita Susswein Gottesman, *The Arts and Crafts in New York, 1726–1776* (New York: New-York Historical Society, 1938), pp. 102–3.
11. "A List of Sundries to be Shipp'd by Messrs. John Noble and Co. Merchts. of Bristol for Accot. & risk Saml. and John Smith." Document no. 1152 (no. 1), Maryland Historical Society.
12. In the collection of Ledlie I. Laughlin. See

Ledlie I. Laughlin, *Pewter in America*, 1: pl. 9, no. 44.

Chapter 9

1. Percy E. Raymond, "What Is a Porringer?" *Pewter Collectors' Club of America Bulletin*, no. 8 (Jan., 1941), unpaged.
2. Banister papers, 1695–1742, Newport Historical Society, DMMC, microfilm 191.
3. Charles Welch, *History of the Worshipful Company of Pewterers of the City of London*. 2 vols. (London: Blades, East and Blades, 1902) Vol. 2, p. 147.
4. *The Diary of Samuel Sewall, II (1699–1714)*, in *Collections of the Massachusetts Historical Society*, 5th ser., vol. 6 (Boston, 1879), p. 116.
5. Percy E. Raymond, "The Princess and the Porringer," *Pewter Collectors' Club of America Bulletin*, no. 31 (May, 1953), pp. 27–30.
6. Laughlin, *Pewter in America*, 1: 86.
7. Laughlin, *Pewter in America*, 3: 56.
8. Laughlin, *Pewter in America*, 2: 158.
9. *American Collector*, April, 1946; May and Nov., 1947. This exhaustive and most useful study by Percy E. Raymond, Joseph France, and Ledlie I. Laughlin was reprinted in *Pewter Collectors' Club of America Bulletin*, no. 39 (Mar., 1958), pp. 144–49; no. 40 (Jan., 1959), pp. 1–9; and no. 41 (Sept., 1959), pp. 19–25. Many English pewter porringer types, on which some American examples were modeled, are illustrated in Ronald F. Michaelis's "English Pewter Porringers," *Appollo 50*, no. 294 (August, 1949), pp. 46–48.

Chapter 10

1. Rita Susswein Gottesman, *The Arts and Crafts in New York, 1777–1799* (New York: New-York Historical Society, 1954), p. 106.
2. For a full description, see Worth Bailey, "Joseph Copeland, Seventeenth Century Pewterer," *Antiques* 33, no. 4 (April, 1938): 188–90.
3. Charles James Jackson, *An Illustrated History of English Plate* (London: Country Life Ltd. and B. T. Batsford, Ltd., 1911), pp. 519–20 and Figs. 664, 665.
4. *Bulletin of the Antiquarian and Landmarks Society* 1 (Nov., 1949): 9.
5. The writer has also seen examples made by Hall and Cotton, William Savage, and James Weekes. Carl Jacobs, in his *Guide to American Pewter* (New York: McBride Co., 1957), p. 102, lists a similar ladle made by Ashbil Griswold.

Chapter 11

1. Austin Dobson, ed., *The Diary of John Evelyn*, 3 vols. (London: Macmillan, 1906), 1: 15.
2. *Diary and Correspondence of Samuel Pepys*, edited by Lord Braybrooke and Rev. M. Bright (London: Bickers and Son, 1875), vol. 1, p. 192.
3. J. H. Buck, *Old Plate, Its Makers and Marks* (New York: The Gorham Manufacturing Co., 1903), pp. 117–18.
4. Rodris Roth, "Tea Drinking in 18th-Century America: Its Etiquette and Equipage," *U.S. National Museum Bulletin No. 225, Contributions from the Museum of History and Technology*, Paper 14 (Washington, D.C.: Smithsonian Institution, 1961), p. 65.
5. Alice Morse Earle, *Home Life in Colonial Days* (New York: Macmillan, 1898), p. 164.
6. William Babcock Weeden, *Economic and Social History of New England, 1620–1789*, 2 vols. (Boston and New York: Houghton Mifflin, 1890), vol. 2, p. 539.
7. As quoted in Roth, "Tea Drinking," p. 66.
8. *Valuable Secrets Concerning Arts and Trades* (Norwich, Conn.: Printed by Thomas Hubbard, 1795), p. 197. This text was plagiarized from a book printed in Philadelphia some years before, which was in turn translated from the French book *Secrets Concernant les Artes et Métiers* of 1775.
9. Inventory of William Burnet. Suffolk County Probate Records, vol. 27, pp. 337–45.
10. The silver was valued at 20 shillings per ounce Massachusetts money.
11. The "other one" from the same mold is illustrated in Laughlin, *Pewter in America*, 3: pl. 93, no. 763.
12. See *101 Masterpieces of American Primitive Painting* from the collection of Edgar William and Bernice Chrysler Garbisch (New York: American Federation of the Arts, 1961), p. 33.
13. Although Ledlie Laughlin suggests that the oval teapot (see Laughlin, *Pewter in America*, 3: pl. 92, no. 761) is the earliest American pewter teapot, the writer is convinced that its oval form is a copy of 1770–80 creamware teapots, and that its mark—*F D* with a rampant lion—is in all likelihood the mark of Frederick or Francis Bassett II rather than Francis Bassett I.
14. *New York Packet*, see Laughlin, *Pewter in America*, 2: 12. See also Ledlie I. Laughlin, "Cornelius Bradford, Pewterer," *Antiques* 18, no. 2 (Aug., 1930): 144–45.
15. One of these unmarked pots in the Winterthur Museum collections appears to be identical except for the spout, the other is in the collection of Charles V. Swain. See Charles F.

Montgomery, "John Townsend, English Quaker with American Connections," *Pewter Collectors' Club of America Bulletin*, no. 51 (Dec., 1964), pp. 23–26.

16. Two of the earliest instances of the use of the neoclassical forms and ornament in American crafts are the silver tea urn marked by Richard Humphries of Philadelphia and presented by the Continental Congress in 1774 to Charles Thomson, its secretary, and the line-inlaid writing desk made by Benjamin Randolph in 1776 for Thomas Jefferson on which he wrote the Declaration of Independence. These are, however, isolated instances of the introduction of new classical forms and ornament. In general, the introduction of all neoclassical styles can be fairly accurately documented as occurring in the late 1780's at the time the new government was established.

17. *Daily Advertiser* (New York), Nov. 19, 1787, as quoted in Rita Susswein Gottesman, *The Arts and Crafts in New York, 1777–1799* (New York: New-York Historical Society, 1954), p. 106.

18. Percy E. Raymond, "Britannia Teapots: Their Styles," *Pewter Collectors' Club of America Bulletin*, no. 28 (June, 1951), pp. 184–86.

19. See Nancy A. Goyne, "Britannia in America: The Introduction of a New Alloy and a New Industry," in *Winterthur Portfolio 2*, ed. Milo M. Naeve (Winterthur, Del.: The Henry Francis du Pont Winterthur Museum, 1965), pp. 160–96.

20. For a listing of pewter found in the inventory of Thomas Byles, see Laughlin, *Pewter in America*, 2: Appendix 2, pp. 156–58.

21. Charles James Jackson, *An Illustrated History of English Plate*, 2 vols. (London: Country Life Ltd., and B. T. Batsford, Ltd., 1911), vol. 2, p. 944, fig.

22. Percy E. Raymond, "Coffeepot? Teapot!" *Antiques* 47, no. 6 (June, 1945): 326–27.

23. J. Stewart Johnson, *New York Cabinetmaking Prior to the Revolution* (unpublished Master's Thesis, University of Delaware, 1964), pp. 55–56.

24. Edwin T. Freedley, *Leading Pursuits and Leading Men* (Philadelphia: Edward Young, 1856), p. 402.

25. A. Forbes and J. W. Greene, *The Rich Men of Massachusetts* (Boston: Fetridge and Company, 1851), p. 167.

Chapter 12

1. *Pennsylvania Gazette*, May 15, 1746, as quoted in Alfred Coxe Prime, *The Arts and Crafts in Philadelphia, Maryland, and South Carolina, 1721–1785* (Topsfield, Mass.: The Wayside Press, 1929), p. 111.

2. *Staatsbote* (Philadelphia), April 28, 1772, as quoted in Prime, *Arts and Crafts, 1721–1785*, p. 111. *Federal Gazette* (Philadelphia), March 27, 1798, as quoted in Alfred Coxe Prime, *The Arts and Crafts in Philadelphia, Maryland, and South Carolina, 1786–1800* (Topsfield, Mass.: The Wayside Press, 1932), p. 145.

3. *New-York Gazette*, reviewed in the *Weekly Post-Boy*, March 23, 1752 (supplement), as quoted in Rita Susswein Gottesman, *The Arts and Crafts in New York, 1726–1776* (New York: New-York Historical Society, 1938), pp. 103, 104.

4. *New-York Mercury*, June 17, 1754, as quoted in Gottesman, *Arts and Crafts, 1726–1776*, p. 100.

5. *Daily Advertiser* (New York), Nov. 19, 1787, as quoted in Rita Susswein Gottesman, *The Arts and Crafts in New York, 1777–1799* (New York: New-York Historical Society, 1954), p. 106.

6. *Pennsylvania Packet*, May 29, 1775, as quoted in Prime, *Arts and Crafts, 1721–1785*, p. 107.

7. Laughlin, *Pewter in America*, 2: 157, 158.

8. *Daily Advertiser*, July 25, 1803, as quoted in Rita Susswein Gottesman, *The Arts and Crafts in New York, 1800–1804* (New York: New-York Historical Society, 1965), p. 209, no. 543.

9. Laughlin, *Pewter in America*, 2: 159.

10. Laughlin, *Pewter in America*, 2: 156–58, 155.

11. Laughlin, *Pewter in America*, 2: 159, 155.

12. See footnote 38, Chapter 1. In the stock of the New York merchant D. Hall on January 1, 1836, 432 caster frames were divided equally between four-, five-, and six-bottle sizes.

13. For John Love's advertisement I am indebted to John Hill, former Winterthur Fellow, who first brought it to my attention in 1965, and to Miss Hester Rich, of the Maryland Historical Society, who found it for me again after I had misplaced it. The notice first appeared on July 16, 1814, in the *Federal Gazette* and *Baltimore Daily Advertiser* and ran intermittently over the next several months.

14. Laughlin, *Pewter in America*, 2: 45.

15. *Pewter Collectors' Club of America Bulletin*, no. 57 (Dec., 1967), pp. 147–48. See also J. D. S. Snow, *Antiques* 11, no. 2 (Feb., 1927): 124–27.

16. Gottesman, *Arts and Crafts, 1726–1776*, pp. 103, 100. *Arts and Crafts, 1777–1799*, p. 106.

17. Laughlin, *Pewter in America*, 2: 159.

18. Nancy A. Goyne, "Writing Accessories Used in Early America," *Winterthur Newsletter* (Dec. 31, 1962), pp. 1–5.

19. *Pennsylvania Packet*, May 29, 1775, as quoted in Prime, *Arts and Crafts, 1726–1785*, pp. 107–8.

20. *New-York Packet*, July 21, 1786, as quoted in Gottesman, *Arts and Crafts, 1777–1799*, p. 107, no. 327.

21. A Thomas Danforth III marked example owned by Joseph France is illustrated in Laughlin, *Pewter in America*, 1: pl. 30, no. 209. A closely similar example owned by the Henry Ford Museum is illustrated in *Pewter Collectors' Club of America Bulletin*, no. 49 (Sept., 1963), pp. 174–76. Therein John Carl Thomas discusses the problems of attribution of these shakers.

22. Frances Trollope, *Domestic Manners of the Americans* (London: Whittaker, Trencher and Co., 1832), pp. 37, 189; Mrs. Basil Hall, *Aristocratic Journey*, ed. Una Pope-Hennesy (New York: G. P. Putnam's Sons, 1931), p. 41.

23. Reginald French, "About Time," *Pewter Collectors' Club of America Bulletin*, no. 46 (Feb., 1962), pp. 104–6.

24. *Boston News-Letter*, April 8, 1742, as quoted in George Francis Dow, *The Arts and Crafts in New England, 1704–1775* (Topsfield, Mass.: Wayside Press, 1927), p. 75.

Chapter 13

1. Hazel E. Cummin, *Handbook of the Concord Antiquarian Society* (3rd ed.; Portland, Me.: The Anthoensen Press, 1948), p. 7.

2. *Art Journal* (1899), pp. 313–16, 347–50; *Scientific American* (Dec. 26, 1903), pp. 487–89; Arthur Lasenby Liberty, "Pewter and the Revival of Its Use" (An address before the Applied Art Section of the Society for the Encouragement of Arts, Manufactures, and Commerce, London, May 17, 1904. Reprinted from the *Journal of the Society of Arts,* June 10, 1904), *Smithsonian Annual Report* (1904).

3. Moore, *Old Pewter, Brass, Copper, and Sheffield Plate* (New York: Frederick H. Stokes, 1905).

4. Gale, *Pewter and the Amateur Collector* (New York: Charles Scribner's Sons, 1909), p. 78.

5. As quoted in Edna T. Franklin, "Pewter Collecting in 1903," *The Pewter Collectors' Club of America Bulletin*, no. 16 (July, 1945), pp. 4–5.

6. Dyer, *The Lure of the Antique* (New York: Century Co., 1910), pp. 402–403.

7. Henry Watson Kent and Florence N. Levy, *Catalogue of an Exhibition of American Paintings, Furniture, Silver and Other Objects of Art*, vol. 2, *The Hudson-Fulton Celebration* (New York: The Metropolitan Museum of Art, 1909), p. 155.

8. *Catalogue, Retrospective Exhibition of the Decorative Arts* (Boston: Copley Society, 1911), pp. 13–14.

9. *Museum of Fine Arts Bulletin*, Boston, 14, no. 86 (Dec., 1916), pp. 46–49.

10. *Bulletin of The Wadsworth Atheneum* 1, no. 2 (Mar. 15, 1923): 2–6.

11. "Some Early American Pewter from the Twentieth Century Club Exhibit," *Antiques* 7, no. 4 (April, 1925): 192–99.

12. Kerfoot, *American Pewter* (Boston: Houghton Mifflin, 1924), p. 8.

13. Kerfoot, *American Pewter*, p. 8.

14. Kerfoot, *American Pewter*, p. 9.

15. Review of *American Pewter* by J. B. Kerfoot, *Antiques* 7, no. 2 (Feb., 1925): 88–89.

16. *Antiques* 9, no. 6 (June, 1926): 362.

17. *Antiques* 7, no. 1 (Jan., 1925): 36.

18. *Antiques* 7, no. 2 (Feb., 1925): 61.

19. *The Antiquarian* 7, no. 5 (Dec., 1926): 8.

20. *Antiques* 11, no. 5 (May, 1927): 329.

21. "John Barrett Kerfoot," *Antiques* 11, no. 6 (June, 1927): 455.

22. *The Pewter Collectors' Club of America Bulletin*, no. 1 (1934), unpaged.

23. John W. Poole, "Early American Pewterers," *New York Sun*, Feb. 8, 15, 22, 29, Mar. 7, Oct. 17, 31, 1936. In this series, Poole publicly expressed for the first time the importance of eighteenth-century teapots .

24. *Early American Pewter*, The Notable Collection formed by Albert C. Bowman (New York: American Art Association, Anderson Galleries, Feb. 11, 12, 1938). Sale no. 4373.

25. *Notable Early American Pewter*, The Private Collection of P. G. Platt. (New York: American Art Association, Anderson Galleries, April 14, 15, 1939). Sale no. 4447. My remarks on collectors and their collections are in large part based on personal remembrance and will be confined to collections that are no longer privately owned.

26. Louis G. Myers, *Some Notes on American Pewterers* (Garden City, N.Y.: Country Life Press, 1926).

27. Graham Hood, "American Pewter: Garvan and Other Collections at Yale," *Yale University Art Gallery Bulletin* 30, no. 3 (Fall, 1965).

28. Percy E. Raymond, "A Diversified Collection of American Pewter," *The Pewter Collectors' Club of America Bulletin*, no. 30 (April, 1952), a discussion of Mrs. FitzGerald's 380 marked American pieces made by 107 American makers.

29. For a sample of 19 pieces in Dr. Brown's fine collection, see J. K. Ott, *Rhode Island Pewter*, catalogue of a loan exhibition, July 1–Oct. 30, 1959 (Providence: Rhode Island Historical Society, 1959).

30. In 1939, Mrs. Blair lent her entire collection of 91 pieces of American pewter to The Metropolitan Museum of Art for a special loan exhibition. Many of those pieces were eventually given by her to the museum.

31. Marshall B. Davidson, "The France Gift of American Pewter," *The Metropolitan Museum of Art Bulletin* 3, no. 2 (Oct., 1944).

32. Downs, "A Loan Exhibition of American Pewter," *The Metropolitan Museum of Art Bulletin* 34, no. 3 (March, 1939): 61.
33. On the occasion of a meeting of The Pewter Collectors' Club of America at C. K. Davis's house on June 9, 1945, he gave a list of his pewter, then 289 pieces, to all in attendance. The practice of preparing such lists for Pewter Club meetings has been followed by other collectors and museums since Davis began it.
34. Percy E. Raymond, "Why Collect Pewter?," *The Pewter Collectors' Club of America Bulletin,* no. 22 (July, 1948), pp. 59–60.
35. In the catalogue with the same title published by New York Graphic Society in 1976, all 31 pieces of pewter are illustrated.
36. Nor did that group include a small number of important forms that could not be borrowed for the exhibition.

A Special Note on Thomas Danforth III and Blakeslee Barns.

Recently the writer has acquired two account books of Thomas Danforth III—a day-book and a ledger—which indicate the magnitude of this pewterer's business and the complexity of his operations. The daybook, which is largely confined to tinsmithing accounts, runs from March 20, 1809, to June 24, 1820. In it some of the nine journeymen tinsmiths on Danforth's payroll in 1809 are shown to have been working in Wethersfield, Connecticut, and others in Philadelphia. Barzillai Bulkley worked in Wethersfield, but Richard Pratt, Timothy Hubbard, and John Dunham were working in Philadelphia. These three were paid at the rate of "26 dollars pr month besides pay for what they do over their days work as pr Statement on their Bill as agreed with Blakeslee Barns the 25th August 1809." A "bill of days work" following the preceding statement details the number to be made of forty-seven different items as a standard day's production. That list begins with ovens, "large, second size and third size, dutch buckets, dish kettles, large pails" etc. The quota for a day's work varied from three large ovens to 18 "gallon pots" and 144 "pint scollups." The weekly production of each of the nine journeymen varied from 300 to 700 objects, (depending on their kind) and totalled about 4000 pieces of tinware. (Alas, Danforth's "pedlars" or "peddling book" to which he frequently refers is missing, as is his day-book of pewter and tin sales.)

Although not completely detailed, the accounts of Blakeslee Barns indicate a close business relationship. For example, Barns makes payments for horse and wagon to "Galpim, Phelps, Steel, Chapman and Foster" who, among others listed in the ledger, surely hawked Danforth's wares over the countryside. There is insufficient information to indicate the full extent of Barns's and Danforth's dealings, but Danforth's charges for the period, July 8, 1809, to November 15, 1810, totalled $10,041.23. Items for many of the charges are not specified, but the following explain why pint and quart mugs, ladles, and bed pans are not found in Barns's work. On September 3, 1812, Danforth charged Barns for "240 Quart cups" at four shillings (66⅔¢) and "282 pints" at two shillings sixpence (41⅔¢). During the next five years Barns bought 673 quart cups, 891 pint mugs, 133 chamber pots ($1.12 each), 672 soup ladles (30¢ each), and 41 dozen more with "bent handles" ($4.00 per dozen). Danforth also paid Thomas D. Boardman for 57 teapots which he supplied to Barns.

Many of Danforth's customers appear to have been storekeepers located in Philadelphia and Connecticut. One customer, John Davis, is noted as being in Charleston.

Danforth's business was extensive for the period from 1809, through November 1810; his charges in his ledger totalled more than $35,000. It is impossible to say if these represent his total sales, but the evidence suggests they are incomplete figures. In a day when a standard craftsman's wage was a dollar a day, and veal and beef cost 5¢ a pound, they seem tremendous. Surprisingly, tea was credited in his records at $1.10 per pound and coffee at 16¢ per pound. For comparison it should be noted that the price of new block tin was 22¢, old pewter 25¢, new pewter 32 to 37¢, and lard 12¢ a pound.

Pewterers and Britannia Makers and Their Marks Represented in A History of American Pewter

Austin, Nathaniel (1741–1816)
Charlestown, Mass., 1763–1807

Austin, Richard (1764–1817)
Boston, 1793–1807

Babbitt, Crossman & Co.
Isaac Babbitt and William W. Crossman
Taunton, Mass., 1827–29

Badger, Thomas (1764–1826)
Boston, 1787–1815

Barns, Blakeslee (1781–1823)
Philadelphia, 1812–17

Barns, Stephen
Probably Middletown or Wallingford, Conn.,
1791–1800

Barton, Charles E.: See Leonard, Reed & Barton, and Reed & Barton

Bassett, Francis, I (1690–1758)
New York City, 1718–58

Bassett, Francis, II (1729–1800)
New York City, 1754–80; Horseneck and Crane-town, N.J., 1780–85; New York City, 1785–99

Bassett, Frederick (1740–1800)
New York City, 1761–80; Hartford, 1780–85; New York City, 1785–99

Bassett, John (1696–1761)
New York City, 1720–61

Beebe: See Sage & Beebe

Belcher, Joseph (1729–81)
Newport, R.I., 1769–76
Belcher, Joseph, Jr. (b. 1751/52)
Newport, R.I., 1776–84; New London, Conn., 1784–ca. 1787

Bidgood: See Plumly & Bidgood

Billings, William (1768–1813)
Providence, 1791–1806

Boardman, Henry S.: See Hall, Boardman & Co.

Boardman, Luther & Co.
Chester, Conn., 1839–42; East Haddam, Conn., 1842–70

Boardman, Thomas D. (1784–1873)
Hartford, 1804–60 and later

Boardman, Thomas D. and **Sherman** (1787–1861)
Hartford, 1810–50

Boardman, Timothy (1798–1825) & Co.
New York City, 1822–25

———◆———

Boardman and Company
New York City, 1825–27

———◆———

Boardman and Hall
Henry S. Boardman and Franklin D. Hall
Philadelphia, 1844–45

———◆———

Boardman and Hart
T. D. and S. Boardman and Lucius Hart
New York City, 1828–53

———◆———

Bonynge, Robert
Boston, 1731–ca. 1763

Boyd, Parks (1771/72–1819)
Philadelphia, 1795–1819

———◆———

Bradford, Cornelius (1729–86)
New York City, 1752–53; Philadelphia, 1753–70;
New York City, 1770–85

———◆———

Bradford, William, Jr. (1688–1758)
New York City, 1719–58

277

Brigden, Timothy (1774–1819)
Albany, 1816–19

Brook Farm
West Roxbury, Mass., 1844–47

Brower, Abraham
New York City, ca. 1820

Byles, Thomas (ca. 1685–1771)
Newport, R.I., ca. 1711–12; Philadelphia, 1738–71

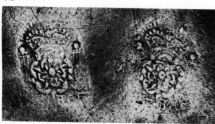

G. C. (unidentified)
America, late eighteenth century

Calder, William (1792–1856)
Providence, 1817–56

Capen & Molineux
Ephraim Capen and George Molineux
New York City, 1848–54

Carnes, John (1698–1760)
Boston, 1723–60

Chandlee, Goldsmith (ca. 1752–1821)
Nottingham Township, Pa., 1780–ca. 1800; Winchester, Va., ca. 1800–1821
See Figure 12–23

Coldwell, George (d. 1811)
New York City, 1787–1811

Copeland, Joseph (ca. 1650–1691)
Chuckatuck and Jamestown, Va., 1675–91
See Figure 10–5

Cowles, George: See Lewis & Cowles

Crossman, West & Leonard
William W. Crossman, William A. West, and Zephaniah Leonard
Taunton, Mass., 1829–30

Curtis, Stephen: See Yale & Curtis

Curtiss, Daniel (1799/1800–1872)
Albany, 1822–40

Danforth, Edward (1765–1830)
Hartford, 1786–95

Danforth, John (1741–ca. 1799)
Norwich, Conn., 1773–93

Danforth, Joseph (1758–88)
Middletown, Conn., 1780–88

Danforth, Joseph, Jr. (1783–1844)
Richmond, Va., 1807–12

Danforth, Josiah (1803–72)
Middletown, Conn., 1821–ca. 1843

Danforth, Samuel (1772–1827)
Norwich, Conn., 1793–1802

Danforth, Samuel (1774–1816)
Hartford, 1795–1816

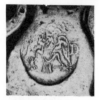

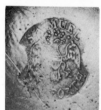

Danforth, Thomas, I (1703–86)
Taunton, Mass., 1727–33; Norwich, Conn., 1733–
ca. 1775, or Thomas, II or possibly Thomas, III

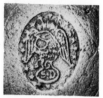

Danforth, Thomas, II (1731–82)
Middletown, Conn., 1755–82 and possibly Thomas,
III

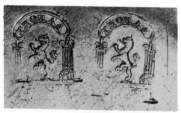

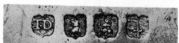

Danforth, Thomas, I, and **John** or **Thomas, II**
(or **III?**), and **Joseph**

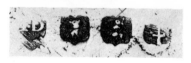

Danforth, Thomas, III (1756–1840)
Stepney, Conn., 1777–1818; Philadelphia, 1807–
13

Day, Benjamin (ca. 1706–57)
Newport, R.I., 1744–57

280

Derby, Thomas S. (ca. 1786–1852)
Middletown, Conn., 1822–50

Derr, Peter
Berks County, Pa., ca. 1820–50

Dolbeare, Edmund
Boston, ca. 1671–ca. 1684; Salem, Mass., ca. 1684–
ca. 1692; Boston, ca. 1692–ca. 1711

Dolbeare, John
Boston, ca. 1690–1740

Dunham, Rufus (1815–ca. 1882)
Westbrook, Me., 1837–60

R. E. (unidentified)
America, 1725–1800

Edgell, Simon (d. 1742)
Philadelphia, 1713–42

Eggleston, Jacob (1773–1813)
Middletown, Conn., and Fayetteville, N.C., ca.
1796–1807

Elsworth, William J. (1746–1816)
New York City, 1767–98

Endicott & Sumner
Edmund Endicott and William F. Sumner
New York City, 1746–1851

Fenn, Gaius and **Jason**
New York City, 1831–43

Forbes, Elizur B.
Probably Westbrook, Me., ca. 1840–ca. 1860

Gleason, Roswell (1799–1865)
Dorchester, Mass., 1821–71

Griswold, Ashbil (1784–1853)
Meriden, Conn., 1807–35

Griswold, Giles (1755–1840)
Augusta, Ga., 1818–20

Hall, Boardman & Co.
Franklin D. Hall and Henry S. Boardman
Philadelphia, 1846–48

Hamlin, Samuel (1746–1801)
Hartford, 1767–ca. 1768; Middletown, Conn., ca. 1768–73; Providence, 1773–1801

Hamlin, Samuel E. (1774–1864)
Providence, 1801–56 (probably used all of his father's marks, except the rose mark)

Hart, Lucius: See Boardman & Hart

Hera, Christian (1762/63–1817) and **John** (1767–1812)
Philadelphia, 1800–1812

Hersey, Samuel S.
Belfast, Me., ca. 1840–60

Heyne, Johann Christoph (1715–81)
Lancaster, Pa., ca. 1756–80

282

Hill, T. (Thomas?)
Probably England, ca. 1800–1850

Hopper, Henry
New York City, 1842–47

Hyde, Martin
New York City, ca. 1850–60

Johnson, Jehiel (1784/85–1833)
Middletown, Conn., 1815–25
Fayetteville, N.C., 1818–19

Jones, Gershom (1751–1809)
Providence, 1774–1809

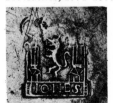

Keene, Josiah (1778/79–1868)
Providence, 1801–17

Kilbourne, Samuel (ca. 1770–1839)
Baltimore, 1814–39

Kirby, William (1740–1804)
New York City, 1760–93

Kirk, Elisha (d. 1790)
York, Pa., 1780–90

Leddell, Joseph, Sr. (ca. 1690–1754)
New York City, 1712–53

283

Leddell, Joseph, Jr. (d. 1754)
New York City, ca. 1740–54
See Figure 4–5

Lee & Creesy
Philip Lee (b. 1786) and [?] Creesy
Beverly, Mass., ca. 1807–ca. 1812

Lee, Richard, Sr. (1747–1823)
Grafton, N.H., 1788–90; Ashfield, Mass., 1791–93;
Lanesborough, Mass., 1794–1802; Springfield, Vt.,
1802–20

Lee, Richard, Sr. and
Lee, Richard, Jr. (b. 1775)
Springfield, Vt., 1795–1816

Leonard, Zephaniah: See Crossman, West &
Leonard

Leonard, Reed & Barton
Gustavus Leonard, Henry Reed, and Charles Barton
Taunton, Mass., 1837–40

Lewis & Cowles
I. C. Lewis and George Cowles
East Meriden, Conn., 1834–36

Lightner, George (1749–1815)
Baltimore, 1806–15

"Love" mark of unidentified pewterer
Probably Philadelphia, ca. 1750–1800

Love, John
Baltimore, 1814–?

McEuen, Malcolm (ca. 1740–1803) and **Duncan**
(b. 1769)
New York City, 1793–1803

McQuilkin, William
Philadelphia, 1839–53

284

Melville, David (1755–93)
Newport, R.I., 1776–93

Melville, Samuel and **Thomas, I** (d. 1796)
Newport, R.I., 1793–96

Miller, Josiah
Probably Rhode Island or Connecticut, eighteenth
century
See Figure 12–21

Molineux, George: See Capen & Molineux

Nichols, O.
Probably New England, ca. 1800–1825

Norris, George: See also Ostrander & Norris
New York City, 1848–50

Nott, William (1789–1836/41)
Fayetteville, N.C., 1817–25, or Middletown,
Conn., 1809–17

Olcott, J. W.
Baltimore, ca. 1800–1810

Ostrander & Norris
Charles Ostrander and George Norris
New York City, 1848–50

Palethorp, John Harrison
Philadelphia, 1820–45

Palethorp, Robert, Jr. (1797–1822)
Philadelphia, 1817–22

Pierce, Samuel (1767–1840)
Greenfield, Mass., 1792–1830

Plumly & Bidgood
Charles Plumly and [?] Bidgood
Philadelphia, ca. 1825

Porter, Freeman
Westbrook, Me., 1835–65

Porter, James
Middletown, Conn., 1790–1803; Baltimore, 1803–
ca. 1809

Potter, W.
Probably New England, ca. 1830–40

Putnam, James H. (1803–55)
Malden, Mass., 1830–55

R——N. (unidentified)
Probably New England, 1830–60

Reed & Barton
Henry G. Reed and Charles E. Barton
Taunton, Mass., 1840–present

Reed, Henry G.: See Leonard, Reed & Barton, **and**
Reed & Barton

Richardson, George (1782–1848)
Boston, 1818–28; Cranston, R.I., 1830–45

T. S. (unidentified)
America [?], 1750–1800

Sage, Timothy
St. Louis, 1847–48

Sage & Beebe
Timothy Sage and [?] Beebe
St. Louis, ca. 1849–50

Sellew & Co.
Enos, Osman, and William Sellew
Cincinnati, 1832–60
See Figure 5–7

Semper Eadem device
Boston, 1725–72;

Shoff, John
Probably Lancaster County, Pa., ca. 1775–1800

Skinner, John (1733–1813)
Boston, 1760–90

Smith, Eben
Beverly, Mass., ca. 1814–56

Southmayd, Ebenezer (1775–1831)
Castleton, Vt., 1802–20

Stafford, Spencer (1772–1844)
Albany, ca. 1820–27

Stedman, Simeon
Hartford, ca. 1818–25

Sumner, William F.: See Endicott & Sumner

Taunton Britannia Manufacturing Co.
Taunton, Mass., 1830–34

Thompson, Andrew
Albany, 1811–17

Trask, Israel (1786–1867)
Beverly, Mass., ca. 1813–ca. 1856

Trask, Oliver (1792–1847)
Beverly, Mass., 1832–39

E. W. (unidentified maker; cast initials unidentified)
Virginia, after 1740

Weekes, James
New York City, 1820–35

287

West, William A.: See Crossman, West & Leonard

Whitehouse, E.
England or America, 1800–40
(Several britannia makers of this name were work-
ing in Birmingham, England, during the first half
of the nineteenth century)

Whitmore, Jacob (1736–1825)
Middletown, Conn., 1758–90

Wildes, Thomas
New York City, 1833–40

Will, Henry (ca. 1735–ca. 1802)
New York City, 1761–75; Albany, 1776–83; New
York City, 1783–93

Will, John (ca. 1707–ca. 1774)
New York City, 1752–74

Will, Philip (1738–87)
New York City, 1766 and later; Philadelphia,
1763–87

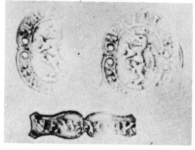

Will, William (1742–98)
Philadelphia, 1764–98

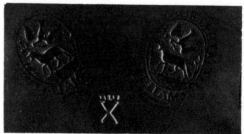

288

Will, William (1742–98) (Continued)

Woodbury, J. B.
Probably Beverly, Mass., ca. 1830–35; Philadelphia, 1835–38

Yale & Curtis
Henry Yale and Stephen Curtis
New York City, 1858–67

Yale, Hiram (1799–1831)
Wallingford, Conn., 1822–31

Yale, William (1784–1833) and **Samuel** (1787–1864)
Meriden, Conn., 1813–20

Yates, John
Birmingham, England, ca. 1800–1840

Young, Peter (1749–1813)
New York City, 1775–85; Albany, 1785–95

Public Collections of American Pewter

Fine collections of American pewter are exhibited in almost fifty American museums. With few exceptions, the foundations of those collections were gifts or bequests from enthusiastic private collectors who prized the metal. Their names belong on a roll of honor, and insofar as I have been able to discover them, they are listed for each institution with the most important donor usually listed first. I am grateful to these collectors as is an ever increasing public that finds old American pewter beautiful.

Albany Institute of History and Art
Albany pewter, in part the bequest of Blanche V. Nolan

American Museum in Britain, Bath
Gift of Mr. and Mrs. John H. Ballantine

Antiquarian and Landmarks Society of Connecticut, Hartford

Art Institute of Chicago
Gift of William Goodman

Bennington Museum, Vt.
Gift of Hall Park McCullough

Brooklyn Museum
The collection of John W. Poole (by purchase) with additions

Chester County Historical Society, West Chester, Pa.
Gifts from Mr. and Mrs. Francis D. Brinton and L. Carstairs Pierce

Colonial Williamsburg, Va.
Although the emphasis here is on English pewter, there are important pieces of American pewter in the collection.

Concord Antiquarian Society, Mass.
In part the gift of Cummings E. Davis

Connecticut Historical Society, Hartford
Connecticut church pewter

Currier Gallery of Art, Manchester, N.H.
The collection of Edward Pushee (by purchase)

Detroit Institute of Arts

Essex Institute, Salem, Mass.

Governor William Pyncheon Memorial, Connecticut Valley Historical Museum, Springfield, Mass.
Gift of Mrs. Stephen S. Fitzgerald

Greenfield Village and Henry Ford Museum, Dearborn, Mich.

Henry Francis du Pont Winterthur Museum
Major gifts from Henry Francis du Pont, Charles K. Davis, and Joseph France, and important purchases from the collections of Mrs. Harry Horton Benkard, Maurice Brix, Ivan Culbertson, Charles F. Hutchins, Melville T. Nichols, and Senator and Mrs. Richard S. Quigley.

Hershey Museum, Pa.
Johann Christoph Heyne and William Will pewter

Historic Deerfield, Mass.
Gift of Mr. and Mrs. Henry N. Flynt. Samuel Pierce's tools, the gift of Ledlie I. Laughlin

Historical Society of Pennsylvania, Philadelphia

Litchfield Historical Society and Museum, Conn.
Largely the gifts of Mrs. Arthur Hamilton and Julia Wolcott

Metropolitan Museum of Art, American Wing, New York
Major gifts from Mrs. J. Insley Blair, Mrs. Stephen S. Fitzgerald, and Joseph France

Museum of Early Southern Decorative Arts,
Winston-Salem, N.C.
Pewter from the Moravian settlement
and gifts of Mr. and Mrs. Ralph P. Hanes
and Frank L. Horton

Museum of Fine Arts, Boston
Largely the bequest of Mrs. Stephen S.
Fitzgerald

Museum of Fine Arts, Houston,
Bayou Bend Collection
Gift of Miss Ima Hogg

New Canaan Historical Society, Conn.
Gift of Mrs. T. Ferdinand Wilcox

New Hampshire Historical Society, Concord
Pewter from New Hampshire churches
and gift of Mrs. Katherine Prentis Murphy

New Haven Colony Historical Society
In large part the bequest of Eugene
de Forest and a large gift of Connecticut
pewter from Charles K. Davis

New Jersey State Museum, Trenton

New-York Historical Society, New York
In part the gift of Mrs. Katherine Prentis
Murphy

Newport Historical Society, R.I.
Gift of Dr. Madelaine R. Brown

Old Sturbridge Village, Mass.
Largely the gift of A. B. Wells

Philadelphia Museum of Art
In part the gifts of Mrs. M. L. Blumenthal
and J. Stodgell Stokes

Pocumtuck Valley Memorial Association,
Deerfield, Mass.

Presbyterian Historical Society, Philadelphia
Sacramental vessels from many
Presbyterian churches including five
examples by William Will

Rhode Island Historical Society, Providence
Gift of Charles A. Calder

Shelburne Museum, Vt.
Gift of Mrs. J. Watson Webb

Smithsonian Institution, Washington, D.C.
Permanent loan from Dr. Joseph H. Kler

Society for the Preservation of New England
Antiquities, Boston
American pewter largely the gift
of Charles K. Davis

Springfield Art and Historical Society, Vt.
Thirty-five marked pieces of Richard Lee
pewter and two Lee and Creesy teapots,
all the bequest of Mark C. La Fountain

Van Cortlandt Manor, near Croton-on-
Hudson, N.Y.

Wadsworth Atheneum, Hartford

William Penn Memorial Museum, Harrisburg
An outstanding porringer collection,
the gift of Joseph France

Worcester Art Museum, Mass.
Bequest of Charles F. Hutchins

Yale University Art Gallery, New Haven
Gift of Francis P. Garvan in honor
of his wife Mabel Brady Garvan

Plates and Dishes in the Winterthur Museum

Unless otherwise noted, the plates and dishes listed below have single-beaded brims. Those with smooth brims are designated by an SB after the diameter.

Maker	Place	Working Dates	Diameter in Inches	Accession No.
6-inch Plates:				
Blakslee Barns	Philadelphia	1812-17	6 3/6	65.1472
			6 1/8	65.1474
Frederick Bassett	New York City	1761-1800	6 7/16	53.32
Thomas D. Boardman	Hartford, Conn.	1804-60	6 1/2	53.155.21, Gift of Charles K. Davis
Daniel Curtiss	Albany, N.Y.	1822-40	6 7/16	52.113
Samuel Danforth	Hartford, Conn.	1795-1816	6 3/16	56.46.19, Gift of Charles K. Davis
Thomas Danforth III	Stepney, Conn. or Philadelphia	1777-1818	6 1/4	55.48.48, Gift of Charles K. Davis
			6 3/16	65.1475
Johann C. Heyne	Lancaster, Pa.	ca. 1756-80	6 3/8	62.605
			6 7/16	62.606
Richard Lee, Sr.	prob. Springfield, Vt.	1788-20	6 1/8	65.1526
Love mark	Pennsylvania, poss. Philadelphia	ca. 1750-93	6 1/16	65.1473
Jacob Whitmore	Middletown, Conn.	1758-90	6 1/4	53.35
William Will	Philadelphia	1764-98	6 1/4	52.10
			5 5/8 SB	58.650
			6 1/4	58.655
7⅞- to 9-inch Plates:				
Thomas Badger, Jr.	Boston	1787-1815	7 7/8	65.1545
Blakslee Barns	Philadelphia	1812-17	7 15/16	64.1147
Stephen Barns	Middletown or Wallingford, Conn.	1791-1800	8 3/4	65.1458
Francis Bassett I	New York City	1715-40	8 1/2	65.2493
			8 15/16 SB	67.1366
Frederick Bassett	New York City	1761-1800	8 1/2	65.2492
Joseph Belcher, Jr. or Sr.	Newport, R.I.	1769-87	8	53.155.9, Gift of Charles K. Davis
Parks Boyd	Philadelphia	1795-1819	8 9/16	63.652
William Bradford, Jr.	New York City	1719-58	8 15/16	56.46.16, Gift of Charles K. Davis
Edward Danforth	Hartford, Conn.	1786-95	7 7/8	60.1100
Joseph Danforth, Sr.	Middletown, Conn.	1780-88	7 7/8	60.945
Joseph Danforth, Jr.	Richmond, Va.	1807-12	8 3/4	58.644
			8 13/16	60.2

MAKER	PLACE	WORKING DATES	DIAMETER IN INCHES	ACCESSION No.
Samuel Danforth	Hartford, Conn.	1795-1816	7 7/8	65.1544
Thomas Danforth I or II	Norwich or Middletown, Conn.	ca. 1760-86	7 13/16	56.46.17, Gift of Charles K. Davis
Thomas Danforth I or II, or partnership	Norwich or Middletown, Conn.	ca. 1755-82	8	66.1183
Thomas Danforth II	Middletown, Conn.	1755-82	8	66.1184
Thomas S. Derby	Middletown, Conn.	1822-50	8 3/4	64.1156
Giles Griswold or North & Rowe	Augusta, Ga.	1818-23	8 5/8	58.7.1, Joseph France Fund
Jehiel Johnson	Middletown, Conn. or Fayetteville, N.C.	1815-25	7 15/16 7 15/16 8 3/4	53.24 58.643 56.46.18, Gift of Charles K. Davis
Gershom Jones	Providence, R.I.	1774-1809	8 5/16	53.155.12, Gift of Charles K. Davis
Samuel Kilbourn	Baltimore	1814-39	8	53.155.3, Gift of Charles K. Davis
William Kirby	New York City	1760-93	8 15/16	55.30
George Lightner	Baltimore	1806-15	7 15/16	58.639
David Melville	Newport, R.I.	1776-93	8 1/4	60.946
Samuel and Thomas Melville	Newport, R.I.	1793-1800	8 5/8	56.59.13, Gift of Joseph France
J. W. Olcott	Baltimore	ca. 1800-10	7 7/8	58.640
Robert Palethorp, Jr.	Philadelphia	1817-22	8 7/16	53.155.4, Gift of Charles K. Davis
Samuel Pierce	Greenfield, Mass.	1792-1830	8 8 1/16	53.17 58.53.3, Joseph France Fund
Plumly & Bidgood	Philadelphia	ca. 1825	7 11/16	63.665
James Porter	Middletown, Conn. or Baltimore	1795-1809	7 15/16	55.48.36, Gift of Charles K. Davis
Semper Eadem mark	Boston	1725-72	7 7/8 8 1/2	56.59.12, Gift of Joseph France 56.59.14, Gift of Joseph France
Spencer Stafford	Albany, N.Y.	1820-27	8	55.48.37, Gift of Charles K. Davis
Henry Will	New York City	1761-93	8	63.663
William Will	Philadelphia	1764-98	8 7/16	53.26
Hiram Yale	Wallingford, Conn.	1822-31	8 7/16	66.1190
William Yale, Jr.	Meriden, Conn.	1813-20	8 7/16	56.59.8, Gift of Joseph France
Peter Young	Albany, N.Y.	1775-95	8 13/16 8 13/16	65.2494 65.2495

9- to 10-inch plates:

MAKER	PLACE	WORKING DATES	DIAMETER IN INCHES	ACCESSION No.
Joseph Belcher, Sr. or Jr.	Newport, R.I. or New London, Conn.	1769-90	9 7/16 SB	56.46.14, Gift of Charles K. Davis
Thomas D. and Sherman Boardman	Hartford, Conn.	1810-50	9 5/8	65.1454
Boardman and Company	New York City	1825-27	9 3/8	65.1453
Boston mark	Boston	1730-65	9 1/2 SB	57.131
Cornelius Bradford	Philadelphia or New York City	1752-85	9 SB 9 15/16 SB	65.2459 67.1367

Maker	Place	Working Dates	Diameter in Inches	Accession No.
John Danforth	Norwich, Conn.	1773-93	9 7/16	56.46.15, Gift of Charles K. Davis
Christian and John Hera	Philadelphia	1800-12	9 1/4 SB	65.2458
Malcolm and Duncan McEuen	New York City	1793-1803	9 5/16 SB	65.2457
George Richardson	Boston	1818-28	9 11/16	56.59.18, Gift of Joseph France
D. S. (unidentified)	poss. Pennsylvania	1750-1800	9 1/4 SB	56.59.15, Gift of Joseph France
E. W. (unidentified)	Virginia	ca. 1740-1816	9 1/16 SB	65.2238
John Will	New York City	1752-74	9 1/16	67.1365
William Will	Philadelphia	1764-98	9 1/2 SB	58.659
			9 3/8 SB	58.660

Dishes (10 to 19 inches):

Maker	Place	Working Dates	Diameter in Inches	Accession No.
Nathaniel Austin	Boston	1763-1807	15 1/8	56.46.11, Gift of Charles K. Davis
Richard Austin	Boston	1793-1807	15	56.46.12, Gift of Charles K. Davis
			15	65.2191
Thomas Badger, Jr.	Boston	1787-1815	15 1/8	65.2190
Blakslee Barns	Philadelphia	1812-17	13 5/8	65.1553
Frederick Bassett	New York City	1761-1800	16 1/2	65.2753
Boardman and Company	New York City	1825-27	10 13/16	65.1533
Parks Boyd	Philadelphia	1795-1819	12	65.1459
Thomas Byles	Philadelphia	1738-71	10 7/8	56.46.13, Gift of Charles K. Davis
William Calder	Providence, R.I.	1817-56	11 3/8	65.1460
			10 3/8	65.1534
Daniel Curtiss	Albany, N.Y.	1822-40	11 3/16 (deep)	63.668
Edward Danforth	Hartford, Conn.	1786-95	13 1/4 (deep)	66.1180
Samuel Danforth	Norwich, Conn.	1793-1802	12 5/16	56.59.2, Gift of Joseph France
Thomas Danforth III	Philadelphia	1807-1813	11 5/8 (deep)	63.669
Att. Edmund Dolbeare	Boston or Salem, Mass.	ca. 1670-1706	15 3/8 SB	55.60.1
			16 5/8 (multiple reeded)	55.60.2, Gift of Charles K. Davis
Att. John Dolbeare	Boston	1690-1740	15 (multiple reeded)	53.179
Simon Edgell	Philadelphia	1713-42	19	53.28
Jacob Eggleston	Middletown, Conn.	ca. 1796-1807	13 1/8 (deep)	66.1179
Giles Griswold	Augusta, Ga.	1818-20	11 1/8 (deep)	58.641
Jehiel Johnson	Middletown, Conn. or Fayetteville, N.C.	1815-25	13 1/4 (deep)	56.59.5, Gift of Joseph France
Joseph Leddell, Sr.	New York City	1712-53	14 15/16	65.2754
William Nott	Middletown, Conn. or Fayetteville, N.C.	1813-25	13 1/4	56.59.6, Gift of Joseph France
John Shoff	possibly Lancaster County, Pa.	ca. 1775-1800	10 7/8 SB	65.2239
John Skinner	Boston	1760-90	13 1/2	65.1555
Spencer Stafford	Albany, N.Y.	1820-27	13 5/8	65.1554
William Will	Philadelphia	1764-98	16 1/2	58.642
(Unknown)	America	1740-1800	11 5/8	56.59.1, Gift of Joseph France

The Composition of American Pewter and Britannia Objects

During the last few months before this book went to press, the Winterthur Museum Analytical Laboratory, under the direction of Victor F. Hanson, began to run tests to determine the composition of pewter objects in the Winterthur collection. For this purpose, the laboratory uses a Kevex nondispersive analyzer. Because this instrument operates on the principle of x-ray fluorescence, it measures the content of the alloy in only a small area very near the surface. At the present time, research is being carried on by the laboratory to determine the homogeneity of pewter castings and whether the metal is uniform throughout a casting, there being the possibility of segregation on the surface or elsewhere in the casting. However, the writer supposes that the initial skimming or scraping of the casting and subsequent wear on a pewter or britannia vessel would have eliminated surface segregation if it did occur.

On the basis of preliminary tests, it appears that some American pewterers were able to control the composition of their alloy, varying it according to the form or method of casting being employed (such as slush casting). For example, the tin content of mug and tankard handles (slush cast), thumbpieces, and lids appears to be higher in most cases than that of bases and barrels. Spoons and plates usually contain less tin and more lead. City-made pewter usually has a higher tin content than pewter made in country districts. And the pewter of such makers as John Bassett, Francis Bassett, John Will, and others is often amazingly pure—the tin content running as high as 95 to 99 per cent.

In the britannia era, the percentage of antimony was higher and the percentage of lead lower than was true in the eighteenth century. In some vessels of this era the alloy approximated that of earlier pewter. All of which supports the revelations of William Calder's account books to the effect that Calder was producing both britannia and pewter in his shop at the same time—the britannia being lead free with $2\frac{1}{2}$ to 10 per cent of antimony. In the objects tested to date, there appears to be very little bismuth present except in spoons and in other objects with a high lead content. The amounts of copper present are also surprisingly low. More tests will undoubtedly reveal new information about the practices of the American pewterer and lead to further investigation of the craft.

THE COMPOSITION OF AMERICAN PEWTER AND BRITANNIA OBJECTS

DATE	OBJECT	MAKER	ACC. NO.	LOCATION	TIN	LEAD	COPPER	ANTIMONY	BISMUTH
1671–1711	Dish (bottom)	E. Dolbeare	55.60.1	Boston & Salem	97.38%	1.66%	.91%	.00%	.00%
1671–1711	Dish (bottom)	E. Dolbeare	55.60.2	Boston & Salem	88.85	9.16	1.34	.00	.00
1690–1740	Dish (bottom)	J. Dolbeare	53.179	Boston & Salem	95.23	2.53	1.04	.00	.00
1712–54	Plate (bottom)	J. Leddell, Sr. or Jr.	65.2754	New York City	92.90	.48	6.43	.00	.00
1713–42	Tankard	S. Edgell	65.553	Philadelphia					
	bottom				90.87	6.57	1.47	.61	.08
	side				90.08	7.35	1.31	1.07	.08
	lid				96.66	1.07	.84	1.18	.20
	handle				95.93	2.23	.67	.98	.15
	thumbpiece				94.23	3.64	1.06	.83	.18
1718–58	Plate (bottom)	Francis Bassett I	67.1366	New York City	94.42	2.84	.95	1.62	.00
1720–61	Funnel (side)	J. Bassett	65.2241	New York City	97.16	.42	.70	1.72	.00
1720–61	Porringer (body)	J. Bassett	67.1372	New York City	93.96	4.18	.71	1.15	.00
1723–60	Tankard	J. Carnes	65.2268	Boston & Salem					
	bottom				97.43	.52	1.00	.74	.00
	body				98.01	.00	.71	.81	.00
	lid				97.90	.00	1.14	.42	.00
	thumbpiece				97.31	.94	.55	.58	.00
	handle				98.01	.00	.98	.57	.00
1733–82	Plate (bottom)	T. Danforth I or II	56.46.17	Norwich or Middletown, Conn.	81.04	16.77	.83	.90	.00
1738–71	Dish (bottom)	T. Byles	56.46.13	Philadelphia	97.09	.50	.51	1.57	.00
1752–74	Tankard	J. Will	55.48.28	New York City					
	bottom				96.35	3.27	.08	.10	.00
	body				99.13	.00	.01	.01	.00
	lid				99.45	.00	.03	.07	.00
	thumbpiece				99.37	.00	.05	.07	.00
	handle				99.00	.00	.19	.00	.00
1752–74	Tankard	J. Will	55.75	New York City					
	bottom				91.05	5.54	1.10	2.18	.07
	side				94.47	3.28	.81	1.31	.10
	lid				93.83	3.55	.80	1.66	.10
	handle				95.53	1.86	.84	1.50	.22
	thumbpiece				95.26	1.25	.82	2.43	.17
1752–74	Beaker (side)	J. Will	58.64	New York City	95.83	1.45	.97	1.53	.17
1752–74	Creamer (side)	J. Will	65.2756	New York City	95.98	.42	.31	3.12	.13
1752–74	Mug (side)	J. Will	65.2759	New York City	91.96	5.29	.73	1.90	.05
1752–74	Plate (bottom)	J. Will	67.1365	New York City	92.99	3.93	.57	2.28	.00
1752–74	Creamer (side)	J. Will	67.1368	New York City	96.94	.39	.62	1.88	.11

DATE	OBJECT	ACC. NO.	MAKER	LOCATION	TIN	LEAD	COPPER	ANTIMONY	BISMUTH
1752–85	Plate (bottom)	65.2459	C. Bradford	New York City & Philadelphia	95.99%	.00%	.34%	3.07%	.00%
1752–85	Teapot (bottom)	65.2500	C. Bradford	New York City & Philadelphia	96.63	.81	.83	1.73	.00
1752–85	Tankard (side)	65.2757	C. Bradford	New York City & Philadelphia	94.28	2.60	.89	1.71	.34
1755–82	Plate (bottom)	66.1184	Attributed to T. Danforth II	Middletown, Conn.	89.57	7.64	.73	2.06	.00
1760–90	Plate (bottom)	66.1183	T. Danforth I or II & John or Joseph	Norwich or Middletown, Conn.	81.91	14.00	1.18	2.30	.00
1760–90	Dish (bottom)	65.1555	J. Skinner	Boston	96.96	.59	.78	1.54	.09
1761–93	Plate (bottom)	63.663	H. Will	New York City & Albany	82.89	13.49	.67	2.20	.16
1761–93	Tankard (side)	65.2752	H. Will	New York City & Albany	90.89	4.86	.85	3.28	.07
1761–99	Mug bottom body handle	65.2242	Frederick Bassett	New York City & Hartford	96.29 95.92 98.83	2.25 2.81 .00	.39 .16 .08	1.07 1.11 .53	.00 .00 .00
1761–99	Porringer body handle	65.2499	Frederick Bassett	New York City & Hartford	91.12 93.37	6.98 4.77	.47 .15	1.43 1.71	.00 .00
1761–99	Tankard (body)	65.2758	Frederick Bassett	New York City & Hartford	94.10	3.29	.04	2.57	.00
1763–1807	Dish (bottom)	56.46.11	N. Austin	Charlestown, Mass.	87.73	9.17	.76	1.76	.51
1763–1807	Mug (side)	60.944	N. Austin	Charlestown, Mass.	85.90	10.73	.89	1.94	.40
1764–98	Hot-water plate (bottom)	54.97.2	W. Will	Philadelphia	95.20	2.22	.38	2.20	.00
1764–98	Dish (bottom)	58.642	W. Will	Philadelphia	96.85	2.00	.00	.72	.00
1764–98	Tankard (body)	58.653	W. Will	Philadelphia	97.16	1.38	.70	.58	.00
1764–98	Plate (bottom)	58.659	W. Will	Philadelphia	94.35	2.30	.63	.92	.00
1764–98	Spoon (bowl)	58.666	W. Will	Philadelphia	71.14	25.78	1.36	1.31	.00
1764–98	Spoon (bowl)	58.667	W. Will	Philadelphia	74.33	22.26	1.10	1.20	.04
1764–98	Spoon (bowl)	58.668	W. Will	Philadelphia	72.47	23.55	1.67	1.14	.17
1764–98	Bedpan (bottom)	61.103	W. Will	Philadelphia	85.07	12.54	.58	1.81	.00
1764–98	Teapot (bottom)	61.1680	W. Will	Philadelphia	95.65	1.47	.00	2.88	.00

—continued

The Composition of American Pewter and Britannia Objects/ 297

THE COMPOSITION OF AMERICAN PEWTER AND BRITANNIA OBJECTS (cont.)

DATE	OBJECT	ACC. NO.	MAKER	LOCATION	TIN	LEAD	COPPER	ANTIMONY	BISMUTH
1785–98	Coffee pot body bottom	54.33	W. Will	Philadelphia	94.00%	2.91%	.24%	2.72%	.00%
1785–98	Teapot (bottom)	58.656	W. Will	Philadelphia	98.45	1.10	.00	.45	.00
1785–98	Teapot (bottom)	58.657	W. Will	Philadelphia	97.83	1.17	.06	.94	.00
1787–98	Basin (bottom)	53.43	W. Will	Philadelphia	90.38	7.13	.69	1.73	.04
1787–98	Plate (bottom)	58.660	W. Will	Philadelphia	90.01	8.05	.78	.96	.00
1767–1801	Porringer bottom handle	67.1375	S. Hamlin	Hartford & Middletown, Conn. and Providence	79.17 59.72	17.69 35.45	.92 1.87	1.21 .63	.07 .41
1775–95	Plate (bottom)	65.2494	P. Young	New York City & Albany	88.96	8.13	.50	2.15	.00
1775–95	Plate (bottom)	65.2495	P. Young	New York City & Albany	79.81	16.25	.61	2.91	.08
1776–93	Porringer bottom handle	67.1374	D. Melville	Newport, R.I.	78.68 89.37	18.33 7.42	.99 .69	2.00 2.00	.00 .00
1787–1815	Plate (bottom)	65.1545	T. Badger	Boston	92.44	4.41	.68	2.15	.29
1787–1815	Dish (bottom)	65.2190	T. Badger	Boston	90.36	6.77	.73	1.74	.36
1788–1820	Porringer (bottom)	58.676	R. Lee, Sr. or Jr.	Rural New England	84.08	13.00	.75	2.09	.00
1792–1830	Plate (bottom)	53.17	S. Pierce	Greenfield, Mass.	89.76	6.80	1.05	2.18	.14
1792–1830	Plate (bottom)	53.53.3	S. Pierce	Greenfield, Mass.	82.39	12.58	.84	3.93	.16
1793–1807	Dish (bottom)	56.46.12	R. Austin	Boston	89.87	6.75	.69	2.23	.42
1793–1807	Dish (bottom)	65.2191	R. Austin	Boston	78.58	17.17	.83	2.49	.82
1795–1819	Tankard (body)	52.293	P. Boyd	Philadelphia	91.93	4.97	.43	2.58	.05
1795–1819	Plate (bottom)	63.652	P. Boyd	Philadelphia	75.22	23.30	1.12	.08	.00
1795–1819	Dish (bottom)	65.1459	P. Boyd	Philadelphia	66.48	29.92	1.43	1.71	.00
1804–60	Plate (bottom)	53.155.21	T. D. Boardman	Hartford	81.30	14.03	.89	3.38	.00
1807–13	Porringer bottom handle	67.1373	T. Danforth III	Philadelphia	66.90 77.68	28.64 19.30	1.62 .78	1.56 1.51	.00 .16
1812–17	Plate (bottom)	65.1472	B. Barns	Philadelphia	77.06	20.74	.63	1.41	.00
1812–17	Dish (bottom)	65.1553	B. Barns	Philadelphia	77.50	19.50	.93	1.72	.00
1813–56	Teapot (sheet metal, bottom)	58.673	I. Trask	Beverly, Mass.	98.67	.00	.94	.00	.00

DATE	OBJECT	ACC. NO.	MAKER	LOCATION	TIN	LEAD	COPPER	ANTIMONY	BISMUTH
1814–56	Teapot (bottom)	63.664	E. Smith	Beverly, Mass.	97.93	.78	.19	.10	.98
1817–56	Teapot body spout	53.31	W. Calder	Providence	85.64 97.55	.00 .00	1.89 .45	11.43 1.85	.00 .00
1817–56	Cup (side)	53.155.18	W. Calder	Providence	90.55	.00	.18	8.91	.00
1817–22	Plate (bottom)	53.155.4	R. Palethorp, Jr.	Philadelphia	94.18	3.64	.23	1.93	.00
1820–27	Dish (bottom)	65.1554	S. Stafford	Albany	73.12	25.12	.87	.09	.00
1821–71	Creamer (handle)	64.86.3	R. Gleason	Dorchester, Mass.	93.24	.11	.81	5.81	.00
1821–71	Pitcher (bottom)	64.1157	R. Gleason	Dorchester, Mass.	88.23	1.82	1.72	8.08	.04
1821–71	Flagon (body)	64.1162	R. Gleason	Dorchester, Mass.	94.04	.03	1.05	4.88	.01
1827–29	Box (body)	60.334	Babbitt & Crossman	Taunton, Mass.	95.45	.15	3.02	.13	1.19
1828–53	Cup (bottom)	55.48.35	Boardman & Hart	New York City	90.28%	.73%	3.49%	5.42%	.00%
1828–53	Beaker (body)	63.653	Boardman & Hart	New York City	91.02	.57	1.10	6.60	.00
1830–34	Candlestick (base)	53.155.22	Taunton Britannia Manufacturing Co.	Taunton, Mass.	97.21	.10	1.20	1.48	.01
1830–34	Candlestick (shaft)	64.1152.1	Taunton Britannia Manufacturing Co.	Taunton, Mass.	94.43	.18	.78	4.57	.01
1830–38	Lamp (knop)	56.46.5	J. B. Woodbury	Beverly, Mass. & Philadelphia	89.15	4.10	2.33	3.71	.00
1830–45	Sugar bowl (side)	53.155.27	G. Richardson	Cranston, R.I.	94.95	1.91	.23	2.91	.00
1830–45	Teapot (side)	69.212	G. Richardson	Cranston, R.I.	91.67	4.75	1.00	2.68	.00
1830–55	Lamp (base)	65.1539	J. H. Putnam	Malden, Mass.	94.33	.60	1.27	3.75	.02
1835–65	Pitcher (side)	63.662	F. Porter	Westbrook, Me.	80.18	14.20	.90	3.72	.00
1837–40	Bowl (base)	56.46.22	Leonard, Reed & Barton	Taunton, Mass.	93.42	.00	1.23	5.26	.00

Cleaning Old Pewter

When pewter is discovered in attic or closet after a hundred years, it is usually dingy, dirty gray, or encased in a crusty scale of black oxide sometimes called "tin pest." To give it life, to release it from its chrysalis, requires patience and love—laundry soap, 0000 steel wool, metal polish, elbow grease, and sometimes lye or muriatic acid. OLD PEWTER MUST NEVER BE BUFFED on a motor-driven buffing wheel.

To clean pewter that is tarnished or dull gray, but not black or scaly, use 0000 or 00000 steel wool (000 will scratch and spoil the pewter), Noxon metal polish (available at most grocery stores), yellow laundry soap, Bon Ami, and cheesecloth or other porous cloth.

1. Wash the pewter with soap and water.

2. After washing, polish the pewter with soaped steel wool moistened with Noxon and covered with Bon Ami.

3. For objects that were originally skimmed on a lathe, rub in a circular motion in the direction of the skimming. In other words, rub around and around a plate, or the barrel of a mug or tankard. Sometimes it takes a half hour of polishing to get the pewter really clean.

4. After polishing with steel wool, wash the object thoroughly in sudsy water; then dry and polish with a soft, porous cloth until no black comes off on the cloth. This last operation is important. Without it, pewter will not stay bright very long.

Pewter that is black and scaly. If subjected to cold and damp, pewter will oxidize and become diseased, its surface covered with a black oxide or scale. This scale consists of tiny eruptions on the surface of the metal. Black scale is oxidized pewter, and when it is removed, the surface of the pewter will probably be pitted.

Scale can be removed by immersion in a solution of lye or muriatic acid, but this is a dangerous operation and should be undertaken only by an expert.

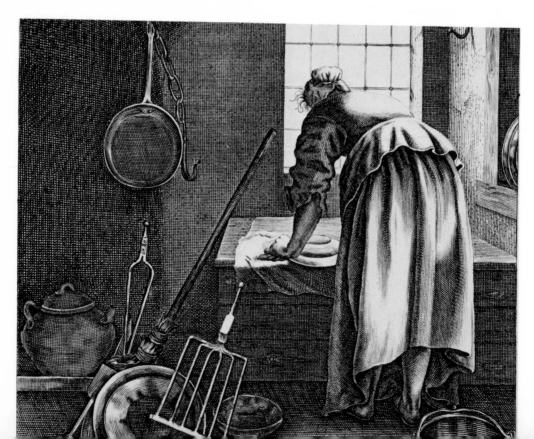

Bibliography

The *Bulletin of the Pewter Collectors' Club of America,* published semiannually since the founding of the club in 1934, charts the course of pewter collecting in the United States and provides much information not to be found elsewhere for the study of pewter objects. The club, with about 500 members, has proved a strong force in stimulating interest in pewter and encouraging research and dissemination of information on the subject. Of particular value for references to articles in the *Bulletin* as well as to other sources is Carolyn Denman's "A Bibliography of Pewter," which appeared in *Bulletin* no. 15 (October, 1945). In addition to its coverage of American pewter, the Denman bibliography also contains references to British, European, and Oriental pewter plus catalogues of exhibitions and sales.

Since 1945, indexes of *Bulletin* articles have been published at five-year intervals. These, with Miss Denman's bibliography, provide an excellent place to begin any research on pewter. Of great use are in-depth articles that often enable the reader to identify objects on the basis of small details. Notable among these are the following: "American Baptismal Bowls" by Charles V. Swain (*Bulletin,* nos. 60 and 61, August and December, 1969); a series of essays on the designs of American pewter porringers by Percy E. Raymond (*Bulletin,* nos. 39, 40, 41, March, 1958, January and September, 1959); "American Pewter Lamps" by Sandy Macfarlane (*Bulletin,* no. 57, December, 1967); "The Boardman Group" by Wendell Hilt (*Bulletin,* no. 52, May, 1965); "The Chalices of Johann Christoph Heyne—A Remarkable Survival" by John H. Carter, Sr. (*Bulletin,* no. 59, December, 1968); "Lee-Marked Pewter Porringer Handle Designs" by M. Ada Young (*Bulletin,* no. 67, December, 1972); "Nineteenth Century Chalices" by John F. Ruckman (*Bulletin,* no. 48, March, 1963). *Bulletin* no. 67 (December, 1972) contains many illustrations of communion sets including fine William Will and Johann Christoph Heyne examples.

Antiques magazine over a period of more than fifty years has carried many authoritative articles on both American and European pewter. These can be located through the magazine's periodic indexes.

Three long and extraordinarily useful articles on pewter and britannia appeared in the *Winterthur Portfolio,* published annually by The Henry Francis du Pont Winterthur Museum. A splendid survey of craft technology and wares of the nineteenth century was prepared by Nancy A. Goyne. Entitled "Britannia in America: The Introduction of a New Alloy and a New Industry," it appeared in *Winterthur Portfolio 2* (1965). A rich fund of Germanic cultural and craft influences on American pewtermaking is found in Eric de Jonge's study "Johann Christoph Heyne, Pewterer, Minister, Teacher." This long and well-illustrated article on Heyne appeared in *Winterthur Portfolio 4* (1968). Suzanne C. Hamilton's "The Pewter of William Will: A Checklist" is found in *Winterthur Portfolio 7* (1972). The article, listing 182 pieces of Will's pewter and illustrating 29, is based on one phase of Mrs. Hamilton's M.A. dissertation, "William Will, Pewterer: His Life and His Work, 1742–98," submitted to the University of Delaware in 1967. Her thesis is the first extensive study of an American pewterer and his products.

Of the many books written about American pewter, the standard and definitive work is Ledlie Irwin Laughlin's *Pewter in America: Its Makers and Their Marks.* Originally published in two volumes by Houghton Mifflin Company (Boston, 1940), it was reprinted in one volume in 1969 by Barre Publishers (Barre, Massachusetts) and updated in 1970 with a third volume, also published by Barre. Along with a tremendous number of facts on American pewter and pewterers, these large books contain all known marks and an excellent bibliography.

John Barrett Kerfoot's *American Pewter,* first published in 1924 (Boston: Houghton Mifflin Company), has been available for the past several years in reprint editions. Although this pioneer book is completely out of date, it is a delight to read.

National Types of Old Pewter by Howard H. Cotterell (New York: Antiques, 1925) is out of date, but it is still a worthwhile guide to the national characteristics of pewter forms. An expanded reprint edition (New York: Charles Scribner's Sons) is available.

A useful book for the collector is *A Guide to American Pewter* (New York: McBride Company, 1957), written by Carl Jacobs, a well-known antiques dealer of the 1950's and 1960's specializing in pewter. The book lists all known forms by each American pewterer and gives market prices for each object as of 1957. Since that time prices have increased tremendously, but the relationships remain comparatively unchanged. *The Pocket Book of American Pewter: The Makers and The Marks* (rev. 2d ed., Boston: Cahners, 1970), by Celia Jacobs is a handbook with drawings of the marks of most known American pewterers and useful for identification.

Because some American pewter forms and marks are similar to British examples, students and collectors often need to refer to English sources. The best book for this purpose is Howard H. Cotterell's *Old Pewter, Its Makers and Marks in England, Scotland, and Ireland.* First published in 1929 and reprinted in 1963 (Rutland, Vt.: Charles E. Tuttle Company), it includes all known marks and secondary marks of British pewterers as of 1929 with illustrations of hundreds of British pewter articles. This standard work, has not been superseded.

Index

Page numbers in **boldface** refer to illustrations.
Page numbers in *italics* refer to the makers' marks.

Chandlee, Goldsmith, **203**, 204, *278*
Chase, Benjamin, 14
Chippendale, Thomas, 30
Cleeve, Richard, 13
Clements, Geoffrey, 2
Coldwell, George, 71, 72, **160**, **178**, 191, **254**, **261**, *278*
Comer, John, 53
Compleat Appraiser, The, 27–28, 105, 133, 135, 143
Concord Antiquarian Society, 205
Coney, John, 170
Connecticut Historical Society, 58
Copeland, Joseph, 158, **161**, **253**, 270, *278*
Copley, John Singleton, 197
Cotterell, Howard Herschel, 51
Cotton, John, 58, 65
Couch, Ira, *264n*
Cowles, George (Lewis and Cowles), **188**, 189, *284*
Creesy [?] (Lee and Creesy), 40, 176, *284*
Crossman, West and Leonard (William W. Crossman, William A. West, and Zephaniah Leonard), 178, **194**, *278*
Crossman, William W., **202**, *275*, *278*
Culbertson, Ivan, 2, 223
Curtis, Stephen (Yale and Curtis), **99**, *289*
Curtiss, Daniel, 28, 130, **131**, 185, **187**, *279*

Danforth, Edward, 52, 61, 70, **122**, 123, 138, 148, 150, *279*
Danforth, Job, Jr., 33, *266n*
Danforth, John, 150, 152, *279–80*
Danforth, Joseph, Jr., *279*
Danforth, Joseph, Sr., 55, 61, 69–70, 138, 152, *279–80*
Danforth, Josiah, **110**, **146**, 148, 150, 166, 204, *279*
Danforth, Samuel (Hartford), 32, 61, **62**, 70, 79, 87, **108**, 109–10, 123, 144, **146**, **148**, **150**, 177, 213, 226, **230**, **236**, **252**, *258*, *280*
Danforth, Samuel (Norwich, Conn.), *279*
Danforth, Thomas I, 148, *265n*, *280*
Danforth, Thomas II, 70, 123, 213, **248**, *280*
Danforth, Thomas III, 61, **115**, 123, **146**, 159, 173, 176, **177**, **200**, 202, 213, **259**, *273*, *280*
Danforths, the, 28, 55, 66, 109, 138, 153, 227
Davis, Charles K., 2, 213, 219, 220–22, 223
Day, Benjamin, **120**, 121, 153, 227, **245**, *265n*, *280*
Delaplaine, Joshua, 183
Deming, Oliver W., 87
Derby, Thomas S., 55, *281*
Derr, Peter, **159**, 161, **163**, 164, *281*
Dixon, James, 178, 194
Dolbeare, Benjamin, 28, 121, *265n*
Dolbeare, Edmund, 28, 55, **136**, 137, 141, 227, **249**, **250**, *281*
Dolbeare, John, **45**, *281*
Dolbeare, Joseph, 141
Dolbeares, the, 58, *265n*
Dooley, William Germain, 209

Downs, Joseph, 1, 216, 219–20
du Pont, Henry Francis, 1, 141, 219, 222–23, 225
Dummer, Jeremiah, 73
Dunham, Rufus, 41, **98**, 101, 130, *281*
Dyott, Thomas W., 102

R. E. (unidentified maker), *281*
Earle, Alice Morse, 58, 88, 168
Edgar and Curtis, 156
Edgell, John, 227
Edgell, Simon, 2–3, 28, 46–47, 49, 55, 111, **115**, 116, 121, 133, 137–39, 141, 170, 201, 213, **216**, 217, **218**, 228, **244**, **248**, **249**, *265n*, *281*
Eggleston, Jacob, *281*
Elsworth, William J., 3, 158, **160**, *281*
Emerson, Charles, 15
Endicott, Edmund (Endicott and Sumner), **98**, *281*
Endicott and Sumner (Edmund Endicott and William F. Sumner), **98**, *281*
Estabrooke, Richard, 145
Evans, John J., Jr., *268n*
Evans, Nancy Goyne, 182
Evelyn, John, 168

Fenn, Gaius and Jason, **198**, 199, *282*
Fergus, William, 10
FitzGerald, Agnes, 213, 215
FitzGerald, Stephen, 213
Flagg and Homan (Asa F. Flagg and Henry Homan), **96**
Forbes, Elizur B., **131**, *282*
France, Joseph, 2, 116, 216, 223
Franklin, Benjamin, 15
Franklin, Paul J., 222
French, Reginald, 204
Fryers, John, 194

Gale, Edwards (*Pewter and the Amateur Collector*), 6, 205–06
Garvan, Francis P., 213, 225
Garvan, Mabel Brady, 213, **214**
Geare, Randolph L., 205
Girard, Stephen, 17
Glassford, James, 10
Gleason, Roswell, 38, 39, 41, 78, **86**, 87, 99, **100**, 101, 130, **131**, 168, **169**, 178, 184, 189, **190**, **240**, 246, *282*
Glenn, Eric, 2
Gooch, John, 21
Grame, Samuel, 20
Graves, Richard, 20, 22
Griswold, Ashbil, 19, 25–26, 41, **71**, 72, **201**, 203, *264n*, *270n*, *282*
Griswold, Giles, *282*

H. Yale and Company (Hiram and Charles Yale), 78
Haines, Edmond, 14
Hall, Boardman and Company (Franklin D. Hall and Henry S. Boardman), 185, **188**, *282*
Hall, H. B., 19, 72, *264n*